Praise for Harold Schechter's *Hell's Princess: The Mystery of Belle Gunness, Butcher of Men*

AN AMAZON CHARTS BESTSELLER

"In Harold Schechter's lucid and well-researched *Hell's Princess*, Gunness—his ruthless, devious protagonist and, according to the book's subtitle, a 'butcher of men'—deserves a prominent place in the annals of America's serial killers."

—*Wall Street Journal*

"With riveting and thorough detail, Schechter tracks the mystery of Lamphere's culpability in the arson and closes with a possibly related murder that took place decades after the 1908 house fire. True-crime fans will be hooked from the start."

—*Publishers Weekly*

"Featuring previously undiscovered details and rich historical context, this authoritative account firmly establishes Schechter as one of America's leading crime chroniclers. A fascinating and dramatic page-turner that will be a new favorite among true-crime fans."

—*Kirkus Reviews*

"[Schechter's] goal is to help us understand not just what his subjects did but also why they did what they did—what internal torments and psychological traits drove them to become brutal killers. A sharply written, compelling account from a proven winner."

—*Booklist*

"*Hell's Princess* is an excellent, spellbinding read. Schechter is a master storyteller and a true ethnographer of the old Midwest."

—New York Journal of Books

"This biography of a prolific and brutal serial killer will be of interest to Midwestern regional history buffs as well as true-crime fans."

—*Library Journal*

"Schechter's deep research and storytelling flair ensure readers will hang in to see if he can solve this century-old puzzle."

—*Ellery Queen's Mystery Magazine*

"The best books regarding criminality involve serial killers, and that is certainly the case for the best true-crime books of 2018 . . . Harold Schechter delivers a full-length background and overview of one of the worst murderers in American history that no one has heard of."

—Criminal

"This true-crime narrative does justice to the larger-than-life Belle Gunness and her fascinating context, keeping the reader immersed in the story even as we recoil from its many horrors."

—CrimeReads

"*Hell's Princess* takes its place among Schechter's other true-crime classics as the definitive rendering of one of the most beguiling and brutal of all female serial killers. His gruesome page-turner about Belle Gunness, grounded in meticulous historic research, confirms his reputation as one of the top true-crime writers of our time."

—Katherine Ramsland, *Psychology Today*

RIPPED
FROM THE
HEADLINES!

ALSO BY HAROLD SCHECHTER

NARRATIVE NONFICTION

Killer Colt: Murder, Disgrace, and the Making of an American Legend

The Devil's Gentleman: Privilege, Poison, and the Trial That Ushered in the Twentieth Century

The Mad Sculptor: The Maniac, the Model, and the Murder That Shook the Nation

Man-Eater: The Life and Legend of an American Cannibal

Hell's Princess: The Mystery of Belle Gunness, Butcher of Men

NONFICTION

Psycho USA: Famous American Killers You Never Heard Of

Savage Pastimes: A Cultural History of Violent Entertainment

Fatal: The Poisonous Life of a Female Serial Killer

Fiend: The Shocking True Story of America's Youngest Serial Killer

Bestial: The Savage Trail of a True American Monster

Depraved: The Shocking True Story of America's First Serial Killer

FICTION

RIPPED

FROM THE

HEADLINES!

**THE SHOCKING TRUE STORIES BEHIND THE
MOVIES' MOST MEMORABLE CRIMES**

HAROLD
SCHECHTER

Little
a

Published by Little A, New York

www.apub.com

Amazon, the Amazon logo, and Little A are trademarks of Amazon.com, Inc., or its affiliates.

ISBN-13: 9781542041805 (hardcover)

ISBN-10: 1542041805 (hardcover)

ISBN-13: 9781542041829 (paperback)

ISBN-10: 1542041821 (paperback)

Cover design by Faceout Studio, Jeff Miller

Printed in the United States of America

First edition

For the families of my wonderful nieces:

Beth, Avi, Ben, and Adam Davidovich

Ilene, Phil, Seth, and Justin Lewis

CONTENTS

AUTHOR'S NOTE

In the far-distant past, when boomers like me were kids, there was only one way to see a movie that you had failed to catch in theaters. You waited until it showed up on TV, where it would be interrupted every twenty or so minutes by commercials and, more often than not, edited with a cleaver to fit into a programming slot shorter than the original running time. So it's a source of unceasing wonderment to me that I now live in a moment when virtually every movie I want to see is instantly available on Netflix, Amazon Prime Video, YouTube, or any of the other excellent streaming services, not to mention on DVD and Blu-ray. This miraculous facet of the present age enabled me to rewatch (or, in a few cases, see for the first time) all of the movies covered in the following pages, and it is my hope that my necessarily brief treatments of these films will inspire readers to do the same.

FOREWORD

The 1956 thriller *The Wrong Man* opens with an overhead shot of what appears to be a cavernous soundstage completely shrouded in darkness, except for an illuminated slice of the floor. Into the light steps the tiny silhouette of a rotund gentleman who comes to a halt and begins to talk in an unmistakable British voice:

> This is Alfred Hitchcock speaking. In the past, I have given you many kinds of suspense pictures. But this time, I would like you to see a different one. The difference lies in the fact that this is a true story, every word of it. And yet, it contains elements that are stranger than all the fiction that has gone into many of the thrillers that I've made before.

Following this prologue, the film proper begins: the actual, Kafkaesque case of a down-at-the-heels musician falsely accused of robbery.

What strikes the modern viewer, watching *The Wrong Man* on Turner Classic Movies or Netflix, is Hitchcock's sense that he is presenting something unique, a startling true story. Clearly, filmgoers back then weren't accustomed to such a thing. Nowadays, of course, shocking reality—or its convincing simulation—is precisely what audiences demand.

For fans of true crime, our current cultural moment is a golden age, when the genre enjoys more legitimacy than ever before. Today's entertainment media—podcasts, network TV, cable stations, streaming services—offer a non-stop banquet of titillating, blood-soaked docudramas for forensic fans to feast on. An entire channel, Investigation Discovery, is devoted to round-the-clock

true-crime programming. As for the movies, prefacing a picture with the words "based on true events" has become the go-to way of ramping up audience interest.

The situation used to be different. With rare exceptions like Hitchcock's film, the crime stories that thrilled audiences in the past were assumed to be the pure products of the screenwriters' colorful imaginations.

However, the fact is that actual, notorious crimes have provided the raw material for fictional movies from the very beginning of the film industry. The first narrative film ever made, Edwin S. Porter's 1903 *The Great Train Robbery*—in which a band of six-gun-wielding desperados rob an express car—was modeled on the exploits of Butch Cassidy's Hole in the Wall gang. In the century that followed, scores of films—from acknowledged classics like Billy Wilder's *Double Indemnity* to blockbusters like Don Siegel's *Dirty Harry*—have been inspired by true crimes. *The Wrong Man* is the only film in which Hitchcock openly acknowledges his real-life source. As readers of this book will discover, however, other suspense thrillers by this master auteur were rooted in stranger-than-fiction reality.

Long before movies were invented, of course, American authors had turned to true crime as the basis for their fiction. One of the first novels ever published in this country, Charles Brockden Brown's 1798 Gothic thriller *Wieland*, was based on the case of a religious fanatic named James Yates who slaughtered his wife and four children in upstate New York. Some of Edgar Allan Poe's most famous tales were likewise inspired by sensational homicides of his time. "The Tell-Tale Heart," for example, sprang from newspaper accounts of a notorious New Jersey murderer who buried his victim beneath the basement floorboards.

In later generations, such great American novelists as Frank Norris, Theodore Dreiser, and Richard Wright forged literary masterpieces out of widely publicized murder cases. These and other artists recognized that the crimes that exert the most powerful grip on the public imagination are not necessarily the most savage or sadistic but those that tap into widely prevailing cultural fears, fantasies, and taboo desires.

In creating their own crime dramas, Hollywood filmmakers have drawn on real-life cases for much the same reasons: to explore (and exploit) the social problems of the day, to illuminate the dark recesses of the human mind, and to indulge viewers in the vicarious thrills of the forbidden. And, of course, there is

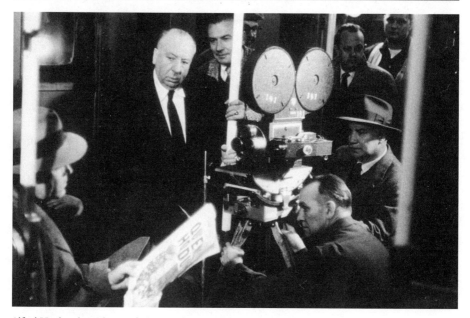

Alfred Hitchcock on the set of *The Wrong Man*, 1956.

the reason Alfred Hitchcock gives in his prologue to *The Wrong Man*: at times, real life offers stories, characters, and situations far more fantastic than anything even the most imaginative screenwriter can dream up.

In the following pages, readers will discover the sensational, often-shocking truth behind dozens of movies, ranging from art films like Terrence Malick's *Badlands* and Gus Van Sant's *Elephant* to cult classics like *Eaten Alive!* and *The Hills Have Eyes*. Full of fascinating revelations and believe-it-or-not facts, it is meant to be an eye-opening book both for movie lovers and for those true-crime aficionados that the genre's preeminent practitioner, Edmund Lester Pearson, memorably dubbed "murder fanciers."

ALPHA DOG
(2007)

DIRECTED AND WRITTEN BY NICK
CASSAVETES. WITH BRUCE WILLIS,
EMILE HIRSCH, BEN FOSTER, ANTON YELCHIN,
HARRY DEAN STANTON, SHARON STONE,
AND JUSTIN TIMBERLAKE.

This acclaimed crime drama/black comedy by Nick Cassavetes (son of John, the legendary godfather of indie cinema) opens with a home-video montage of bright-eyed little boys frolicking in what appear to be idyllic Southern California households circa the 1980s. These images of all-American childhood innocence are reinforced by Eva Cassidy's achingly lovely rendition of "Over the Rainbow" on the soundtrack. The movie proper—a sort of *Scarface* meets *Beverly Hills, 90210*—takes place twenty-odd years later when these adorable tots have grown up to be a gang of dimwitted potheads, who spend all their time getting high, watching rap videos, and having sex with their proudly slutty girlfriends.

The leader of this sleazeball crew is aspiring drug kingpin Johnny Trueblood (Emile Hirsch), a junior-league Tony Montana (whose poster occupies an honored place on the bedroom wall of one character). Johnny's criminal enterprise has the full support of both his dope-dealing dad (Bruce Willis) and his

profanity-spewing godfather (cult fave Harry Dean Stanton, as delightfully seedy as ever).

Trouble enters the carefree, drug-addled lives of Johnny and his posse in the lavishly tattooed form of Jake Mazursky, a junkie acquaintance who reneges on a $1,200 debt. Played by the scarily intense Ben Foster, Jake is a quivering mass of heavily muscled instability who can go from reasonable to rabidly unhinged in a heartbeat. In short order, the two are embroiled in a progressively violent vendetta.

After Jake breaks into Johnny's pad, smashes up the place, steals his flat-screen TV, and takes a dump on the living room rug, Johnny retaliates by abducting Jake's kid half brother, Zack (played by Anton Yelchin, the promising young actor who would come to a tragically premature end a few years later when his supposedly parked SUV rolled down a hill and crushed him to death). Since Zack's captivity consists of hanging out and partying with Johnny's right-hand dude, Frankie Ballenbacher (an excellent Justin Timberlake), he is not eager to be freed. When Frankie offers him a chance to escape, Zack turns him down, dreading the thought of returning home to his wussy dad and shrill, overprotective mom (Sharon Stone). This seems like a reasonable decision when he finds himself getting stoned with a couple of Frankie's girlfriends, who think that getting kidnapped makes Zack "fucking hot" and relieve him of his virginity during an orgiastic pool party.

By then, however, Johnny has discovered that the kidnapping might earn him serious jail time and decides that the best way to protect himself is to have his captive murdered, a job eagerly undertaken by one of his slavish minions. The movie—which, to this point, has functioned mostly as a luridly entertaining, suburban-kids-gone-wild dramedy—becomes genuinely heart-wrenching when Zack, believing that his new pals are taking him home, is driven out to the desert and executed. Unsurprisingly, Johnny's supposedly foolproof scheme to evade the law does not work out as intended, and the film concludes with the roundup of the various lunkheaded conspirators, whose fates we learn in the epilogue.

Since the film doesn't specify that it is based on true events, viewers can be forgiven for thinking that it must be pure Hollywood invention, especially in light of the behavior of Johnny and his crew, whose stupidity defies belief. In fact, the movie sticks close to the facts of a sensational case that riveted Southern

California at the start of the new millennium: the kidnap-murder of fifteen-year-old Nick Markowitz on the orders of Jesse James Hollywood.

Though it seems exactly like the kind of pseudonym a cocky young Angeleno drug dealer would concoct for himself, Jesse James Hollywood is, improbably enough, the actual name of the felon now serving a life sentence in California's Calipatria State Prison. Following in the illicit footsteps of his dad, a convicted drug dealer, young Hollywood began selling marijuana in high school. By the time he was nineteen, he was raking in as much as $10,000 a month, driving a black Mercedes, and living in a three-bedroom stucco house purchased with the proceeds of his booming operation. Like many pint-sized men, the five-foot-five-inch Hollywood was apparently afflicted with a Napoleon complex, manifested in the tyrannical sway he exerted over his sycophantic followers, especially a lost, fawning soul named Ryan Hoyt.

Among the crew who sold pot on consignment for Hollywood was an old high school buddy and seriously loose cannon named Ben Markowitz. Though he grew up in what, by most accounts, seems to have been a caring, upper-middle-class household, Ben was a deeply troubled kid who was slashing tires

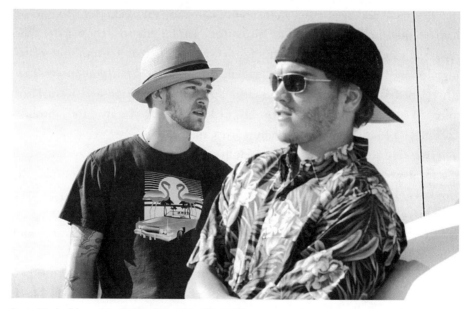

Justin Timberlake and Emile Hirsch in *Alpha Dog*, 2006.

at eleven, joyriding in stolen cars at twelve, and hanging out with street gangs at thirteen. Prone to terrifying outbursts of unbridled rage, he was kicked out of high school after smacking a girl during a lunchroom altercation. Soon afterward, he was arrested after splitting open a guy's head with brass knuckles. A frequent runaway from home, he left for good at fifteen, taking up temporary residence with a professional tattoo artist and part-time bounty hunter who eventually kicked him out for bringing drugs into his house.

In contrast to most of Hollywood's posse, Ben, who had a black belt in tae kwon do and a well-earned reputation as a street fighter, was not one to be intimidated by the swaggering young pot dealer. When a drug transaction gone bad left Ben about $1,200 in debt to Hollywood, the boyhood pals, who had played together in the same junior baseball league, got involved in a feud.

It began when one of Hollywood's flunkies made harassing middle-of-the-night phone calls to Ben. Things heated up after Hollywood and his girlfriend ran up a fifty-dollar tab at the brewery where Ben's fiancée worked as a waitress and stiffed her for the money, writing "Take this off Ben's debt" on a napkin. (In the movie, which adds a few sensational flourishes to the already sordid facts, the Hollywood character, Johnny Trueblood, leaves an even more inflammatory message inscribed on the check: "Tell your kike boyfriend to pay.")

Ben retaliated by alerting an insurance company to a scam that Hollywood had recently pulled when he sold his customized Honda to a chop shop, then reported it stolen and put in a claim for $35,000. From that point on, their late-night phone messages became increasingly threatening. "Yeah, you know where I live," Ben said in one voice mail, after spotting Hollywood and Ryan Hoyt loitering in front of his apartment. "But I know where you live, too, motherfucker. And I know where your family lives, too."

Not long afterward, Ben went to Hollywood's house with a pal and smashed the front windows, then left a taunting phone message: "How'd you like the window job? This is just the beginning, bitch! You're fucking dead, you little midget!" (The corresponding scene in the movie—in which the Ben surrogate, Jake, breaks into Johnny's house, steals his TV, and defecates on the living room rug—is another of the writer/director's lurid embellishments.)

A few days later, on Sunday, August 6, 2000, Ben's fifteen-year-old brother, Nick, who had snuck out of his house after an argument with his parents, was ambling along a sun-drenched sidewalk near a park when a white utility

van screeched to a stop. Inside were Jesse James Hollywood and two of his cronies, William Skidmore and Jesse Rugge (the real-life prototype for Justin Timberlake's Frankie Ballenbacher). The three were on their way to party at Fiesta, Santa Barbara's annual weeklong celebration of Spanish culture. Leaping from the van, they shoved Nick against a tree and demanded to know the where-abouts of his "asshole brother." When Nick insisted that he had no idea, they began "beating the crap" out of him (as one passing eyewitness later reported), then shoved him into the van and drove off.

Finding themselves with a hostage on their hands—and no idea what to do with him—Hollywood and his pals took him to Santa Barbara, where Nick was brought to the apartment of one of Rugge's friends. Though initially bound, gagged, and blindfolded, he was soon smoking pot and playing video games with his knuckleheaded captors. Over the next forty-eight hours, he was treated more like a junior member of Hollywood's inner circle than a prisoner. Taken to the home of Rugge's father, he spent his time watching TV, getting stoned, and par-tying with some teenage girls who affectionately dubbed him "Stolen Boy." From there, the group adjourned to a nearby hotel, the Lemon Tree Inn, where Nick found himself in a hot tub with a couple of young women, practicing (unsuc-cessfully) the pickup tips he had learned from his new friends. Throughout the forty-eight hours of his captivity, Nick was repeatedly assured that he would soon be released. Given the fun he was having, he was in no hurry to go home.

By then, however, Hollywood had confided in his lawyer, who enlightened him to the full legal ramifications of his reckless act. Deciding that the safest way to avoid imprisonment on a kidnapping charge was to eliminate his hos-tage, he assigned the task to the slavish Ryan Hoyt. On the night of August 8, Hoyt, Rugge, and a seventeen-year-old stoner named Graham Pressley drove Nick to a remote hiking trail called Lizard's Mouth. Semistupefied from the various substances he had imbibed during his long evening of partying at the Lemon Tree Inn, Nick was bound with duct tape and tossed into a freshly dug grave, then shot nine times by Hoyt, who was wielding a semiautomatic pistol provided by Hollywood.

Nick's hastily buried corpse, already badly decomposed, was discovered by some hikers a few days later. Within the week, police—having been tipped off by some of the teenage girls who had taken a shine to the Stolen Boy during his captivity—arrested Hoyt, Rugge, and several others of those involved.

Hoyt was eventually sentenced to death by lethal injection, and Rugge was sentenced to life in prison with the possibility of parole after seven years.

At the time of their trials, Hollywood—the so-called mastermind behind Nick's kidnap-murder—was long gone. With the aid of friends and family members (particularly his ever-devoted father, who provided financial support, along with a helpful network of shady business connections), Hollywood remained at large for five years. Pursued by the FBI and featured on the TV show *America's Most Wanted*, he eventually made his way to Brazil, where, under the name Michael Costa Giroux, he settled in the beach resort of Saquarema, an hour east of Rio de Janeiro. He was seated at an outdoor café with his seven-months-pregnant girlfriend on March 8, 2005, when the law finally caught up with him. Arrested by Interpol officers, he was deported to the United States. His month-long trial, which began in mid-May 2009, culminated with his conviction for kidnapping and first-degree murder. He was sentenced to life in prison without the possibility of parole.

ANATOMY OF A MURDER (1959)

DIRECTED BY OTTO PREMINGER. WRITTEN BY WENDELL MAYES. WITH JAMES STEWART, LEE REMICK, BEN GAZZARA, EVE ARDEN, ARTHUR O'CONNELL, GEORGE C. SCOTT, AND BROOKS WEST.

A native of Michigan's Upper Peninsula—"a wild, harsh, and broken land," as he described it—John D. Voelker worked as a lawyer at several small firms in the early 1930s before being elected to the position of prosecuting attorney of Marquette County. Following a defeat for reelection in 1952, he returned to private practice, while writing nonfiction books under the pen name Robert Traver. A few years later, while contemplating a book on the influence of weather conditions on human behavior, he had, as he later recounted, "a sudden impulse to write my first novel." The result was *Anatomy of a Murder*. Published in 1958, it immediately shot to the top of the bestseller lists and, the following year, was brought to the big screen by the brilliant, legendarily difficult director Otto Preminger (whose frothing outbursts and tyrannical treatment of underlings earned him the nickname "Otto the Ogre").

Long regarded as one of the greatest courtroom dramas ever made, Preminger's film was also notable for its groundbreaking frankness on sexual matters then regarded as taboo under the so-called Hays Code, the puritanical guidelines that Hollywood had adopted in the 1930s to avoid official censorship. Jimmy Stewart (whose own father is said to have found the movie so offensive that he took out an ad in his local newspaper urging his neighbors not to see it) stars as small-town lawyer and dedicated fly fisherman Paul Biegler, a character closely modeled on Voelker himself. As Biegler's trout-packed refrigerator attests, he's had plenty of free time to hit his favorite fishing holes. Clients have been scarce, a fact of which he is repeatedly reminded by his wry, long-suffering secretary, Maida (Eve Arden), whose loyalty never wavers, even though her salary is among the expenses her boss is too broke to pay. So Biegler's interest is naturally piqued when a big case suddenly comes his way.

Frederick Manion (Ben Gazzara), an arrogant, hot-headed army lieutenant, is in the local lockup after putting five bullets into a tavern keeper named Barney Quill, who allegedly raped Manion's young sexpot wife, Laura (Lee Remick). The lieutenant is confident that he will be acquitted on the basis of the "unwritten law," according to which a husband who finds another man in bed with his wife is justified in killing him. As Biegler informs him, however, the unwritten law is a myth. Moreover, since an hour elapsed between the time Manion learned of the assault and the moment he walked into the bar and started shooting, the crime clearly was not committed in the heat of the moment but was coldly premeditated. Biegler, whose folksy, aw-shucks manner cloaks a keen legal mind, must find a defense that will save his client from a conviction for first-degree murder.

Complicating matters is the questionable character of Laura, a vixen-like beauty in the habit of dolling herself up, heading alone to the nearest bar, and coming on to every man within range. When Biegler first meets her, she is sporting a black eye and other facial bruises, supposedly administered by Quill during his attack. However, another, equally plausible explanation for her injuries soon becomes clear: her possessive, violence-prone husband beat her up because he suspected that she was messing around with Quill. Indeed, *Anatomy of a Murder* is sometimes classified as a film noir, partly because of its atmospheric, black-and-white cinematography but mostly because Laura can be seen as an archetypal femme fatale, the seductress whose irresistible allure wreaks havoc on the life of any man unlucky enough to fall under her spell.

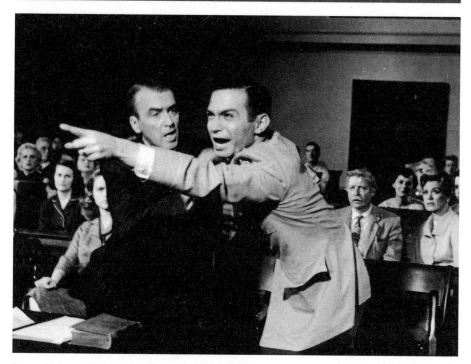

Jimmy Stewart and Ben Gazzara in *Anatomy of a Murder*.

The second half of Preminger's 161-minute movie is devoted entirely to the trial, in which Biegler—aided by a beloved old friend, Parnell McCarthy (Arthur O'Connell), a wise but washed-up attorney whose career was derailed by his love of the bottle—mounts a defense based on the obscure legal precedent of "irresistible impulse." Facing off against Biegler are the slightly buffoonish district attorney (Brooks West, Eve Arden's real-life husband) and, in his big-screen debut, George C. Scott as the slick (not to say oily) big-city prosecutor Claude Dancer.

Though the courtroom jousting between the opposing attorneys generates a fair amount of tension, Biegler's victory is never really in doubt. His triumph, however, is undercut by the film's concluding scene. Accompanied by Parnell (now on the wagon and promoted to full-time law partner), Biegler drives out to the Manions' trailer park to collect his long-deferred fee, only to discover that they have absconded in the dead of night, leaving nothing but a mocking note from the client he had fought so hard to free. This cynical twist reinforces the unresolved mystery at the heart of the movie: Was Barney Quill a rapist who

got what he deserved or just a red-blooded guy who fell victim to a husband's murderously jealous rage?

John Voelker, who had nothing but praise for Preminger's movie, always insisted that *Anatomy of a Murder* was a work of "pure fiction," inspired by various "bang-up murder trials" that he'd been involved with as a lawyer. In Michigan's Upper Peninsula, however—where the novel is set and the entire movie was shot—it was common knowledge that the novel was a thinly disguised version of an actual, highly sensational case. Indeed, in July 1960, exactly one year after the movie's release, both Voelker's publisher and Preminger's studio were hit with a $9 million libel suit filed by a Michigan nurse, Mrs. Hazel A. Wheeler, the widow of a man named Maurice "Mike" Chenoweth, whose 1952 slaying by US Army lieutenant Coleman Peterson was the basis for *Anatomy of a Murder*.

A tough-talking "man's man" in the old-fashioned, Hemingwayesque mold, Chenoweth had spent several years in the jungles of Nicaragua as a noncommissioned officer in the US Marines before joining the Michigan State Police, where he taught pistol shooting and judo, in addition to his other duties. He was featured on the front pages of local newspapers in 1946, when he was involved in the arrest and interrogation of Charles Gilbert, a thirty-five-year-old foundry worker who bludgeoned his young wife and four-year-old stepdaughter with an auto crank, then buried them in a shallow grave, possibly while they were still alive. The sheer horror of the crime raised doubts about Gilbert's sanity, but after being examined by three court-appointed psychiatrists, he was quickly tried, convicted of two counts of first-degree murder, and sentenced to life in prison. Six years later, Chenoweth himself would be at the center of a murder case involving the issue of the defendant's sanity. This time, however, he wouldn't be the arresting officer. He would be the victim.

After leaving the state police, Chenoweth became owner and bartender of the Lumberjack Tavern in Big Bay, a popular watering hole with locals. Though short, he was built like a bouncer and had no trouble dealing with rowdy customers, one of whom sued him for assault after being violently ejected from the bar. Chenoweth, who liked to display his marksmanship by shooting off the tops of clothespins while his wife was hanging laundry on the wash line, was known to keep a pistol behind the bar. He also had a reputation as a "hound dog" whose

marriage did not prevent him from hitting on tipsy female patrons (several of whom, according to local rumor, had suffered sexual assaults at his hands).

Among the regulars at the Lumberjack Tavern in 1952 were a recently arrived couple, the Petersons. The husband, Coleman—a square-jawed thirty-eight-year-old with a pencil moustache—was a first lieutenant in the US Army who had seen action in World War II and Korea. Assigned to an antiaircraft artillery range in the area, he lived in a trailer park with his wife, Charlotte, four years his senior. Photographs of Charlotte show an attractive woman in her middle years with wavy auburn hair, cat-eye glasses, and (as newspapers would describe her) a "shapely" figure. It was whispered around town that, when her husband was away on bivouac, as was often the case, she would show up at the tavern alone, where she would advertise her availability by behaving in a provocative way.

At around nine o'clock on the evening of Wednesday, July 31, 1952, while her husband was napping in their trailer, Charlotte, who had been cooped up all day, decided to visit the tavern. According to her own account, she spent the next couple of hours in a perfectly innocent way, having a few beers and playing shuffleboard. Witnesses, however, would report that she had been "carrying on" in a highly inappropriate manner for a married, middle-aged woman—dancing barefoot to the jukebox and flirting openly with the proprietor, Mike Chenoweth.

Exactly what happened when she left the bar around 11:00 p.m. is shrouded in uncertainty, though Charlotte would never waver from her version of events. As Charlotte was preparing to head back to the trailer park, Chenoweth offered her a lift, remarking that "there were too many rough lumberjacks around here for a woman to walk alone at night." Since she and her husband had always been on friendly terms with the bartender, she saw no reason to refuse. Instead of taking her home, however, he drove her into the woods, beat her, raped her, then threw her out of the car.

Around 11:45 p.m., according to his own later testimony, Lieutenant Peterson was awakened by a scream. Leaping from bed, he hurried to the door, where he found his wife "sobbing and breathless and hysterical." Her hair was disheveled, her face bruised and swollen, her skirt badly torn. Leading her to the daybed, he "tried to quiet her down and find out what happened." When she finally was calm enough to speak, she told him that she had been "assaulted and raped" by

Mike Chenoweth. As Peterson helped his wife out of her clothes, he saw that her panties were missing and one thigh was stained with semen.

After making her swear on a rosary that she was telling the truth, Peterson fetched the semiautomatic pistol he kept in the trailer "for protection"—a German Luger he had brought home from the war after removing it from the body of an enemy soldier. Stepping outside the trailer, he stood for a few minutes, scanning the surroundings to see if Chenoweth was lurking in the dark. Then he got into his car and drove to the tavern.

A dozen or so customers were seated at tables when Peterson arrived a few minutes later. Chenoweth was behind the bar, facing the entrance. Without a word, Peterson strode up to the bar, raised his pistol, and began firing. As Chenoweth collapsed, Peterson leaned over the bar and pumped the last few rounds into the proprietor's chest, stomach, and shoulder. He then straightened up and calmly strolled from the tavern.

Tavern manager Adrian Wentzl, who had been chatting with some friends at one of the tables, leapt to his feet, ran outside, and called, "Lieutenant!" As Wentzl would testify, Peterson turned and "asked me if I wanted one through the head." Peterson then got into his car and drove off.

Back at the trailer park, Peterson sought out the caretaker of the park, Fred Marsh, and informed him that he had just killed a man and that Marsh should notify the police. He was promptly taken into custody and locked up in the Marquette County jail.

Charged with first-degree murder, he retained the services of John Voelker, who scored an unlikely courtroom triumph by persuading the jury that his client had committed the murder while in the grip of an "irresistible impulse" that rendered him temporarily insane. Immediately following his acquittal, Peterson was ordered to undergo an examination by court-appointed psychiatrists to see if he merited confinement in a hospital for the criminally insane. Four days later, he was declared sane and released.

Expecting to be greeted warmly by his grateful client, Voelker went to the trailer park to collect his fee, only to discover that the Petersons had skipped town. Though cheated out of $3,000, Voelker ended up with something infinitely more valuable: the raw material for the novel that would make him rich and famous.

A HERO OF HIS TIME

Jimmy Stewart's fictional defense lawyer, Paul Biegler, may have been the hero of Otto Preminger's *Anatomy of a Murder*. But, as filmgoers of the 1950s were fully aware, he was sharing the screen with a real-life legal hero who had achieved celebrity status five years earlier, during the so-called McCarthy era.

That shameful episode in American history was named after Wisconsin senator Joseph McCarthy, who rose to political prominence and power in the post–World War II period by fueling a nationwide hysteria over the supposed infiltration of every corner of American life—from the government to classrooms to the entertainment industry—by Communist sympathizers bent on undermining our system of government. The lives and careers of countless citizens, falsely accused of treasonous activities, were destroyed during this notorious political witch hunt.

The beginning of the end for the red-baiting McCarthy came in 1954 during nationally televised hearings into the alleged existence of Communist agents within the US Army. Serving as special counsel for the army was sixty-four-year-old attorney Joseph N. Welch, a midwestern native and life-long Republican known for his incisive and commanding intelligence.

As the proceedings went on, Welch coolly and calmly demolished each of the accusations leveled by McCarthy, who grew increasingly agitated. The dramatic climax of their clash—witnessed on TV by an estimated eighty million viewers—came on June 9, 1954, when McCarthy accused a young member of Welch's law firm of being a member of a Communist organization. Welch, visibly stunned, took a moment to collect himself before delivering a rebuke that has become justifiably famous in US political history: "Until this moment, Senator, I think I never really gauged your cruelty or your recklessness . . . Let us not assassinate this lad further, Senator. You have done enough. Have you no sense of decency, sir? At long last, have you left no sense of decency?"

The audience in the chamber burst into wild applause. McCarthy never recovered from this public shaming. A week later, he was officially censured

by his colleagues in the US Senate. His insidious career—along with the paranoia he had stoked in the country—was effectively over.

When Otto Preminger set out to film *Anatomy of a Murder*, he insisted on absolute authenticity, transporting his cast and crew to Michigan's Upper Peninsula and shooting the entire movie at the actual locations connected to the real-life murder case, including the Lumberjack Tavern, John Voelker's home and law office, and the courthouse where the trial had taken place. In a shrewd bit of casting that brought the movie widespread publicity, including a lavish spread in the May 11, 1959, issue of *Life* magazine, Preminger also persuaded a genuine legal giant to appear in the movie: Joseph N. Welch, who turns in a winning performance as the presiding, no-nonsense Judge Weaver.

ARSENIC AND OLD LACE (1944)

DIRECTED BY FRANK CAPRA. SCREENPLAY BY JULIUS J. EPSTEIN AND PHILIP G. EPSTEIN, BASED ON THE PLAY BY JOSEPH KESSELRING. WITH CARY GRANT, PRISCILLA LANE, RAYMOND MASSEY, PETER LORRE, JOSEPHINE HULL, JEAN ADAIR, JOHN ALEXANDER, JACK CARSON, AND EDWARD EVERETT HORTON.

There's a common misconception that all serial killers are men. And it's certainly the case that, as culture critic Camille Paglia has noted, "there is no female Jack the Ripper." But this truism doesn't mean that there is no such thing as a female serial killer. It only means that women and men commit serial murder in different ways. There have been plenty of female psycho killers in our nation's history. Rather than butchering their victims, however, they almost always dispatch them with poison.

At first glance, this fact suggests that women serial killers are less sadistic than their male counterparts. However, compared to the lingering agonies

suffered by poisoning victims, the deaths inflicted by Jack the Ripper—who killed his victims swiftly by cutting their throats, then butchered their bodies postmortem—were humane.

There is another feature of female serial homicide that, in certain respects, seems even crueler than that perpetrated by men. Male serial killers tend to prey on strangers: prostitutes, pickups, and assorted "victims of opportunity," while women poisoners almost always murder people closest to them: husbands, children, siblings, friends, and trusting souls who rely on them for care.

In the late nineteenth and early twentieth centuries, when arsenic was readily available and medicine was still in a shockingly primitive stage, there was a rash of American Borgias (as they were called in homage to the notorious Renaissance femme fatale Lucrezia Borgia). One of the most prolific of these was Mrs. Amy Archer-Gilligan of Windsor, Connecticut.

Little is known about her background. She was born in 1868, the eighth of ten children of James and Mary Duggan of Milton, Connecticut. She was educated at country schools and worked briefly as a teacher. In later years, after her terrible crimes came to light, stories would emerge of a streak of mental instability in her family: a brother who spent his days sawing away at a violin in front of his bedroom mirror and ultimately was committed to the Connecticut General Hospital for the Insane and a sister who became a permanent invalid after throwing herself from the upper story of the family home.

In 1897, the twenty-nine-year-old Amy married James H. Archer. They became parents of a daughter, Mary, in 1898. Three years later, the family moved to Newington, Connecticut, and took up residence in the home of an elderly widower, John D. Seymour. While James worked at the Underwood Typewriter factory in Hartford, Amy served as Seymour's caretaker. In exchange for her services, the Archers were given their living quarters free of charge.

When Seymour died in 1904—apparently of natural causes—his heirs rented the house to James and Amy, who began to take in old and infirm boarders. They operated this fledgling nursing home until 1907, when the building's owners decided to sell the place. By then, James had quit his factory job. Relocating to Windsor, he and Amy purchased a three-story brick house and opened the Archer Home for Elderly People and Chronic Invalids. In exchange for a payment of $1,000—just short of $30,000 in today's money—inmates (as Amy referred to them) were guaranteed care for the remainder of their lives, plus a proper burial.

Just two years later, the Archers found themselves at the center of a scandal when they were sued by Narcissa J. McClintock of West Hartford, whose mother, Theresa, was a resident of the nursing home. The lawsuit accused the Archers of abusing the elderly Mrs. McClintock by "failing to care for her at such times as she needed care and refusing to administer to her wants when called upon and leaving her to suffer from severe chills without giving her water or medicine and upbraiding her for calling for assistance." It further charged that she was "allowed to remain in a filthy and unclean condition in a room which was filled with impure odors and improperly ventilated." Another patient, Mrs. Lucy Durand, lodged a similar complaint with the Connecticut Humane Society, which dispatched an agent to investigate the conditions at the Archer Home.

These early signs of trouble at the nursing home, however, were trivial compared to the outrages to come.

In February 1910, shortly after taking out a life insurance policy at his wife's behest, James Archer died suddenly. Though he had displayed no previous symptoms of the ailment, the official cause of death was given as Bright disease, a now-obsolete term for nephritis, or inflammation of the kidneys. In November 1913, Amy wed her second husband, Michael W. Gilligan, a wealthy widower nearly twenty years her senior. Three months later, having signed a will leaving his whole estate to his new wife, the seemingly healthy Mr. Gilligan suddenly fell ill and died, reportedly of "acute indigestion."

By then, the mortality rate at the Archer Home for Elderly People had undergone a shocking increase. There were just a dozen deaths at the residence between 1907 and 1911. That number quadrupled in the five succeeding years: forty-eight dead inmates between 1911 and 1916. One of them was Franklin R. Andrews, a vibrant sixty-one-year-old who spent the morning of May 29, 1914, working happily in the nursing home garden and was dead by evening after suffering a sudden onset of severe abdominal pain, nausea, and vomiting. The doctors attributed his death to "gastric ulcers."

Two years would pass before Andrews's sister, Mrs. Nellie Pierce—suspicious of the circumstances of her brother's death—prevailed upon authorities to investigate conditions at the Archer Home. On Tuesday, May 2, 1916, Andrews's body was exhumed from its grave in the Cheshire cemetery and carried to a toolshed, where an autopsy established that he had died from arsenic poisoning.

Interviewing the proprietor of the W. H. H. Mason drug store in Windsor, detectives learned that Mrs. Archer-Gilligan had purchased two ounces of arsenic, presumably as rat poison, four days before Andrews's death.

Other exhumations quickly followed. All revealed lethal quantities of arsenic in the stomachs of the deceased. "After our general investigation of affairs at the Archer Home," State's Attorney Hugh M. Alcorn announced, "we became certain that something was wrong. Then we exhumed the bodies and were convinced that it was a case of cool, calculating premeditated murder of inmates of the home."

The case became a nationwide sensation after the *Hartford Courant* ran a screaming banner headline on May 9, 1916: POLICE BELIEVE ARCHER HOME FOR AGED A MURDER FACTORY. A subhead declared MAY BE 20 WHO HAVE BEEN POISONED.

That estimate, according to some crime historians, was too low by half. "It is possible to conclude," writes one chronicler, "that forty persons came to their ends at her hands." Among her victims was her second husband, Michael Gilligan, whose exhumed body contained deadly levels of arsenic and whose will, leaving everything to his wife, was proved to be a forgery, written in her hand.

Indicted on five counts of first-degree murder, Amy Archer-Gilligan was, upon the motion of her attorney, tried for only one, the killing of Franklin Andrews. The proceedings opened on June 18, 1917. Witnesses for the state included Dr. Arthur J. Wolff, an expert toxicologist, who testified that the organs of the deceased contained enough arsenic to kill at least "four or five men," and druggist W. H. H. Mason, who produced records showing that, during one nine-month period, the defendant had "purchased one pound and eleven ounces" of the poison. Efforts by the defense to show that the arsenic found in Andrews's body was an ingredient of the embalming fluid were easily rebutted by the prosecution.

Summing up, State's Attorney Alcorn thundered at the atrocities perpetrated in the defendant's "dark and damnable murder hole." On Friday, July 13, after four hours of deliberation, the jury returned a guilty verdict, and Archer-Gilligan was sentenced to hang.

Two years later, however, after a successful appeal, she was granted another trial. It ended abruptly when, two weeks into the proceedings, she changed her plea from insanity to guilty of murder in the second degree and was sentenced

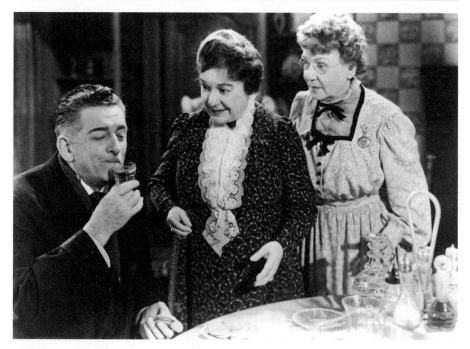

Edward Everett Horton, Josephine Hull, and Jean Adair, in *Arsenic and Old Lace*, 1944.

to life in the state prison in Wethersfield. In July 1924, she was declared insane by the prison physician, Dr. Percy B. Battey, and transferred to the state mental hospital in Middletown, where she lived out the remaining thirty-eight years of her life—a quiet, cooperative patient, who, as her April 24, 1962, obituary in the *Hartford Courant* noted, "became fond of playing funeral marches on the piano and carrying on long telephone conversations with herself."

As the contents of this book make clear, movies in various dramatic genres—thrillers, film noirs, horror flicks, et cetera—have been based on real-life multiple murderers. The case of Amy Archer-Gilligan represents a striking exception to this general rule. She is a rare, perhaps unique instance of a historical serial killer whose crimes served as the inspiration for a beloved comedy: Frank Capra's macabre madcap farce *Arsenic and Old Lace*.

The 1944 film is a screen adaptation of Joseph Kesselring's Broadway smash, which opened three years earlier and ran for over 1,400 performances. The stage origins of the movie are clear from its setting. With a couple of brief exceptions, the entire film takes place in a single, highly circumscribed space: the combined parlor and dining room of a two-story Victorian house in 1940s Brooklyn.

The home is the residence of two endearingly dotty old ladies, Abby and Martha Brewster (played by Josephine Hull and Jean Adair, who originated the roles on Broadway). The Brewster sisters are the maiden aunts of the film's star, Cary Grant, in the role of Mortimer Brewster. A famous theater critic, Mortimer is also known as a die-hard bachelor who has authored a bestselling book, *Marriage: A Fraud and a Failure.* When we meet him, however, he is in line at the city clerk's office for a marriage license, having fallen in love with a minister's daughter, Elaine Harper (Priscilla Lane), whose family lives next door to the Brewster home. After getting hitched, the couple heads to Brooklyn to inform their families of their wedding and pack their things for a Niagara Falls honeymoon.

Shortly after his arrival at his aunt's home, Mortimer discovers the corpse of an elderly man stashed in a window seat. He immediately assumes that the body has been placed there by his clinically insane brother, Teddy (John Alexander, also reprising his original Broadway role). A portly, mustachioed fellow who believes that he is President Theodore Roosevelt, Teddy divides his time between charging upstairs as if taking San Juan Hill and digging in the cellar under the delusion that he is excavating the Panama Canal.

When a stunned Mortimer tells his aunts that Teddy has killed a man, they laugh off the notion and cheerfully reveal their own "little secret." Known for their charity to needy strangers, the sisters have opened their home to lonely old men, who are then delivered from their travails with a nice glass of poisoned elderberry wine and given decent Christian burials in the cellar.

In an attempt to protect his aunts—badly misguided but thoroughly lovable creatures—Mortimer spends the rest of the film in an increasingly frantic attempt to have Teddy committed to a nuthouse, believing that, should the dozen corpses planted in the cellar ever be discovered, his blatantly crazy brother will take the blame. Though the epitome of debonair charm and grace, Cary Grant, who began his stage career as an acrobat, was a master of broad physical comedy and turns in a performance that would do any slapstick vaudevillian proud.

Adding to Mortimer's troubles is the unexpected arrival of his other brother, Jonathan (Raymond Massey), a homicidal maniac whose face has been turned into a crudely stitched Frankenstein mask by his companion, an alcoholic plastic surgeon named Dr. Einstein (played by the great Peter Lorre). In a running joke throughout the movie, people are constantly remarking on Jonathan's resemblance to Boris Karloff, who played the part in the original Broadway production.

The film, like the play, was both a critical and commercial success, offering audiences what the *New York Times* described as "a pleasant few hours escape from the real homicide en masse going on in World War II." It also had another, more lasting effect. Thanks to Capra's classic, people tend to think of Victorian-era female poisoners as quaint, almost comical figures: nutty old spinsters who enjoyed nothing better than spicing up a houseguest's meal with a little arsenic. But the deaths meted out by the likes of Amy Archer-Gilligan were no laughing matter.

BADLANDS
(1973)

**PRODUCED, DIRECTED, AND WRITTEN BY
TERRENCE MALICK. WITH MARTIN SHEEN,
SISSY SPACEK, WARREN OATES, RAMON BIERI,
AND ALAN VINT.**

The 1950s has been recast in the popular imagination as a bland, balmy era of simplicity and innocence—of sock hops and going steady and after-school milkshakes at Pop's Sweet Shoppe. Like all nostalgic myths about the long-vanished "good old days," this one is a heavily photoshopped picture of reality, omitting the fears and anxieties that kept Americans awake at night.

Along with nuclear fallout and the purported Communist infiltration of our schools, government, and entertainment industry, the specter that haunted the decade was the juvenile delinquent, the antisocial teen with his black leather jacket, duck's-ass haircut, and perpetual Elvis Presley sneer. Adult America's worst nightmares about its out-of-control youth seemed shockingly realized in January 1958, when a pair of thrill-hungry teens from Lincoln, Nebraska, perpetrated the decade's most horrifying murder spree.

Mercilessly teased since boyhood over his pint-sized stature, bowed legs, carrot-colored hair, and dirt-poor home life, Charlie "Little Red" Starkweather grew

Sissy Spacek stars alongside Martin Sheen in *Badlands*, 1973.

into a teenager filled with rage and, as he put it, a "hate hard as iron." Dropping out of school after ninth grade, he worked for a while as a garbage collector until his habit of yelling insults at strangers from the window of his garbage truck got him canned. A James Dean wannabe who affected the look and mannerisms of his idol, he saw himself as a romantic young rebel. In reality, the nineteen-year-old Charlie was a sawed-off sociopath with a grudge against everyone in the world—everyone, that is, except his underage sweetheart, fourteen-year-old Caril Ann Fugate, whose mother and stepfather did everything they could to discourage her relationship with the "swaggering, good-for-nothing" punk.

Charlie's simmering rage boiled over into homicide in early December 1957, when he knocked over a gas station on the outskirts of Lincoln, abducted the twenty-one-year-old attendant, drove him to the countryside, and shot him in the head with a hunting rifle. That brutally gratuitous slaying turned out to be a mere warm-up for the horrors to come.

Seven weeks later, on the afternoon of January 21, 1958, he showed up at the Fugate house carrying his rifle. Caril hadn't gotten back from school, so Charlie made himself at home. When her mother and stepfather let him know that they

didn't want him hanging around their daughter anymore, Charlie, as he later put it, "let both of them have it with my rifle." He then murdered their two-and-a-half-year-old daughter—Caril's half sister—by beating in her skull with the rifle butt. He stuck the baby's corpse in a cardboard box and stashed Caril's mom and stepdad in an outhouse and a chicken coop, respectively.

Exactly how much Caril knew about this bloodbath has never been clear. She later claimed that, by the time she returned from school, Charlie had hidden the bodies and she had no idea that her family was dead. As skeptics would point out, however, the single-story house was so small that it would have been hard to conceal evidence of a triple murder from anyone occupying the same cramped quarters.

In any event, Caril did not behave like someone terribly concerned with the whereabouts of her missing family. Within hours of the slaughter, she was snuggling happily on the sofa with Charlie. They stayed shut up in the house for the next six days, watching TV, pigging out on junk food, and having sex. To make sure they weren't interrupted during this romantic idyll, Caril tacked a note to the front door: "Stay a Way Every Body is Sick with the Flu."

With the food running low and Caril's relatives growing more suspicious by the day, the teen lovers took off in Charlie's souped-up jalopy, embarking on what *Life* magazine would call an "orgy of slaughter." On a farm southeast of the city, Charlie killed seventy-one-year-old August Meyer with a shotgun blast to the head, then beat the old man's dog to death for good measure. With their car bogged down in the mud outside Meyer's home, he and Caril hitched a ride with two high schoolers, seventeen-year-old Robert Jensen and his sixteen-year-old sweetheart, Carol King. In short order, the two were forced at gunpoint into a deserted storm cellar, where Charlie put three bullets into Jensen's head, raped King, then "forced a knife into her vagina" and "left her lying on top of [her boyfriend's] body."

Returning to Lincoln in Jensen's car, Charlie and Caril drove to a fashionable neighborhood that was familiar to Charlie from his former garbage-collecting days and entered the house of a prominent businessman, C. Lauer Ward. Ward's wife, Clara, and their housemaid were forced into a bedroom, then bound, gagged, and stabbed to death. Ward was shot to death when he returned from work later that day.

Exchanging Jensen's stolen Ford for Ward's high-end Packard, the killer couple headed for Wyoming, where Charlie hoped to find refuge at the home of his brother. In the meantime, with the discovery of the massacre at the Ward home, panic gripped the region. The local sheriff formed a hundred-man posse, the governor called the National Guard, parents kept children home from school, and companies booked hotel rooms so that their employees wouldn't have to drive home along the roads where the killers might be roaming.

Ten hours after fleeing the Ward home, Charlie spotted a car parked along the side of a deserted highway. Deciding to ditch the Packard because it was "too hot," he pulled up beside the car and fired nine shots through the driver's window, killing a traveling salesman named Merle Collison who was napping behind the wheel. It would be Charlie's last murder. Shoving Collison's body onto the passenger seat, he and Caril got into the car. Charlie, however, couldn't manage to release the emergency brake. When another motorist stopped to offer help, Charlie brandished his rifle, and the two were soon locked in a death struggle over the gun. Just then, a highway patrol car driven by an officer named William Rohmer happened onto the scene. As Rohmer pulled to a stop, Caril burst from Collison's car, shouting, "Help! It's Starkweather! He's crazy! He's going to kill me!"

Relinquishing the rifle, Charlie leapt into the Packard and sped off. Rohmer called for backup, then took after him. During the high-speed chase that followed, the pursuing officers managed to shoot through Charlie's windshield. Braking his car, he staggered out, moaning that he had been hit and was bleeding to death. In reality, one ear had been slightly cut from the shattered glass. "You're a real tough guy, ain't you?" sneered the policeman who cuffed him and led him away.

In custody, Charlie readily, even proudly, admitted to all eleven murders. At first, he went along with Caril's claim that she had been his captive and had no part in the slaughter. It wasn't until she offered to testify against him that he turned on her, accusing her of being an active accomplice in the killing spree. Convicted of first-degree murder, Charlie was sentenced to the electric chair. Caril likewise was convicted but received a sentence of life imprisonment; she won parole after only eighteen years behind bars. "I just want to be an ordinary dumpy housewife," she announced upon her release. "Wash the socks, burn the toast."

Fitting neatly into the mold of a favorite Hollywood genre—the doomed, young outlaw lovers on the lam, which dates back to Fritz Lang's 1937 *You Only Live Once*—the Starkweather-Fugate saga became the basis for several films. The cheap shocker *The Sadist* (1963) portrays a teenage psycho couple who spend their screen time terrorizing a trio of schoolteachers. Oliver Stone's assaultive, hyperviolent *Natural Born Killers* (1994) transformed the tragedy into a lurid cartoon.

By far, the finest motion picture inspired by the case—and the one that sticks closest to the facts—is Terrence Malick's remarkably accomplished debut, *Badlands*. Martin Sheen (thirty-three at the time, though easily passing for twenty) plays the Starkweather stand-in, Kit Carruthers. Sissy Spacek is his baton-twirling inamorata, Holly Sargis, a freckle-faced teenybopper whose sensibility, as conveyed in a trademark Malickian voice-over, seems to have been entirely shaped by pulp true-romance magazines. As they make their way across a landscape infused with the director's usual visual poetry, Kit casually slaughters a string of innocent victims, while Holly hovers nearby, displaying no more emotion than a schoolgirl on a slightly boring date. Her closing voice-over, delivered in her unvaryingly flat, detached tone, sums up their fate following their capture:

> Kit and I were taken back to South Dakota. They kept him in solitary, so he didn't have a chance to get acquainted with the other inmates, though he was sure they'd like him, especially the murderers. Myself, I got off with probation and a lot of nasty looks. Later I married the son of the lawyer who defended me. Kit went to sleep in the courtroom while his confession was being read, and he was sentenced to die in the electric chair. On a warm spring night, six months later, after donating his body to science, he did.

THE SADIST

If *Badlands* transforms the Starkweather-Fugate saga into cinematic poetry, James Landis's *The Sadist*—released a decade before Malick's brilliant debut—turns it into unapologetic, down-and-dirty pulp. This no-budget grindhouse

classic concerns a trio of high school teachers: wimpy fifty-two-year-old Carl, strapping army vet Ed, and buttoned-up beauty Doris. In venerable horror-movie tradition, they venture off the beaten path on their way to a Los Angeles Dodgers game and end up in the clutches of the titular psycho, Charley Tibbs, and his underage sweetie, Judy.

Played by Arch Hall Jr. (beloved by aficionados of schlock cinema for his starring role in the giant-caveman howler *Eegah*, certified as one of the worst movies ever made), Charley is a blue-jean-wearing troglodyte with an extravagant pompadour, a moronic giggle, and a Colt .45-caliber semiautomatic pistol with which he has already dispatched a half-dozen victims. His gum-chewing girlfriend, who does not utter a single intelligible word in the movie, is a sexed-up teenybopper; when she isn't adding to the general repulsiveness of the proceedings by sloppily French-kissing her porcine beau, she whispers inaudible suggestions in his ear on ways to further torment their victims.

Unfolding in real time and set almost entirely in a creepy automobile junkyard, this genuinely harrowing film—inventively shot by future famed cinematographer Vilmos Zsigmond (credited as William Zsigmond)—subjects viewers to ninety-two minutes of relentless tension. The climax would become a hallmark of later masterworks like *The Texas Chain Saw Massacre*: the frantic "final girl" in desperate flight from an implacable, weapon-wielding monster.

BLOOD & ORCHIDS (1986)

DIRECTED BY JERRY THORPE. WRITTEN BY NORMAN KATKOV. WITH KRIS KRISTOFFERSON, JANE ALEXANDER, MADELEINE STOWE, MATT SALINGER, JOSÉ FERRER, SEAN YOUNG, JOHN LILUOHE, AND WILLIAM RUSS.

Given the sheer number of sensational murder cases that generated frenzied media coverage in the decades between the 1906 shooting of celebrity architect Stanford White and the 1994 double slaying that culminated in the O. J. Simpson trial, most people would have a hard time singling out a crime of the century. Some might pick the 1924 "thrill killing" committed by Leopold and Loeb, others the 1932 kidnapping of the Lindbergh baby, others the 1966 mass murder perpetrated by Richard Speck or the 1969 enormities of the Manson family. The situation is different, however, in Hawaii, where, if asked to name the most notorious crime of the twentieth century, residents would not hesitate to name the Massie Affair, a once internationally famous case that has mostly faded from the collective memory of mainland Americans.

Its name derives from its central figure, Thalia Massie. Twenty at the time of the events that propelled her onto the front pages of newspapers around the world, Thalia was the daughter of two high-living parents with fancy pedigrees but limited financial resources. Her father, Granville Roland Fortescue—the illegitimate son of Teddy Roosevelt's "raffish" Uncle Robert—burned through his relatively modest inheritance by the time he was in his forties and shunned gainful employment as beneath his social status. Her mother, Grace—a near relative of telephone inventor Alexander Graham Bell—was a strong-willed beauty reduced to giving bridge lessons to keep the household afloat.

Shipped off to exclusive boarding schools by beneficent relations, Thalia saw relatively little of her increasingly acrimonious and neglectful parents. Afflicted with a thyroid condition that left her with bulging eyes, severely impaired vision, and a lifelong struggle with her weight, she grew into a heavy-drinking, cigarette-smoking, ungoverned teen with a reputation for her "extremely immodest . . . actions in front of young men." In 1927, at the age of sixteen, she met and married twenty-two-year-old Naval Academy cadet Thomas Massie, a fun-loving fellow who shared her enjoyment of such high-spirited pranks as snatching an unattended baby from the lobby of a movie theater and scaring the parents into believing that their child had been kidnapped.

Thanks to Thalia's increasingly unfettered behavior—which, according to rumor, included "running around . . . with almost any man who looked prosperous and clean"—their relationship soon deteriorated into a constant round of drunken, sometimes physically violent quarrels, often conducted in public. In May 1930, they moved to Hawaii, where Tommie had been assigned to a submarine squadron in Pearl Harbor. Under threat of divorce, Thalia made some effort to mend her irresponsible ways, but she continued to find her life almost unbearably stultifying, while Tommie found himself caught in a marriage that was a source of unending conflict and humiliation.

On the evening of Saturday, September 12, 1931, the Massies, along with two other couples, drove to the Ala Wai Inn, a popular Waikiki nightclub. Left alone while Tommie hung out with his buddies, Thalia, bored and angry, drifted upstairs, where she managed to get into a nasty altercation with a drunken naval lieutenant who called her an insulting name and was repaid with a smack on the face. Shortly afterward—sometime around midnight—Thalia left the nightspot on her own.

Several people later testified that they saw her walking in the direction of the beach, "as if . . . under the influence of alcohol." Not far behind was a white man in a dark-brown suit who, according to one of the witnesses, "looked like a soldier."

A few minutes before 1:00 a.m., two couples driving to a restaurant for a late bite after an evening of card playing, Mr. and Mrs. Eustace Bellinger and the George William Clarks, were flagged down by a frantic young woman, her face badly bruised. After assuring herself that they were "white people," the woman, who gave her name as Thalia Massie, told them that she had been attacked by "five or six Hawaiian boys" who had pulled up behind her as she was walking home, dragged her into their car, punched her in the mouth, then drove her to "a clump of trees" and dumped her out before speeding away. In response to the delicately phrased query of Mrs. Clark, Thalia said that she had not been sexually assaulted and asked to be driven home.

Not long after she was dropped off, Tommie, who had continued carousing with his pals, called home to check on Thalia's whereabouts. "Come home," she cried. "Something awful has happened." By the time he arrived a few minutes later, Thalia's story had changed. Sobbing hysterically, she now claimed that she had not only been "kidnapped and beaten by a gang of Hawaiians" but dragged into some bushes and "violently raped six or seven times."

Over Thalia's objections, Tommie telephoned the police. Questioned by detectives, Thalia repeated the story of her rape. Beyond identifying her assailants as "Hawaiian," however, she could provide few details. In the dark of the moonless night—and without her eyeglasses—she had not been able to make out the faces of the men. When asked about the car, she replied that she believed it was a black "old-model" Ford with a ripped cloth top.

By the time Thalia finished her story, police already had their suspects in mind. About ninety minutes earlier, at 12:45 a.m., a married couple driving home from a party—Homer Peeples and his wife, Agnes—had nearly gotten into a collision with a carload of young men. Both vehicles screeched to a halt, angry words flew between the occupants, and one of the young men, a prizefighter named Joe Kahahawai, burst from his car shouting threats at the Peepleses. Not one to be intimidated, the formidable Mrs. Peeples, a tall Hawaiian woman "built like a Sherman tank" (in the words of her daughter), stepped out of her car and got into a shoving match with Kahahawai, who cuffed her on the ear.

Before their fight could escalate, the two were separated and the cars sped off in different directions, though not before Mrs. Peeples wrote down the license plate number of the other vehicle. She then ordered her husband to drive to police headquarters, where she reported the assault and provided the plate number, 58-895.

Assuming that Thalia's assailants and the young rowdies who had scuffled with the Peepleses were the same, the police quickly tracked down the owner of the car, a Japanese woman, Haruyo Ida. Miss Ida, they learned, had loaned the car that evening to her brother Horace, who had driven it to a luau with four of his buddies, Joe Kahahawai, Benny Ahakuelo, David Takai, and Henry Chang. Under interrogation, Ida and the others admitted that they were the ones who had engaged in the tiff with Mrs. Peeples but adamantly denied any involvement in the attack on Thalia Massie.

The five suspects had an array of facts in their favor: airtight alibis as to their whereabouts at the time of the attack and a parade of corroborating witnesses; Thalia's insistence that all the assailants were Hawaiian, whereas Ida and Takai were Japanese; her description of their car as a black Model T with a big tear in its top, whereas Ida's vehicle was a new, light-tan Model A with a perfectly intact cloth roof. Moreover, several physicians who examined Thalia found no evidence that she had been raped.

None of these factors, however, kept the local tabloids from denouncing the five suspects as a "gang of fiends" who had kidnapped and repeatedly ravished a young "white woman of refinement and culture." Rumors flew that Thalia had been "violated" in "all three orifices," that her abductors had "kicked her and broke her pelvis and . . . bit the nipple practically off one of her breasts." In the meantime, Thalia—who had initially stated that she had not caught a glimpse of her assailants' license plate—now suddenly remembered the number, 58-805, a nearly exact match of the plate on Ida's car. Though this sudden recollection was undoubtedly facilitated by the fact that police radios had repeatedly broadcast Ida's plate number within Thalia's hearing, investigators took it as confirmation of the guilt of the five "dark-skinned brutes."

The trial of Ida and his four companions began on November 16, 1931, and continued for three weeks. The prosecution did its best to portray the defendants as a vicious gang of "lust-sodden beasts" who had horribly violated the innocent victim, reducing her to an outraged "mass of beautiful young flesh." With no

corroborating evidence beyond Thalia's highly dubious testimony, however, the case against the five young men was easily dismantled by the defense. After deliberating for more than ninety-seven hours, the mixed-race jury declared themselves hopelessly deadlocked, and the defendants were released pending retrial.

The outcome raised racial tensions on the islands to a fever pitch. Among the nonwhite population, there was little doubt that Ida and the others were being framed for a rape they didn't commit—indeed, that might not have happened at all. Most whites, on the other hand, were infuriated by the jury's failure to arrive at a verdict. As one tabloid editorialized, if the legal system could not convict criminals as manifestly guilty as the five "depraved mongrels," Honolulu would never be safe from all the "foul, slimy creatures crawling through the streets" and attacking "innocent and defenseless" white women. Lashed into a frenzy by the racist press, a group of sailors abducted Horace Ida at gunpoint, drove him to a remote area, and subjected him to a savage assault with fists, belts, and gun butts.

Worse, however, was still to come. Fiercely determined to vindicate her daughter's good name, Thalia's domineering mother, Grace Fortescue, decided to take matters into her own hands. Convinced that the only way to ensure a conviction was to wrest a confession from one of the accused, she enlisted Tommie and two other navy men, Albert Jones and Edward Lord, in a nefarious plot. On January 8, 1932, as Joe Kahahawai was leaving the Judiciary Building following his daily check-in with a probation officer, he was abducted in broad daylight by the conspirators and driven to Grace's home; after threatening to kill him unless he confessed, one of the sailors shot him dead with a bullet in the chest.

Wrapping the bloody corpse in a bedsheet and loading it into the back seat of their automobile, Grace, Tommie, and Edward Lord headed toward Hanauma Bay, intending to dump the body off the promontory Koko Head and into the surging waters at the base of the cliff. As a precaution, Grace, seated in the back, pulled down the rear window shades. By then, however, Kahahawai's cousin Eddie, who had been with him that morning and witnessed the abduction, had alerted the police and provided a description of the kidnappers' blue Buick sedan. On the lookout for the car, two officers spotted a blue Buick with its rear window shades suspiciously drawn. Giving chase, they forced it off the road, discovered the murdered man's body, and arrested Grace and her cohorts.

The Massie case, until then mostly a local affair, now exploded onto the front pages of newspapers around the country. Far from displaying remorse, Grace expressed unalloyed pride in having avenged her daughter's shame, declaring to one interviewer that "she originally came from the South" where "they had their own way of dealing with 'niggers.'" By and large, the mainland media not only endorsed but celebrated her crime, portraying the lynching of Joe Kahahawai as a justifiable "honor killing."

"Before you condemn the individuals for the astounding drama which rocked Honolulu on January 8, 1932," ran one typical article, "ask yourself this question":

> What would you do if your girlish wife—your lovely daughter— had been brutally assaulted, raped . . . by five men of alien blood, beaten with such violence that her jaw was broken and her body maimed by cruel blows? What would you do if you felt that police had bungled the investigation—if, despite positive identification, a jury had failed to convict—if the criminals, admitted to bail, moved insolently about the city after the mistrial, virtually flaunting their legal victory—*what would you do?*

Though Grace couldn't begin to afford his services, her high-society friends chipped in to retain the greatest defense attorney of the day, Clarence Darrow. A lifelong champion of progressive causes, the seventy-four-year-old legend was in desperate financial straits, his retirement funds having been wiped out by the stock market crash. Much to the dismay of his admirers, the man who had recently been involved in the defense of the Scottsboro Boys—the nine African American teenagers falsely accused of raping two white women on an Alabama-bound train—now agreed to represent four racist vigilantes.

In the course of the three-week trial, which occupied most of April 1932, Darrow argued that Joe Kahahawai's murder was justified under the "unwritten law"—the widely held belief that a husband has the right to kill a man who has assaulted his wife. His emotional closing speech, broadcast live on the radio, lasted nearly four-and-a-half hours and brought listeners to tears. Despite this typically bravura performance, the jury was not convinced. Grace and her three codefendants were found guilty of manslaughter, a verdict that carried a mandatory ten-year sentence.

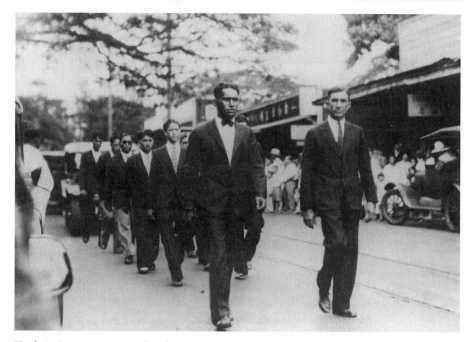

The funeral procession in Honolulu for Joseph Kahahawai.

Justice, however, would not be served. Bowing to political pressure from the mainland, Territorial Governor Lawrence Judd commuted the sentences from ten years to one hour, which the four defendants spent in his office—drinking champagne, by some accounts. Four days later, they boarded an ocean liner for San Francisco, where, upon their arrival, they were greeted like Hollywood celebrities.

Exactly what happened to Thalia on the night of September 12, 1931, remains a matter of speculation. A thorough, month-long investigation by Pinkerton detectives concluded that, while there was "a preponderance of evidence that Mrs. Massie did in some manner suffer numerous bruises about the head and body," there was "nothing in the record . . . to establish the occurrence of rape upon her." Whatever the extent of the assault, moreover, it was "impossible

to escape the conviction" that it was "*not* caused by the accused." Rumor laid the blame for her battered face on various suspects: the unidentified man seen following her on the night of the incident, an illicit lover, or even Tommie, who—so the whispers went—had flown into a rage when he got home from the nightclub and discovered her in the arms of a shipmate.

There is no such ambiguity in the 1986 made-for-TV movie *Blood & Orchids*, the fictionalized version of the Massie Affair, based on a novel by Norman Katkov. At the very start of the movie, the Thalia Massie character—here, a pretty young navy officer's wife, Hester Ashley Murdoch (Madeleine Stowe)—leaves a country-club dance for an outdoors tryst with her husband's best buddy, Bryce Parker (Matt Salinger). When, following their lovemaking, he announces that he is breaking off their affair, she informs him that she is pregnant with his child and has no intention of aborting it. Flying into a rage, he brutally beats her and hurries away, leaving her naked and bleeding in the shrubbery.

Shortly afterward, she is discovered by four Hawaiian youths who have been out for some innocent Saturday-night fun—drinking beer, skinny-dipping in the ocean, riding around in a borrowed roadster. Though his pals urge him not to get involved, one of the young men, Robert André (John Liluohe), insists on taking her to the emergency room. When the doctors cast suspicious looks at André and his pals, wondering what the young Hawaiians are doing with a naked white woman, the four Good Samaritans take flight.

Shortly thereafter, Hester's cold-blooded socialite mother, Doris Ashley (Jane Alexander), shows up at the hospital. Hester, an infinitely more sympathetic character than her real-life prototype, reveals the truth to her mother: she was beaten up by her lover, Bryce, and is carrying his baby. Since her daughter's adultery, if revealed to the world, would bring disgrace on the family name, Doris browbeats the decent but weak-willed Hester into claiming that she was raped by the young Hawaiians, who are promptly arrested.

While the movie's hero—the tough-talking, fedora-wearing detective Captain Curt Maddox (Kris Kristofferson)—works to uncover the truth, the four innocents are brought to trial. In the shocking climax to the first half of what was originally a two-part miniseries, Hester's cuckolded hubby, Lieutenant Lloyd Murdoch (William Russ), shamed into action by a racist subordinate named Butrick, leaps from his seat in the spectator section of the packed courtroom and shoots André in the head.

Tried for murder, Lloyd is defended by the elderly, Darrow-like Walter Bergman (José Ferrer), whose sexy, much-younger wife, Leonore (Sean Young), loses no time in hopping into bed with Detective Maddox. In the meantime, the three remaining Hawaiian boys are abducted by a group of sailors led by the vicious redneck Butrick, strung up by the arms, and savagely flogged with heavy-buckled garrison belts.

Though Kristofferson's character is pure Hollywood invention, most of the events in *Blood & Orchids* have analogies in the Massie case. Where the movie departs most dramatically from reality is in its depiction of the Thalia figure, Hester. During her husband's trial, when Bergman argues that his client was merely avenging his wife's rape by the four Hawaiians, Hester can no longer stand the lie and leaps from her seat, shouting that the boys are innocent. By contrast, Thalia stoutly maintained during both trials that Joe Kahahawai and his friends were the men who raped her, a direct contradiction of her statement to police on the night of the incident, when she insisted that it was too dark for her to make out the faces of her assailants.

Moreover, in the final moments of the movie, Hester, wracked by anguish, hangs herself in the shower. The real-life Thalia did, in fact, commit suicide but not until 1963, when, after decades of a highly troubled life, she overdosed on barbiturates. As for her feelings about the murder of Joe Kahahawai, she breezily declared that, while she was "sorry that the man was shot, he got no more than he deserved."

THE BODY SNATCHER (1945)

DIRECTED BY ROBERT WISE. WRITTEN BY PHILIP MACDONALD AND VAL LEWTON (UNDER THE PSEUDONYM CARLOS KEITH). WITH BORIS KARLOFF, BELA LUGOSI, HENRY DANIELL, RUSSELL WADE, AND EDITH ATWATER.

Following an early career as a newspaper reporter and novelist whose oeuvre included a pulp bestseller and a pseudonymous book of pornography, Russian-born Val Lewton made his way to Hollywood, where he became the right-hand man of legendary producer David O. Selznick. In 1942, after eight years of working on films such as *Gone with the Wind* and *A Tale of Two Cities*, he was named head of a new unit at RKO studios, dedicated to turning out low-budget horror movies. His first production, *Cat People*—regarded by many cinema buffs as the greatest B movie ever made—established the darkly poetic approach that would distinguish all his films: a type of horror that works not by delivering cheap monster-movie scares but by stirring up shadowy fears through atmospheric effects and the power of suggestion.

Before his premature death by heart attack at the age of forty-six, Lewton produced a string of these "horror noir" gems, the last three of which starred fright-film icon Boris Karloff: *Isle of the Dead*, *Bedlam*, and—arguably the creepiest of the bunch—*The Body Snatcher*. Though most of Lewton's films were original stories generated from titles supplied by his studio bosses, *The Body Snatcher* was based on a preexisting work, a short story by the great Scottish author Robert Louis Stevenson. Stevenson's tale, in turn, was inspired by one of the most sensational criminal cases in British history, the corpse-harvesting murders of William Burke and William Hare.

In early nineteenth-century Britain, aspiring young physicians flocked to Edinburgh, Scotland, the country's leading center of medical education. In addition to its renowned university, the city was home to a group of talented younger surgeons who ran private anatomy schools. These instructors, however, faced a radical shortage of a basic teaching resource: human cadavers for dissection. Under the provisions of the law then in effect—the so-called Murder Act of 1792—the only corpses that could be legally dissected for research or teaching purposes were those of hanged criminals.

With the demand for freshly dead human specimens far exceeding the available supply, a new breed of entrepreneurs sprang up, practitioners of what one scholar has called "the foulest trade in human history." Variously known as body snatchers, resurrectionists, and sack-'em-up men, these enterprising ghouls, typically working in small teams, would sneak into a churchyard at night, dig up a freshly buried coffin, pry open the lid, extract the corpse, stuff it in a sack, and—after restoring the grave to its former condition—deliver their plunder to one of their regular medical school customers. So brisk was this business that, to prevent their recently deceased loved ones from ending up on a dissection table, the citizens of Edinburgh resorted to various measures, including the posting of armed guards in graveyards and the installation of iron cages known as "mortsafes" around newly interred coffins.

Though Burke and Hare have entered popular lore as the most infamous of all British body snatchers, they were not, strictly speaking, members of that

loathsome fraternity. Disinclined to engage in the difficult, dirty, and dangerous business of grave robbing, they hit on another, less strenuous method of obtaining marketable human corpses: serial murder.

Born sometime between 1792 and 1804 (according to varying accounts), William Hare spent his early manhood as a farm laborer in his native Ireland. When construction began on a new canal connecting Edinburgh and Glasgow, he migrated to Scotland to work on the waterway. After several years of toil, he settled in Edinburgh, where he boarded in a tenement lodging house run by a man named Logue and his hard-bitten wife, Margaret. When Logue died, Hare lost no time in taking his place both in Margaret's bed and as landlord of the squalid doss-house.

Among the lodgers at that time was another Irish immigrant, William Burke, roughly the same age as Hare and also a former canal worker. Having deserted a young wife and two children back home, he was living bigamously with a former prostitute named Helen McDougal—Nelly, as he called her—and eking out a living as a cobbler. The two fellow transplants from Ulster quickly forged a close bond of friendship.

The commercial partnership that would earn them everlasting infamy began in November 1827 with the passing of an elderly lodger named Donald, who died owing Hare four pounds of back rent. To recover the debt, Hare hit upon the idea of selling the old man's corpse to an anatomist. Promised a share of the proceeds, Burke helped his friend convey the cadaver to the anatomy school of celebrated surgeon Dr. Robert Knox, where they received the handsome sum of seven pounds, ten shillings and were told that they were always welcome to return "when they had another [body] to dispose of."

An opportunity to accept that invitation arose a few months later when another lodger, an elderly widower named Joseph, fell ill with typhus. Afraid that having a contagious old man on the premises might scare off potential customers, Hare once again enlisted Burke's assistance. After feeding Joseph enough whiskey to put him in a stupor, the two made short work of him: one pressed a pillow to his face while the other lay across his chest, which both kept the victim from thrashing around and sped up the suffocation process by making it harder for him to breathe. This time, Knox forked over ten pounds for the corpse. At no point, either then or thereafter, did the doctor inquire as to the provenance of the goods that he was paying for.

There is some dispute over the identity of the next victim. Historians of the case disagree on whether it was another ailing lodger, an unnamed Englishman in his forties, or "an old beggar woman" named Abigail Simpson, who was plied with drink and lured to Hare's premises. However, all agree that, in dispatching this individual, the two murderers perfected the smothering technique that would come to be known as "burking": Hare would press his hands over the person's mouth and nose while Burke lay across the upper body.

Over the next six months—between April and October 1828—the two fiends (as they would soon be branded in newspapers throughout the United Kingdom) would murder an additional fourteen people, for a total of sixteen. Among their victims were a destitute old woman and her mute, twelve-year-old grandson; an elderly female lodger named Mary Haldane and her grown daughter, Peggy; an eighteen-year-old simpleton nicknamed "Daft Jamie"; and a teenage prostitute, Mary Paterson, whose body was of such "voluptuous form and beauty" that Knox preserved it for three months in a barrel of whiskey before dissecting it.

The atrocities of the ghoulish pair climaxed—appropriately enough—on Halloween, October 31, 1828. That morning, Burke—who was now living with his wife at a different lodging house, after a brief falling-out with his partner—lured a poor Irishwoman named Madgy Docherty to his rooms. After seeking out and notifying Hare that he had found fresh meat for Dr. Knox's dissection table, Burke returned to his rooms, where, in preparation for the murder, he persuaded the other lodgers, a couple named Gray and their child, to spend the night elsewhere. Once the Grays were gone and Hare was on the scene, the two dispatched the old lady by their usual method and stuffed her corpse beneath a heap of straw at the foot of a bed.

The following morning, Mrs. Gray's suspicions were aroused when, having returned to the rooms to fetch a pair of her child's stockings, she approached the bed and was sharply warned away by Burke. Later in the day, when Burke left the house on an errand, she took the opportunity to satisfy her curiosity by looking under the straw and was horrified to see the old lady's dead body, stripped of its clothing, blood leaking from her mouth. By the time Mrs. Gray reported her ghastly discovery, the two serial murderers had already delivered the corpse to Dr. Knox's quarters, where police found it the following day. Burke and Hare were promptly taken into custody.

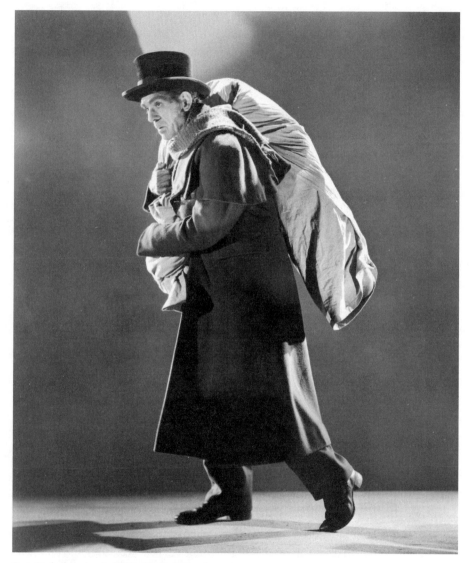

Boris Karloff starring in 1945's *The Body Snatcher*.

To save his own skin, Hare agreed to turn King's evidence and testify against his accomplice; betrayed by Hare, Burke was tried for the Docherty murder, convicted, and sentenced to death. An estimated 25,000 people turned out for his hanging on January 28, 1829. It took Burke about ten minutes to die. After dangling from the rope for an additional thirty or so minutes, his corpse was cut down and transported to an anatomy school run by one of Dr. Knox's rivals, where it was dissected before a standing-room-only audience of medical students.

The following morning, the corpse was placed on public exhibition. By the end of the day, some 30,000 eager citizens had filed through the anatomy hall for a glimpse of the ghastly remains. The cadaver was then stripped of its flesh and the skeleton given to the University of Edinburgh, where it can be viewed today at the school's Anatomical Museum. Some of the skin was tanned and fashioned into various ghoulish artifacts, including a calling card case (on display at Edinburgh's Police Museum) and a wallet.

William Hare was released, made his way out of Scotland, and vanished from the historical record. Dr. Knox was never charged with any crime, and though his reputation was permanently blighted by his association with the infamous corpse peddlers, he remained professionally active until his death in 1862.

Cowritten by producer Lewton and directed by Robert Wise (who would later win Oscars for both *West Side Story* and *The Sound of Music*), *The Body Snatcher* takes place in Edinburgh in 1831, two years after William Burke's execution. The opening sequence introduces us to the young hero, medical student Donald Fettes (Russell Wade), who is eating lunch among the tombs in a churchyard. At his feet lies a despondent dog that has refused to leave the grave of his young master since the lad's burial a week earlier. When the dead boy's mother shows up, she tells Fettes that it's just as well that Robbie (as the "wee doggie" is named) won't come home, since he serves as a guard against body snatchers. "They're uncommon bold, the grave robbers," she sighs, "and the daft doctors that drive them on."

Having briskly established its ghoulish subject matter, the film then introduces its other principals: Dr. Toddy MacFarlane (Henry Daniell), an eminent surgeon who runs an anatomy school, and the film's villain, a cab driver named John Gray who moonlights as a grave robber and who is played with malevolent glee by Boris Karloff. Though we initially assume that the seedy cabman is an underling of the suave, successful surgeon, it soon becomes clear that Gray exerts a dark hold over his employer and takes sadistic delight in taunting MacFarlane.

Offered the job of MacFarlane's assistant, the innocent Fettes, who believes that the anatomy school is run according to strict regulations, is promptly divested of his illusions. MacFarlane informs him that, to obtain a sufficient supply of bodies for dissection, the school must resort to unlawful means. We get a glimpse of those means that very night, when a shadowy figure, wielding various digging tools, sneaks into the churchyard where the faithful dog, Robbie, remains on guard. Though his features are shrouded in darkness, we can tell that this intruder is the sinister Gray. In the movie's most heinous act (at least as far as any animal lover is concerned), he kills the pooch with his shovel. Shortly thereafter, Gray shows up at the medical school with a freshly exhumed corpse and cheerfully collects his standard ten-pound fee.

The following morning, during one of his anatomy classes, MacFarlane flies off the handle when one of his students makes a joke about Burke and Hare. Later in the film, we learn why he is so sensitive on the subject when he and Gray share a few drinks at a tavern. The two, it turns out, have a long history together, dating back to MacFarlane's student days, when he was the assistant of Dr. Robert Knox. Gray's knowledge of this dark secret—MacFarlane's close association with Knox and involvement with the infamous Burke and Hare—is the source of his power over the surgeon.

Gray himself progresses from resurrection man to murderer when, rather than risk plundering another grave so close on the heels of his last job, he kills a beautiful beggar girl and delivers her corpse to the anatomy school. Discovering this crime, MacFarlane's menial, Joseph (played by Karloff's fellow horror legend, Bela Lugosi), shows up at Gray's cheerless living quarters and demands hush money. Pretending to be impressed with Joseph's grit, Gray suggests that they go into the "burking" business together. The dimwitted Joseph, who hails from Lisbon, has never heard of Burke and Hare, so Gray treats him to a lively recap of their story, complete with a climactic demonstration of their trademark

suffocation technique, performed on the would-be blackmailer. Gray then carries Joseph's corpse to MacFarlane's school and presents it to his old friend as a "gift."

Determined to rid himself of his tormentor, MacFarlane visits Gray and offers him a bribe to go away. When Gray refuses, the enraged doctor leaps at him and, after a ferocious struggle, beats him to death. As the film has suggested all along, however, Gray is not merely the surgeon's nemesis but his doppelgänger, his shadow self—the personification of MacFarlane's inescapable, guilt-haunted conscience. "You'll never get rid of me that way, Toddy," are the last words that Gray speaks before MacFarlane sets upon him.

The ending of the movie—"as hair-raising a climax to a horror film as you are ever likely to see," in the words of famed film critic James Agee—confirms that prediction. Seated with Fettes at a tavern, celebrating his liberation from Gray, MacFarlane learns that a young woman has just been interred in a remote churchyard. Seeing an opportunity to procure a fresh subject for his students, the doctor pressures Fettes into helping him exhume the corpse. After loading it onto the front seat of their carriage, they gallop away in a thunderstorm. As the rain lashes down and the wind howls, MacFarlane hears Gray's mocking voice cry, "Never get rid of me! Never get rid of me!" Drawing the carriage to a halt, MacFarlane pulls aside the shroud of the body propped up beside him and, in the flash of a lightning bolt, sees the face of Gray. As he cries out in horror, the horse bolts, and the carriage goes plunging through the darkness and over a cliff, with Gray's naked corpse enfolding the doctor in a ghastly embrace.

BURKE AND HARE
AT THE MOVIES

Though the serial murders by Burke and Hare served as the inspiration for Val Lewton's *The Body Snatcher*, the Edinburgh fiends do not appear as characters in the film. We only hear about them from the grave robber, John Gray, who describes their crimes to the soon-to-be-"burked" blackmailer, Joseph.

A number of other films, however—which vary widely in tone, quality, and historical accuracy—have been made about the odious pair.

In 1948, three years after Lewton's movie hit the screens, the Burke and Hare story was retold in a low-budget British shocker, *The Greed of William Hart* (retitled *Horror Maniacs* for its US distribution). Adhering closely to the facts, the movie was originally conceived and shot as a nonfiction account, using the actual names of the principal characters and titled *Burke and Hare*. At the insistence of British censors, however, the names were changed from Burke, Hare, and Knox to Moore, Hart, and Cox, and the title altered accordingly. For fans of British horror cinema, a prime attraction of the film is the typically over-the-top lead performance by actor Tod Slaughter, a shameless scenery chewer who first gained fame on stage for his wildly popular role as Sweeney Todd, the legendary Demon Barber of Fleet Street.

Twelve years after this version, its screenwriter and assistant director, John Grilling, did a remake called *The Flesh and the Fiends* (a.k.a. *Mania*). Restoring the actual names of the main characters, the movie features a distinguished trio of British character actors in the roles of Knox, Burke, and Hare: Peter Cushing (costar, with Christopher Lee, of the much-beloved Hammer horror movies, beginning with 1957's *Curse of Frankenstein*); Donald Pleasence (best known to horror fans as psychiatrist Sam Loomis in John Carpenter's *Halloween* and various sequels); and George Rose (a multiple Tony Award–winning actor who ended up as the victim in a real-life horror story when, during a visit to the Dominican Republic in 1988, he was tortured and murdered by a group of men that included his own adopted son).

Pseudonyms are used again in 1985's *The Doctor and the Devils*, a film with a particularly classy pedigree. Directed by Freddie Francis, who began his career as an Academy Award–winning cinematographer, the film was written by acclaimed playwright Sir Ronald Harwood, who based it on an unproduced screenplay by the great Irish poet Dylan Thomas. Its cast includes future 007 Timothy Dalton as the Dr. Knox character (here called Dr. Rock) and, in the roles of Burke and Hare (renamed Broom and Fallon), Stephen Rea (Oscar nominee for best actor in 1992's *The Crying Game*) and Jonathan Pryce (a much-lauded star of stage, screen, and TV, perhaps best known nowadays as the High Sparrow in *Game of Thrones*).

Though the movie embellishes the gruesome tale with various Hollywood-style flourishes, including a romantic subplot involving Rock's assistant (Julian Sands) and an improbably fresh-faced prostitute played by 1960s supermodel Twiggy, it sticks relatively close to the facts. Pryce and Rea are thoroughly convincing as the two scuzzy, murderous lowlifes, and the squalid slum setting in which they conduct their ghastly business is so richly evoked that the reek of corruption virtually wafts off the screen.

John Landis's *Burke and Hare* (2010) also boasts first-rate production values and a stellar cast. In stark contrast to all previous versions, however, it plays the story for laughs. Landis, who first hit it big as director of the 1978 blockbuster *National Lampoon's Animal House*, is much admired in the world of movie geekdom for his 1981 horror-comedy, *An American Werewolf in London*, a movie that struck a perfect balance between bona fide scares and black humor. *Burke and Hare* tries for the same combination of tones but with much less effect. The title characters are played by Andy Serkis (the master of motion-capture acting, best known for his roles as Gollum in *The Lord of the Rings* trilogy and the heroic simian Caesar in the recent *Planet of the Apes* series) and Simon Pegg (a frequent comic presence in movies since his breakout role as Shaun in *Shaun of the Dead*). As presented in the movie, the two aren't the heinous corpse merchants of fact but a pair of slapstick bumblers, "an evil Laurel and Hardy," as Landis has described them. Though intermittently amusing and rich in period detail, the film is less funny and creepy than it tries to be (or thinks it is)—the reason, clearly, for its dismal performance at the box office.

BUTTERFIELD 8
(1960)

DIRECTED BY DANIEL MANN. WRITTEN BY
CHARLES SCHNEE AND JOHN MICHAEL HAYES.
WITH ELIZABETH TAYLOR, LAURENCE HARVEY,
EDDIE FISHER, DINA MERRILL, MILDRED
DUNNOCK, BETTY FIELD, AND JEFFREY LYNN.

The juiciest Hollywood scandal of the late 1950s involved the recently widowed Elizabeth Taylor. Not long after her third husband, producer Mike Todd, died in a plane crash, the superstar actress embarked on a torrid affair with Todd's best friend, singer Eddie Fisher (father of the future Princess Leia), who was married at the time to America's sweetheart, Debbie Reynolds. The Liz-Eddie-Debbie soap opera (which climaxed in May 1959, when the two illicit lovebirds tied the knot) kept the American public riveted—and titillated—for months.

Seeking to capitalize on Taylor's notoriety as an oversexed homewrecker, her studio cast her as the lead in the movie version of John O'Hara's controversial 1935 bestseller, *BUtterfield 8* (the title refers to old-fashioned telephone exchanges in New York City, which used place names instead of numbers, such as PEnnsylvania 6-5000 for 736-5000). Though Taylor balked at playing a character she regarded as a "sick nymphomaniac," she finally agreed after the studio

Elizabeth Taylor starring in *BUtterfield 8*, 1960.

acceded to her various demands, which included casting her new hubby in the plum role of the protagonist's platonic best friend. Her decision would eventually pay off when she won the 1961 Academy Award for best actress.

Though often misleadingly described as a call girl, Taylor's character in the film, Gloria Wandrous, is not a professional sex worker but a promiscuous party girl. Indeed, she gets highly incensed in the opening scene when she wakes up in the bed of her latest pickup, a philandering husband named Weston Liggett (Laurence Harvey), and discovers that he has left her an envelope full of cash after going to work. The crux of the movie—one of those lush studio melodramas that, to a contemporary viewer, often borders on high camp—involves the tortured love affair between the sexually besotted Liggett and the bed-hopping Gloria. A once-promising lawyer who gave up his career when he married into wealth, Liggett now finds himself with a high-paying but meaningless job in his father-in-law's chemical company and a beautiful, devoted, boringly conventional wife (Dina Merrill). Wallowing in self-contempt, he has taken to heavy drinking and compulsive skirt chasing.

Gloria is equally full of self-loathing. Molested by a family friend when she was thirteen, she describes herself in periodic outbursts as "the biggest tramp in the whole city," "the slut of all time." Though her relationship with Liggett begins for each as nothing more than another cheap one-night stand, it quickly explodes into a tempestuous affair full of steamy sex, violent quarrels in fancy restaurants, and some of the most groan-worthy dialogue ever to issue from the pen of a Hollywood screenwriter. (At one point, as they are boarding Liggett's sailboat for a bout of below-deck lovemaking, Gloria asks, "Where are you bound for, Captain?" "Bound for ecstasy," he breathlessly replies.) Their mutually self-destructive relationship comes to its inevitable, melodramatic conclusion when, fleeing in her sports car from one final rendezvous at a tawdry motel (or "roadside brothel," as its cynical proprietress calls it), Gloria crashes into a construction site, goes airborne, and is killed in a fiery crash.

Gloria Wandrous's death by automobile accident is one of the many differences between the cinematic version of *BUtterfield 8* and its literary source, which climaxes with its heroine's fatal plunge from a passenger boat. That ending, like much else in the novel, derives from the sensational real-life case that served as John O'Hara's acknowledged inspiration: the mysterious death of the wayward young socialite Starr Faithfull.

Though it sounds like the contrivance of a cheesy romance novelist, Starr Faithfull was her actual name. She came from a socially prominent family that had fallen on hard times. Her mother, the former Helen Pierce, was a native of Andover, Massachusetts, who traced her lineage to colonial times. Her stepfather, a luckless entrepreneur named Stanley E. Faithfull, counted Oliver Cromwell among his forebears. Despite their impressive bloodlines, the Faithfulls—who resided in a Greenwich Village apartment that was a few doors down from the home of New York City mayor Jimmy Walker—were chronically cash-strapped and depended on handouts from wealthy relatives, particularly Andrew J. Peters. A career politician with powerful friends and a formidable résumé—US congressman from Massachusetts, assistant secretary of the treasury under Woodrow Wilson, mayor of Boston between 1918 and 1922—Peters was married to Mrs. Faithfull's first cousin Martha.

Born in 1906, Starr grew up to be a brown-haired beauty with hazel eyes, a flawless complexion, and a "lusciously curved" figure (in the words of chronicler Fred J. Cook). She would achieve international notoriety—and become a tragic symbol of the fast-living, free-loving, hard-drinking, post–World War I lost generation—following the events of June 8, 1931. That morning, Daniel Moriarty, a municipal worker scouring a Long Island beach for any treasures that might have washed up with the tide, found her partially clad corpse lying facedown in the sand. The physician who performed the autopsy concluded that she had drowned, probably in shallow water, judging from the quantity of sand in her lungs. Nasty bruises on her torso and limbs suggested that she had been subjected to "rough handling" before her death. There was also enough barbiturate in her system to have put her into a stupor.

At first, her stepfather—whose bulging brow, goggle-sized glasses, and toothbrush moustache gave him the look of a cartoon mad scientist—portrayed her to reporters as a sweet-tempered, virginal homebody. It wasn't long, however, before the shocking truth came to light: a lurid tale of decadence and depravity tailor-made for tabloid exploitation.

Beginning at age eleven, when she was a student at a private school in Lowell, Massachusetts, Starr had been "instructed in the mysteries of life," as the newspapers coyly put it, by a male relative old enough to be her father. This individual, initially identified in the press as a "prominent and respected member of the community [with] children of his own," had continued to molest her for years, sometimes sedating her with whiffs of chloroform or ether before subjecting her to "perverted sexual acts." Though her parents noticed disturbing changes in their daughter's behavior during her adolescence, they remained ignorant of the situation until June 1926, when the twenty-year-old Starr returned from an overnight stay in a Manhattan hotel with her "fatherly" relative and finally spilled the truth. Stanley Faithfull's response to this appalling revelation was to immediately retain a lawyer, who negotiated a $25,000 settlement in exchange for the Faithfulls' silence.

With the payoff money from her abuser, Starr was sent on various supposedly recuperative cruises to the Mediterranean, the West Indies, and Europe, during which she routinely engaged in sex with ship officers. Back in New York City, she developed a habit of crashing the bon voyage parties aboard docked ocean liners, getting drunk, and coming on to the crew. On one occasion, she

wasn't identified as a stowaway until the ship had left the pier, at which point she was forcibly removed to a passing tug and transported in hysterics back to land. She was also a habitué of speakeasies, sleazy nightclubs, wild parties attended by mobsters, and hot-sheet hotels, at one of which she was badly beaten up by her male pickup. A memory book discovered among her possessions detailed her sex life with nearly twenty men, identified in the diary by their initials.

Given her history of sneaking aboard steamships on the night before their departure, police initially surmised that Starr, doped-up and suicidal, had stowed away on an ocean liner, the *Ile de France*, and thrown herself overboard soon after it sailed. The theory that she had killed herself was reinforced when one of her lovers turned over several letters recently sent to him. "It's all up with me now," she had written in one,

> I intend to accomplish my end this time . . . I want oblivion. If there is any afterlife it will be a dirty trick. Nothing makes any difference now. I love to eat and can have one delicious meal with no worries over gaining . . . It's a great life when one has twenty-four hours to live. I don't have to dread being a lonely old woman or poverty or obscurity. I certainly have made a sordid, futureless mess of my worthless, disorderly bore of an existence. I am dead, dead sick of it. It is no one's fault but my own—I hate everything so—life is horrible. I take dope to forget and drink to try and like people, but it's no use. I have strangely enough more of a feeling of peace or whatever you call it now that I know it will soon be over.

Stanley Faithfull, however, insisted that his stepdaughter had been murdered. He was also convinced that the perpetrator was her longtime abuser, the older relative whose identity he finally revealed to a stunned and titillated world: his wife's cousin, the powerful politician and former Boston mayor, Andrew J. Peters. According to Faithfull, Peters had hired thugs to murder Starr to ensure that she would never expose him for the monster he was.

Questioned by detectives, Peters indignantly denied that he had engaged in "immoral relations" with the girl. His claim, however, was seriously undercut both by his readiness to shell out $25,000 in hush money and by descriptions in Starr's diary of her sexual affair with "AJP." His reputation in ruins, Peters

suffered a nervous breakdown soon afterward and was dead before the decade ended. Still, while it seemed clear that this seemingly upstanding citizen was, in fact, a sex criminal, there was no evidence to implicate him in Starr's death.

The mystery of Starr Faithfull's death, which dominated front pages for weeks, would never be solved. There were those who clung to the suicide theory, others who continued to suspect Peters's involvement, and some who believed that Starr had been killed by one of her many random pickups, who had then staged her accidental drowning. One chronicler of the case, British crime historian Jonathan Goodman, points the finger at a gang of Long Island mobsters.

Whatever the case, the members of her immediate family displayed a striking lack of grief at her demise. "I'm not sorry Starr's dead," said her younger sister, Tucker (who promptly parlayed her family's notoriety into a part in a Broadway show). "She's happier; everyone's happier." Exactly one year after her body washed up on the beach, Starr Faithfull's cremated ashes, packaged in a pasteboard box, remained unclaimed in a Long Island undertaking parlor.

CHICAGO (1927)

―

DIRECTED BY FRANK URSON. WRITTEN BY LENORE J. COFFEE. WITH PHYLLIS HAVER, VICTOR VARCONI, VIRGINIA BRADFORD, AND ROBERT EDESON.

ROXIE HART (1942)

―

DIRECTED BY WILLIAM A. WELLMAN. WRITTEN BY NUNNALLY JOHNSON. WITH GINGER ROGERS, ADOLPHE MENJOU, GEORGE MONTGOMERY, NIGEL BRUCE, PHIL SILVERS, WILLIAM FRAWLEY, AND SPRING BYINGTON.

A long with the other cultural phenomena that defined the era—the speakeasies and bathtub gin, hot jazz and petting parties, bob-haired flappers and tommy-gun-toting bootleggers—the so-called Roaring Twenties were the heyday of the tabloids, those shamelessly sensationalistic dailies that fed the American

public's insatiable appetite for lurid titillation. And nowhere was tabloid journalism practiced with more cynical gusto than in Chicago, where bare-knuckled reporters vied with each other to come up with the most brazenly exploitative stories. Operating on the principle that nothing sells more papers than a spicy tale of sex and murder, the tabloids gleefully dished up a steady diet of lip-smacking scandals for their readers' delectation.

Though nearly all of Chicago's buccaneering reporters were men, there were some exceptions, among them Maurine Watkins. A Kentucky-born minister's daughter, Watkins was an aspiring playwright from an early age. After graduating first in her class from Butler College in Indianapolis, she moved to Cambridge, Massachusetts, where she was accepted into George Pierce Baker's famous playwriting seminar at Harvard, whose former students included Eugene O'Neill and Thomas Wolfe. Encouraged by Baker to immerse herself in the world outside academia—to seek material in the "great, bustling crowded American life of the present"—Watkins soon made her way to Chicago, where she landed a job as a cub reporter at the *Tribune*. Shortly afterward, she found herself covering a pair of particularly juicy murders: the inspiration for a work that, in a few years, would bring her fame and fortune.

At around 1:00 a.m., Wednesday, March 12, 1924, police officers David Fitzgerald and Morris Quinn of the Fiftieth Street station on Chicago's South Side were walking their beat when they spotted a woman getting into a Nash sedan that was parked in front of 4809 Forrestville Avenue, a three-story house divided into rental apartments. Thinking little of it, they rounded the corner of Fiftieth Street to put in their routine call on the police signal box. They were still making their report when three gunshots rang out from the direction they had just come. Hurrying back around the corner, they saw the driver of the car slumped against the steering wheel. He had been shot in the head. Lying on the floor were an automatic pistol and a half-empty bottle of gin. The woman they had seen entering the automobile was gone.

Unsure of what they were dealing with—suicide, robbery, or even a gang-land hit—the patrolmen immediately notified their station. Within minutes, other officers arrived at the scene, along with deputy coroner Joseph Springer, who determined that the man had been killed by a single steel-jacketed bullet that "punched through [his] right cheek and exited through his left ear." His wallet, still inside his coat pocket, contained papers identifying him as

Victor Varconi and Phyllis Haver in *Chicago*, 1927.

Walter Law, a twenty-nine-year-old automobile salesman with a wife and a three-year-old child.

The car, however, didn't belong to Law. Reporting the license plate number to the vehicle bureau, Fitzgerald and Quinn learned that the owner was Mrs. Belva Gaertner, a resident of 4809 Forrestville Avenue. Hurrying up to her apartment, they pounded on the door. It was opened by a woman "in her late thirties," as the newspapers reported. "She was not beautiful, but she had an indefinably attractive quality . . . Interesting was the word that might be applied to her. She had chic." She was wearing only a robe. A dress and fur coat, both soaked in blood, lay on the floor by the sofa.

As investigators soon learned, the thirty-eight-year-old, twice-divorced Mrs. Gaertner was a former cabaret singer who had performed under the name Belle Brown and been married to a wealthy industrialist in his sixties who, as the public learned during their highly publicized breakup, liked to be horsewhipped when making love. Pacing around the living room while Fitzgerald and Quinn

questioned her, she admitted that she had been out with Law but, despite the glaring evidence of her bloody clothing, insisted that she knew nothing about his death. Finally, she admitted that the pistol was hers—she "always carried it because of her fear of robbers," she explained—but continued to give the same answer when pressed as to the actual shooting: "I don't know. I was drunk."

Taken into custody, she revised her story the following day, coming up with a bizarre tale that would soon earn her the tabloid nickname "the Flip-Coin Murderess." According to this account, she and Law had been drinking gin at the Gingham Inn on Cottage Grove Avenue and were driving back to her place after midnight when they "began talking about stick-up men. 'I told Law we were taking an awful risk going home so late. What if some bandit stopped and robbed us, and maybe tried to get rough with me? What would we do?'"

Gradually, their "conversation drifted" to the question of which of them was "the better shooter":

> "I suggested jokingly that we toss up a coin and that the winner shoot the loser. I said if the winner missed the loser, the latter would get a chance to shoot, and vice versa, until one of us was shot. There were nine bullets in the pistol.
>
> "And then—oh, I don't know just what did happen. I was too drunk. I remember seeing him collapse over the steering wheel but I had no idea what was the matter.
>
> "'Walter! Walter!' I called. But he did not move or answer me. Then I tried to pull him out of the driver's seat so I could drive the car home, but I couldn't budge him, he was so limp. His head fell on my arms, and that's how my clothing came to be spattered with blood. I became frightened and ran home."

Questioned later that day by Assistant State's Attorney Stanley Klarkowski, she varied the story in one significant way, "declaring that Law was the one who had proposed the duel." Pressed for more details, however, she reverted to her standard denial, breaking into hysterical sobs and wailing: "Oh, Mr. Attorney, I can't remember anything—not if I have to hang for it!"

At the coroner's inquest, however, the arresting officers maintained that Mrs. Gaertner "was not as drunk as she pretended." According to the manager

of the Gingham Inn, one "Curley" Brown, she and Law "didn't have any gin. Just ginger ale. We don't allow gin."

The most devastating testimony, however, came from one of Law's colleagues, a fellow automobile salesman named Paul E. Goodwin. "Walter told me Monday that he planned to take out more life insurance because Mrs. Gaertner threatened to kill him," Goodwin said under oath. "Three weeks before, he told me she locked him in her flat with her and threatened to stab him with a knife unless he stayed there."

Goodwin's testimony supported the contention of Assistant State's Attorney Klarkowski. "The motive which the state believes lies behind the case is this," he declared. "Mrs. Gaertner had ensnared Law. He tried to break away, to stick to his wife and family. She killed him rather than lose him." The coroner's jury agreed. After deliberating for twenty minutes, they found that Law "came to his death from a bullet fired by Mrs. Belva Gaertner" and recommended that she be held without bail.

Thanks in large part to the front-page reporting of Maurine Watkins, Belva became a tabloid sensation, basking in her celebrity and regaling reporters with her highly quotable "discourse on love, gin, guns, sweeties, wives and husbands."

"Why, it's silly to say I murdered Walter," she breezily declared during an interview at the Cook County jail. "No woman can love a man enough to kill him. They aren't worth it, because there are always plenty more." Exactly how he ended up dead was still a mystery to her. The most she could say was that "we got drunk and he got killed with my gun in my car."

Belva, however, didn't have much time to enjoy the criminal limelight. Just a few weeks after her arrest, she was overshadowed by another, younger, even sexier man-killer, a twenty-three-year-old, red-haired knockout named Beulah May Annan.

At a few minutes before five o'clock on the afternoon of April 3, 1924, Beulah's husband, Albert, a "humble garage mechanic" who routinely put in fourteen-hour days to provide a comfortable life for his idolized, much younger wife, received a call from home. "I've shot a man, Albert," said Beulah. "He tried to make love to me."

After rushing home in a cab, Albert paced hysterically around the floor. Hunched against a wall in the bedroom was a young man in shirtsleeves, bleeding from a bullet hole in his back. His suit jacket, vest, hat, and overcoat were

carelessly tossed over a chair. Empty wine bottles, along with a pair of tumblers, stood on the bureau. Music was blaring from the Victrola—a popular Hawaiian-flavored jazz record, "Hula Lou," about "the kind of gal who could never be true."

When the police arrived, Beulah, reeking of alcohol, fed them the same story that her husband initially swallowed. The victim was a young man named Harry Kalstedt, a coworker with Beulah at the laundry where she had a part-time book-keeping job. That afternoon, he had shown up at her apartment, invited himself inside, and "made himself at home. Although I scarcely knew him," Beulah said through her tears, "he tried to make me love him. I told him I would shoot. He kept coming anyway and I—I did shoot him."

After a night of intense grilling by a pair of assistant state's attorneys and Police Captain Edward Murname of the Hyde Park station, however, the sobered-up beauty broke down and poured out the truth. Beulah—who already had one marriage behind her—had been "fooling around" with the handsome Kalstedt for the past two months, while her "fall-guy" husband (as the papers now referred to Albert) slaved away at the garage. The previous morning, "as soon as my husband left for work," Beulah recounted, "Harry called me up. I told him I wouldn't be home, but he came over anyway. We sat in the flat for quite a time, drinking. Then I said in a joking way that I was going to quit him. He said he was through with me and began to put on his coat. When I saw he meant what he said, my mind went into a whirl and I shot him."

Afraid that her neighbors, overhearing the disturbance, might come knocking at her door, she turned on the phonograph and continued playing it while she figured out what do. It wasn't until five o'clock—three hours after the shooting—that she telephoned Albert at work. According to the testimony of coroner's physician Dr. Clifford Oliver, Kalstedt had not been killed instantly; he remained alive for nearly two hours before succumbing to his wound. During all that time, Beulah played "Hula Lou" over and over while her lover lay dying at her feet.

The tabloids had a field day with the story. The ravishing Beulah—instantly branded "Chicago's Most Beautiful Murderess"—became a nationwide sensation: a "modern Salome" who had "danced to the tune of jazz records a passionate death dance [over] the body of the man she had shot and killed." Dislodged from the front pages and feeling like yesterday's news, Belva Gaertner—"Chicago's

Most Stylish Murderess," as she became known—could only maneuver herself back into the spotlight by posing for pictures with Beulah. "Killers of Men" ran the caption for the duo.

Though the cuckolded Albert Annan initially vented disgust at both his faithless wife and himself—"I've been a sucker, that's all, simply a meal ticket!" he cried after Beulah's arrest—it wasn't long before his hopelessly uxorious nature reasserted itself. "I haven't much money," he told reporters a few days later, "but I'll spend my last dime in helping Beulah."

His money went to retaining the services of one of Chicago's most colorful attorneys, W. W. O'Brien. A flamboyant courtroom performer who spent twelve years as a theatrical promoter before taking up the law, O'Brien was a fast-living, womanizing character who became the go-to defense attorney for some of Chicago's most notorious gangsters when, after being shot in a saloon in 1921, he refused to name his attackers, thereby proving himself the kind of stand-up guy who kept his mouth shut around coppers. Though he normally demanded his hefty fee up front and in cash, the high-profile case of "Cook County's Prettiest Slayer" (another of Beulah's tabloid designations) was too tempting to refuse.

Beulah's confidence in her ultimate acquittal was bolstered not only by O'Brien's impressive record of courtroom victories but by the general belief that no all-male jury was likely to convict a woman of her irresistible appeal. Shortly before her trial, however, one of her jail mates on "Murderess's Row," Elizabeth Unkafer, was found guilty of killing her lover and sentenced to life in prison. Not wanting to take any chances, Beulah came up with an ingenious ploy to ensure the public's sympathy. "On May 8, the day after Unkafer's conviction," journalist Douglas Perry writes, "she gathered the press and told them she was pregnant."

At her trial in late May 1924, O'Brien pulled out all the histrionic stops, portraying the victim as a "bum" who had done jail time for assaulting a woman and who had showed up at his client's door the morning of the shooting, asking to borrow money to buy liquor. To get rid of him, Beulah—"a frail, little, virtuous working girl," as O'Brien described her—gave him a few dollars and sent him on his way. That afternoon, however, he returned bearing a half gallon of booze and forced his way into the apartment. Frightened, she begged him to leave, but he refused.

"And then she foolishly took a drink, just to humor him and get him to go, and played the Victrola to drown out his loud talking," said O'Brien. Boasting "that he had served time for having his way with a woman," the "drunken brute" began to advance on her. When her pleas failed to stop him, the terrified "mother-to-be" started for the telephone "to tell her husband the danger she was in." At the same time, Kalstedt went for the pistol that Albert Annan kept tucked beneath his pillow. Seeing this, Beulah leapt for the gun and, after a fierce struggle, wrested it free and pulled the trigger.

It took the jury less than two hours to vote for acquittal. "Another pretty woman gone free," Prosecutor William F. McLaughlin said bitterly. While Beulah pressed each juror's hand and thanked them profusely, her husband wept with joy and cried, "I knew my wife would come through all right!"

Thirty-six hours later, Beulah—who, as it turned out, was not pregnant—showed up at a newspaper office with her lawyer in tow and announced that she was divorcing Albert. "He doesn't want me to have a good time," she said. "He never wants to go out anywhere and he doesn't know how to dance. I'm not going to waste the rest of my life with him—he's too slow." Certain that she could parlay her notoriety and her looks into a career as a motion-picture actress, she was thinking of moving to Hollywood. "I want lights, music, and good times—and I'm going to have them!"

By the following month, however, the public had forgotten about Beulah. On Tuesday, June 3, her rival, Belva Gaertner, reclaimed the spotlight when her own trial began. The general consensus among courtroom observers was that Belva—who sported a different, though equally chic, outfit on each of the four days of the proceedings—was "not so pretty" as Beulah but had "more class." The jury in her case took somewhat longer to acquit her, six-and-a-half hours. After tearfully thanking the twelve men, she hurried from the courthouse and went home to celebrate with her sister, stopping briefly at the jail to pack up her "elaborate wardrobe."

Beulah's starry-eyed dreams never materialized. Six months after her divorce, she took a third husband, a twenty-six-year-old boxer who proceeded to administer black eyes and broken ribs during their frequent altercations. That marriage lasted less than four months. A few years later, in March 1928, she died of tuberculosis at the age of thirty-two. Among the few people to attend her funeral in her hometown of Owensboro, Kentucky, was her still-besotted second husband,

Albert—the "poor boob," as he would forever be known in the tabloids—who had spent the past few years "work[ing] off the debts he had incurred in paying her way to freedom."

Beulah Annan never made it into the movies, but thanks to Maurine Watkins, she became a big-screen immortal in the form of a barely disguised surrogate. Not long after Belva Gaertner's trial, Watkins quit the *Tribune* and, after a stint in New York City as a film critic, moved to New Haven, Connecticut, where her mentor, George Pierce Baker, was now teaching at Yale. Reenrolled in his workshop, she completed a play initially called *The Brave Little Woman*, drawing heavily on the two sensational murder cases she had covered for the *Tribune*. A biting satire on celebrity-obsessed American culture, the gross inequities of the justice system, and the public's voracious appetite for scandalous, true-crime entertainment, the play—retitled *Chicago*—was a critical and commercial success when it opened on Broadway in 1926.

Though Watkins had invented fictitious names for its main characters—Roxie Hart, Velma, and Billy Flynn—her contemporaries had no trouble recognizing their real-life inspirations: Beulah Annan, Belva Gaertner, and W. W. O'Brien. Incorporating dialogue and details from the actual cases, the play opens in Roxie's bedroom, where she guns down her lover, Fred Casely, who has just announced his intention to dump her. Her hapless hubby, Amos, a stand-in for Albert Annan, initially buys her story that the victim was a burglar. Even after learning that his gorgeous young wife has been cheating on him with Casely for months, he remains—like his pathetic prototype—abjectly devoted to her.

Though terrified that she will hang, Roxie is reassured by a cynical tabloid journalist named Jake that the crime is the best thing that has ever happened to her. "Here you're gettin' somethin' money can't buy—front-page advertisin'," he exclaims. "Who knows you now? Nobody! But this time tomorrow your face will be known from coast to coast. Who cares today whether you live or die? But tomorrow they'll be crazy to know your breakfast food and how did yuh rest last night. They'll fight to see you, come by the hundred for a glimpse of your house."

Jake's prediction comes true. Roxie becomes an overnight sensation, squealing with delight in jail as she pores over the city's papers. "A whole page of pictures! Why, it's just like I was president or somethin': 'Beautiful Roxie Hart, the Jazz-Slayer.'" She has instantly eclipsed the city's previous tabloid star, the "classy" Velma, who, echoing Belva Gaertner's claim, denies all knowledge of her crime. "I'm sure I don't know," she replies when Roxie asks who the killer was. "I was drunk, my dear. Passed out completely and remember nothing from the time we left the café till the officers found me washing blood from my hands. But I'm sure I didn't do it."

With money scrounged up by Amos, supplemented by the proceeds from an auction of Roxie's now-priceless possessions ("a teacup drunk out of by a real-live murderess," "the record she played while the boyfriend lay dying"), Roxie hires the hot-shot lawyer Billy Flynn, who immediately concocts a life story for her that runs in the tabloids under the title "From Convent to Jail":

> "Beautiful Southern home, every luxury and refinement, parents
> dead, educated at the Sacred Heart, swept away, runaway mar-
> riage . . . You're a lovely, innocent child, bewildered at what has
> happened. Young, full of life, lonely, you were caught up in the
> mad whirl of a great city . . . and you were drawn inevitably like a
> moth to the flame! And now the mad whirl has ceased: a butterfly
> crushed on the wheel . . . And you sob with remorse for the life
> you have taken."

When another young murderess, "Go-to-Hell Kitty, the Tiger Girl," threatens to displace her from the headlines, Roxie counters by announcing that she is pregnant, a scoop the tabloids find irresistible. ("Gosh—it's a whale of a story!" Jake cries. "Young Mother Awaits Trial.")

The play concludes with Roxie's trial, a courtroom circus where Billy "earns his five thousand dollars," turning in a show-stopping performance that keeps the jury "hypnotized, enthralled, hang[ing] on every word and follow[ing] every gesture." The moment after she is acquitted, Roxie dumps Amos, announces her plan to go into vaudeville, and reveals that she was never pregnant. At that very instant, another woman shoots down her lover right outside the courtroom. As the reporters flock to Chicago's latest criminal sensation, "Machine Gun Rosie,

the Cicero Kid," a stunned Roxie is forced to face the hard truth. "Forget it," Flynn informs her. "You're all washed up!"

Millions of people are familiar with Watkins's play as a splashy, sexy Broadway musical brought to the big screen in 2002 with Renée Zellweger, Catherine Zeta-Jones, and Richard Gere in the roles of Roxie, Velma, and Billy Flynn. That Oscar-winning blockbuster, however, is actually the third adaptation of *Chicago* to come out of Hollywood. The earliest, released in 1927, is a silent movie nominally directed by Frank Urson, though most film scholars believe the true auteur was its producer, the legendary Cecil B. DeMille. Much of it hews closely to the play. In the starring role, Phyllis Haver—a bubbly blonde comedienne who often played gold-digging flappers and conniving femme fatales ("vamps," in the parlance of the age)—is irresistible as the amoral, utterly self-involved Roxie. Character actor Robert Edeson, resembling an especially well-tailored walrus, is equally fine as the unscrupulous Billy Flynn. His summation to the jury, during which he emotes like a third-rate thespian in a Victorian melodrama, is a comic highlight.

Where the movie deviates most drastically from its source is in its depiction of Amos Hart, here played by Hungarian matinee idol Victor Varconi. Far from the weak-chinned sap in Watkins's play (and in real life), Varconi's Amos is a handsome, highly sympathetic figure who nobly stands by his wife during her crisis, despite his deep moral misgivings. In a subplot concocted by screenwriter Lenore J. Coffee to add an element of whiz-bang action to the proceedings, Amos gets the money to pay Flynn's exorbitant fee by sneaking into the lawyer's home and stealing some of his ill-gotten gains—a sequence that culminates with a knock-down, drag-out fight between Amos and Flynn's Japanese manservant.

In the tidy moralistic climax of the film, both Amos and his two-timing wife get their just deserts. She is cast out into the rain-swept streets, where she sees a newspaper with her front-page photograph being trampled by pedestrians then washed into a gutter drain. Upstairs, a lovely, unmarried young neighbor who does housekeeping for the Harts shows up in their apartment and casts goo-goo eyes at the now-available Amos, clearly determined to become the dutiful, adoring little woman he deserves.

Fifteen years later, Watkins's play was remade as a forties romantic comedy, *Roxie Hart*, starring Fred Astaire's famous dance partner, Ginger Rogers, in the title role. Directed by William A. Wellman (one of the great Hollywood auteurs,

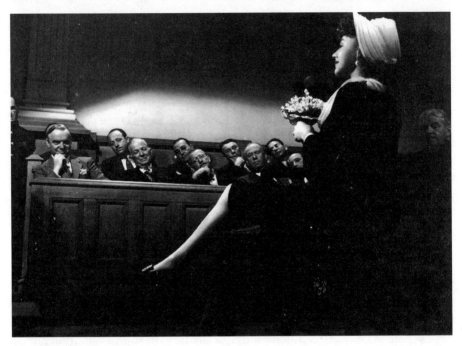

Ginger Rogers dazzles in *Roxie Hart*, 1942.

whose filmography includes such classics as *Wings*, *The Public Enemy*, and the original *A Star Is Born*), this version, like DeMille's, takes some interesting liberties with its source. For one thing, it's told as a flashback. In the opening scene, set in 1942, we meet longtime Chicago reporter Homer Howard (George Montgomery), who, after covering a run-of-the-mill murder of a two-bit gambler, retreats to a bar where he reminisces about the good old days of the 1920s when "everything was big—big money, big crooks, big murders, big stories." He then proceeds to regale the other patrons with the biggest story of them all—the saga of Roxie Hart, "the prettiest woman ever tried for murder in Cook County."

Though the movie (scripted by Oscar-nominated screenwriter Nunnally Johnson) retains much of Watkins's plot and dialogue, it alters the main character in a dramatic way. Unlike Watkins's protagonist (and the killer on whom she was based), this Roxie turns out to be innocent. A wannabe dancer who has been turned away by every talent agency in town, she lets herself be arrested for the murder (actually committed by her sleazy husband, Amos) after being convinced by a smooth-talking booking agent that the notoriety will jumpstart her career.

Ginger Rogers, a thoroughgoing delight as the sassy, gum-snapping, publicity-hungry Roxie, gets to show off her terpsichorean chops when she demonstrates the latest ballroom craze, the Black Bottom, to a roomful of reporters, a rollicking performance that sets the entire jailhouse dancing. Later, she does a playful tap dance for reporter Homer, who has fallen hard for the radiant Roxie.

Following a hilariously over-the-top trial (complete with play-by-play radio announcing and sponsorship by a quack medication guaranteed to cure "cancer, dropsy, gout, Bright's disease, lumbago, sleeping sickness, or any combination of such diseases in five days"), Roxie is acquitted. In the end, following the social conventions of the period, she abandons her ambitions for the happy domestic life of housewife and mother. The final scene, a return to the framing device set in 1942, shows Homer leaving the bar to join his wife, who, along with their five kids, is picking him up in the overpacked family car. The little woman behind the wheel is none other than Roxie, who breaks some news to her hubby: They're about to have another blessed event—or, as she says in the film's closing kicker, "We're going to have to have a bigger car next year."

CHILD 44 (2015)

DIRECTED BY DANIEL ESPINOSA. WRITTEN BY RICHARD PRICE. WITH TOM HARDY, NOOMI RAPACE, JOEL KINNAMAN, GARY OLDMAN, PADDY CONSIDINE, VINCENT CASSEL, AND JASON CLARKE.

This screen adaptation of Tom Rob Smith's page-turning bestseller is part political drama about life in a totalitarian society and part serial killer procedural—as if George Orwell had written *The Silence of the Lambs*. Set in an unrelentingly grim USSR at the tail end of the Stalin era, the film stars Tom Hardy (terrific as always) as Leo Demidov, a member of the Soviet secret police, the MGB (precursor of the KGB). Possessed of an unusually sensitive nature for someone in his line of work, Demidov regularly clashes with his colleague Vasili (Joel Kinnaman), a cowardly psychopath who, after arresting a peasant couple suspected of harboring a traitor, casually executes them in front of their children. "Maybe they can grow up and learn a lesson from this," he blandly explains.

Vasili will prove to be one of the movie's two monsters. The other is a nondescript family man, factory employee, and sexually demented pedophile, Vladimir Malevich (Paddy Considine). In a scene that pays homage to Fritz Lang's serial killer classic *M* (see p. 179), we first meet Malevich as a shadowy figure who approaches a young boy at play and lures him to a grisly doom.

Though a medical examination of the child's recovered corpse clearly reveals that he was tortured and drowned, his death is officially designated an accident since state policy decrees that murder is "strictly a capitalist disease" and that "there is no murder" in the worker's paradise of the Soviet Union. This willful, ideological blindness to the truth has allowed Malevich to perpetrate dozens of atrocities—forty-four to be exact—without fear of detection.

Demidov, however, is unable to ignore the evidence. When he and his wife, Raisa (Noomi Rapace), fall afoul of the authorities, they are shipped off to the remote, hideously depressing industrial town of Volsk ("the asshole of the earth," as one character describes it). Now demoted to the rank of lowly militiaman under the command of General Mikhail Nesterov (the great Gary Oldman), Demidov, with Raisa's assistance, surreptitiously pursues the unknown killer. At the same time, they themselves continue to be persecuted by the obsessed, Javert-like Vasili, who has assumed Demidov's former position in the MGB.

Ultimately, Demidov comes face-to-face with Malevich, who (in another echo of Peter Lorre's anguished psycho killer in *M)* cries out that his crimes were the product of a terrible compulsion. "I can't help it!" he sobs. For an instant, it is possible for the viewer to feel a twinge of sympathy for this tormented creature. The same cannot be said of the irredeemably loathsome Vasili, who, in the movie's brawling climax, comes to a gratifyingly violent end.

In terms of sheer unspeakable monstrosity, the pedophiliac killer of *Child 44*, creepy as he is, doesn't compare to the real-life sex fiend on whom he was based: Andrei Romanovich Chikatilo, one of the most appalling lust murderers of the twentieth (or any other) century.

Chikatilo was born in the Ukraine in 1936, during the dark aftermath of the *Holodomor*—the infamous man-made famine, engineered by Joseph Stalin, that killed millions of Ukrainians and produced such widespread cannibalism that the Soviet government found it necessary to distribute posters declaring "To eat your own children is a barbarian act." Chikatilo, whose childhood was blighted by such dire poverty that he was twelve before he ate his first piece of

bread, would later claim that an older brother, Stepan, had been killed and eaten by starving peasants.

An introverted and painfully shy boy afflicted with severe myopia and chronic enuresis, Chikatilo became, as he put it, "an object of ridicule" to his schoolmates, who mocked him unmercifully for his terrible eyesight and effeminate mannerisms. His sense of humiliation was compounded during his late adolescence when, following several failed attempts at sex with young women, he discovered that he was impotent.

He married in 1963 but was unable to consummate the marriage for some time. "I'm a healthy woman and I wanted to be intimate with him," his wife later revealed. "Whenever I asked him to be with me, he would always refuse. He would say, 'Do you want a stallion for a husband?' We had practically no sexual intimacy." The two children born to the couple, a daughter, Lyudmilia, and son, Yuri, were reportedly the product of artificial insemination, with Chikatilo "ejaculating externally and pushing his semen inside [his wife's] vagina with his fingers."

After working for a time as a telephone engineer, while earning his college degree through a correspondence course, Chikatilo embarked on his life as a vocational schoolteacher, a job for which he was painfully unsuited. His pathological shyness made it impossible for him to exert discipline upon his students, who treated him with unconcealed derision. Colleagues, too, found him odd and withdrawn. But Chikatilo had his own reasons for pursuing his pedagogical career. By then, he had discovered his perverted attraction to children. It wasn't long before he began molesting them, groping one teenage girl during an outing at a local reservoir and another in a locked classroom before she managed to escape by climbing out a window. Eventually, he was driven from his job as a school dormitory supervisor after attempting to perform fellatio on a sleeping boy.

He progressed from pedophilia to murder in December 1978, at the age of forty-two, when he lured a nine-year-old girl named Lena Zakotnova to a run-down shack. "Literally shaking" with the "urge to have sexual relations with the girl," as he later described the incident, he pulled off her pants and "began thrusting my hands into her sexual organs. At the same time, to keep her quiet, I began squeezing her throat. I began ripping at her sexual organs. I had an

Poster art for *Child 44*, 2015.

orgasm while lying on top of her and tearing her sexual organs. I did not have intercourse as such with her. The semen either went between her legs or on her stomach." He finished her off with his pocketknife, stabbing her repeatedly in the abdomen. Then he "dressed her and threw her body in the river. I threw her school case in too. I washed my hands and put my clothes in order. Then I . . . went home."

Despite strong evidence linking him to the crime, the police remained stubbornly convinced that the killer was a young man, Aleksander Kravchenko, with a prior conviction for the rape and murder of a teenage girl. Though Kravchenko had an airtight alibi for his whereabouts on the day of the murder, he was coerced into a confession and ultimately convicted and executed for the crime. It was the first of many official blunders that would allow Chikatilo to remain at large for another dozen years and lead to untold horror and suffering.

Following the loss of his teaching job, Chikatilo moved his family to the industrial town of Rostov-on-Don, where he found work as a factory supply clerk. At this point, his inner beast was truly unleashed. For the next twelve years, he prowled bus stops and train stations in Rostov and farther afield. His method was simple. He would approach his victim—girls or boys or young women—and offer food or money or a car ride. Then he would lead his unwary prey into the woods where, like some dark creature from a fairy tale, the seemingly harmless middle-aged man would undergo a terrifying metamorphosis. Overpowering his victims, he would bind them with rope. Then, in an ecstatic frenzy, he savaged them with knife, teeth, and bare hands, ripping open their bellies, chewing off their noses, gouging out their eyes, slicing off and eating their tongues, nipples, and genitals—sometimes while they were still alive. He wallowed in their internal organs and would later confess to having a particular fondness for the taste and texture of the uterus. "When murdering women," he calmly explained, "I'd have the desire to get inside their abdomen, to . . . slice open the stomachs of my victims and cut out the uterus." He found that organ "so elastic" that he couldn't resist "chewing it."

Because Soviet dogma insisted that serial murder was a product of capitalist decadence—something that could never exist in a Communist state—the gruesome murders were never reported in the press, leaving the unaware even more vulnerable to the depredations of the monster. Chikatilo fell under suspicion but was let go each time for lack of solid evidence. In 1984, he was arrested on a theft

charge but released after just three months in jail. Within weeks, he butchered eight more victims.

In 1985, Lieutenant Colonel Viktor Burakov, chief of special homicides in Rostov, approached that city's leading psychiatrist, Dr. Alexander Bukhanovsky, and asked him to draw up a profile of the likely killer. Ten days later, Bukhanovsky turned in a sixty-five-page report. In it (as summed up by author Robert Cullen in his book *The Killer Department*), Bukhanovsky described the perpetrator as:

> a reclusive man, aged between 45 and 50 years[,] who had endured a painful and isolated childhood and who was incapable of flirting or courtship with women. This individual was of average intelligence, likely to be married and to have fathered children, but also a sadist who suffered from impotence and could only achieve sexual arousal by seeing his victims suffer. The murders themselves were an analogue to the sexual intercourse this individual was incapable of performing, and his knife became a substitute for a penis which failed to function properly. Because many of the killings had occurred on weekdays near mass transport hubs and across the entire Rostov Oblast, [it was probable that] the killer's work required him to travel regularly, and based upon the actual days of the week when the killings occurred, the killer was most likely tied to a production schedule.

Despite a massive manhunt, five more years would pass before the "Rostov Ripper" was finally nabbed. Under a plan proposed by Burakov, hundreds of uniformed police—deliberately meant to be as conspicuous as possible—were assigned to all the larger train stations in the Rostov area. Burakov's thinking was that the killer, seeing that his normal hunting grounds were under police surveillance, would seek his prey at smaller, less busy stations where, unbeknownst to him, undercover agents would be posted.

The plan worked. In November 1990, an undercover officer assigned to a remote station noticed a suspicious man emerging from the nearby woods and asked to see his papers. Having no reason to detain him, he let the man go but, upon returning to his office, filed a report containing the man's name.

A week later, after the mutilated body of a twenty-two-year-old woman was found in the woods near the station, Burakov discovered Chikatilo's name in the undercover agent's report. Knowing that Chikatilo had been previously questioned for the murders and placed on an official list of suspects, Burakov put him under surveillance. One week later—having been repeatedly observed attempting to strike up conversations with young women and children at train stations and bus stops—he was arrested.

At first, he denied his guilt. A few days later, Burakov called in Dr. Bukhanovsky to interview the prisoner. As the psychiatrist read excerpts from his profile, Chikatilo suddenly burst into tears. "Yes, it's me," he wept. He then proceeded to confess to the mutilation-murder of fifty-three victims, most of them children.

"I am a freak of nature, a mad beast," he declared at his 1992 trial. Jamming the courtroom, relatives of his victims howled for his blood, while the Rostov Ripper—locked inside a steel cage for his own protection—ranted, raved, tore off his clothes, waved his penis at the crowd, and spewed obscenities at the trial judge. As the trial progressed, his behavior grew increasingly outrageous. At one point, he claimed that he was pregnant and lactating and accused prison guards of hitting him in the stomach to deliberately damage his baby.

If his wildly bizarre behavior was, as some people believed, a calculated attempt to prove that he was insane, the tactic failed. On February 14, 1994, after his appeal for clemency was rejected by President Boris Yeltsin, he was taken from his cell on death row, led into a soundproof room, and executed with a bullet to the base of his skull.

CITIZEN X

For all its attention to historical detail, *Child 44* is a work of pure make-believe, a Hollywood thriller about a brawny action hero fighting for survival while tracking down a fictionalized version of Andrei Chikatilo in the early 1950s. Those looking for a far more accurate depiction of the case of the "Rostov Ripper" should check out the 1995 docudrama *Citizen X*, originally shown on HBO.

It opens in 1982. The hero is Lieutenant Colonel Viktor Burakov (Stephen Rea), whose hangdog mien and tendency to burst into tears at regular intervals exist alongside a steely determination and a keen investigative mind. A forensics specialist who, at the start of the movie, is horrified to discover incontrovertible evidence that a sadistic lust killer is on the loose, Burakov is put in charge of what will turn out to be an eight-year search for the monster; as in actuality, his efforts are hampered both by the relatively primitive state of Soviet forensics ("our blood test is for eleven variables," he complains at one point, "the FBI's is for 149") and by the insistence of party officials that "there are no serial killers in the Soviet state. It's a decadent Western phenomenon."

The story alternates between the manhunt and scenes of Chikatilo (a supremely creepy Jeffrey DeMunn) at home and on the prowl. While not wallowing in gore, the film makes the horrific nature of the "mad beast's" atrocities shockingly clear.

Besides the understated urgency that Stephen Rea brings to his portrayal of Burakov, the film features top-notch performances by two other outstanding actors: Donald Sutherland as Colonel Mikhail Fetisov, Burakov's immediate superior and sole ally, and Max von Sydow as Dr. Alexander Bukhanovsky, the psychiatrist who produced Russia's first forensic profile and who was instrumental in coaxing a confession from Chikatilo.

Based on *The Killer Department*, Robert Cullen's 1993 nonfiction book about the hunt for Chikatilo, *Citizen X*, as *Variety* wrote, is a made-for-TV movie of "uncommon quality"—a powerful "picture of humanity's worst instincts, and unlikeliest heroes."

DIRTY HARRY (1971)

DIRECTED BY DON SIEGEL. WRITTEN BY HARRY JULIAN FINK, R. M. FINK, AND DEAN RIESNER. WITH CLINT EASTWOOD, HARRY GUARDINO, RENI SANTONI, JOHN VERNON, ANDY ROBINSON, AND JOHN LARCH.

R eal life has a vexatious way of not tying up loose ends. Appalling crimes go unsolved, terrible injustices go unpunished, grievous wrongs go unavenged. This unfortunate fact is precisely one reason that we have movies (*reel* life, as it were): to supply gratifyingly neat, clear-cut resolutions to dilemmas that are a source of bitter frustration in actuality. Few movies deliver this kind of payoff as satisfactorily as the original *Dirty Harry*.

In 1971, with the homicide rate on the rise, riots breaking out in inner cities, and young revolutionaries resorting to violent acts against "the system," the country seemed to be plunging into social chaos. The apparent impotence of the police and judicial systems in the face of this upheaval had produced a widespread sense of fear and anger in the public. Millions of God-fearing Americans desperately longed for a savior: someone who would single-handedly restore good old-fashioned law and order. Clint Eastwood's Dirty Harry proved

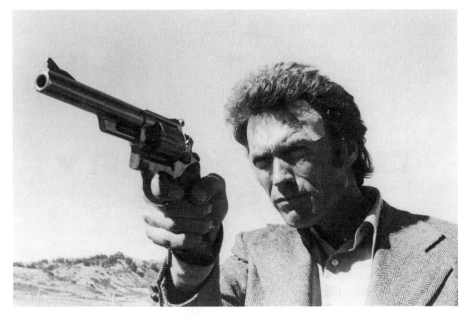

Clint Eastwood as the now-iconic Dirty Harry, 1971.

to be just the man for the job: an implacable vigilante cop who refuses to let such little things as civil rights and due process keep him from fulfilling his life's mission—that is, ridding the streets of criminal scum by blasting as many bad guys as possible with his .44 Magnum.

Though Harry makes short shrift of the occasional rapist and bank robber, his main nemesis in the film (the first in an eventual series of four) is a cackling long-haired psycho who calls himself Scorpio (played to loathsome perfection by Andy Robinson). We first see Scorpio, a serial killer who enjoys sending taunting letters to the police, shooting a random young woman doing laps in a hotel rooftop pool. Vowing to keep killing unless his ransom demands are met, he makes good on his promise by aiming his sniper rifle at a few prospective victims before gunning down an African American boy.

After kidnapping a teenage girl, burying her alive, and demanding a ransom for her release, Scorpio is hunted down by Harry. Knowing that time is of the essence if the girl is to be saved, Harry applies a bit of enhanced interrogation technique to force a confession from the sniveling creep. Unfortunately, by the time the police dig her up, she has suffocated. Even worse, owing to some pesky

legal technicalities involving Harry's unorthodox methods, the maniacal Scorpio is set free to work further evil on society.

Directed by Don Siegel—revered, no-nonsense auteur of such low-budget classics as *Invasion of the Body Snatchers* and *Riot in Cell Block 11*—*Dirty Harry* does a brutally effective job of exploiting the rampant anxieties of its 1970s audience. For viewers in Northern California, it also tapped into a very specific source of communal fear: the reign of terror unleashed three years earlier by the infamous night-prowling madman known as the Zodiac killer.

His first known victims were a high school couple, Betty Lou Jensen and David Faraday, residents of Benicia, California, about an hour north of San Francisco. On the night of December 20, 1968, after spending a few hours at a friend's house, they drove to a remote lover's lane and were evidently so engrossed in each other that they didn't notice another car pulling up alongside them. As police later reconstructed the crime, the driver of the second car, armed with a .22-caliber semiautomatic pistol, stepped out and started firing through the rear passenger window of Faraday's 1960 brown Rambler. Pushing open his door, Faraday was killed with a bullet to the back of his head as he tried to escape. Jensen made it out of the car and took off, but she was chased down and killed with five bullets to her back before she was more than a few yards away.

Six months later, shortly before midnight, July 4, 1969, twenty-two-year-old Waffle House waitress Darlene Ferrin and her nineteen-year-old date, Michael Mageau, were sharing the front seat of her 1960 Chevy Corvair in the parking lot of the Blue Rock Springs golf course, another popular lover's lane just a few miles from the site of the earlier murders. They hadn't been there long when another car pulled up beside them, drove away, then returned a few minutes later. Stopping his car about ten feet behind the Corvair, the driver, wielding a powerful flashlight and a 9 mm Luger, began blasting away at the trapped couple. He then strolled back to his car, but hearing moans from Mageau, he returned to the Corvair and fired two more rounds into the teenager. Miraculously, Mageau survived. Ferrin was not as lucky.

Forty minutes after the attack, the Vallejo Police Department received an anonymous phone call from a gruff-voiced man. "I want to report a double murder," said the caller. "If you will go one mile east on Columbus Parkway to the public park, you'll find kids in a brown car. They were shot with a 9 mm Luger. I also killed those kids last year."

The matter-of-fact tone in which this message was delivered made it clear that a homicidal maniac was on the loose. The full extent of his madness, however, didn't become apparent until six weeks later, when he sent three separate letters to local newspapers, the *Vallejo Times-Herald, San Francisco Examiner*, and *San Francisco Chronicle*. Each contained a cryptogram. Working with his wife Bettye June, Donald Harden, a Salinas high school teacher and amateur cryptographer, managed to crack the code. Taken together, the three enciphered passages formed a single, misspelled, wildly deranged message:

I LIKE KILLING PEOPLE BECAUSE IT IS SO MUCH FUN IT IS MORE FUN THAN KILLING WILD GAME IN THE FORREST BECAUSE MAN IN THE MOST DANGEROUE ANAMAL OF ALL TO KILL SOMETIMES GIVES ME THE MOST THRILLING EXPERIENCE IT IS EVEN BETTER THAN GETTING YOUR ROCKS OFF WITH A GIRL THE BEST PART IS THAT WHEN I DIE I WILL BE REBORN IN PARADICE AND ALL THEI HAVE KILLED WILL BECOME MY SLAVES I WILL NOT GIVE YOU MY NAME BECAUSE YOU WILL TRY TO SLOI DOWN OR ATOP MY COLLECTING SLAVES FOR THE AFTERLIFE.

The letter was signed with a peculiar symbol that resembled the sight of a rifle scope—a circle intersected by a cross.

Even before the decoded message was made public, the killer sent another letter to the *San Francisco Examiner*, establishing his malign credentials by providing details of the murders—"the good times I have had in Vallejo," as he mockingly called them—that only the perpetrator would know. True to his previous message, he did not provide his name. Instead, he used the pseudonym that immediately entered the mythology of modern-day serial murder.

"This is the Zodiac speaking," the letter began. From that point on, he would start each of his communications with the same ominous greeting.

Two months passed. On September 27, 1969, college students Bryan Hartnell and Cecilia Shepard were picnicking at a lake near Vallejo when a frightening figure emerged from behind some trees. His face was hidden beneath an oversized black hood, its eyeholes covered with clip-on sunglasses. A bizarre

bib, embroidered with the Zodiac's crossed-circle device, was draped over his chest. Hanging from his belt was a large wood-sheathed knife—possibly a bayonet. In his hand, he clutched a semiautomatic pistol.

"I just want your money and your car keys," he announced. "Just do what I say and nobody gets hurt."

Extracting precut lengths of plastic cord from his jacket, he hog-tied the couple at gunpoint. Then, as the pair lay face down on the grass, he holstered his pistol, pulled out his knife, and began plunging the blade into Hartnell's back. When he was done, he turned his attention to the terror-stricken young woman. The frenzied attack over, he walked to their car and, with a black Magic Marker, inscribed his crossed-circle logo on the door, along with the dates and locations of his three Bay Area attacks. An hour later, he put in a call to the police, calmly informing them that he had just committed "a double murder." As it happened, he was wrong. Stabbed ten times, Cecilia Shepard would die a few days later. Her boyfriend would survive his half-dozen wounds.

His last confirmed victim was twenty-nine-year-old Paul Lee Stine, a student at San Francisco State University and part-time taxi driver. On the night of October 11, 1969, exactly two weeks after the attack on Hartnell and Shepard, Stine was killed with a point-blank shot to the head by a passenger he had driven to Pacific Heights. Before fleeing the scene, the killer cut off a piece of the victim's shirttail, soaked it in the dead man's blood, and carried it away with him.

A few days later, the editor of the *San Francisco Chronicle* received an envelope. Inside was a swatch of Stine's bloodstained shirt and a letter from Zodiac. "I am the murderer of the taxi driver over by Washington St. + Maple St," it began. "I am the same man who did the people in the north bay area." After taking a swipe at the incompetence of the police—who "could have caught me if they had searched the park properly"—he signed off with a bone-chilling scenario: "School children make nice targets, I think I shall wipe out a school bus some morning. Just shoot out the front tire + then pick off the kiddies as they come bouncing out."

Fortunately, he never acted on his threat. Nor did Zodiac ever kill again, as far as anyone knows. He did, however, keep up his bizarre correspondence, sending sporadic greeting cards and letters to the papers for the next several years. His identity remains a mystery. Various suspects have been proposed, among them former army medic and newspaperman Richard Gaikowski, Dr. George Hodel

(also fingered by his son as the Black Dahlia murderer), and even the so-called Unabomber, Ted Kaczynski. However, the leading expert on the case, Robert Graysmith—whose books provided the basis for David Fincher's gripping 2007 movie, *Zodiac*—has named Arthur Leigh Allen, a gun buff and convicted child molester who died in 1993, as the likeliest suspect.

Though the Zodiac murders remain officially unsolved, *Dirty Harry* provided its own fictional coda to the case. In the climax of the film, Harry's nemesis, Scorpio, actually carries through on Zodiac's final threat, hijacking a busload of schoolchildren. Before he can accomplish whatever nefarious plan he has in mind, however, Harry and his trusty .44 Magnum come to the rescue and mete out long-overdue justice, providing audiences with the type of supremely satisfying resolution that actuality all-too-often denies.

DOUBLE INDEMNITY (1944)

DIRECTED BY BILLY WILDER. WRITTEN BY BILLY WILDER AND RAYMOND CHANDLER. WITH FRED MACMURRAY, BARBARA STANWYCK, EDWARD G. ROBINSON, TOM POWERS, PORTER HALL, AND JEAN HEATHER.

It has gone down in newspaper history as the most infamous tabloid picture of all time: a blurry black-and-white photograph of a condemned female prisoner at the instant of her execution. Beneath a screaming headline consisting of a single word—DEAD!—the image occupied the entire front page of the *New York Daily News* on January 13, 1928. Its publication provoked outrage from state officials, but ordinary New Yorkers ate it up. One million copies of the issue flew off the stands that day, more than twice the normal sales. The public's eagerness to see the dying moment of the criminal was a sign of the notoriety she had achieved as the most reviled female killer of her day. Her name was Ruth Snyder.

Christened Mamie Ruth Brown at her birth in March 1895, Ruth was a sickly child who developed into a young woman with "good features marred

only by a hard jaw and an icy look"—and exuding a raw sexuality that made her more magnetic to men. Dropping out of school in early adolescence, she worked at various office jobs for the next several years, turning over most of her meager salary to her struggling family. In 1914, while employed as a switchboard operator at Tiffany Studios, she mistakenly directed a call to a bad-tempered stranger who began berating her for interrupting him at work. A short time later, he phoned back. Introducing himself as Albert Snyder, art editor of *Motor Boating* magazine, he apologized for his rudeness. After a pleasant chat, he invited her for a job interview. By that afternoon, she had been hired as a secretary in his office.

Thirteen years Ruth's senior, Snyder lost little time in coming on to the vivacious young woman, dazzling her with trips to theaters, nightclubs, and swanky restaurants. Though Ruth loved few things more than a night on the town and was happy to date Snyder, she wasn't especially attracted to him and turned him down when he proposed to her that Christmas. A few months later, however, when he surprised her on her twentieth birthday with a box of chocolates containing a diamond engagement ring, she couldn't resist. "I just couldn't give up that ring," she later explained to a friend. They were wed in July 1915, less than a year after they met.

Their marriage proved disastrous almost from the start. An almost stereotypical specimen of early twentieth-century American manhood, Snyder, as the family's sole breadwinner, demanded that his wife attend to all domestic chores, leaving him free to pursue his favorite weekend pastimes: boating, fishing, tinkering in his garage workshop. He also had a hair-trigger temper, exacerbated by his increasingly heavy drinking. Ruth, in the meantime, seethed with resentment. A fun-loving female with a craving for all the excitement that the Jazz Age had to offer, she found herself trapped in her suburban Queens home with a surly, stick-in-the-mud husband whose idea of a good time was tuning up the engine of their automobile.

Eventually, Ruth took to going out on her own, riding the subway to Manhattan to meet friends for lunch and enjoy the bright lights of the city. It was during one of these outings that she met the man who would become her partner in a crime that riveted the nation.

A mousy, myopic little fellow who sold corsets for a living, sang in the church choir, and—to all outward appearances—was devoted to his wife and

daughter, Judd Gray was no one's idea of a ladies' man. As soon as he and Ruth were introduced at a Manhattan restaurant, however, they were involved in a torrid affair—meeting clandestinely in Midtown hotel rooms, exchanging love letters composed in cloying baby talk, addressing each other by saccharine nicknames. To Judd, the domineering, brazenly sexual Ruth was his "Momsie." She called her milksop paramour "Lover Boy."

One year after meeting Gray, Ruth resolved to do away with her detested husband. After tricking him into taking out a life insurance policy with a double indemnity clause providing nearly $100,000 in the event that he met a violent end, she set about trying to kill him: spiking his whiskey with bichloride of mercury, sprinkling poison on his prune whip, piping gas into his bedroom while he slept. Snyder survived these attempts; despite his wife's barely disguised abhorrence, he apparently never suspected her.

Finally, "the Granite Woman" (as the tabloids eventually dubbed her) decided to enlist her lover's help. Though Gray was genuinely appalled when his Momsie first broached the subject, he was helplessly in her thrall (the tabloids would brand him "the Putty Man"). In the early hours of March 20, 1927, they put their plan into effect.

Fortified with bootleg liquor and armed with a heavy iron sash weight, Gray snuck into the Snyders' home after dark, entering through a side door that Ruth had left unlatched. When the victim was soundly asleep, Gray crept into the Snyders' bedroom and brought the bludgeon down on the sleeping man's head. The blow was so weak, however, that it only caused Albert Snyder to sit up with a roar and grab his assailant's necktie.

"Momsie!" screamed Gray. "For God's sake, help!"

Rushing to the bedside, Ruth grabbed the sash weight from Lover Boy's hand and delivered a crushing blow to her husband's skull. Albert subsided onto the bed with a shuddering moan. For good measure, the assassins garroted him with a wire and stuffed chloroform-soaked rags up his nostrils.

Putting the second phase of their scheme into action, the pair proceeded to ransack the house to make it look as if Snyder had been killed in the course of a break-in. They upended furniture, opened drawers, even ripped the stuffing out of pillows. Ruth wanted Gray to make off with her jewels, but for unexplained reasons, he refused. They settled for hiding her valuables under her mattress and stashing her fur coat in a bag inside her closet. Their clever idea of disposing

of the murder weapon was to rub it with ashes and stick it in Albert Snyder's basement tool chest.

Though Ruth urged Gray to knock her unconscious, he couldn't bring himself to hurt her. Instead, he bound her wrists and ankles, gagged her with cheesecloth, and made off into the night.

A few hours later, at around 7:30 a.m., Ruth dragged herself to her sleeping daughter's bedroom and managed to rouse the eleven-year-old child, who immediately summoned help. Though Ruth stuck to her rehearsed story, police were wise to her from the start. All the evidence was against her. Burglars are not known for knocking over armchairs and tearing open pillows in their search for booty. And Ruth's claim of being knocked unconscious by the intruder failed to persuade the medical examiner, who was unable to find a single contusion on her scalp. Her cause wasn't helped when detectives turned up her "stolen" jewelry under her mattress and found the bloodstained murder weapon in her husband's tool chest.

Believing they had pulled off the "perfect murder," the bumbling conspirators had managed to perpetrate a crime so incompetent that the celebrity journalist Damon Runyon dubbed it "the Dumbbell Murder." The pair was in custody within twenty-four hours. The Snyder-Gray case became an immediate sensation, not only in New York City but throughout the country. Ruth Snyder instantly became the most detested woman of her time—the Whore of Babylon in the guise of a curvaceous Queens housewife. The Snyder-Gray trial—attended by such Jazz Age luminaries as David Belasco, D. W. Griffith, Sister Aimee Semple McPherson, and the Reverend Billy Sunday, among others—received almost as much attention as the Lindbergh flight and was rich in both lurid melodrama and coarse comedy, particularly when Ruth was on the stand. (In one memorable exchange, Assistant District Attorney Charles W. Froessel—trying to establish Ruth's earlier affair with a man named Lesser—asked, "Did you know Mr. Lesser carnally?" "Yes," Ruth replied, "but only in a business way.")

Public sentiment was so inflamed against Ruth that, after she and Gray were convicted and sentenced to death, every member of the court of appeals received a copy of the following postcard: "We will shoot you if you let that Snyder woman go free. She must be electrocuted. The public demands it. If she is not done away with, others will do the same thing. She must be made an example of. We are watching out." The message was signed "The Public."

The public got its wish. Shortly after 11:00 p.m. on Thursday, January 12, 1928, Ruth Snyder went to the electric chair, followed eight minutes later by Judd Gray. Seated among the spectators was a man named Tom Howard. Though posing as a reporter, Howard was a photographer brought in from Chicago by the *New York Daily News.* Secretly strapped to his left ankle was a miniature camera. When the first jolt hit Snyder, he released the shutter with a cable that ran up his pants leg to his pocket. The resulting shot—the only picture ever taken in this country of the electrocution of a woman—earned Howard a $100 bonus and a lasting place in the annals of American photojournalism.

The Dumbbell Murder became known by another, more enduring nickname in 1943, when it served as the basis for James M. Cain's hard-boiled bestseller, *Double Indemnity.* The following year, director Billy Wilder, working with novelist Raymond Chandler, transformed Cain's book into a Hollywood classic, a movie regarded by many screen historians as the first film noir ever made.

Fred MacMurray (best known to later generations for his comic roles in Disney films like *The Shaggy Dog* and *The Absent-Minded Professor,* as well as for his starring turn in the long-running TV sitcom *My Three Sons*) shines as Walter Neff, a sleazy insurance salesman who falls hard for a calculating California housewife, Phyllis Dietrichson (Barbara Stanwyck). One of the screen's most memorable femme fatales, Phyllis instantly sizes up the tough-talking Neff as the perfect chump to help her out of her soul-crushing marriage. Within days of their first meeting, she has seduced him into planning a supposedly foolproof crime: knocking off her sour-tempered hubby in an apparent fatal accident and collecting on a life insurance policy with a double indemnity clause.

"We're gonna do it, and we're gonna do it right," says Neff, who has given a good deal of thought to how such a scam might be pulled off. "There's not going to be any slipup. Nothing sloppy. Nothing weak. This has got to be perfect, straight down the line."

In short order, they are putting Neff's devious scheme into action. First, believing that he is merely renewing his automobile policy, the curmudgeonly Mr. Dietrichson is tricked into insuring his life for $50,000, with twice that amount paid to his grieving widow should he come to his death in some statistically unlikely way—say, by falling off a moving train. Shortly thereafter, Dietrichson, who has been planning to drive to Palo Alto for his annual college reunion, breaks his leg and decides that he will travel by train. On the night of

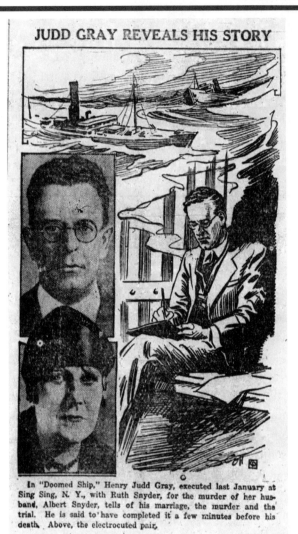

JUDD GRAY REVEALS HIS STORY

In "Doomed Ship," Henry Judd Gray, executed last January at Sing Sing, N. Y., with Ruth Snyder, for the murder of her husband, Albert Snyder, tells of his marriage, the murder and the trial. He is said to have completed it a few minutes before his death. Above, the electrocuted pair.

"Judd Gray Reveals His Story," *Leader-Telegram* of Eau Claire, Wisconsin, December 2, 1928.

his departure, Neff, wearing a fake leg cast and a suit resembling Dietrichson's, hides in the back of the car as Phyllis drives her husband to the station. At a prearranged signal from Phyllis, who has pulled into a deserted side street, Neff rises up and strangles Dietrichson, breaking his neck. He then boards the train, makes his way on crutches to the open platform of the rear observation car, and—after a tense, unexpected encounter with another passenger—jumps off.

He and Phyllis then drag her husband's corpse onto the tracks and make their getaway.

The plan seems to have worked perfectly. Neff, however, has failed to reckon with his colleague and close friend, the dogged claims investigator Barton Keyes (Edward G. Robinson in a typically dynamic, scene-stealing performance). Though Keyes initially accepts the official verdict that Dietrichson's death was accidental, he soon develops gnawing doubts. Before long, he has not only concluded that Dietrichson was murdered but has worked out exactly how the crime was accomplished. He gets only one detail wrong: he believes that Phyllis's accomplice was not Neff but a surly young man, Nino Zachetti, the boyfriend of Dietrichson's daughter, Lola.

Seeing a way to wriggle free of suspicion, Neff goes to the Dietrichson home, intending to kill Phyllis and frame Nino for her murder. Phyllis, however, has plans of her own. In the emotionally fraught final confrontation between the two mutually double-crossing lovers, the scarily cold-blooded Phyllis shoots Neff in the shoulder, then—to her own surprise—finds that she actually cares too much for him to finish him off. This atypical qualm allows Neff to plug her in the gut. Neff, desperately wounded, makes it back to his office to leave a full confession on his Dictaphone. The movie concludes with a touching exchange between Neff and Keyes as they wait for a police ambulance to arrive. This, however, was not the intended climax of the film. Though the footage has been lost, some production stills survive of the original ending filmed by Wilder: Keyes witnessing Neff's execution in the San Quentin gas chamber—a sequence very much in keeping with the ultimate fates of the real "Double Indemnity" murderers.

PICTURE SNATCHER

The Snyder-Gray case spawned not only *Double Indemnity* but a nifty little film called *Picture Snatcher*. Released in 1933, the movie stars James Cagney, in a typically high-voltage performance, as an ex-con named Danny Kean. Following his release from Sing Sing, Danny becomes a daredevil cameraman for a sleazy New York City tabloid. He scores his biggest coup after learning that an infamous murderess is about to be executed: he sneaks into the prison

with a camera hidden under his pants leg and snaps a picture of the prisoner at the instant of her execution. When the photo is plastered on page one of the next day's paper, the issue becomes a sellout (though Danny suffers some unfortunate personal consequences, since the security guard he has managed to sneak past—and who is demoted as a result—is none other than his girl-friend's father).

Cagney's hustling, anything-for-a-scoop "picture snatcher" was based on Tom Howard, the real-life photographer who took the infamous photo of Ruth Snyder's electrocution that ran on the front page of the January 13, 1928, issue of the *New York Daily News*. Howard's notorious feat was also the basis for a 1942 B-movie remake of *Picture Snatcher* called *Escape from Crime*.

EATEN ALIVE!
(1976)

DIRECTED BY TOBE HOOPER. WRITTEN BY KIM HENKEL, ALVIN L. FAST, AND MARDI RUSTAM. WITH NEVILLE BRAND, MARILYN BURNS, CAROLYN JONES, STUART WHITMAN, MEL FERRER, ROBERT ENGLUND, AND WILLIAM FINLEY.

In 1974, Austin-based filmmaker Tobe Hooper cowrote and directed *The Texas Chain Saw Massacre*, originally decried as a mindless drive-in gorefest and now widely recognized as one of the greatest and most influential horror films of all time—the *Citizen Kane* of dismemberment movies. Like other artists who produce a masterpiece right off the bat, however, Hooper was never able to repeat that achievement. His subsequent filmography is full of potentially terrifying movies that never manage to deliver on their promised scares.

A case in point is Hooper's follow-up to *Chain Saw*: an unapologetic exploitation film with the delightfully lurid title *Eaten Alive!* In contrast to his prior effort, which consisted entirely of local amateurs, *Eaten Alive!* features professional actors who, at one point, had legitimate Hollywood careers. These include Neville Brand, a veteran character actor who played gravel-voiced

heavies in scores of movies and TV shows; Carolyn Jones, an Academy Award nominee best remembered as Morticia in the TV version of *The Addams Family*; Stuart Whitman, a handsome B-list actor who costarred in some memorable 1960s Westerns, most notably *The Comancheros* alongside the immortal John Wayne; Mel Ferrer, known for his work in such classics as *The Sun Also Rises* and *Scaramouche* (and for guiding the career of his third wife, Audrey Hepburn); and the future Freddy Krueger, Robert Englund. The only holdover from *Chain Saw* is Marilyn Burns, the "final girl" who manages to escape the clutches of Leatherface and his cannibal clan.

Eaten Alive! opens with a scene that looks like it was shot on the set of a particularly sleazy 1970s porno film, the kind that used to run in Times Square peep shows. A young whorehouse patron named Buck (Robert Englund) tries to force his unwilling partner, Clara—a newcomer to the world's oldest profession—into having anal sex. When she refuses, she is kicked off the premises by the madame, Miss Hattie (Carolyn Jones), and takes refuge at the Starlight, a swampland fleabag that makes the Bates Motel look like the Ritz-Carlton. The proprietor, Judd (Neville Brand), a demented, lank-haired recluse who bears a close family resemblance to the redneck psychos in *Chain Saw*, immediately identifies her as "one of Miss Hattie's girls" and proceeds to throw her down a flight of stairs, hack her up with a rake hoe, then dump her, still alive, into the swamp to be polished off by his pet crocodile.

Shortly thereafter, an all-American family on a road trip makes a pit stop at the Starlight: squabbling mom and pop, Faye and Roy (the former played by *Chain Saw's* Marilyn Burns and the latter played by quirky character actor William Finley, wearing Coke-bottle eyeglasses and coming off as even crazier than the mentally unhinged bad guy); adorable little daughter, Angie; and even more adorable pup, Snoopy. While Roy uses the facilities, Snoopy wanders away and is promptly devoured by the croc. Angie collapses in hysterics and is carried into a hotel room, where her parents try to comfort her while exchanging ugly recriminations.

Stung by his wife's contempt for his unmanly behavior, Roy rushes outside and fetches a double-barreled shotgun from the trunk of his car, intending to take revenge on the killer croc. He is blasting away at the water when a maniacally cackling Judd cuts him down with a long-handled scythe. As the dying Roy lies bleeding at water's edge, the giant reptile rises from the water and finishes him off.

Heading back inside, Judd brutally attacks Faye as she is freshening up in the bathtub, then, as Angie flees in terror, goes after the little girl with his scythe. When Angie manages to escape by wiggling into the crawl space beneath the hotel, Judd gives up the chase and goes upstairs to beat Faye unconscious and tie her to the bed for future torture.

In the meantime, another pair of potential victims has arrived at the Starlight: Harvey Wood (Mel Ferrer), father of the missing young prostitute from the opening sequence, and his younger daughter, Libby. In the final third of the film, Harvey gets dispatched by the scythe-wielding Judd; randy young Buck from the first scene makes a reappearance and promptly becomes croc fodder; and—in a departure from the slasher-film convention of leaving just one victim alive—Libby, Faye, and Angie all manage to escape. In a pat piece of poetic justice, Judd ends up in the jaws of his ravenous pet while chasing the three who get away through the swamp.

Though *Eaten Alive!* falls seriously short of the harrowing heights of *The Texas Chain Saw Massacre*, it shares several attributes with its illustrious predecessor, including a genuinely disturbing atmosphere of rustic depravity and an abundance of sadistic violence so gleefully over the top that it verges on the blackly comic. Also like *Chain Saw*, which was inspired by the atrocities of the Wisconsin necrophile Ed Gein (see sidebar, p. 241), *Eaten Alive!* is loosely based on the legendary crimes of a real-life serial killer.

His name was Joe Ball. The son of the wealthiest man in Elmendorf, Texas—a blink-and-you'll-miss-it railroad stop about fifteen miles southeast of San Antonio—Joe served overseas during the Great War before coming home and turning his hand to bootlegging. With the repeal of Prohibition, he opened a tavern on the outskirts of town, a rowdy roadside joint named (ironically enough) the Sociable Inn. For entertainment purposes, he installed a concrete pool out back and stocked it with five fully grown alligators, amusing his hard-bitten customers on Saturday nights by tossing live animals—puppies, kittens, possums, raccoons—to the frenzied reptiles. Cockfights were another attraction, as were the women Joe hired as waitresses and "dance hall girls," who seemed to come and go with surprising regularity.

One of these women, Minnie Gotthardt, won Joe's heart despite being, in the words of local historian Elton Cude Jr., "a bossy, displeasing, obnoxious person." However, after three years of sharing his bar-running duties (as well as

his bed), Minnie was supplanted in his affections by a pretty young newcomer, Dolores Goodwin, whose passion for Joe remained undiminished even after he hit her with a beer bottle that left her with a badly scarred face. Complicating Joe's love life even further was the arrival, in spring 1937, of a dark-haired beauty, Hazel "Schatzie" Brown, who, judging from her one surviving photograph, could have been cast as the tough-talking moll in a Depression-era gangster movie.

Not long after Schatzie appeared on the scene, Minnie abruptly vanished. To customers who inquired after her, Joe explained that she had become pregnant and gone to Corpus Christi to give birth. Joe indicated that the father was a black man, though he used a different word to describe him. With Minnie out of the way, Joe lost no time in marrying Dolores. Their union lasted less than a year. By April 1938, Dolores was gone, having fled to her sister's home in San Diego. Beautiful Schatzie Brown, who had become Joe's lover, disappeared not long afterward.

On Friday, September 23, 1938, an elderly Mexican laborer—identified in contemporary news accounts only as "Manuel"—showed up at the county sheriff's office with a disturbing tale. According to Manuel, who did odd jobs for Joe's sister, Mrs. Jimmy Loap, Joe had recently brought a 55-gallon iron barrel to the Loap farm and stowed it behind the barn. A few days later, when Joe had dropped by again, Manuel overheard Mrs. Loap tell her brother, "That barrel you left here is stinking and there are flies all over the place and I want it moved." Joe had promised to return the next day with his pickup truck to haul it away.

Leaning close to the night chief, Albert Stahl, Manuel said, "There is a human body in that barrel, Mr. Sheriff. She was killed by Mr. Joe."

The morning after Manuel made this startling allegation—Saturday, September 24—a pair of deputies, John Gray and John Klevenhagen (later captain of the Texas Rangers), drove to the Loap farmstead. Mrs. Loap confirmed that there was such a barrel. She had no idea what it contained. From its stench, however, she assumed it was some of the rotten meat that Joe was known to feed his pet gators. In any case, it was no longer there; her brother had come by and removed it, as promised.

Aware of rumors about sinister goings-on at the Sociable Inn, Gray and Klevenhagen proceeded to the seedy roadhouse, where they found the proprietor

sitting at a table along with Clifton Wheeler, a young African American described in newspapers as Joe's "Man Friday." When the lawmen explained that they had received information "about the body in the barrel" and were taking him in for questioning, Joe raised no objection but asked if he could first "get my money out of the cash register and close up the place."

"Lock it up and let's go," said Klevenhagen.

Joe walked behind the bar and opened the cash register. Suddenly, he whipped around, a .45-caliber automatic pistol in his right hand.

"Don't!" shouted Klevenhagen, as he and his partner yanked their own guns from their holsters.

Joe hesitated for an instant. Then he pointed his pistol at the center of his chest, pulled the trigger, and fell dead on the barroom floor. "This suicide to avoid arrest was an unspoken confession of crime," newspapers reported. "But what crime?"

The answer came from Joe's right-hand man, Clifton Wheeler. Taken to San Antonio for questioning, Wheeler readily confirmed Manuel's story. The suspicious barrel had, in fact, contained a human body: the remains of Hazel "Schatzie" Brown.

According to Wheeler, Joe had shot Hazel after she announced her intention to leave him for another man—one of the bar regulars who had a good job and a nice house and wanted to make an honest woman of her. Joe had then stuffed her body into the barrel and stored it temporarily at his sister's house.

A few days later, he and Wheeler had loaded the barrel onto the pickup and driven it to a bluff overlooking the San Antonio River. While Wheeler looked on, Joe dismembered the body with a meat saw he had brought from the tavern kitchen and chopped off the head with an axe. The two men then dug a shallow grave, tossed in the torso and severed limbs, and covered them with sand and some logs. They then built a blazing bonfire about twenty-five miles away and threw the head in the flames. The barrel went into the river.

By the time Wheeler finished his confession, the sun had gone down. Armed with flashlights, a party of lawmen brought him back to Elmendorf, where he led them to the burial site and, using the old rusted shovel that Joe had discarded there, dug up the decomposed torso and limbs. A portion of Hazel's jawbone with the teeth still intact was recovered from the ashes of the bonfire and proved instrumental in establishing the victim's identity.

Authorities were still puzzled about Joe's motives for killing Hazel. Jealousy didn't seem reason enough. Wheeler cleared up that mystery, too. "Maybe she knew too much about his shooting Miss Minnie," he said.

About eighteen months earlier, Wheeler calmly explained to his startled audience, Joe, having tired of Minnie's overbearing presence, had taken her on a picnic to a Gulf-side beach. For reasons that were not immediately clear to him, Wheeler was invited along. Seated side by side on a blanket, Joe and Minnie enjoyed sandwiches and cold beer, watched the foam breaking on the sand, and threw scraps to the gulls. There were more gulls than Minnie had ever seen, hundreds of them, and as she sat there marveling at them, Joe pulled out his .45 pistol and shot her in the head.

"Bury her and let's go," Joe said to Wheeler, who was seated nearby and who now understood why he had been brought along.

Wheeler (who would ultimately receive a two-year sentence as an accessory to murder) agreed to take the officers to Minnie's grave. When they arrived at the spot, however, he was unable to locate it. Windstorms had altered the landscape, filling in the hollows between the dunes with up to twenty feet of sand. After two days of fruitless digging, authorities put in a request to the county commissioner for funds to conduct an extensive excavation. Three weeks would pass before, with the aid of a steam shovel from the State Highway Department, Minnie Gotthardt's decomposed remains were disinterred from the sand.

In the meantime, a pair of Texas lawmen, eager to question Joe's estranged wife, Dolores, traveled to San Diego, where they found her in jail serving a fifteen-day sentence for public drunkenness. She revealed that, during a car ride to Corpus Christi Bay, Joe had told her about killing Minnie a few days before and had even stopped and gotten out of the car, supposedly to check on the grave. Despite his obvious capacity for violence, however—as evidenced by her scar from the time he had struck her with a beer bottle—she "didn't believe he would do such a thing as that." Still, she had to admit that Joe "had affairs with a lot of women" and often "acted fishy" when they suddenly went missing.

Newspapers, which had begun referring to Joe as "the Bluebeard of South Texas," reported that he had killed "at least a half-dozen women." Among them were a "blond 'hostess' named Estelle" who "suddenly disappeared, leaving her clothes in a back room of the roadhouse" and twenty-seven-year-old Julia

Alligators are confiscated as evidence from the property of accused murderer Joe Ball, 1938.

Turner, who, according to her roommate, Margie Casbeer, "never returned home after leaving one night for Joe Ball's place."

What earned Joe his lasting notoriety, however, wasn't the number of his presumed victims but the horrifying method by which he had—at least according to one source—disposed of some of them. On October 4, 1938, an Elmendorf

deputy constable, S. C. "Sonny" Cain, announced that he had been approached by a man who was willing to testify that Joe Ball "had chopped up the bodies of his victims and fed them to his pet alligators."

According to this individual (never identified in the press by name), six years earlier, on May 24, 1932, he had "walked around the roadhouse to the back yard to surprise Ball dragging the body of a woman toward the concrete pit where Ball kept his five pet alligators." Spotting the man, Joe drew a gun and "threatened to kill him, his wife, and his children if he did not keep his mouth shut and leave the state." Within days, the man had packed up his family and fled to California, not daring to return and reveal the shocking truth until he read of Joe's suicide in the papers.

The story made headlines throughout the Southwest: FED VICTIMS TO ALLI-GATORS; ALLIGATORS FED HUMAN FLESH ON MURDER FARM; SLAIN WOMEN FED TO 'GATORS; DISSECTED BODIES FED TO ALLIGATORS. Those who bothered to read the accompanying articles learned that "there was no way to ascertain the truth of this story"; in fact, it was laughed off by everyone closely involved in the case. Even Joe's divorced wife, Dolores, who bore no great love for her abusive ex, dismissed the sensational claim as mere rumor. "Joe never put no people in that alligator tank," she told interviewers years later. "Joe wasn't no horrible monster."

By the time she made that statement, however, the legend of "Alligator Joe" and his "murder farm" had been firmly established in local lore. In succeeding decades, it would continue to be promulgated by writers for pulp detective magazines, authors of serial killer encyclopedias, and filmmakers like Tobe Hooper—proving once again the validity of the famous line from John Ford's *The Man Who Shot Liberty Valence*: "When the legend becomes fact, print the legend."

ELEPHANT
(2003)

—

DIRECTED AND WRITTEN BY GUS VAN SANT. WITH ALEX FROST, ERIC DEULEN, JOHN ROBINSON, ELIAS MCCONNELL, JORDAN TAYLOR, CARRIE FINKLEA, NICOLE GEORGE, BRITTANY MOUNTAIN, AND TIMOTHY BOTTOMS.

In the closing years of the 1990s, America seemed to be in the grip of a terrifying crime epidemic: a rash of mass murders perpetrated by armed adolescent sociopaths who turned their schools into slaughterhouses. In October 1997, nine Mississippi high schoolers were gunned down—two fatally—by a rampaging classmate, Luke Woodham (who began his murder spree by knifing his mother to death). A few months later, fourteen-year-old Michael Carneal of West Paducah, Kentucky, opened fire with a .22-caliber Luger on the eight members of his high school prayer group, killing three of them. The following March, in Jonesboro, Arkansas, a pair of schoolboy snipers, Mitchell Johnson and Andrew Golden—ages eleven and thirteen—ambushed their classmates, killing four female students and a teacher and wounding nine other children.

Eric Deulen in a still from Gus Van Sant's *Elephant*, 2003.

Even the Jonesboro massacre, however, paled beside the bloodbath that took place the following year at Columbine, the Colorado high school that has become synonymous with the nightmare of juvenile gun violence.

In 1999, Columbine High School—situated at the foothills of the Rockies in the Denver suburb of Littleton—had a proud history of academic and athletic excellence: the highest SAT scores in the county, a 93-percent graduation rate, state championship sports teams. The school motto, engraved above the entranceway, expressed a sentiment sincerely shared by its faculty and administrators: "The finest kids in America pass through these halls." Four years earlier, the building had undergone a $15-million renovation that added, among other upgrades, a handsome new student cafeteria. A model of white, middle-American ideals and aspirations—"the kind of place," as one journalist wrote, "to which parents send their children to escape the problems of big cities, such as school violence and rising crime rates"—it was an incongruous setting for the horror that unfolded there on April 20, 1999.

The perpetrators of that atrocity were two seniors, Eric Harris and Dylan Klebold. In the aftermath of their rampage, the media promulgated various myths about the pair that are still widely believed by the public: they were social outcasts, possibly gay; they belonged to a Goth-style clique called the Trench Coat Mafia; and they were specifically targeting minorities, Christians, and the jocks who had bullied them. Those and other myths—that April 20 was chosen as the date of the massacre because it was Hitler's birthday, for example, or that one of the victims, Cassie Bernall, later revered as a Christian martyr, was slain for affirming her belief in God—are debunked by journalist Dave Cullen in his definitive account of the crime, the 2009 book *Columbine.*

Far from being a dorky adolescent misfit, Eric Harris—the driving force behind the massacre—was a cool, self-possessed charmer who smoked, partied, and cultivated an edgy, "military chic" look. He was an avid fan of baseball, liked to drink with his buddies, and drove around blasting hard rock from his car speakers. Successful with girls, he had "made it to the homecoming dance as a freshman," writes Cullen, "and had scored with a twenty-three-year-old at seventeen."

He was also a textbook psychopath. Outwardly normal, with a bright and engaging personality, he was a frighteningly aberrant being behind his "mask of sanity": a cunning, manipulative, and utterly remorseless creature who secretly exulted in his (supposed) superiority to the mere mortals around him and who viewed other human beings as contemptible vermin, deserving of nothing but annihilation at his godlike hands.

He bore, in fact, a striking similarity to another adolescent sociopath who had gained nationwide notoriety seventy-five years earlier: the 1920s "thrill killer" Richard Loeb. Like "Dickie" Loeb, Harris was an academic star, took strutting pride in his success with women, saw himself as a Nietzschean superman, and reveled in criminal risk-taking, engaging in petty crime as a run-up to murder. And like Loeb—one-half of Jazz Age America's most infamous criminal duo—Harris held pernicious sway over a subordinate personality who would become his willing partner in a monstrous *folie à deux.*

A math prodigy and computer whiz from a loving and affluent household, Dylan Klebold, like Eric Harris, appeared to be a normal high schooler—a kid who excelled at fantasy-league baseball, had an after-school job at a strip-mall pizza shop, and, despite his almost painful shyness, was going with a "sweet,

brainy Christian girl" whom he proudly squired to the senior prom. He was also an extreme depressive who, beginning in the spring of his sophomore year, began pouring out his tormented musings in a journal discovered after his death. Alternating between spiritual introspection and expressions of abject self-loathing—"My existence is shit"; "I have no happiness, no ambitions, no friends, no love"; "Oooh god I want to die sooo bad"—the entries are those of a desperately unhappy boy who almost certainly would have ended up taking his own life in the all-too-common way of other suicidal teens had he not formed a malignant bond with a psychopathic sadist.

Eric Harris also recorded his thoughts, both on a website and in a journal. In sharp contrast to Dylan's, they were not the tortured reflections of a self-hating, suicidal teen but the spewing of a hate-filled megalomaniac. "I feel like God," he ranted. "I am higher than almost everyone else in terms of human intelligence." The rest of humanity was composed of nothing but "pathetic fuckheads" too dense to perceive the hollowness of their own zombie-like existence or to appreciate his dazzling insights into the true meaning of life. "What the fuck is the point if only *some* people see what I am saying, there will always be ones who don't, ones that are too dumb or naive or ignorant or just plain retarded. If I can't pound it into every single person's head then it is pointless. Fuck mercy, fuck justice, fuck morals, fuck rules, fuck laws . . . All you fuckers should die! DIE!"

Eric began putting his antisocial fantasies into action in his sophomore year when, with Dylan as an eager accomplice, he embarked on a series of so-called missions: petty crimes and misdemeanors that escalated from malicious acts of property damage to the break-in of an unoccupied van, an offense that landed them in police custody. But these small-time infractions were just a warm-up to the enormity that Eric, in typically grandiose fashion, called Judgment Day.

Preparations began a year in advance: producing explosives, assembling an arsenal, plotting an onslaught with military precision. This was to be nothing as banal as a mere school shooting but an act of apocalyptic carnage, one that would outdo the mass destruction of the Oklahoma City bombing perpetrated four years earlier by the domestic terrorist Timothy McVeigh. As Dave Cullen shows, the intended holocaust would occur in distinct stages. After diverting police and firefighters with a decoy bomb planted several miles from the school, Eric and Dylan, armed to the teeth, would blow up the crowded cafeteria with two other propane bombs, then—having positioned themselves on a hillside

outside the main entrance—mow down fleeing survivors of the blast. Finally, after the crowds of first responders, frantic parents, and local reporters had rushed to the scene, the killers' parked cars, rigged with more time bombs, would explode, wiping out everyone in the vicinity. In one of their so-called basement tapes—a series of video messages mostly recorded in the basement of Eric's house in the weeks leading up to the massacre—Dylan, addressing his schoolmates, expresses the hope that he and his cohort might "kill 250 of you."

They might have reached or even surpassed that awful goal if Eric had known more about explosives. At around 11:15 a.m. on Judgment Day—Tuesday, April 20—the pair brazenly carried two duffel bags, each containing a twenty-pound time bomb, into the cafeteria and set them down by the lunch tables. They then headed back outside and waited for the fireworks to begin. When the bombs failed to detonate, they pulled out their weapons and advanced on the school, firing first at some students lounging outside, then heading back into the building. Over the next forty-nine minutes, they rampaged through the school, shooting randomly at fellow students and teachers, tossing homemade pipe bombs, exchanging exultant cries—"This is awesome!" "This is what we always wanted to do!"—as they went. The bulk of their victims—ten of an eventual thirteen fatalities—were slaughtered in the library, where, at 12:08 p.m., the murderers ended their own lives with simultaneous blasts to their heads.

Though the Columbine killers intended something far worse, they still managed to perpetrate the deadliest school massacre in American history up to that point. They also left a terrifying legacy. In April 2007, their ghastly record was broken when college senior Seung-Hui Cho, armed with two semiautomatic handguns, shot and killed thirty-two people and wounded seventeen more at Virginia Tech. Before embarking on his murderous spree, Cho produced a rambling rationalization of his crimes in the form of a videotaped manifesto. Among his self-professed motives was his admiration for the homicidal pair he saw as heroic models: his brother "martyrs" (as he called them), Eric Harris and Dylan Klebold.

Several films have been based on the Columbine massacre, among them Uwe Boll's overwrought *Heart of America* (2002), the riveting found footage *Zero Day* (2003), and the cult black comedy *Duck! The Carbine High Massa*cre (1999). By far the finest of the lot is Gus Van Sant's 2003 *Elephant* (a title derived from British director Alan Clarke's 1989 short film about the violence in Northern

Ireland, referring to the expression "the elephant in the room"—that is, a glaringly obvious problem people refuse to acknowledge).

Viewers looking for a hard-hitting thriller or Hollywood-style teen melodrama will be disappointed by Van Sant's film. Winner of the Palme D'Or at the 2003 Cannes Film Festival, it has the look, feel, and pace of a European arthouse movie. Cast almost entirely with teenage unknowns and lacking anything resembling a plot, it follows a handful of students at a Portland high school as they go about their completely mundane daily business. Extended sequences are devoted to nothing more action-packed than kids walking slowly from the athletic field or parking lot into the school building and along the halls.

Even the scenes with the two Klebold and Harris stand-ins—here named Alex (Alex Frost) and Eric (Eric Deulen)—are utterly lacking in drama. Hanging out in Alex's bedroom while planning the massacre, they seem like any pair of bored teenage buddies loafing after school. They carry out the shootings in the same affectless way. Van Sant's refusal to sensationalize the story—his understated, cinema verité approach—only makes the climactic murders more devastating, creating a shattering sense of how an utterly ordinary day can suddenly erupt in unspeakable horror.

If there is one criticism to be leveled at Van Sant's version of the Columbine killers, it is his perpetuation of certain myths spread by the media in the immediate aftermath of the atrocity—myths thoroughly debunked by Dave Cullen. In keeping with the rumor that Klebold and Harris were homosexual lovers (as if that would explain their sociopathic act), Van Sant includes a brief scene of Alex and Eric embracing in the shower and another of their exchanging a kiss. He also shows Alex being pelted with something gross by the classroom jocks, suggesting that bullying drove the teen killers to their apocalyptic act. And in the scene in Alex's bedroom, we see Eric reclining in bed, playing a first-person shooter game on a computer—a heavy-handed affirmation of the tired argument that media violence is to blame for adolescent criminality. The unsettling truth is that there is ultimately no way to account for horrors like the Columbine massacre, a fact that makes them all the more appalling.

FIVE STAR FINAL (1931)

**DIRECTED BY MERVYN LEROY. WRITTEN BY
ROBERT LORD AND BYRON MORGAN. WITH
EDWARD G. ROBINSON, MARIAN MARSH, H. B.
WARNER, ANTHONY BUSHELL, OSCAR APFEL,
AND BORIS KARLOFF.**

Among its many other signature events, from Charles Lindbergh's transatlantic flight to the St. Valentine's Day Massacre, the Roaring Twenties are known for a trio of courtroom melodramas that, thanks to the tabloid press, generated unprecedented levels of media hysteria. Two of them have remained alive in the public memory, thanks to the compelling nature of their central figures: the 1924 sentencing hearing of the college-age "thrill killers," Leopold and Loeb, and the 1927 trial of the adulterous Queens hausfrau, Ruth Snyder, and her mousy boyfriend, Judd Gray, the "Double Indemnity" slayers (see pp. 243 and 83, respectively). The third of the major Jazz Age murder trials has been largely forgotten. At the time of its occurrence, however, it was the greatest tabloid sensation of them all, a three-ring media circus the likes of which would not be see again until the trial of Bruno Richard Hauptmann nearly a decade later.

Though this extravaganza would not get fully underway until the fall of 1926, the case began four years earlier. On the morning of September 16, 1922, twenty-three-year-old Raymond Schneider and his underage girlfriend, fifteen-year-old Pearl Bahmer, were making their way along a little dirt road in New Brunswick, New Jersey, used by trysting couples as a lover's lane. All at once, they spotted a man and a woman stretched on their backs beneath a crabapple tree. The man was handsomely dressed in a dark-gray suit, a white shirt with a stiff white collar, and a white tie. His Panama hat had been placed over his face as though to shield him from the sun. At his side lay the woman, her legs demurely crossed, her head pillowed on her companion's outstretched right arm, her left hand resting on his knee. She wore a polka-dotted blue dress, the hem tugged as far below her knees as the fabric would allow. A brown woolen scarf covered her throat. Schneider and Bahmer could tell at a glance that both were dead.

Hurrying to the nearest home, they informed the owner, who immediately telephoned the police. Two officers were on the scene within minutes. They had

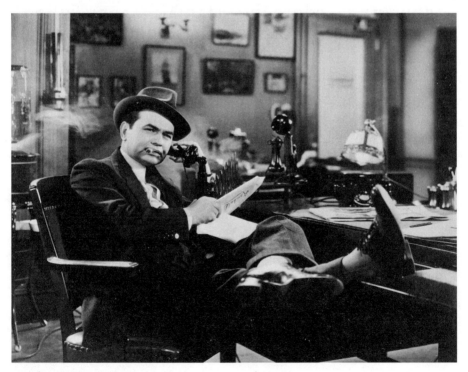

Edward G. Robinson in *Five Star Final*, 1931.

no trouble identifying the victims. Propped against the sole of the dead man's left shoe was his business card. He was the Reverend Edward Wheeler Hall, pastor of St. John's Episcopal Church and a pillar of the community. He was married to Mrs. Frances Hall, née Stevens, seven years his senior and daughter of one of New Brunswick's most prominent families. The dead woman at his side, however, was not his wife. She was Mrs. Eleanor Mills, a pretty thirty-four-year-old who sang in the congregation choir and was married to the church's sexton.

For years, members of the church had whispered about the suspiciously close relationship between the minister and his comely choir singer. That gossip was now confirmed by some other evidence found at the crime scene: a batch of torrid love letters scattered in the grass around the corpses. "Sweetheart, my true heart," Eleanor Mills had written in one. "I know there are girls with more shapely bodies, but I'm not caring what they have. I have the greatest part of all blessings, a noble man's deep, true, eternal love . . . How impatient I am and will be! I want to look up into your dear face for hours as you touch my body close."

The pastor's replies were equally ardent. "Darling Wonder Heart," he had written. "I just want to crush you for two hours. I want to see you Friday night alone by our road, where we can let out, unrestrained, that universe of joy and happiness we call ours." He signed himself "D. T. L.," short for *Deiner Treuer Liebhaber* ("Thy True Lover" in German). Mrs. Mills, preferring a less formal endearment, referred to the pastor as "Babykins."

Though their bodies had been arranged in "attitudes of peaceful repose," both victims had met a shockingly violent end. Autopsies revealed that the Reverend Hall had been shot at point-blank range with a .32-caliber automatic pistol. The bullet "entered his head near the right temple and came out at the back on the left side." Mrs. Mills had been shot three times in the head. "One of the bullets entered the woman's forehead about two inches above the nose," the *New York Times* reported, "another ploughed through the right cheek, and the third pierced the right temple." In addition, her throat had been cut so deeply that her jugular vein, windpipe, esophagus, and neck muscles were completely severed and "her backbone could easily be seen."

This steaming porridge of lust, murder, and scandal proved irresistible to the tabloids. As one eminent chronicler of the period states: "The Hall-Mills case had all the elements needed to satisfy an exacting public taste for the sensational. It was grisly, it was dramatic (the bodies being laid side to side as if to

emphasize an unhallowed union), it involved wealth and respectability, it had just the right amount of sex interest—and, in addition, it took place close to the great metropolitan nerve-center of the American press."

The frenzied coverage turned the old Phillips farm, where the bodies were found, into a major tourist attraction. On weekends, the crime scene became a virtual carnival with vendors hawking popcorn, peanuts, soft drinks, and balloons to the hordes of the morbidly curious who arrived "at the rate of a thousand cars a day." Within a few weeks, the crabapple tree had been completely stripped of every branch and bit of bark by ghoulish souvenir hunters, while one enterprising individual peddled samples of the dirt surrounding the now-infamous tree for twenty-five cents a bag.

Despite one detective's confident prediction that the crime would be solved in a matter of days—"the case is a cinch," he declared to reporters—the investigation dragged on for weeks. Two months after the murders, the killer's identity remained unknown, though the likeliest candidates were the pastor's wronged wife and her two brothers, one of whom was reputed to be a crack shot. A grand jury was finally convened in November. After five days of hearings, however, it failed to issue an indictment. Mrs. Hall promptly set sail for Europe, and the nation was compelled to seek its titillation elsewhere.

Four years later, in a bid to boost its circulation, William Randolph Hearst's fledgling tabloid, New York's *Daily Mirror*, dredged up new evidence in the case and plastered the front page of its July 16, 1926, edition with a sensational headline: HALL-MILLS MURDER MYSTERY BARED. Over the course of the following week, the tabloid trumpeted one frenzied charge after another: HALL'S BRIBERY REVEALED; MRS. HALL'S SPIES HELD TOWN IN TERROR; HOW HIDDEN HAND BALKED HALL MURDER JUSTICE.

The strategy worked. Not only did the *Mirror*'s circulation jump, but its strident calls for action forced the governor of New Jersey to reopen the case. On July 28, 1926, Mrs. Frances Stevens Hall, along with her brothers, Willie and Henry, was arrested for the murder of her husband, Edward, and his inamorata, Mrs. Eleanor Mills.

"The Trial of the Century" (as the tabloids predictably hyped it) began on the morning of Wednesday, November 3, 1926, in Somerville, New Jersey. The courthouse was crammed with hundreds of reporters who would file more than twelve million words during the trial's spectacular twenty-three-day run. The notoriously stodgy *New York Times*, which normally sniffed at such lurid matters, not only kept four full-time stenographers on the scene but actually covered the case more extensively than the tabloids. (When asked about the seeming contradiction, publisher Adolph S. Ochs loftily replied, "The yellows see such stories only as opportunities for sensationalism. When the *Times* gives a great amount of space to such stories, it turns out authentic sociological documents.") Among the celebrity spectators were evangelist Billy Sunday (whose campaign against "demon rum" helped bring about Prohibition), novelist and playwright Mary Roberts Rinehart (creator, among other characters, of a caped figure called "the Bat," an acknowledged inspiration for Bob Kane's Batman), and legendary newsman Damon Runyon (best known as the author of *Guys and Dolls*).

The trial offered more than its share of melodramatic moments, including the public reading of the Reverend Hall's steamy love letters; the questioning of Mrs. Hall (nicknamed "the Iron Widow" because of her stoic demeanor); and—most sensationally—the testimony of a purported eyewitness, a farmwife named Jane Gibson, dubbed "the Pig Woman" because she raised Poland China hogs. Dying of cancer, Mrs. Gibson, attended by a doctor and two nurses, was carried into the courtroom on a stretcher and placed on an iron hospital bed facing the jury box. During her testimony—a gripping (if highly dubious) account of the grisly double murder—her own aged mother sat in the front row of the gallery, wringing her gnarled hands and muttering, "She's a liar! She's a liar! She's a liar!"

For three solid weeks, the dramatic doings in Somerville kept the country in thrall. Every morning, Americans followed the case in their daily papers as though devouring the latest installment of the world's juiciest potboiler. During the height of the Hall-Mills hysteria, only the most extraordinary news could dislodge the trial from the headlines or distract the public from the sensational proceedings, from the Iron Widow's steely testimony to the Pig Woman's shocking tale. In the end, the jury believed the former over the latter. Mrs. Hall and her brothers were acquitted (and promptly sued the *Mirror* for $3 million).

In the years since the Hall-Mills case came to its official end, writers have put forth various theories about the culprit, ranging from Eleanor Mills's jealous

husband to the Ku Klux Klan. Others believe that the prosecutors were right and that Mrs. Hall and her brothers got away with murder. All that can be said for certain is that the Hall-Mills case remains one of the country's most notorious unsolved murders.

Of the three great murder sensations of the 1920s, two of them—the Leopold and Loeb and the Snyder-Gray cases—became the bases of classic works of American cinema: Alfred Hitchcock's *Rope* and Billy Wilder's *Double Indemnity* (see pp. 243 and 83, respectively). For whatever reason, the Hall-Mills case was never transformed into any comparably important film. It did, however, help inspire a fascinating movie that has fallen into undeserved obscurity: *Five Star Final*.

Nominated for an Oscar for best picture in 1931, this pre–Hays Code gem—a savage takedown of tabloid journalism—deals with a tawdry sex-and-scandal rag, the *Evening Gazette*. Concerned about its flagging circulation, its owner, Bernard Hinchecliffe (Oscar Apfel), looks for ways of putting his paper back on top of the tabloid trash heap. As William Randolph Hearst did with the Hall-Mills case, Hinchecliffe hits on the idea of resuscitating a long-dead crime that had riveted the public years earlier: the notorious case of "the Love-Mad Stenographer," a young woman named Nancy Voorhees (Frances Starr), who was impregnated by her boss, then shot him when he refused to marry her. Following a sensational trial, she was acquitted by a sympathetic jury.

Convinced that, as he puts it, the "story will certainly interest a new generation who never heard of the case," Hinchecliffe turns the assignment over to his editor-in-chief, Joseph Randall, played by the ever-watchable Edward G. Robinson (fresh off his star-making turn as Rico in *Little Caesar*). A once-idealistic journalist who has sacrificed his principles for the sake of a regular paycheck, Randall, despite his scruples, throws himself into the task. Looking to dig up any new, exploitable details related to the case, he calls on the perfect reporter for the job: an oily creep with the suitably slimy name of Isopod, played to unctuous perfection by a young Boris Karloff.

We soon learn that, in the two decades since she dominated the headlines, the former Nancy Voorhees has settled into a respectable, happily married life with an adoring banker husband, Michael Townsend (H. B. Warner). The couple has a lovely grown daughter, Jenny (Marian Marsh), who is about to marry an equally adoring fellow, Phillip Weeks (Anthony Bushell), son of a socially prominent family. Nancy has put her scandalous past far behind her, and other than her husband, no one in her immediate circle, her daughter included, has any idea that she was once New York City's most infamous murderess.

On the night before Jenny's wedding, Isopod (a former divinity student kicked out of his seminary for dissolute behavior) disguises himself as a minister and insinuates himself into the Townsend household, where he not only learns of the impending nuptials but sneakily acquires a photograph of the bride-to-be. By the following morning, that photo—along with the entire sordid story of the Vorhees case—has been splashed on the *Gazette*'s front page.

When the bridegroom's insufferably snooty parents discover the truth about their son's prospective mother-in-law, they demand that the wedding be called off. Fearing that her daughter's life is about to be ruined by the tabloid's heartless actions, Nancy puts in a desperate phone call to both Hinchecliffe and Randall. When the two ignore her pleas, she retreats to the bathroom, removes a bottle of poison from the cabinet, and swallows a fatal dose. When her husband discovers her corpse, he finishes off the bottle.

In the film's climactic scene, their daughter, Jenny—until then little more than a vapid, pretty face—shows up at the newspaper office with a pistol and delivers a shattering denunciation of Hinchecliffe and Randall. "Why did you kill my mother!" she shrieks with mounting hysteria. Only the timely intervention of her fiancé prevents her from becoming a murderess like her mother. In the end, overcome with guilt and self-disgust, Randall washes his hands of the "dirty rag."

"Hinchecliffe's got to get himself a new head butcher," he cries. "I've had ten years of filth and blood! I'm splashed with it, drenched with it! I've had all I can stand." Then (using language that would soon be forbidden under the censorship of Hollywood's Hays Code), he hurls a telephone through the boss's glass door, shouting that Hinchecliffe can take his paper and "shove it up his—!"

FRENZY (1972)

DIRECTED BY ALFRED HITCHCOCK. WRITTEN BY ANTHONY SHAFFER. WITH JON FINCH, BARRY FOSTER, ALEC MCCOWEN, ANNA MASSEY, BARBARA LEIGH-HUNT, VIVIEN MERCHANT, JEAN MARSH, BILLIE WHITELAW, AND CLIVE SWIFT.

Alfred Hitchcock's penultimate film, *Frenzy*, was adapted from the 1967 novel *Goodbye Piccadilly, Farewell Leicester Square* by Arthur La Bern, who found the movie so "distasteful" (as he wrote in a letter to the *Times* of London) that he publicly disavowed any connection to it. La Bern, however, was virtually alone in his low estimation of the film.

After his classic thrillers of the 1930s and 1940s (*The 39 Steps, Suspicion, Shadow of a Doubt, Notorious,* etc.), his elegant masterpieces of the 1950s (*Vertigo, Rear Window, To Catch a Thief, North by Northwest*), and his groundbreaking shockers of the early 1960s (*Psycho, The Birds*), Hitchcock had gone into a sudden, sharp decline, turning out a string of clunkers (*Marnie, Torn Curtain, Topaz*) that suggested he had lost his edge. *Frenzy*, released in 1972, was hailed by reviewers as a welcome return to form by the master of cinematic suspense.

The movie opens with a quintessentially Hitchcockian scene. On the banks of the Thames, outside a government building, a politician is addressing a crowd of citizens (among whom is Hitchcock himself, making his trademark cameo).

Thanks to the efforts of local authorities, he proclaims, the river will shortly be restored to its formerly pristine condition. "Let us rejoice that pollution will soon be banished from the waters of this river and that there will soon be no foreign—" Before he can get the word "bodies" out of his mouth, one of the listeners spots something floating in the river: the naked body of a young woman garroted with a necktie, the latest victim of the so-called Necktie Killer who has been terrorizing London.

The film then cuts to its protagonist, an embittered loser named Richard Blaney (Jon Finch). A former squadron leader in the Royal Air Force who—through a combination of bad luck and his own exceptionally prickly personality—has ended up on the skids, Blaney, like so many of Hitchcock's heroes, finds himself caught up in nightmarish circumstances. Possessed of a violent temper that explodes at the slightest provocation, he strikes pretty much everyone he meets as precisely the sort of dangerously unstable individual who might indulge in serial homicide. When his ex-wife and girlfriend are both slain by the Necktie Killer, he is wrongfully accused, arrested, and convicted of their murders.

The real culprit turns out to be Blaney's best friend, Bob Rusk (Barry Foster), a successful produce merchant in Covent Garden. A sharp-dressing, smooth-talking charmer who projects an air of avuncular benevolence, Rusk, as viewers soon learn, is a profoundly warped mama's boy with kinky sexual tastes and a deep-seated hatred of the opposite sex. Like others of his aberrant breed, he regards all women as whores who are just asking to be raped and murdered. The scene in which he assaults and strangles Blaney's ex-wife, Brenda (Barbara Leigh-Hunt), in the office of her matchmaking bureau is one of the most disturbingly violent in the Hitchcockian canon.

Even more chilling is the murder of Blaney's girlfriend, Babs Milligan (Anna Massey), which takes place entirely off-screen. Needing a place to crash before fleeing with Blaney to Paris, Babs accepts an invitation to stay overnight at Rusk's flat while he (ostensibly) goes on a trip. The camera follows the two up the stairs to the door of his apartment. As Rusk leads Babs inside, we hear him speak the same words that he said to his previous victim before turning on her: "You're my type of woman." After the door closes behind them, the camera silently glides back down the staircase, out of the building, and onto the busy street, where workers and passersby go about their routine affairs, oblivious to

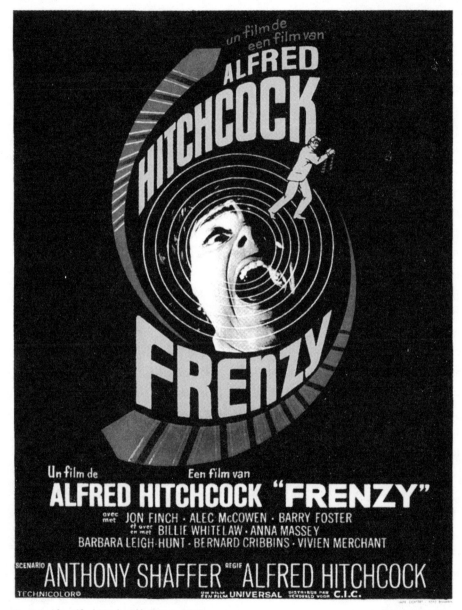

Poster art for Alfred Hitchcock's *Frenzy*, 1972.

the atrocity taking place right above their heads. It is a tour de force demonstration of how the unseen can be far more terrifying than the most graphically portrayed horror.

This harrowing moment is followed by a celebrated set piece. After stuffing Babs's body into a potato sack and loading it onto a farm truck, Rusk discovers that the monogrammed stickpin he keeps in his lapel is missing and realizes, to his horror, that Babs must have pulled it off during her death struggle. Desperate to retrieve it, he clambers into the truck, which then takes off down the highway. In a sequence that mixes heart-racing tension with ghoulish slapstick, he wrestles with her naked corpse while struggling to pry the incriminating evidence from her fingers, which are stiff with rigor mortis.

Comic relief is provided by a subplot involving the main investigator on the case, the soft-spoken Inspector Oxford (Alec McCowen). Two matters are of preoccupying importance to Oxford: solving the murders and getting a decent meal from his dotty wife (Vivien Merchant), an aspiring French cook who insists on using him as a culinary guinea pig. Oxford's gnawing doubts about Blaney's guilt lead to a thrilling climax and a delicious punch line that (as film scholar Raymond Foery shows in his book on the making of *Frenzy*) grew out of the active collaboration between Hitchcock and screenwriter Anthony Shaffer.

With its inimitable mix of ingredients—dark comedy and macabre violence, sardonic wit and nail-biting suspense, psychological complexity and pure pop entertainment—*Frenzy* seems like a sheer fabrication, concocted entirely out of classic Hitchcockian ingredients. However, the truth is that, much like *Psycho* (see p. 235), this work of apparent artifice was inspired by a real-life criminal case known variously as "the Thames Nude Murders," "the Thames-side Murders," and the "Jack the Stripper" murders.

In contrast to *Frenzy*'s fictitious villain—who, in the course of the film, murders an enterprising businesswoman and a hardworking barmaid—the still-unidentified psycho who served as his model was a classic "harlot slayer," the common variety of serial killer who preys exclusively on prostitutes. Though there is some dispute as to precisely when his murder spree began, most historians of the case trace its origins to the night of June 17, 1959, when the partially clothed body of twenty-one-year-old hooker Elizabeth Figgs was found in Dukes Meadows, a riverside park in West London that served, in warm weather, as a popular trysting spot. The postmortem revealed that she had been killed by

manual strangulation sometime between midnight and 2:00 a.m. The last person known to have seen her alive was a john, Ernest Forrest, who had paid thirty shillings to have sex with her in the back seat of his car before dropping her off shortly after 1:00 a.m. A devout Catholic who consulted his priest before turning himself in, Forrest was fully cooperative with the police, who quickly dismissed him as a suspect. An intensive investigation conducted over the following weeks turned up no clues as to the perpetrator's identity.

A common characteristic of serial murderers is that they tend to kill more frequently the longer they remain at large. Between Jeffrey Dahmer's first murder in June 1978, for example, and his second in September 1987, nine years elapsed. By contrast, in the two months prior to his arrest in July 1991, he committed no less than six homicides, killing at the approximate rate of one young man per week. This pattern (known to criminologists as "escalation") was true of the psycho killer soon to be known as "Jack the Stripper."

On the afternoon of November 8, 1963—four years after the strangulation murder of Elizabeth Figgs and not far from where her body was found—the badly decomposed corpse of a woman, naked except for a nylon stocking rolled down around one ankle, was uncovered in a garbage dump under two feet of rubbish. From the evidence of her fractured hyoid—a small, horseshoe-shaped bone located in the throat—the pathologist who performed the postmortem considered it "highly likely" that the woman had been strangled to death.

Though the remains were putrefied beyond recognition, lab technicians were able to recover a thumbprint that led to the victim's identity: Gwynneth Rees was a hard-living, twenty-two-year-old prostitute who had racked up a dozen convictions for solicitation in the course of her abbreviated life and who counted among her intimates several known associates of the Kray twins, London's most notorious gangsters. More than eleven hundred people were interviewed by police in the course of their investigation, but—as in the case of Elizabeth Figgs—no suspect was ever arrested.

While the bodies of Figgs and Rees were discovered near the banks of the Thames, the next corpse was found in the river itself, like the Necktie Killer's nude victim, who washes ashore at the start of *Frenzy*. Shortly after 1:00 p.m. on Sunday, February 2, 1964, two brothers, members of a sailing club, were preparing for a boat race when they spotted the naked body of a woman in the water, her head and shoulders covered with driftwood, her nylons bunched around

her ankles. When the arriving officers pulled her water-logged corpse onto the shore, they discovered a pair of semen-stained panties shoved down her throat. An autopsy revealed that—like both Figgs and Rees—she had several missing teeth and had evidently died from strangulation.

Fingerprints identified her as thirty-one-year-old Hannah Tailford. As investigators would discover, she had begun prostituting herself as a teenage runaway; performed in cheaply made, 8 mm pornographic films; took part in orgies, some allegedly organized by high-society libertines; and once tried to make money by advertising the sale of her newborn baby. Despite another intensive investigation by police, lasting three months and involving interviews with approximately seven hundred people (with a special emphasis on johns who, according to their prostitute partners, "liked to manually strangle while having sex"), the murder went unsolved.

Even as the search for Tailford's killer was going on, another naked female corpse washed up on the riverbank. From fingerprints and a tattoo, she was quickly identified as Irene Lockwood, a twenty-six-year-old prostitute and scam artist who, at the time of her death, was between fourteen and eighteen weeks pregnant. Like the previous victims, she was missing several front teeth. The case seemed to break wide open when one of her acquaintances, a deaf, fifty-four-year-old tennis club caretaker named Kenneth Archibald, walked into the Notting Hill police station and confessed to the crime. Despite glaring discrepancies in his story, he was charged with her murder. At his trial in June, however, he retracted his confession, explaining that he had been severely depressed at the time and had let his "imagination run riot." By then, it was clear that Archibald could not be the serial murderer whom the tabloids had now dubbed "Jack the Stripper." While the pathetic little man was in custody, the real killer had struck again.

On the morning of April 24, 1964, a resident of a quiet residential neighborhood in West London stepped outside his house to empty a bucket of ashes and found the naked corpse of a young woman lying on a rubbish heap just outside his garden gate. She was quickly identified as Helen Barthelemy, a one-time circus trapeze artist who had become a stripper and then a hooker.

Like the earlier victims, she had died from strangulation and was missing several of her front teeth, which had evidently been extracted after death. Unlike those earlier unfortunates, her body had been dumped at some distance

from the Thames, her killer clearly seeking to avoid the dozens of police officers now patrolling the riverfront area where the first four bodies had been found. Although eager to avoid detection, the Stripper had left a potentially important clue. A close examination of Barthelemy's body turned up microscopic particles of black silicone paint that had come from the nozzle of a spray gun.

Identical particles were found on the corpses of the Stripper's next—and final—three victims: thirty-year-old Mary Flemming, found in a garage drive-way in Chiswick on July 14; twenty-year-old Frances Brown, dumped in a Kensington car park in November; and twenty-eight-year-old Bridget O'Hara, whose partially mummified body was discovered on February 16, 1965, behind a storage shed in the Heron Trading Estate, an industrial park in Acton. Forensic analysis of the paint residue found on Barthelemy and the others eventually established that all four corpses had been stored in the same place. Employing all the resources of Scotland Yard, investigators were able to trace the source of the paint to a transformer shed on the Heron Trading Estate.

With this breakthrough, an arrest of London's most notorious "harlot killer" since Jack the Ripper seemed imminent. The likeliest suspect appeared to be forty-six-year-old Mungo "Jock" Ireland, a hard-drinking night security guard at the industrial park. Before he could be picked up by police, however, Ireland locked himself inside his garage and killed himself with the exhaust fumes from his idling car. "I can't stick it any longer," he wrote in his suicide note. Though the Stripper murders ended abruptly with his death, subsequent investiga-tion—which established that he had been back home in Scotland when Bridget O'Hara's body had been dumped—cast doubt on his culpability.

Over the years, other names have been put forth as suspects, including Freddie Mills, a world-champion boxer and TV personality with a sadistic sexual streak; Harold Jones, a Welshman who moved to London after spending twenty years in prison for murdering two girls when he was fifteen; and Andrew John Cushway, a disgraced ex–police detective with a grudge against his former col-leagues. No definitive proof, however, links any of them to the Stripper murders. Unlike the tidy wrap-up of *Frenzy*, the true-life case that inspired Hitchcock's great comeback film remains officially unsolved.

THE FUGITIVE (1993)

DIRECTED BY ANDREW DAVIS. WRITTEN BY JEB STUART AND DAVID TWOHY. WITH HARRISON FORD, TOMMY LEE JONES, SELA WARD, JOE PANTOLIANO, ANDREAS KATSULAS, JEROEN KRABBÉ, AND JULIANNE MOORE.

On the evening of August 29, 1967, an unprecedented 78 million people—the largest audience ever to tune in to a weekly TV show up to that time—sat transfixed in front of their TV sets to watch the final episode of the hit series *The Fugitive.* For four years, the program's protagonist, falsely accused physician Richard Kimble (David Janssen), had been on the run, searching for the one-armed intruder who had murdered his wife and eluding capture by an Indiana state police detective, Lieutenant Philip Gerard (Barry Morse), an implacable pursuer cut from the same obsessive cloth as Inspector Javert in *Les Misérables.*

A quarter century later, in keeping with the contemporary Hollywood trend of recycling boomer-era TV series (*Maverick, Dragnet, The Wild, Wild West,* etc.), Warner Bros. released a big-budget version of *The Fugitive,* arguably the best of this justly maligned cinematic genre. Harrison Ford stars as Kimble, here no mere small-town pediatrician (as in the TV show) but a world-famous

cardiovascular surgeon. Directed at a breakneck pace by Andrew Davis, the movie loses no time in getting down to its slam-bang business. Before the opening credits have finished rolling, the hero's stunningly gorgeous wife, Helen (Sela Ward), has been brutally murdered, and Kimble is arrested, convicted, sentenced to the electric chair, and loaded onto a bus headed for prison. When his fellow passengers attempt a breakout, the bus careens down a hill and onto the tracks before an oncoming train. The spectacular collision that follows was accomplished—in those bygone days before CGI—by placing an actual full-sized bus in the path of a speeding freight train, a stunt that reportedly cost $1.5 million and was worth every penny (the wreckage remains where the sequence was shot in the Great Smoky Mountains of North Carolina and is still a popular tourist attraction).

Needless to say, Kimble makes a hair's-breadth escape from the bus and finds himself on the run, pursued by Deputy US Marshal Gerard (here rechristened Samuel), an alpha-dog lawman played with his usual manly bravura by Tommy Lee Jones, who scored an Academy Award for best supporting actor for his performance. Their initial confrontation climaxes when Kimble takes a desperate leap from atop a 225-foot hydroelectric dam—a thrilling scene marred only slightly by the fact that the figure plunging from the dizzying height is an obvious dummy.

Back on dry land, Kimble shaves his beard, dyes his hair black, and returns to Chicago, where he embarks on a search for the real killer of his wife, a nasty customer named Sykes who is equipped with a prosthetic arm. Hunted not only by the relentless Gerard but by the entire Chicago police force—and with the whole population of the city on the lookout for him—the remarkably resourceful physician manages to capture the one-armed man, uncover the nefarious scheme that led to Helen's death, and defeat the evil mastermind behind her murder.

Though guns are regularly brandished and frequently fired, Kimble, true to his Hippocratic oath, never inflicts lethal harm. At one point, disguised as a hospital orderly, he even takes time to save the life of a badly injured little boy, risking imminent capture to read the child's X-rays, revise his medical chart, and rush him into surgery. The film ends with a heartwarming moment of male bonding as the newly exonerated Kimble and his former nemesis, Gerard,

exchange a few pleasantries before riding off together into the sunset in the rear of a cop car.

Though Roy Huggins, creator of the original TV drama, has claimed that he came up with the idea for *The Fugitive* independent of any outside influence, it is widely believed that the show was inspired by one of the most sensational murder cases of the 1950s, a crime with unmistakable parallels to the central premise of Huggins's series.

The murder occurred in the early morning hours of July 4, 1955. The previous evening, Sam and Marilyn Sheppard—former high school sweethearts who had been (to all appearances) happily married for almost ten years—had entertained another couple at their lakefront home in Bay Village, Ohio, an upper-class suburb of Cleveland. By the time their guests departed, "Dr. Sam"—an osteopathic physician who had spent an exhausting day at the private hospital he ran with his father and two brothers—had already conked out in the living room. Leaving her husband asleep, thirty-one-year-old Marilyn, an attractive brunette who was four months pregnant at the time, retired upstairs. Sound

Harrison Ford in *The Fugitive*, 1993.

asleep in the next bedroom was the Sheppards' seven-year-old son, Samuel Reese, nicknamed "Chip."

Since all the suspects in the case are long dead, no one will ever know precisely what happened next. Sam Sheppard would tell the same story over and over again, without ever deviating from its main details: Sometime in the middle of the night, he was awakened by the cries of his wife, who was moaning and calling his name. Drowsily, he made his way upstairs and, entering the bedroom, saw a "white form" looming over his wife's pajama-clad body. He "started to wrestle" with the figure but was suddenly struck on the head and lost consciousness.

When he came to, he was lying on the floor beside his wife's bed. Marilyn had been so savagely beaten that, even at a glance, he could tell that "she was gone." Her face was battered beyond recognition, her nose was broken, several teeth were missing. There was blood everywhere. It drenched the mattress and was spattered all over the walls. Later, police also would discover a trail of blood leading from the bedroom all the way down to the basement.

Dashing into his son's room, Sheppard found the boy fast asleep. Suddenly, he heard a noise from below and bolted downstairs. The back door was open, and through it, he could make out "a form progressing rapidly toward the lake." It appeared to be a middle-aged man about six feet, three inches tall, with dark "bushy hair" and a white shirt.

Chasing the fleeing figure across the lawn and down the wooden steps to the beach fifty feet below, Sheppard threw himself at the man and grabbed him from behind. After a brief, violent struggle, the thirty-year-old physician—a 170-pound six-footer who had been captain of his high school football team—felt "a choking sensation" and lost consciousness.

Dawn was already beginning to break when he next came to. Staggering back into the house and upstairs to his bedroom, he checked his wife's pulse and determined that she was dead. At around 6:00 a.m.—after wandering dazedly around the house for a while, he called his neighbor, village mayor Spencer Houk. "My God, Spen, get over here," he cried. "I think they've killed Marilyn."

The first newspaper stories speculated that Marilyn had been killed by either a jewel thief or a junkie "seeking narcotics." According to these accounts, Sheppard had been severely injured by the intruder while coming to the rescue of his wife. Before long, however, Sheppard himself emerged as the prime

suspect in the murder. According to the police, there were no signs of a break-in at the house. Though Sheppard had indeed suffered significant injuries—including a fractured vertebra in his neck—the notion that the athletic six-footer had been knocked out twice by the mysterious assailant seemed hard to swallow. And there were plenty of other suspicious elements: Sheppard's inability to account for the two-hour lapse between Marilyn's death and his call to Spencer Houk; the unaccountable disappearance of the white T-shirt he had been wearing when he fell asleep on the downstairs daybed; the fact that the family dog hadn't barked and that seven-year-old Chip had somehow slept through his mother's savage murder and his father's supposed struggle with the "bushy-haired intruder."

Though he stoutly denied his guilt, Sheppard's case wasn't helped by his apparent reluctance to cooperate with the police (he refused to take a lie-detector test and immediately retained a well-known criminal defense attorney) or by the fact that—contrary to his assertions of marital devotion—a young woman named Susan Hayes came forward and confessed that she and Dr. Sam had been conducting a torrid affair. Within days, the case had turned into a full-fledged media circus, with Cleveland newspapers openly accusing Sheppard of the murder and demanding his arrest. QUIT STALLING AND BRING HIM IN ran the headline in one local paper. With an inflamed public already convinced of his guilt, Sheppard was taken into custody on July 30, 1954.

The outcome of his trial, which began in October, was a foregone conclusion. On December 21, after six weeks of testimony, the jury delivered a verdict of guilty in the second degree. Sheppard was given a life sentence by a judge who—even before the proceedings began—reportedly told a nationally syndicated columnist that the defendant was "guilty as hell. There's no question about it."

While Sheppard languished in the Ohio Penitentiary, his family kept up the fight to prove his innocence. In 1961, they retained F. Lee Bailey, at that time an ambitious young attorney determined to make a national name for himself. By April 1963, he had filed a petition in federal court, arguing that unbridled media coverage of the case had made it impossible for Sheppard to receive a fair trial. The following summer, in a stunning turn, Sheppard was released from prison by District Judge John Weinman, who agreed that Sheppard's constitutional rights had been violated by the irresponsible behavior of the press, which had turned his trial into a "mockery of justice." "If ever there was a trial by newspaper,"

he wrote, "this is a perfect example." Two years later, on June 6, 1966, the US Supreme Court upheld Judge Weinman's findings, declaring that "the massive, pervasive, and prejudicial publicity attending petitioner's prosecution prevented him from receiving a fair trial consistent with the Due Process Clause of the Fourteenth Amendment."

That fall, November 1966, the state of Ohio put Sheppard on trial again. Twelve years had passed since his original conviction, and circumstances were very different this time. For one, he was being represented by one of the most colorful and effective defense lawyers of the age, F. Lee Bailey; in addition to his legal prowess, Bailey was a master of public relations and had managed to generate considerable sympathy for his client through the media.

Perhaps just as significant was the enormous popularity of the top-rated prime-time TV drama *The Fugitive*. The American public's deep sympathy for and identification with the program's hero, Dr. Richard Kimble, inevitably spilled onto his real-life inspiration, Dr. Sam Sheppard. On November 16, 1966, the jury delivered a not-guilty verdict. Sheppard was a free man and F. Lee Bailey's reputation was made.

Sheppard's nightmare, however, hadn't really ended. Indeed, his life went into a dreadful spiral following his exoneration. Readmitted to the practice of medicine, he was sued for malpractice after the death of one of his patients. He took to alcohol and drugs. In 1968, the woman he had married in prison divorced him, claiming that he had stolen money from her, threatened her life, and thrown bottles at her. He became—of all things—a professional wrestler, in a pre-WWE era, when a profoundly disreputable, freak-show air hung about the so-called sport. In April 1970, he was found dead of liver failure. He was only forty-six years old.

In subsequent years, the case was back in the news, thanks to the unremitting efforts of the grown-up Samuel Reese Sheppard to establish, beyond any remaining doubt, that his father was innocent of the murder and that the "bushy-haired intruder" really existed. Employing modern-day DNA tests (unavailable at the time of the murder), experts showed that the trail of blood leading from the bedroom to the basement of the Sheppard home belonged to a third party. Proof also emerged that, contrary to the initial claims of the police, the lock on the basement door had, in fact, been tampered with.

The likeliest culprit, most people agree, was the Sheppards' window washer, a man named Richard Eberling, who ended up in prison after being convicted of bludgeoning an old woman to death in a scheme to inherit her estate. Eberling (who was familiar with the Sheppard home, fit the general description of the "bushy-haired intruder," and was arrested for robbery in 1959 with Marilyn Sheppard's diamond ring in his possession) certainly had both a motive and an opportunity. But the former window washer—who died in prison in July 1998—went to his grave denying that he committed the murder. Two years later, still determined to clear his father's name, Samuel Reese Sheppard brought a civil suit against the state of Ohio for wrongful imprisonment. After an eight-week trial, the jury found against him, declaring that the prosecution had failed to prove Dr. Sam Sheppard innocent of the murder of his wife.

FURY (1936)

DIRECTED BY FRITZ LANG. WRITTEN BY
BARTLETT CORMACK AND FRITZ LANG. WITH
SYLVIA SIDNEY, SPENCER TRACY, BRUCE
CABOT, WALTER BRENNAN, WALTER ABEL,
AND FRANK ALBERTSON.

Near the start of Fritz Lang's 1931 masterpiece *M* (see p. 179), an elderly man is approached by a little girl who asks the time. The old gent is promptly set upon by an ugly crowd, accusing him of being the *Kindermörder*, the child murderer terrorizing their city. The scene is an early example of a theme that preoccupied Lang throughout his career: the speed at which ordinary, law-abiding citizens can turn into a savage mob.

That theme is at the center of *Fury*, the first American film made by Lang after he fled Nazi Germany. Spencer Tracy plays the male lead, Joe Wilson, a hardworking, easygoing guy who, during the course of the film, turns into a snarling, bloodthirsty avenger. (Watching Tracy's unsettling metamorphosis, it's easy to see why he would be cast, five years later, as Dr. Jekyll and Mr. Hyde.)

The film itself undergoes a comparable transformation. The opening scene suggests that the viewer is in store for a romantic comedy. Gazing into the display window of a home-furnishing shop are Joe and his doe-eyed fiancée, Katherine Grant (Sylvia Sidney, a major star of the 1930s, now best remembered

for her late-life role as Juno, the chain-smoking, afterlife caseworker who exhales through her gaping slit throat in Tim Burton's *Beetlejuice*). They are contemplating a handsome bedroom suite furnished with throw rugs and twin beds (this being the era of the so-called Hays Code, when married couples weren't allowed to sleep together on-screen). When Joe jokes that he's worried he might slip on the rugs while chasing Katherine around the bedroom, Katherine laughingly replies, "The rugs are out." "And the twin beds, too," says Joe (an ever-so-slightly risqué remark for the time).

We quickly learn, however, that, eager though he is to consummate their relationship, Joe has to wait a full year before he and Katherine can tie the knot. Their finances won't allow it. To save up for their marriage, she has taken a well-paying job in the Midwest.

During their long separation, Joe quits his factory work and, along with his brothers, Tom and Charlie, buys a little gas station that suddenly turns into a cash cow when a racetrack opens nearby, bringing a constant flow of customers to the neighborhood. With his bank account "going up like a July thermometer" (as he writes to Katherine), the newly prosperous Joe purchases a car and heads westward to get married.

At this point, the film takes a very dark turn. Passing through a small Illinois town where a little girl has recently been kidnapped, Joe—a compulsive peanut muncher—is suspected of being the culprit, who (from a "microscopic examination" of the envelope containing the ransom note) was known to carry salted peanuts in his pocket. Even more unfortunate for Joe, a five-dollar bill in his possession turns out to have serial numbers matching those on the ransom money. Despite the flimsiness of the evidence, he is locked up in jail.

In the most powerfully unnerving section of the film, rumors quickly spread through town that the kidnapper has been caught. An increasingly hysterical crowd surrounds the jailhouse. Spurred on by a malevolent lowlife (played by Bruce Cabot, beloved by fantasy-film geeks for his role as John Driscoll, Fay Wray's heroic rescuer in the original *King Kong*), the decent, God-fearing townspeople—men, women, and children—turn into a raging lynch mob, throwing stones at the windows, breaking through the barricaded front door with a battering ram, and ultimately setting fire to the building. As a horrified Katherine looks on, Joe stands at his barred window, pleading helplessly for his life. She faints as the flames reach his cell and he is evidently burned alive.

In some miraculous, never-explained fashion, however, he manages to survive—at least physically. Spiritually, he is a dead man. His former self—the man who, as he puts it, had cherished "a belief in justice, and an idea that men were civilized, and a feeling of pride in this country of mine"—has been utterly destroyed. Consumed with hatred and bitterness, he remains in hiding when twenty-two of the townspeople are put on trial for his murder, knowing that they will escape the gallows if he is shown to be alive. When Katherine discovers the truth, she tracks Joe to his hideout and begs him to forego his revenge. At first, Joe won't hear of it. "I'm legally dead and they're legally murderers," he growls. "And they'll hang for it."

Katherine's love, however, proves redemptive, and Joe makes a dramatic last-minute appearance in the courtroom, saving the defendants' lives. The film concludes with a close-up of Joe and Katherine in each other's arms, exchanging a passionate kiss (a feel-good, Hollywood ending at odds with the brutal reality Lang had witnessed firsthand in Germany with Hitler's rise to power).

One feature of *Fury*, particularly striking to today's viewer, is its opening title card. In diametric opposition to the current convention of announcing that the story about to unfold on-screen is "based on true events," Lang's movie begins by declaring: "The events and characters depicted in this photoplay are fictional and any similarity to actual persons, living or dead, is purely coincidental." In fact, however, the inspiration for the film was an actual case: the 1933 kidnap-murder of Brooke Hart.

On the evening of Thursday, November 9, 1933, sixty-two-year-old Alex Hart, wealthy owner of a San Jose department store and one of the city's leading citizens, was scheduled to attend a chamber of commerce dinner meeting at his country club. Shortly before six o'clock, his twenty-two-year-old son, Brooke, who had agreed to drive his father, left the store to fetch his car, parked in a lot less than a block away. A recent graduate of Santa Clara University, Brooke was a much-beloved individual, a blond, blue-eyed golden boy with a gracious manner and winning personality. Before getting into his sporty new Studebaker—a graduation gift from his doting parents—he exchanged a few pleasantries with

the attendant. Then he drove from the lot and, as far as his family, friends, and the world at large were concerned, vanished into thin air.

Three-and-a-half hours later, his baffled and increasingly worried father received a call from an unidentified male, informing him that his son had been kidnapped and demanding $40,000 for the young man's safe return. Brooke's abandoned car, its lights still burning, was found that same evening on a deserted road a few miles outside the city. The following day, newspapers throughout the state trumpeted the story, speculating that the perpetrator might be the notorious midwestern gangster Charles Arthur "Pretty Boy" Floyd, who had recently been spotted in California. Floyd, however, was quickly eliminated as a suspect.

Over the next few days, Mr. Hart received further communications from the kidnapper—sometimes by phone, sometimes in the form of crudely lettered messages—instructing him on how the ransom should be paid. In the meantime, one of the largest manhunts in California history was underway, involving hundreds of Bay Area police officers, state highway patrolmen, and FBI agents assigned to the case on direct orders from J. Edgar Hoover. At one point, Brooke's wallet, containing his driver's license, library card, and other identification, was discovered on the San Francisco waterfront, leading to the search of a docked Hawaii-bound ocean liner, which had Babe Ruth among its passengers.

The case finally broke on Wednesday, November 15, when the kidnapper telephoned again to work out the details for the delivery of the ransom money. Mr. Hart, as he had been instructed by police, kept the man talking for as long as possible while the operator traced the call to a pay phone at a Market Street garage. Within minutes, police arrived at the garage and arrested the man, a dull-witted filling-station attendant in his twenties named Harold Thurmond.

Initially, Thurmond denied any connection to the kidnapping. It didn't take long, however, for interrogators to wrest the truth from him. His confession, splashed across the next day's front pages, would horrify and outrage the public. "Brooke Hart is dead," he said. He was thrown "off the San Mateo bridge." Thurmond insisted, however, that he wasn't the one who had committed the murder. It was his accomplice, Jack Holmes.

The married father of two young children, Holmes, who earned his living as a salesman for the Standard Oil Company, had an engaging personality that masked a sociopathic streak. He had made Thurmond's acquaintance a year earlier and immediately recognized in the slow-witted gas jockey a potential tool

to assist him in the criminal schemes that had been brewing in his mind. After successfully engineering a couple of small holdups, Holmes, whose eye had been caught by a newspaper story about the young department store heir, proposed the kidnapping—a big score that would make the proceeds from their previous jobs "look like small change."

The day before they put their plan into action, the two men scouted the store to determine Brooke Hart's routine. When, on the fateful evening, he left work and headed for the parking lot, the kidnappers were waiting in Holmes's Chevrolet sedan.

As soon as Hart got into his Studebaker roadster and pulled out of the lot, Holmes intercepted the car, jumped into the passenger seat, and, pointing a gun at the startled young man, ordered him to drive north, while Thurmond followed in the Chevy. At a prearranged spot on a deserted country road in Milpitas, the kidnappers slipped a pillowcase over their victim's head and transferred him to the back seat of Holmes's car.

A mob attempts to break down the jailhouse doors to attack Harold Thurmond and Jack Holmes, accused killers of Brooke Hart, 1933.

Abandoning the Studebaker on the side of the road, they drove Hart to the San Mateo bridge, where—according to Thurmond's confession—he "was ordered out of the car, and Jack Holmes . . . hit him over the head with a brick which I had obtained at a cement company's place in San Jose before we started on the trip." The blow only stunned Hart, who began crying for help. "Holmes hit him over the head again," Thurmond continued, "and knocked Hart unconscious."

The two men then "took some baling wire which [they] had purchased at a hardware store in Santa Clara," bound Hart's arms, lifted him over the railing, and threw him from the bridge. "I recall that as we lifted him up," Thurmond said, "he struggled slightly." Peering into the water, they thought they could hear him splashing around, so Holmes leaned over the railing and fired a gun in the direction of the body. After driving back to San Jose, they split the money they had taken from Hart's wallet before throwing him off the bridge: "one five-dollar bill and two-and-a-half dollars in silver."

Less than an hour after Thurmond finished this brutal tale, Jack Holmes was under arrest. His own confession matched his partner's in most details; unsurprisingly, however, he claimed that Thurmond bludgeoned Hart with the brick and emptied the gun at him.

News of the savage slaying inflamed the community. Its fury was stoked by the local press. An infamous editorial in the *San Jose Evening News*—headlined HUMAN DEVILS—described the kidnapping as the most "fiendish crime ever committed in the United States" and declared: "If mob violence could ever be justified it would be in a case like this." Adding fuel to the intensifying outrage were rumors that Thurmond and Holmes might repudiate their confessions and get off on an insanity defense. The final catalyst occurred on Saturday, November 25, when a pair of duck hunters discovered Brooke Hart's hideously decomposed remains floating in a creek a few miles north of the San Mateo bridge.

On Sunday evening, a mob of between three and six thousand enraged citizens laid siege to the jailhouse, hurling bricks and rocks at the windows and battering down the door with a large metal beam taken from a nearby construction site. Thurmond and Holmes were dragged from their cells, beaten bloody, stripped naked, and strung up from a pair of elm trees in nearby St. James Park, while the frenzied onlookers, many of them women, exulted and jeered. The following day, newspaper reporters found a "curious crowd of sightseers" in

the park, many of them using pocketknives to carve away pieces of the trees as souvenirs.

In Fritz Lang's *Fury*, of the horde involved in the lynching—essentially the entire population of the town—only twenty-two men are put on trial for murder. The real-life situation was far more egregious. Only a single person was ever prosecuted for the murders of Thurmond and Holmes: an eighteen-year-old "ranch boy" named Anthony Cataldi, who bragged in a widely syndicated news story of being the ringleader of the "necktie party." Arrested for violation of California's anti-lynching law, Cataldi spent just five hours in jail before being bailed out by his father. At his preliminary hearing, all charges against him were dismissed. The ruling was applauded by Governor James Rolph, who had already announced that, should Cataldi be convicted, he would be instantly pardoned.

Far from condemning the lynching, Rolph applauded the perpetrators: "It is a fine lesson for the whole country," he proclaimed to reporters. "There will be less kidnapping now." Indeed, continued the governor, he was "checking San Quentin and Folsom to see what kidnappers they have. I'm thinking of paroling them to those fine citizens of San Jose who know how to handle such a situation."

TRY AND GET ME!

Fritz Lang's *Fury* isn't the only film inspired by the Brooke Hart kidnapping. The 1951 crime movie *Try and Get Me!* (also released under the title *The Sound of Fury*) sticks much closer to the facts. Directed by Cy Endfield—soon to be blacklisted during the McCarthy witch hunt—this grim little thriller is a scathing assault on the American penchant for vigilante justice.

The film's ill-starred protagonist is a good-natured loser named Howard Tyler, played by tough-guy character actor Frank Lovejoy (best known for his appearance in the classic 1953 film noir *The Hitch-Hiker* [see p. 153]). Unable to find a job to support his devoted wife and adoring son, Howard falls under the malevolent sway of a preening sociopath, Jerry Slocum, played to repulsive perfection by Lloyd Bridges (Jeff Bridges's father, fondly remembered by viewers of a certain age as the star of the hit Eisenhower-era

TV series *Sea Hunt*). After committing a string of penny-ante holdups, Slocum—who has been using Howard as his getaway driver—decides to go for one big, final score: kidnapping a wealthy young man and demanding a large ransom for his safe return. The pair pull off the abduction, but to Howard's horror, the deranged Slocum murders the victim and dumps the corpse in a river. Overcome with guilt and self-loathing, Howard quickly cracks up and spills his guts to a spinster who (unaware that he is married) has set her sights on him.

In the meantime, the public has been whipped into a frenzy by the sensationalistic crime reporting of ace newspaperman Gil Stanton (played by Richard Carlson, a mainstay of low-budget 1950s sci-fi and horror flicks, including the monster-movie classic *Creature from the Black Lagoon*). In the harrowing climactic sequence, a terrified Howard and raging Slocum are torn from their cells by the blood-crazed mob and dragged outside. Though Endfield doesn't show their deaths, the triumphant cheers of the off-screen lynchers serve as a shattering indictment of the public's potential for mindless savagery.

HIGH SIERRA
(1941)

DIRECTED BY RAOUL WALSH. WRITTEN BY JOHN HUSTON AND W. R. BURNETT. WITH HUMPHREY BOGART, IDA LUPINO, ALAN CURTIS, ARTHUR KENNEDY, JOAN LESLIE, HENRY HULL, DONALD MACBRIDE, CORNEL WILDE, AND BARTON MACLANE.

After years of second-string roles in films like *Bullets or Ballots*, *San Quentin*, *The Roaring Twenties*, and *Angels with Dirty Faces*, Humphrey Bogart became a major star in this noir-like gangster flick directed by Raoul Walsh. Bogie plays a graying, world-weary bank robber, Roy Earle, whose tabloid nickname, "Mad Dog," belies the fundamentally decent heart that beats beneath his tough-guy exterior.

Paroled from prison by the machinations of a politically connected gangster, Big Mac (Donald MacBride), Roy is enlisted to pull off one last heist, knocking over a fancy hotel in the (fictional) resort town of Tropico Springs, California, a job that will net Big Mac a cool half-million dollars in jewelry. To prepare for the job, Roy holes up in a rustic camp in the Sierra Nevada Mountains, where he rendezvouses with his two accomplices, a pair of young novice crooks, Red

and Babe (Arthur Kennedy and Alan Curtis, respectively), along with Babe's dance-hall girlfriend, Marie Carson (Ida Lupino). He also forms an attachment to a scruffy mutt, named Pard, that has been adopted by the camp's African American handyman, Algernon (a squirm-inducing "comic" character in the mold of Stepin Fetchit, typical of the racist attitudes of the era).

Besides his soft spot for dogs and the innate gallantry he displays when he pistol-whips Babe for manhandling Marie, Roy shows his tender-hearted side when he falls hard for a clubfooted young girl named Velma (Joan Leslie), pays for her corrective surgery, and proposes marriage. Apart from gratitude, however, she has no feelings for Roy, being interested mostly in dancing the night away with her oily boyfriend once she has recovered from the operation. His dream of settling down and leading a normal life crushed, Roy returns his attention to the big heist.

At first the robbery goes as planned. When a security guard suddenly appears and draws his pistol, however, Roy has no choice but to shoot him dead. During the getaway, Red and Babe are killed when their car careens off the road. Roy transports the stolen jewelry to Los Angeles, intending to turn it over to the bedridden Big Mac, only to discover that the mob boss has died. Big Mac's henchman, Jake Kranmer (Barton MacLane), tries to commandeer the loot at gunpoint and meets the same fate as the hotel security guard—filled full of lead by the quick-shooting Roy.

Accompanied by Marie, who has fallen deeply in love with him, Roy goes on the lam but is recognized by the owner of the motor court where the fugitive couple are laying low. With the law hot on his trail, Roy puts Marie on a bus to Las Vegas, while he heads back to Los Angeles to collect his payout for the heist. Having given Marie his last few dollars, he makes a quick stop to rob a small-town drugstore. Notified of the holdup, police set up a roadblock, forcing Roy to flee to the Sierras, where he ditches his car and climbs high into the rocks. Armed with a tommy gun, he holds off a small army of pursuers until a sniper manages to sneak above him, and the doomed, defiant outlaw meets his preordained end.

Earlier in the film, Roy is driving with one of his associates, a shady underworld physician named "Doc" Banton (Henry Hull), who remarks: "Remember what Johnnie Dillinger said about guys like you and him? He said you were just rushing toward death—just rushing toward death." The comment is telling.

High Sierra was adapted from a novel by W. R. Burnett, author of the 1931 gangster classic *Little Caesar*, who had been working on a script about Dillinger. Under the constraints of Hollywood's Production Code—which forbade any film that "glamorized" criminals—the Warner Bros. studio vetoed the idea. Burnett then used his research to create the fictional character Roy Earle, who, as "Doc" Banton's comment makes clear, bears a notable resemblance to John Dillinger—the most celebrated badman of an era that produced such larger-than-life gangsters as "Baby Face" Nelson, "Machine Gun" Kelly, "Pretty Boy" Floyd, and Bonnie and Clyde (see p. 311).

Born in Indianapolis in 1903, Dillinger was the son of a stern, hardworking grocer and a mother who died when he was three. Biographers offer radically different pictures of his childhood and adolescence. According to some, young Johnnie was a troublemaker from the start, a "gum-popping street tough" who ran with a juvenile gang called the Dirty Dozen, participated in at least one brutal sexual assault of an underage girl, and enjoyed such sadistic stunts as tying a boy onto a sawmill conveyor belt and throwing the switch, shutting off the power only when the shrieking victim was inches from the huge spinning blade. Other researchers, finding no hard evidence of these rumored transgressions, portray him as a "genial, high-spirited kid given, at worst, to occasional fights and pranks."

Whatever the case, it is certain that he quit school at sixteen to work at various jobs—upholsterer, messenger, machinist—impressing his employers with his energy and intelligence. At the same time, he was still indulging in his reputedly wild ways, staying out all night and haunting poolrooms, bars, and brothels. In 1920, when Johnnie was seventeen, his father, ready for retirement and looking to provide a more wholesome environment for his wayward son, sold his grocery store and moved to a farm in the town of Mooresville. The change, however, had little effect on Johnnie, who continued to work in Indianapolis, commuting the eighteen-mile distance by motorcycle.

In 1923, the twenty-year-old Dillinger, finding himself without a mode of transportation and determined to visit a girlfriend in Indianapolis, stole a car from the parking lot of a Quaker meeting house. Tracked down by the police, he gave them the slip, hid all night in a barn, and, the following morning, enlisted in the navy; he managed to last a few months before going AWOL. Returning to Mooresville, he met and promptly married a sixteen-year-old local girl and

struck up friendships with various unsavory characters, among them the town pool shark, Ed Singleton, memorably described by one chronicler as "a weak, tortured man with webbed fingers who drank heavily."

On the evening of September 6, 1924, Dillinger and his low-life crony, looking to score some easy money, waylaid a local grocer, B. F. Morgan, on his way home from work. Dillinger, who was wielding an iron bolt in one hand and a pistol in the other, slugged the grocer in the head, but Morgan's straw hat cushioned the blow. Shouting for help, the grocer grabbed for the gun, which discharged harmlessly as the two men grappled. Fearing he had shot the grocer, Dillinger fled into the night.

He and his accomplice were promptly tracked down and arrested. Persuaded by his father that the court was bound to be more lenient if he confessed to the crime, Dillinger pleaded guilty, only to be hit with the maximum sentence of ten to twenty years in the Indiana State Reformatory at Pendleton. The harshness of the punishment left him deeply embittered, particularly when Singleton entered a not-guilty plea and ended up serving only two years behind bars.

For Dillinger, as for so many others, prison turned out to offer an advanced education in crime, not a route to rehabilitation. During his nine years of incarceration—first at Pendleton, then in the state penitentiary—he bonded with a group of professional criminals who would ultimately form the nucleus of his gang. Within weeks of his parole in May 1933, he embarked on the year-long crime spree that would turn him into a living legend: he was a remorseless thief and killer in the view of the FBI and a dauntless hero in the eyes of millions of ordinary Americans who, ground down by the Great Depression, took vicarious joy in his forays against the wealthy and powerful. As one of his many citizen admirers put it in a letter to a midwestern newspaper: "Dillinger does not rob poor people. He robs those who became rich by robbing the poor. I'm all for Johnnie!"

After a few paltry stickups of a supermarket, drugstore, and restaurant, Dillinger and his gang robbed their first bank in New Carlisle, Ohio, in June 1933, coming away with $10,000—a significant sum in Depression-era dollars. During his second bank holdup, in Daleville, Indiana, the athletic Dillinger first performed the swashbuckling maneuver that would become his trademark and earn him the nickname "Jackrabbit." Pointing his pistol at the female teller, he announced, "This is a stickup—get me the money, honey"; he then placed his free hand on the counter and vaulted over the grillwork before emptying the trays of all their cash.

Besides knocking over several more banks in the following weeks, Dillinger also managed to smuggle guns to his cronies in the state penitentiary, who staged a breakout in late September. They returned the favor a few weeks later, after Dillinger was arrested in Dayton, Ohio. Pretending to be officers from the Indiana State Prison, three of the escapees, along with a confederate, walked into the county jail and announced that they were there to "see Dillinger." When the sheriff asked for their credentials, one of the men pulled a gun; said, "Here's our credentials"; and shot the sheriff twice. They then took the keys, freed Dillinger, and, after locking the sheriff's wife and a deputy in a cell, made their getaway.

Three days after the jailbreak, Dillinger and his gang pulled off an even more audacious act of criminal derring-do, raiding an Indiana police station and making off with several pistols, two automatic rifles, a Thompson submachine gun, three bulletproof vests, and hundreds of rounds of ammo. Just one week later, they plundered another police station, this time stealing two more Thompsons, along with a pair of sawed-off shotguns, assorted rifles and pistols, and a half-dozen bulletproof vests.

One of those vests saved Dillinger's life in January 1934; while making his getaway after robbing the First National Bank of East Chicago, Dillinger and a policeman named O'Malley exchanged a fusillade of gun shots. Dillinger was hit four times in the chest, but the bullets bounced harmlessly off his vest. O'Malley took eight rounds from Dillinger's submachine gun and died on the spot. It was the first—and last—time Dillinger killed a man.

Not long afterward, while holed up in Tucson, Arizona, Dillinger was tracked down and arrested by local police. His capture was major news across the nation. Such was his celebrity that one local automobile dealership ran advertisements touting its latest model as the car driven by Dillinger during his getaways. Displaying the cool aplomb and easygoing charm that made him a media darling, Dillinger played up to the press by posing chummily with his captors and offering waggish quotes. "I guess my only bad habit is robbing banks," he joked to one interviewer. "I smoke very little and don't drink much."

Extradited to Indiana, Dillinger was locked up in the supposedly "escape-proof" jail in Crown Point, where he used his spare time to fashion a fake handgun, whittling a section of washboard into the rough form of a pistol, then blackening it with shoe polish. On March 3, 1934, he pulled off the most daring escapade in his legendary career. Brandishing the wooden gun, he forced his

GET·DILLINGER!
$15,000 Reward
A PROCLAMATION

WHEREAS, One John Dillinger stands charged officially with numerous felonies including murder in several states and his banditry and depredation stamp him as an outlaw, a fugitive from justice and a vicious menace to life and property;

NOW, THEREFORE, We, Paul McNutt, Governor of Indiana; George White, Governor of Ohio; F. B. Olson, Governor of Minnesota; William A. Comstock, Governor of Michigan; and Henry Horner, Governor of Illinois, do hereby proclaim and offer a reward of Five Thousand Dollars ($5,000.00) to, be paid to the person or persons who apprehend and deliver the said John Dillinger into the custody of any sheriff of any of the above-mentioned states or his duly authorized agent.

THIS IS IN ADDITION TO THE $10,000.00 OFFERED BY THE FEDERAL GOVERNMENT FOR THE ARREST OF JOHN DILLINGER.

HERE IS HIS FINGERPRINT CLASSIFICATION and
DESCRIPTION. —— FILE THIS FOR IDENTIFICATION PURPOSES.

John Dillinger, (w) age 30 yrs., 5-8½, 160½ lbs., gray eyes, med. chest, hair, med. comp., med. build. Dayton, O., P. D. No. 10587. O. S. B. No. 559-646.

F.P.C. (12)

	M	9	R	O	O
	S	14	U	OO	8
13	10	OO	O	O	
u	R	w	w	w	
5	11	15	I	8	
u	U	u	w	u	

FRONT VIEW

Be on the lookout for this desperado. He is heavily armed and usually is protected with bullet-proof vest. Take no unnecessary chances in getting this man. He is thoroughly prepared to shoot his way out of any situation.

GET HIM

DEAD
OR ALIVE

Notify any Sheriff or Chief of Police of Indiana, Ohio, Minnesota, Michigan, Illinois.

or THIS BUREAU

SIDE VIEW

ILLINOIS STATE BUREAU OF CRIMINAL IDENTIFICATION AND INVESTIGATION
J. P. Sullivan, Supt. Springfield, Illinois

A 1933 wanted poster for John Dillinger, soon to become America's public enemy number one.

jailers to open his cell, grabbed two machine guns, then locked up the guards and fled in the sheriff's car. Dillinger, as the newspapers put it, had once again proved himself to be not only a man of extraordinary *sangfroid*—the "Coolest Criminal Alive"—but an unrivaled escape artist—"Houdini of the Outlaws."

By driving the sheriff's stolen car across state lines from Indiana to Chicago, Dillinger violated federal law. Though now pursued by a special FBI task force charged with the mission of getting him dead or alive, Dillinger resumed his lawless spree, robbing banks throughout the Midwest over the next few months and staging yet another raid on a police arsenal, this one in Warsaw, Indiana. Wounded twice in shoot-outs with his pursuers, he underwent plastic surgery in May 1934 to disguise his appearance. One month later, on June 22—his thirty-first birthday— Dillinger was declared America's first "Public Enemy Number One."

His "wild ride" (as one chronicler has called it) came to a suitably spectacular end. In July 1934, Dillinger and his latest girlfriend, a waitress named Polly Hamilton, moved into the Chicago apartment of an acquaintance, Anna Sage, a Romanian-born brothel owner soon to become infamous as "the Woman in Red." Eager to cash in on the reward for Dillinger's capture—and hoping to avoid deportation by cooperating with the Feds—Sage contacted the authorities and informed them that she, Hamilton, and Dillinger would be attending the movies the following evening, Sunday, July 22. At 10:30 p.m. that fateful night, as the trio left the Biograph Theater after watching the Clark Gable crime movie *Manhattan Melodrama*, FBI agents who had staked out the theater drew their revolvers and closed in. Grabbing a gun from his pocket, Dillinger ran for an alley, but he was cut down in a hail of bullets and died at the scene. As news of his killing spread, thousands of people flocked to the spot, "with some dipping handkerchiefs, scraps of newspaper, even the hems of dresses in the dead man's blood"—macabre relics of the last Great American Outlaw.

DILLINGER BIOPICS

While *High Sierra* spins a highly fictitious tale about a Dillingeresque character, two eponymous movies purport to tell the true story of the notorious gangster. A low-budget crime thriller made by the Poverty Row studio Monogram, the

1945 *Dillinger* stars Lawrence Tierney, whose tough-guy demeanor was no act. Dubbed "the meanest man in Hollywood history," the hulking Tierney (perhaps best known to younger filmgoers for his late-in-life turn as crime boss Joe Cabot in Quentin Tarantino's *Reservoir Dogs*) saw his career derailed by his frequent arrests for drunken brawls, some with police officers. He portrays Dillinger as a bona fide mad-dog killer who employs a variety of weapons— revolver, axe, broken beer mug—to dispatch anyone who double-crosses, disrespects, or just looks at him the wrong way. Joining him in his bank-robbing exploits is a gang of hooligans that includes Elisha Cook Jr., the great character actor whose vast filmography includes such classics as *Shane*, *The Killing*, and *The Maltese Falcon*. The movie—advertised as a tale "written in bullets, blood, and blondes!"—features some of the notable episodes from Dillinger's career, such as his jailbreak with a fake gun and his death outside the Biograph Theater after being fingered by "the Woman in Red"; however, despite its claims of authenticity, it is largely a product of screenwriter Philip Yordan's imagination.

Far more faithful to historical fact (though not without its own inaccuracies) is the 1972 *Dillinger*. The directorial debut of macho auteur John Milius—whose credits include *Conan the Barbarian*, *The Wind and the Lion*, and *Red Dawn*, as well as the screenplays for *Apocalypse Now* and the *Dirty Harry* sequel *Magnum Force*—this slick exploitation film plays like a hybrid of *Bonnie and Clyde* and *The Wild Bunch*: a Depression-era period piece punctuated with extended sequences of gun-blazing, blood-splattering carnage. Indeed, the two main actors in the movie—Warren Oates and Ben Johnson—were both featured in *The Wild Bunch*, in which they played the supremely scuzzy Gorch brothers. Here, they are cast as deadly antagonists: Oates is the grandstanding Dillinger, and Johnson is his implacable foe, FBI honcho Melvin Purvis. The first-rate cast also includes the inimitable Harry Dean Stanton as a member of Dillinger's low-life crew; Michelle Phillips (founding member of the hippie folk-pop group the Mamas and the Papas) as Dillinger's main squeeze, Billie Frechette; and a hyperkinetic, pre-*Jaws* Richard Dreyfuss as the sociopathic punk "Baby Face" Nelson. Alternating between Dillinger's bank-robbing exploits and Purvis's crusade against the era's big-name gangsters, the film charts the former's life from midcareer to his movie-house demise.

Other cinematic depictions of the legendary gangster can be found in the shoestring-budgeted exploitation film *The Young Dillinger* (1965); the John Sayles–scripted *The Lady in Red* (1979); the Roger Corman–produced *Dillinger and Capone* (1995); and Michael Mann's *Public Enemies* (2009) with Johnny Depp as Dillinger.

THE HILLS HAVE EYES (1977)

DIRECTED AND WRITTEN BY WES CRAVEN. WITH SUSAN LANIER, ROBERT HOUSTON, VIRGINIA VINCENT, RUSS GRIEVE, DEE WALLACE, MARTIN SPEER, JOHN STEADMAN, JAMES WHITWORTH, CORDY CLARK, JANUS BLYTHE, AND MICHAEL BERRYMAN.

Three years after the release of Tobe Hooper's grindhouse classic *The Texas Chain Saw Massacre*, horror fans were treated to another low-budget shocker in a very similar vein, Wes Craven's *The Hills Have Eyes*. Following the same basic formula—a small group of unwary travelers veers off the main road and falls into the clutches of cannibalistic psychos—Craven's film focuses on a vacationing all-American family, the Carters: Poppa Bob (Russ Grieve), a blowhard ex-cop; his simpering wife, Ethel (Virginia Vincent); their clean-cut teenagers, Bobby (Robert Houston) and Brenda (Susan Lanier); and their married older daughter, Lynne (Dee Wallace), along with her bespectacled hubby, Doug (Martin Speer), and their infant girl, Katy.

Ignoring the sage advice of a crusty old-timer named Fred (John Steadman) who urges them to stick to the highway, Bob takes a detour into the desert and

promptly runs his trailer-toting car off the road. Stuck in the middle of nowhere, he decides to hike back to Fred's decaying gas station, leaving his family stranded in the wasteland and at the mercy of a tribe of inbred mountain dwellers: cannibalistic savages who proceed to subject the Carters (and the audience) to ninety minutes of sadistic violence.

We are witness to such events as the gutting of the family's beloved German shepherd; Bob's crucifixion on a cactus plant and subsequent gasoline-soaked immolation; and the sexual molestation of the nubile Brenda at the hands of the grotesquely malformed Pluto (Michael Berryman, an actor who, because of a rare genetic disorder, requires no prosthetic makeup to play intensely creepy-looking monsters). Though leavened with a dash of sick humor (the appearance and behavior of the various male members of the cannibal clan are so insanely over the top that they sometimes verge on the clownish), the film is profoundly unsettling. It grows even more unnerving when Pluto and his troglodyte brother Mars make off with the adorable infant Katy (or, as they like to refer to her, the "young Thanksgiving turkey"). To rescue his child, the formerly wimpy Doug has to man up and meet the mutant bad guys on their own terms, reverting to savagery and becoming a remorseless killer (a common theme in American action thrillers, perhaps most powerfully epitomized in James Dickey's *Deliverance* and given particular emphasis in Alexandre Aja's no-holds-barred 2006 remake of Craven's film).

While *The Hills Have Eyes* owes an unmistakable debt to *The Texas Chain Saw Massacre*, it had another, even more direct inspiration: the reputedly true-life Scottish monster Sawney Bean. Though recent scholars have raised serious doubts about many of its details—indeed, have questioned whether such a figure existed at all—the legend of Sawney Bean has been promulgated as historical truth since the late 1700s, when it was recounted in the hugely popular collection of true-crime stories the *Newgate Calendar*.

According to that frequently reprinted source, Bean was born in the latter half of the sixteenth century, during the reign of James VI of Scotland. The son of hardworking farmers, he himself was "very much prone to idleness." Averse to "any honest employment," he and his common-law wife—"a woman as viciously inclined as himself"—fled from civilized society and found refuge in a cave on the barren Galloway coast, where "they lived upward of twenty-five years without going into any city, town, or village."

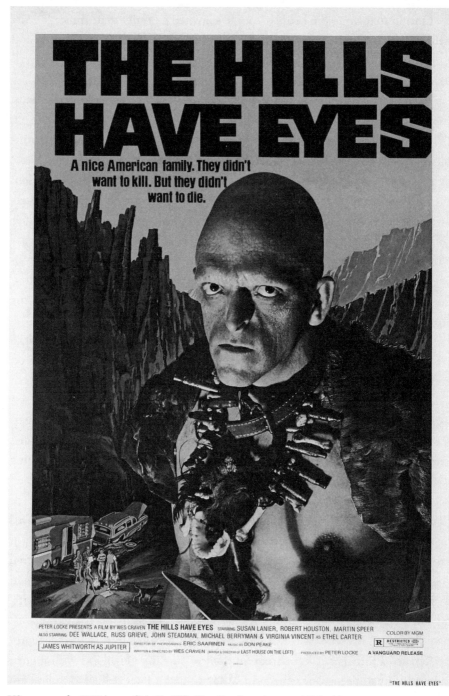

US poster art for 1977 horror flick *The Hills Have Eyes*, featuring actor Michael Berryman.

During that time, the brutish couple spawned a family that, through years of incestuous inbreeding, eventually grew to four-dozen members: children and grandchildren brought up "without any notions of humanity or civil society." Residing in their filthy seaside lair—"a place of perpetual horror and darkness"— this monstrous clan lived by robbery and murder, preying on any traveler who passed along that solitary stretch of coastline.

Once dispatched, moreover, the victim served as sustenance for the cannibalistic Beans. As soon as they had done away with "any man, woman, or child," the *Newgate Calendar* records, "they used to carry off the carcass to their den, where, cutting it into quarters, they would pickle the mangled limbs, and afterwards eat it." Numerous though they were, the Beans were so prolific in their slaughter that they "commonly had superfluity of their abominable food; so that in the night time, they frequently threw legs and arms of the unhappy wretches they had murdered into the sea at a great distance from their bloody habitation. The limbs were often cast up by the tide in several parts of the country, to the astonishment and terror of all beholders."

The inhabitants of the region—"alarmed at such a common loss of their neighbors and acquaintances"—cast about for potential perpetrators. Suspicion fell on several "honest travelers" who were "wrongfully hanged upon bare circumstances." A number of "innocent innkeepers" were likewise "executed for no other reason than that persons who had been thus lost were known to have lain in their houses, which occasioned a suspicion of their being murdered by them and their bodies placed in obscure places to prevent a discovery." Such vigilante justice did nothing to stem the horrors: "Still, the King's subjects were missing as much as before."

How many people died during the Beans' reign of terror is unknown, though "it was generally computed that in the twenty-five years they continued their butcheries, they had washed their hands in the blood of a thousand, at least, men, women, and children." Their remote hideout was finally discovered when a married couple, "coming one evening home from a fair," were attacked by the "merciless savages." Drawing sword and pistol, the husband began fighting off his attackers "in a most furious manner." Even as he battled against them, however, his wife "was instantly murdered before her husband's face; for the female cannibals cut her throat and fell to sucking her blood with a great gusto as if it had been wine. This done, they ripped up her belly and pulled out all her entrails."

Just as it seemed as if the husband, too, was about to be overcome by the frenzied crew of flesh eaters, "twenty or thirty from the same fair" rode up "in a body; upon which Sawney Bean and his bloodthirsty clan withdrew and made the best of their way through a thick wood to their den."

The first person who had ever fallen afoul of the Beans and "come off alive," the husband was immediately brought to Glasgow, where he reported "the affair to the provost of that city, who immediately sent word to the King." A few days later, led by King James himself, an army of "about four hundred men" set out to "apprehend the hellish crew":

> The man who had been attacked was the guide, and care was taken to have a large number of bloodhounds with them that no human means might be wanting towards their putting an entire end to these cruelties.
>
> No sign of any habitation was to be found for a long time . . . but some of the bloodhounds luckily entered this Cimmerian den and instantly set up a most hideous barking, howling and yelping . . . Torches were now immediately sent for, and a great many men ventured in through the most intricate turnings and windings, till at last they arrived at . . . the habitation of these monsters.
>
> Now the whole body, or as many of them as could, went in and were all so shocked at what they beheld that they were almost ready to sink into the earth. Legs, arms, thighs, hands and feet of men, women, and children were hung up in rows, like dried beef. A great many limbs lay in pickle, and a great mass of money, both gold and silver, with watches, rings, swords, pistols and a large quantity of cloths, both linen and woolen, and an infinite number of other things which they had taken from those whom they murdered, were thrown together in heaps or hung up against the sides of the den.

Captured and brought to Edinburgh, the Beans were condemned to a punishment commensurate with their crimes. First the men and boys were castrated, "their privy members cut off and thrown into the fire." Their hands and legs were then "severed from their bodies." They were left to slowly bleed to death while

the female members of the monstrous clan were forced to watch. Afterward, the women and girls "were burnt to death in three several fires." None of the Beans showed "the least sign of repentance; but continued to the very last gasp of life cursing and venting the most dreadful imprecations upon all around."

SAWNEY: FLESH OF MAN

From its title, viewers of this 2012 horror movie might expect that it will be a bloody historical drama set in Scotland's long-ago past—*Braveheart* with cannibalism. In fact, the film is a gleefully sadistic gore fest about a modern-day descendant and namesake of the infamous man-eater, who operates a ghastly subterranean butcher shop in the desolate Highlands. Residing with him in his fetid lair are his two freakish siblings—hoodie-wearing mutants adept (for unexplained reasons) in the martial arts—and their monstrous mother, who is kept locked in a cell and fed regular buckets of reeking human body parts.

To keep his ghoulish larder stocked, Sawney makes nightly trips to Edinburgh in a hearse-like taxicab and abducts attractive young women who are brought back to his cave and turned into chow for his mother, though not before being subjected to various torture-porn outrages at the hands (and tongue) of the lascivious Sawney. The plot, such as it is, concerns a young journalist on the trail of the missing women (among whom are his girlfriend's sister and, ultimately, the girlfriend herself). Also involved in the search is a scruffy police inspector who turns out to have a close (if somewhat ambiguous) connection to the inbred cannibal clan. Though clearly not for every taste, fans of Grand Guignol horror leavened with a bit of black humor will find much to appreciate in this slickly made Scottish exploitation film (sometimes shown under the alternate title *Lord of Darkness*).

THE HITCH-HIKER (1953)

DIRECTED BY IDA LUPINO. WRITTEN BY IDA LUPINO, COLLIER YOUNG, AND ROBERT L. JOSEPH. WITH EDMOND O'BRIEN, FRANK LOVEJOY, WILLIAM TALMAN, JOSÉ TORVAY, SAM HAYES, AND WENDELL NILES.

Though she appeared in nearly five dozen films and scores of TV shows in the course of her forty-eight-year acting career, Ida Lupino's enduring renown rests on her trailblazing, behind-the-scenes role as the first female director to work within the Hollywood studio system. For serious cineastes, her crowning achievement in that capacity was the 1953 thriller *The Hitch-Hiker*—the only classic film noir directed by a woman.

The film stars William Talman who, in a few years, would win fame as Hamilton Burger, the consistently outsmarted district attorney in the popular TV series *Perry Mason*. Here, he plays a character on the opposite side of the law: a seriously frightening psychopath named Emmett Myers, whose MO—killing luckless drivers who offer him a lift—has earned him the nickname "the Hitch-Hike Slayer."

After committing a couple of murders in the opening scene, Myers is picked up by a pair of buddies on a fishing trip, Roy Collins and Gilbert Bowen, played, respectively, by Edmond O'Brien (the Academy Award–winning character actor whose thirty-year résumé includes such classics as *White Heat, D.O.A.*, and *The Wild Bunch*) and Frank Lovejoy (Lloyd Bridges's stooge in *Try and Get Me!* [see sidebar, p. 135]). For the remainder of the relentlessly tense, seventy-minute film, the sadistic Myers, holding the two hostages at gunpoint, leads them on a grueling odyssey through the arid Baja California Peninsula, toward the coastal town of Santa Rosalia, where he plans to escape on a ferry.

Along the way, he loses no opportunity to torment his captives both physically and mentally. Though outnumbered two to one, the fiendish Myers never lets his guard drop for a moment. Aside from his extreme psychopathology, his most distinctive trait is his abnormal right eye, which never completely shuts, even in his sleep. Among the film's most unsettling images are the close-ups of his all-seeing eye, fixed on his cowering captives throughout the night, preventing them from attempting an escape. They are finally rescued, in the film's climactic scene, by Mexican police officers who have been working with American authorities.

Though the grotesque Myers seems like the kind of nightmarish figure that only a Hollywood screenwriter could dream up, he is, in fact, closely based on a real-life serial killer. Indeed, in creating her movie, Lupino conducted her own firsthand research into the case, even interviewing the actual hostages who were the models for the fictional Collins and Bowen. Their actual names were James Burke and Forrest Damron, and their kidnapper was a young homicidal maniac named Billy Cook.

Cook had the kind of background virtually guaranteed to produce a sociopathic personality. Born in a shack in Joplin, Missouri, two days before Christmas 1928, he was an undernourished five-year-old when his mother died, leaving him and his seven siblings in the questionable care of their father, William E. Cook, an Oklahoma sharecropper turned lead miner. Saddled with his brood, the old man drove them to an abandoned mine shaft, supplied them with a few provisions—a couple of blankets, a flashlight, a jar of jam, some crackers, a box of cornflakes, and a can of Spam—then drove away, never to be seen again.

Discovered a few days later by a mining employee, the half-starved children were farmed out to foster families. Billy, however, proved too much of a handful for any of his prospective guardians. Though the clinical category had not yet

Frank Lovejoy, William Talman, and Edmond O'Brien in *The Hitch-Hiker*, 1953.

been labeled, he already displayed symptoms of what is now called antisocial personality disorder: rebelliousness, aggression, a hateful attitude toward the world at large. Adding to these deformities of character was a disconcerting physical flaw: a defective eye that, even after a pair of operations paid for by the county, never closed properly. Unable to find a family willing to put up with the belligerent, unmanageable child, the county consigned him to the Missouri Training School for Boys in Boonville, a facility, according to one journalist, "that was known for overcrowded dormitories, violence, rape, corporal punishment, and lack of rehabilitation." Billy was eleven years old.

His criminal career began at the age of fourteen when—briefly sprung from Boonville by a married older sister who took him into her home—he got hold of a blackjack and robbed a Joplin cab driver of eleven dollars. Promptly arrested, he was returned to the reformatory, where, as he recalled, he received regular beatings with a rubber hose for his many infractions.

He soon managed to break out but, after being nabbed for attempted car theft, found himself back inside. Official records describe him as an incorrigible troublemaker, who "attempted escape by sawing through bars with a smuggled hacksaw blade," was "caught with razor blades, illegal pills, and knives in his

possession," and showed "no interest in learning a trade or skill." The fingers of his left hand now bore the crudely tattooed letters *HARD LUCK.*

Assessed by the counselor assigned to his case as "a walking time bomb," he was transferred to the Missouri State Penitentiary, where he quickly earned a reputation for violent and erratic behavior. When another inmate teased him about his malformed right eye, Billy nearly beat him to death with a baseball bat.

Released in 1950, Billy tracked down his father, by then a broken-down, seventy-year-old drunk subsisting in a mining shack on the outskirts of Joplin. When the old man inquired about his plans for the future—"What're you going to do now they've cut you loose?"—Billy replied, "I'm going to live by the gun and roam."

Thumbing his way to Blythe, California, a desert town near the Colorado border, Billy worked for a time as a dishwasher in a diner, earning enough money to purchase a .32-caliber semiautomatic pistol. Then, just as he said he would, he set out to fulfill his life's ambition—to roam, rob, and kill.

On the evening of December 29, 1950, not far from Lubbock, Texas, a fifty-six-year-old mechanic named Lee Archer offered the hitchhiking Cook a ride. They had traveled for several hours and were nearing Oklahoma City, when Cook drew his gun and ordered the startled driver to pull off the road. After relieving Archer of all the money in his wallet, Cook locked him in the trunk, got behind the wheel, and took off.

Unfamiliar with manual transmissions, the young kidnapper kept stalling the car, while, inside the trunk, Archer worked furiously to free himself with a jack handle. When the car came to a sudden stop, Archer, who had managed to jimmy open the lock, slipped from the trunk and took off running. By the time Cook realized that his captive had escaped, Archer was out of sight.

Speeding off in Archer's Buick, Cook headed northeast. He had passed through Tulsa and was halfway to Claremore when the overtaxed engine finally gave out. Abandoning the car, he waved down a passing 1949 Chevrolet. Inside was the Mosser family: thirty-three-year-old Carl; his twenty-nine-year-old wife, Thelma; their three small children; and their little white dog. They were on their way from their Atwood, Illinois, farm to Albuquerque, New Mexico, to visit Carl's twin brother, Chris, an army lieutenant.

Good Samaritan that he was, Carl offered the stranded young man a lift. No sooner had Cook gotten into the rear seat than he pulled out his gun, stuck it into Mrs. Mosser's side, and ordered her husband to drive.

For the next seventy-two hours, he kept them moving on a nightmarish zig-zag ride through four states. At one point, inside the tiny grocery of a filling station in Wichita Falls, Texas, Mosser managed to grab Cook and pin his arms, while shouting to the elderly attendant, E. O. Cornwall, for help. Believing that the two men had broken into a scuffle, Cornwall—variously described in news accounts as "confused" and "unalert"—pulled a .44-caliber revolver from beneath the counter and ordered them out of his store.

Back in the car, with Cook holding his family hostage at gunpoint, Mosser was forced to drive more than two thousand miles on an aimless course through Texas, New Mexico, Arkansas, and finally into Missouri. Outside Joplin, too exhausted to go on, he pulled off the highway. By then, his wife had collapsed into hysterical sobbing.

Tearing strips of fabric from the clothes in their suitcase, Cook bound and gagged Carl and his wife, then tied up the children's hands with the chin cords from the Hopalong Cassidy hats the boys had received for Christmas. As fast as his finger could work the trigger, he shot all five of them, along with the family dog. He then drove the corpses to an abandoned mine and dumped them down a shaft.

Fleeing to Tulsa, Oklahoma, he left the car in a muddy ditch and caught a west-bound Greyhound bus. By then, Carl and his family had been reported missing by his twin brother, Chris. When a Tulsa cop found the Mossers' ditched car—the seats and floorboards punctured with bullet holes, upholstery caked with dried blood—a nationwide all-points bulletin was issued for Cook, who had been identified, among other ways, by the contents of a duffel bag he had left in Lee Archer's hijacked car and a description provided by E. O. Cornwall, who had informed police about the violent struggle in his filling station.

Despite the thousands of law officers hunting him, Cook, who now topped the FBI's most-wanted list, managed to make his way by hitchhiking and bus to one of his old haunts, Blythe, California. On January 6, deputy Homer Waldrip of the Blythe sheriff's department drove to a local motor court to question a former acquaintance of Cook's, a man named Paul Reese, on the off chance that he might have some knowledge of the fugitive's whereabouts. When the lawman knocked on Reese's door, it was opened by Cook, who stuck his pistol into Waldrip's neck, relieved the deputy of his service revolver, then led him to his patrol car and had him drive into the desert.

Along the way, Cook bragged about slaying the Mosser family and claimed that he had "killed two others in Oklahoma and buried their bodies in a snow-drift." When Cook ordered Waldrip out of the car about forty miles outside Blythe, bound his hands with blanket strips, and made him lie facedown in the sand, the deputy assumed he was about to meet the same fate. Cook, however, had kind feelings for Waldrip's wife, Cecelia, a former coworker in the Blythe diner, and had a sudden change of heart. Leaving the terrified deputy alive, he jumped behind the wheel of the patrol car and sped off.

A few miles up the road, the young killer turned on his red lights and siren and pulled over a 1947 Buick driven by a vacationing oil salesman from Seattle, Robert Dewey. Executing Dewey with a shot to the head, he dragged the corpse into Waldrip's patrol car, then drove toward the Mexican border in the dead man's Buick.

When Dewey's corpse was discovered a few hours later, Cook—now variously referred to in the press as "the Hitch-Hiking Killer," "the Mad Dog Slayer," and "the Squint-Eyed Desperado"—became the object of the biggest manhunt since the days of John Dillinger. City and state police, FBI agents, Texas Rangers, and small-town sheriffs were on the lookout for him in every state west of the Mississippi. By then, however, their quarry was already in Mexico.

A hundred or so miles south of the border, Dewey's Buick broke down. Cook was standing by the side of the road when he was offered a ride by two passing motorists: James Burke and Forrest Damron, a pair of amateur prospectors from El Centro, California, on a gold-hunting expedition. They were taken hostage at gunpoint and, over the next week, forced to drive their young kidnapper on a 450-mile journey through the Baja California desert. Along the way, they listened to regular radio bulletins about the search for the Hitch-Hiking Killer. "He told us that there had been eight passengers in three other cars he had ridden in," Damron later explained, "and all of them were dead. We weren't about to do anything foolish." When they camped at night, Cook would recline with his back propped against a tree or a rock, his finger on the trigger of his semiautomatic pistol, his one bad eye never closing. As Damron would tell reporters, he and his buddy never tried to escape because "they couldn't tell if he was sleeping or not."

Their salvation came on January 15, 1951. Alerted by various informants that the two missing prospectors and their captor had been spotted in Santa Rosalia,

six hundred miles south of the border, Francisco Kraus Morales, chief of the Tijuana police, boarded a small government airplane and flew to the little fishing village. With the local police chief, Parra Rodriguez, at his side, Morales found Cook and his captives seated in a café. Cook was arrested without a struggle.

At virtually the same time, searchers in Joplin made a ghastly discovery. Acting on a tip from a former jail mate of Cook's—who told police that Billy had once bragged about killing a man and disposing of the body in a mine shaft—they began exploring all the abandoned shafts around Joplin and quickly found the bullet-ridden corpses of the Mossers. The five bodies were so badly decomposed that the police and firemen who descended into the shaft to retrieve the remains had to wear gas masks.

Returned to the States, Cook was tried and convicted for the kidnap-murders of the five Mossers and given five consecutive sixty-year sentences, for a total of three hundred years. The outraged federal prosecutor, Thomas Shelton, denounced the decision as "the goddamnedest travesty of justice ever! If ever a crime deserved the death penalty, this is it."

Shelton's hunger for vengeance—shared by the majority of the American public—was satisfied when Cook was turned over to California authorities and tried for the murder of Robert Dewey. After jury deliberations lasting less than an hour, he was convicted and sentenced to death in the San Quentin gas chamber.

Unrepentant to the end, Cook refused to see the prison chaplain or talk to Warden Harley O. Teets. He did, however, briefly meet with one visitor, Ida Lupino, who was eager to secure the rights to his story and came to San Quentin to have him sign a release.

After a final meal of fried chicken, french fries, peas, pumpkin pie, coffee, and milk, Cook was executed on the morning of December 12, 1952. For a while, his corpse was put on public display by a Barnumesque mortician in Comanche, Oklahoma. It was viewed by an estimated twelve thousand morbid curiosity seekers from as far away as Alaska before being claimed by family members and buried under cover of darkness in Joplin's Peace Church Cemetery. When the grave was vandalized and the tombstone stolen, the body of the notorious badman was exhumed and reburied in an undisclosed location somewhere in the cemetery. To this day, no one knows where the remains of "Butcher Billy" Cook lie.

THE HONEYMOON KILLERS (1970)

DIRECTED AND WRITTEN BY LEONARD KASTLE.
WITH SHIRLEY STOLER, TONY LO BIANCO, MARY
JANE HIGBY, DORIS ROBERTS, KIP MCARDLE,
AND MARILYN CHRIS.

While most serial killers pursue their perverted pleasures on their own, some—like the "Hillside Stranglers," Angelo Buono and Kenneth Bianchi, or the unspeakable duo of Henry Lee Lucas and Ottis Toole—prefer to commit their atrocities with a partner. There are also cases of "killer couples": married or cohabiting lovers whose romantic relationship involves a shared enjoyment of serial homicide. A classic case is that of "the Lonely Hearts Killers," Martha Beck and Raymond Fernandez.

Born in Honolulu to Spanish parents in 1914, Ray was three when his family relocated to Bridgeport, Connecticut. Though biographical details about his early life are sparse, he is said to have suffered brutal routine beatings at the hands of his alcoholic father and was jailed for theft at fifteen. At eighteen, he moved to Spain to work on an uncle's farm and, within a few years, had married

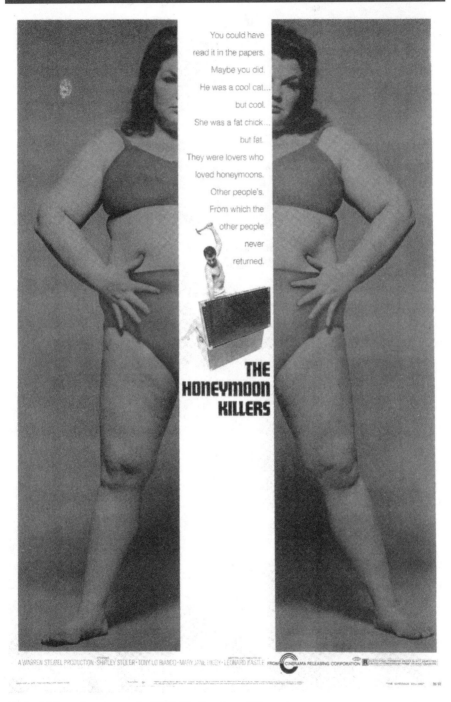

Shirley Stoler on the poster art for 1970's *The Honeymoon Killers.*

and fathered four children. During the Spanish Civil War, he fought for a time on the side of the Fascists. With the outbreak of World War II, he abandoned his wife and children and joined the merchant marines. A severe brain injury, sustained when he was struck in the head by a steel hatch cover, reportedly left him with both a permanent dent in his skull and a dramatically altered personality.

Not long after the war ended, he stole some equipment from a naval vessel simply to see if he "could get away with it." He was sentenced to a year in a federal detention center in Tallahassee, Florida, where according to various accounts, he befriended a Haitian prisoner who initiated him into the mysteries of the voodoo religion. By the time he was paroled in 1946, he had become convinced that, through the use of voodoo ritual, he could exert mystical control over women.

Moving to a dingy apartment in Brooklyn, he supported himself with various daytime jobs—construction worker, freight handler on the docks—while devoting his nights to the pursuit of a potentially more lucrative enterprise: employing his new occult powers to swindle vulnerable women of their assets. Securing the names and addresses of several hundred lovelorn women from a matrimonial agency, Ray began exchanging letters with dozens of these lonely widows, divorcées, and spinsters. Precisely how many he eventually met and embezzled from is unclear. What is certain is that, in the fall of 1947, he began an intensive courtship of Mrs. Jane Lucilla Thompson, "a jolly, plain-faced dietitian in Manhattan's Presbyterian Hospital" (as newspapers described her), who was recently separated from her husband and shared a six-room apartment with her elderly mother on Manhattan's Upper West Side. Before long, Ray had rented a small flat in the same building. A few weeks later, the couple, now newly engaged, embarked on a trip to Spain, where—as Jane informed her mother—Ray planned to "show her the land of his fathers" prior to their marriage. When Ray returned to New York City in December, however, he was alone; Jane had died in her hotel room in Cadiz, ostensibly of a heart attack.

Using documents purportedly signed by Jane that made him her primary beneficiary, Ray took possession of her apartment, evicted her mother, and immediately returned to his typewriter; this time he responded to an ad placed by an agency called Mother Dinene's Family Club for Lonely Hearts. In his letter, Ray described himself as a successful businessman in the import-export trade who owned a Manhattan apartment "much too large for a bachelor." After

a brief, increasingly ardent correspondence, Ray and his new prospective victim arranged to meet. On December 28, 1947, he arrived by train in Pensacola, Florida, for his fateful encounter with his soon-to-be partner in depravity, Martha Beck.

Morbidly obese since childhood owing to a "glandular condition," the twenty-seven-year-old Martha had suffered the sort of relentless humiliation almost guaranteed to produce a sociopathic personality. Her weight and prematurely developed body made her an object of mockery to other children. Before she reached her teens, she was raped repeatedly by an older brother. Pregnant, she resorted to a self-induced abortion using a mixture of turpentine and gun powder. When her mother learned of what had happened, she blamed Martha for provoking the assault and beat her for "causing trouble in the family."

Though she graduated at the head of her class from a Pensacola nursing school, no hospital would hire her, reportedly "because of her overweight appearance." Trained to minister to the living, she was reduced to tending to the dead, taking a job in a funeral home, where she spent her days preparing female corpses for burial.

She was finally able to practice her chosen profession in 1942, when she moved to California and found work as a nurse in an army hospital. Hitting the bars at night, she was impregnated by one of her many pickups, a soldier who—rather than marry her—threw himself off a bridge in a suicide attempt.

Returning in shame to her hometown of Milton, Florida, Martha gave birth to a girl, claiming that the father was a naval officer whom she had married just before he was shipped out to the South Pacific and killed in action. A few years later, she was pregnant again, this time by a bus driver named Alfred Beck, who agreed to make an honest woman of her. Before their marriage ended six months later, Martha had given birth to a second child, this one a boy.

Before long, she found a job at a Pensacola children's hospital, where she quickly rose to the position of supervisor. Though she had finally achieved a degree of professional success, her personal life remained as bleak as ever, and she retreated into the fantasy world of true-confession magazines and cloying Hollywood romances. Sometime in 1947, a coworker—either from pity or as a cruel prank—sent her an application for a lonely hearts club. Overcoming her initial sense of humiliation, Martha enrolled as a member. Two weeks after

placing a notice in the club newsletter, she heard from Ray Fernandez, who was soon on his way to Pensacola.

"When that man stepped down from the train and I saw him for the first time," Martha would later recount, "I believe I was in love—a love so great, it would live as long as I did." Exactly what Ray thought when he first set eyes on Martha—"an altogether unappetizing female," as newspapers described her, about five-and-a-half feet tall and weighing over two hundred pounds—is unknown. Whatever the case, the two quickly became lovers. Not long after he returned to New York City, Martha followed him, her two small children in tow. When Ray made it known that he had no intention of becoming a "family man," Martha, with no apparent hesitation, abandoned them at the nearest Salvation Army center. Several years would pass before she saw them again.

Moved by this display of devotion—and in sexual thrall to the voracious, love-starved Martha—Ray admitted the truth: he was not a legitimate business-man but a gigolo who made money by bilking lonely women he met through matrimonial advertisements. Far from being put off by this revelation, Martha eagerly agreed to become his accomplice.

Shortly before Valentine's Day in 1948, the two miscreants—posing as brother and sister-in-law—traveled to Royersford, Pennsylvania, to meet Ray's latest mark, Esther M. Henne, a forty-one-year-old teacher at the Pennhurst Asylum for "feeble-minded" children. Less than two weeks later, Esther became Mrs. Raymond Fernandez. No sooner had she settled into her new husband's Manhattan apartment than he turned from the "sweet and courteous" gentleman who had swept her off her feet into "a raving maniac."

"For four days," she later told reporters, "he was very polite to me. Then he gave me tongue lashings when I wouldn't sign over my life insurance policies and my teacher's fund to him . . . [He] became coarse, ill-mannered, and vulgar." Returning home from an errand on March 8—nine days after their wedding— Esther discovered that all her jewelry, including her wristwatch and a diamond ring, was missing from the apartment, along with $500 in cash. Police quickly traced the stolen jewelry to a neighborhood pawn shop and discovered that it had been hocked by Ray's ostensible sister-in-law, Martha, who was occupying another bedroom in the apartment.

By then, Esther had reason to wonder why Ray was spending so much time with Martha in her room every evening. "He passed Mrs. Beck off as a

relative," she related, "but I suspected they had intimate relations." Disturbing stories about her husband reached her ears: the former owner of the apartment, Jane Thompson, had traveled with him overseas and "died there mysteriously"; he was already a married man, with a wife and four children in Spain; there was "a woman in Philadelphia who became pregnant by him." On March 31, one month after their wedding, Esther Henne Fernandez packed her things, climbed into her car, sped back to Pennsylvania, and immediately initiated divorce proceedings.

Shortly afterward, Ray and Martha decamped for Chicago, where they both found day jobs, he as a machinist and she as a registered nurse at St. Luke's Hospital. Their evenings were spent scouring the personal ads in newspapers and composing letters to Ray's various lonely hearts pen pals.

That summer, after wasting a few weeks on one disappointing prospect— a North Carolinian named Ruby Mercer who proved to be so poor that Ray abandoned his plan to bilk her—he set his sights on a more promising pigeon: Mrs. Myrtle Young of Green Forest, Arkansas, a well-off forty-year-old divorcée with two grown children. On August 14, two days after she arrived in Chicago to meet the charming gentleman with whom she had been corresponding, Myrtle and Ray were married. Within twenty-four hours, she had been persuaded to deposit half of her $4,000 in savings in a joint account with her new husband and to use the rest to buy him a car. Inflamed with jealousy, Martha—now posing as Ray's sister—did everything she could to prevent Ray from sleeping with his new bride. On August 16, Martha slipped her a heavy dose of barbiturates. Myrtle was then brought to the bus terminal and shipped back to Arkansas, where, on August 21—exactly one week after her marriage—she died in a hospital of "cerebral hemorrhage."

The next few victims of the two reprobates came to an even more terrible end than did Myrtle Young. In late 1948, Ray began corresponding with a woman in Albany, New York, Mrs. Janet J. Fay, who wrote that she was an attractive, church-going widow in her forties who liked dancing and had savings of nearly $7,000. When Ray, accompanied by his "sister" Martha, drove to meet her at the end of December, he discovered that she had not been entirely forthcoming with him. Her age was actually sixty-six and her weight was at least twenty pounds heavier than she had indicated. Still, she had been telling the truth about the only detail that mattered to him, the size of her bank account.

Within days, she had accepted Ray's proposal, signed over her assets to her courtly new fiancé, and driven back with him and her soon-to-be sister-in-law to Long Island, where Ray and Martha were sharing an apartment in Valley Stream. On the night of their arrival, January 4, 1949, Martha—in a paroxysm of jealousy—bludgeoned Fay unconscious with a ball-peen hammer. Ray finished the job by garroting her with a scarf. Stashing the corpse in a closet, they scrubbed the room clean of bloodstains. In the morning, they bought a trunk, stuffed the body inside, and drove it to Queens, where they left it in the basement of Ray's unsuspecting sister for a few days before moving it to a rental house and interring it under cement in the cellar.

Less than three weeks later, the killer couple were on their way to Michigan to meet Ray's newest mark, forty-one-year-old widow Delphene Downing, who lived with her two-year-old daughter, Rainelle, in a suburb of Grand Rapids. Initially taken with Ray's oily charm, Delphene, like so many of his victims, began turning over her finances to the man she expected to marry. Unlike her all-too-trusting predecessors, however, she began to suspect that her prospective husband was not the person he pretended to be. The tipping point apparently came when she happened upon Ray without the toupee he had taken to wearing to conceal his rapidly advancing baldness. Accusing him of deceiving her, she flew into hysterics. She eventually calmed down, though not before accepting some sleeping pills from Martha. Since it seemed clear that Delphene was about to call off the marriage and reclaim her money, Ray shot her as she slept, with a pistol belonging to her late husband, and then, with Martha's assistance, buried the corpse in a hastily dug hole in the cellar. The next day, finding themselves saddled with Delphene's inconsolable two-year-old daughter, Martha drowned the little girl in the cellar sink. After burying her beside her mother and filling in the graves with cement, they celebrated with a night at the movies.

Instead of fleeing the crime scene at once, the two remained in the house for three days, apparently waiting for the cement to harden. Before they could abscond, a pair of police officers, alerted by Delphene's suspicious father-in-law, showed up at the front door. It didn't take them long to discover the two makeshift graves in the cellar.

Under arrest, Ray and Martha spilled out a lengthy confession, admitting to as many as seventeen murders in the course of their criminal spree. "The Lonely Hearts Killers," as they were dubbed, became overnight tabloid celebrities. Extradited to

New York, they were tried for the murder of Janet Fay, convicted, and sentenced to death. Before being led to the chair on March 8, 1951, Ray exclaimed: "What the hell does the public know about love? I want to shout it out—I love Martha!" Martha recorded her final thoughts in a statement for the press:

> My story is a love story. Only those tortured by love as I was can know what I mean. I was pictured as a fat, unfeeling woman. True, I am fat. But if that were a crime, how many of my sex would be guilty? I am not without feeling. I am not stupid. I am not a moron. Prisons and the death house have only strengthened my feeling for Raymond. In the history of the world, how many crimes have been attributed to love?
>
> Here are my last words and my last thoughts:
>
> Let he who is without sin cast the first stone.
>
> I love Raymond.

Eighteen years after their execution, the lurid tale of Martha Beck and Raymond Fernandez was brought to the screen in *The Honeymoon Killers*, a one-hit cinematic wonder by a thirty-nine-year-old opera composer and librettist named Leonard Kastle, who would never make another film. Besides writing the screenplay, Kastle assumed directorial duties after the initial hired director, a young Martin Scorsese, spent so much time creating artfully composed shots that it became clear he would never be able to complete the movie within its miniscule $150,000 budget.

Playing Martha is the extremely full-figured Shirley Stoler, whose initial appearance in starched white uniform and cap suggests Divine in the role of Nurse Ratched. Though her lumbering physique and "homely, pudding face" (as it is uncharitably described in one official biography) limited the number of movie roles available to her, Stoler turns in an unforgettable performance as the depraved, pathetic Martha, who—feeling desired for the first time by a physically attractive male—is more than willing to engage in acts of monstrous cruelty to hold onto her con-man lover.

Tony Lo Bianco (who would appear in scores of films, most memorably as the small-time crook Sal Boca in *The French Connection*) makes his motion-picture debut as Ray. Exuding a creepy charisma, he perfectly embodies the sleazy, Latin-lover charm that made the real-life Ray so irresistible to his victims. The love scenes between the handsome, buff Lo Bianco and the oversized Stoler—who come off like an obscene caricature of the nursery rhyme couple Jack Sprat and his wife—effectively capture the grotesque mutual passion of the incongruous pair, while leaving the viewer feeling appropriately unclean.

The supporting cast is outstanding, too, especially Mary Jane Higby as Janet Fay, portrayed as a fatuous biddy so supremely annoying that even the most kindhearted viewer might be seized by the urge to reach for a ball-peen hammer every time she opens her mouth. Though the scenes with Janet verge on black comedy, her ugly, sordid murder, filmed with unvarnished brutality, is infinitely more disturbing than the highly stylized ultraviolence in such contemporaneous films as *Bonnie and Clyde* and *The Wild Bunch*.

Shot in documentary-style, grainy black-and-white, *The Honeymoon Killers* was initially dismissed by some mainstream critics as a crude exploitation film. "It's such a terrible movie," wrote the normally perceptive Pauline Kael, "I wouldn't recommend it to anyone." Others, however, recognized it as a minor indie masterpiece, hailing it (in the words of a *New York Times* reviewer) as "one of the best and, curiously, most beautiful American movies in recent years." No less a cinematic eminence than French New Wave director François Truffaut proclaimed it his "favorite American film," and its status as a low-budget classic has only grown over the years.

MARTHA AND RAY: A FILMOGRAPHY

Besides *The Honeymoon Killers*, four movies have been inspired by the crimes of Martha Beck and Raymond Fernandez. In 1950, even before the two depraved lovers were led to the chair, the poverty-row production company Republic Pictures released *The Lonely Hearts Bandits*, an hour-long B movie about a pair

of married con artists who, posing as brother and sister, woo, wed, fleece, and (when the occasion demands it) murder the well-off suckers (both male and female) they meet through their mail-order matchmaking club.

Apart from this central premise, the melodramatic plotline of *The Lonely Hearts Bandits*—involving high-speed getaways, blazing gun battles with the police, and a devoted son returning from Saudi Arabia to care for his comatose mother who has been thrown from a moving train—bears only the most tenuous connection to the real-life case. Sticking far more closely to the facts is Arturo Ripstein's *Deep Crimson*. Even more than *The Honeymoon Killers*, this 1996 Mexican film portrays its central characters—the obese, ravenous Coral and her slimeball lover, Nicholas—as a pair of irredeemably repulsive grotesques. Though their two earliest murders have (as *New York Times* reviewer Stephen Holden put it) "an aura of smirking Hitchcockian humor," the film ultimately jettisons its tone of gruesome black comedy and turns into pure grisly horror.

Another slick, scary take on the story is the 2014 Belgian-French shocker *Allélulia*. Spanish actress Lola Dueñas is utterly terrifying as the Martha Beck surrogate, Gloria, a love-starved single mother and morgue worker who is so deeply enamored of the seductive con man Michel (Laurent Lucas) that, whenever she catches him having (graphically filmed) sex with one of his female patsies, she flies into a homicidal rage and savagely murders the woman. By the end of the film—when she incites the grisly axe murder of Michel's last (and most attractive) victim, then goes after the dead woman's hysterical, young, stylish daughter as she flees—Gloria has morphed into a monster straight out of a slasher movie.

Writer-director Todd Robinson's 2006 *Lonely Hearts* takes an entirely different approach to the story, focusing on the police manhunt for the two homicidal grifters. A glossy 1940s period drama along the lines of the (far superior) *L. A. Confidential*, the movie stars John Travolta as Long Island cop Elmer Robinson. Tormented by his wife's suicide three years earlier, Elmer becomes obsessed with tracking down the killer couple when one of Ray's marks slits her wrists after catching him having sex with his "sister." Joining Elmer on his quest is his wisecracking, tough-talking partner,

Charles Hildebrandt, played by the late, always-great James Gandolfini. Though the movie captures the vicious cruelty of Martha and Ray's crimes, it is guilty of the one sin that Leonard Kastle found so objectionable in Arthur Penn's *Bonnie and Clyde*. Like that groundbreaking film, which turned the two distinctly unlovely real-life bandits into a dazzlingly glamorous couple, *Lonely Hearts* casts a pair of Hollywood beauties, Jared Leto and Selma Hayek, as the repulsive Ray and Martha. The result is far easier on the eyes than Kastle's sordid, quasi-documentary film but, for that very reason, not nearly as disturbing.

LOOKING FOR MR. GOODBAR (1977)

DIRECTED AND WRITTEN BY RICHARD BROOKS. WITH DIANE KEATON, TUESDAY WELD, WILLIAM ATHERTON, RICHARD KILEY, RICHARD GERE, AND TOM BERENGER.

An unpleasantly puritanical air pervades this 1977 adaptation of Judith Rossner's runaway bestseller. Essentially, it is a finger-wagging, tongue-clucking attack on the excesses of the freewheeling, pre-AIDS 1970s, when—according to the vision of screenwriter-director Richard Brooks—homicidal gays ran rampant on the streets of New York City and every block featured a swinging-singles bar patronized by predatory studs and lonely young women cruising for casual pickups.

Diane Keaton stars as Theresa Dunn, one of the more winsome of these desperate, doomed females. Brought up in a repressive Irish-Catholic household, Theresa suffers from a deep-seated sense of insecurity, having been afflicted with scoliosis (curvature of the spine) as a child. Though smart, beautiful, and totally dedicated to the deaf students she teaches at her day job, Theresa is hopelessly screwed up when it comes to her personal relationships. She despises the

handsome, idealistic "nice young man" who pursues her (William Atherton). Sweetness and devotion leave her cold; what really turns her on are humiliation and mistreatment, which she receives in abundance from her many sex partners.

After a long-term affair with her insufferable, married college professor, she plunges ever more deeply into a life of sordid one-night stands with a string of increasingly questionable characters (the most memorable of whom is the insanely narcissistic street tough played by Richard Gere in his first major role). Theresa picks up one stranger too many when a sexually confused former convict (effectively portrayed by a young, Brandoesque Tom Berenger) savagely murders her, to prove his masculinity, at the film's powerfully unsettling climax.

In creating the fictional Theresa Dunn—her innermost fantasies, feelings, desires, motivations, et cetera—Judith Rossner relied primarily on her own imagination. The basic story of *Looking for Mr. Goodbar*, however, was inspired by a shocking true-life crime, the brutal 1973 murder of a twenty-seven-year-old New York City schoolteacher named Roseann Quinn.

Like her fictional counterpart, Quinn—the oldest of three children of devout Irish-Catholic parents—developed scoliosis as a child. At thirteen, she had a spinal operation and spent a solid year recuperating. The procedure helped straighten her crooked shoulders but left her with a pronounced limp, an eleven-inch scar on her back, and a profound sense of insecurity, alienation, and self-contempt.

Rebelling against the conservative values of her parents—who expected her to fulfill the traditional roles of housewife and mother—Quinn left home at eighteen, enrolled in a state teacher's college, became involved in the 1960s civil rights movement, and started dating African American men. Eventually, she moved to an apartment in Manhattan. By day, she tended to live a quiet, sedate life as a teacher (first in the public schools of Newark, later at St. Joseph's School for the Deaf in the Bronx). At night, however, the petite, freckle-faced redhead turned into a boisterous, sexually promiscuous party girl, picking up disreputable-looking strangers at neighborhood bars and taking them home for bouts of rough sex.

The last stranger she would ever pick up was a young man named John Wayne Wilson. Born in small-town Indiana, Wilson had been raised by grim, midwestern parents who (according to one social worker) might have served as the models for Grant Wood's famous painting, *American Gothic*. A chronic runaway with a long history of psychiatric problems, he'd been in and out of mental institutions from the time he was twelve. At sixteen—blond, blue-eyed,

muscular—he hitchhiked around the country, eventually ending up in Times Square, where he took to petty thievery and homosexual hustling.

In the summer of 1970, a thirty-nine-year-old accountant named Geary Guest was cruising Times Square for sex and spotted the twenty-year-old hustler. Before long, Wilson was ensconced in Guest's penthouse apartment. The young drifter's life during the next two years was characteristically erratic. After stealing some cash and credit cards from his sugar daddy, he headed to Miami, where he met and married a 17-year-old girl named Candy Cole, got arrested for robbery, and broke out of jail after serving a few months of his one-year sentence.

Returning to New York City, Wilson and his teenage bride settled into the apartment of the all-forgiving Guest. Determined to be a breadwinner for his wife, he hit the streets and started hustling again. When Candy became pregnant, he made a stab at normality, taking a job as a mail clerk. But respectability wasn't Wilson's strong suit, and before long he was back to his old ways.

Late on New Year's Day 1973, both Roseann Quinn and John Wayne Wilson ended up at an Upper West Side bar called Tweed's. Precisely what happened between them will never be known. From later reconstructions (such as the one pieced together by journalist Lacey Fosburgh in *Closing Time: The True Story of the "Goodbar" Murder*), it appears that, after sharing a few drinks and some small talk with the good-looking young stranger, Quinn took him back to her cramped, unkempt apartment a few doors down the block. According to the account Wilson later gave to police, the two of them had sex. Immediately afterward, Quinn (who apparently had a masochistic streak and liked to taunt her pickups into roughing her up) "got real nasty," pushing and shoving Wilson and telling him to leave. Wilson—unstable in the best of circumstances—"flipped out" and savagely attacked her, choking her with his bare hands, strangling her with her panties, stabbing her with a paring knife, stuffing a candle up her vagina, smashing her face with a statuette, and chewing fiercely on her breasts.

After showering her blood off his body and wiping the place clean of fingerprints, he returned home and confessed to Guest, who gave him plane fare and shipped him off to Miami. Two days later, Roseann Quinn's savaged corpse was found by a coworker, concerned about her absence from school. The brutal killing of the young schoolteacher was headline news. Even the *New York Times*, with its high-minded avoidance of anything that smacked of sensationalism, accorded the Quinn murder page-one coverage.

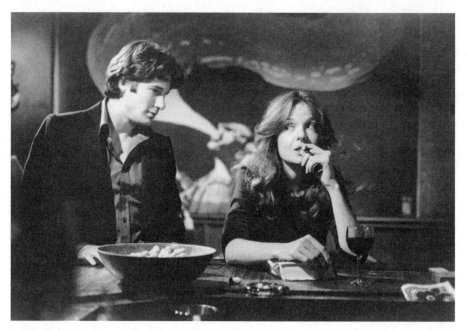

Looking for Mr. Goodbar stars Richard Gere and Diane Keaton, 1977.

A panicky Guest—suddenly afraid that he would be charged as an accomplice—told police about Wilson, who was promptly arrested and returned to New York City, where he was jailed in the Tombs. Five months later, shortly after noon on May 5, 1973, he tossed a sheet over a ceiling bar in his cell and hanged himself. Guest claimed the body and personally escorted it back to Indiana for burial. On the day of the funeral, Wilson's young wife, Candy, gave birth to a stillborn baby—an eerily fitting end to a sordid, sensational case that produced nothing but heartbreak and death.

TRACKDOWN

In addition to Richard Brooks's cinematic version, *Looking for Mr. Goodbar*, the Roseann Quinn murder served as the basis for another, far more obscure film, the 1983 made-for-TV movie *Trackdown: Finding the Goodbar Killer.*

In marked contrast to the theatrical movie, *Trackdown* offers only a fleeting glimpse of the Quinn character, Mary Alice Nolan. We see her at a singles bar being picked up by her killer, then lying dead immediately after the crime (which is never shown). Besides her job at a school for deaf children in the Bronx, we learn virtually nothing about her, though a couple of minor characters make snide references to her promiscuous, "kinky" sex life.

We see very little of her killer, either—a boyishly handsome young creep called John Charles Turner. He appears sporadically in a few scenes: at the apartment of his middle-aged gay lover, checking out newspaper headlines in Miami, boarding a Greyhound bus for the Midwest with his pregnant childlike bride, and finally being arrested in Indianapolis.

The focus of the one-hundred-minute film, as its title suggests, is the investigation of the crime, here led by a fictitious New York City cop, John Grafton, played by George Segal with his usual charm. As to be expected in a made-for-TV drama, much of the film concerns Grafton's domestic issues: the breakup of his marriage and his daughter's decision to go away to college, instead of staying home and attending a commuter school. A dogged, cigar-chewing detective, Grafton is the hero who cracks the case by forcing Turner's sugar daddy to reveal the killer's identity. Though this is a dramatic departure from the truth (John Wayne Wilson's older boyfriend, Geary Guest, volunteered the information in exchange for immunity), *Trackdown* does a reasonably accurate job of tracing the old-fashioned, pavement-pounding police work that led to the killer's arrest. Another virtue of the movie is its on-location shooting, which offers a vivid, often-gritty look at early 1980s New York City. Though *Trackdown* was almost impossible to see for many years, it—like so many other once-unavailable TV shows—can now be enjoyed on YouTube.

M (1931)

**DIRECTED BY FRITZ LANG. WRITTEN
BY FRITZ LANG AND THEA VON HARBOU.
WITH PETER LORRE, OTTO WERNICKE, GUSTAF
GRÜNDGENS, THEO LINGEN, THEODOR LOOS,
GEORG JOHN, AND ELLEN WIDMANN.**

The opening sequence of Fritz Lang's 1931 masterpiece, *M*, demonstrates something that the greatest filmmakers have always understood: it is possible to induce a profound sense of horror in an audience without showing a single image of explicit violence or gore. The movie begins with an overhead shot of a circle of children in a tenement courtyard playing a kind of "eeny, meeny, miny, moe" elimination game. A little girl stands in the center, turning slowly from one playmate to the next and pointing her finger at each while chanting a creepy nursery rhyme:

> Just you wait, it won't be long,
> The Man in Black will soon be here,
> With his cleaver's blade so true
> He'll make mincemeat out of you!

The person she points to when she reaches the last word is out.

A washerwoman in the building complains to her neighbor, Mrs. Beckmann, about the children's "awful song." She doesn't want to hear any more about the monster who has been stalking the city, a pedophiliac serial killer identified in the press as the *Kindermörder*—the child murderer. Mrs. Beckmann, however, finds reassurance in the game. "As long as we can hear them singing," she says, "at least we know they're still there."

It is noon, and Mrs. Beckmann is waiting for her daughter, Elsie, to return from school for lunch. As the mother prepares the meal, we see the little girl, book bag on her back, walking along the street while bouncing a ball on the sidewalk. She pauses to bounce it against a kiosk plastered with a poster offering a reward of 10,000 marks for the murderer. Suddenly a man's shadow falls over the poster. "What a pretty ball you have there," he says in a spookily flat voice. "What is your name?"

The film then cuts back to the mother. It is now twenty past noon and Elsie has still not returned. Mrs. Beckmann goes to the landing and peers over the stairs. Several of her daughter's schoolmates have just arrived home, but they have not seen Elsie.

Back on the street, we see the well-dressed little man buying a balloon for the little girl from a blind street vendor. As he places a few coins in the vendor's hand, the man whistles a distinctive tune, Edvard Grieg's "In the Hall of the Mountain King." He then takes Elsie by the hand and leads her away.

Mrs. Beckmann's clock now reads 1:15 p.m. She steps out to the landing and calls "Elsie!" into the vacant stairwell. She goes to the window and shouts the name. As her cries become increasingly frantic, we see a series of cuts: the table set for her daughter's uneaten lunch; Elsie's ball rolling out of some shrubbery; the balloon caught in telephone wires, then drifting away in the wind. By leaving the specifics of the innocent child's fate entirely to the viewer's imagination, Lang creates a shattering experience of the unspeakable.

As jostling crowds snatch up the newspaper extras trumpeting the latest atrocity, we get our first full glimpse of the killer, Hans Beckert. Played by Peter Lorre in a star-making performance, Beckert, with his protruding eyes, pudgy face, and pillowy lips, resembles a monstrously overgrown baby. His repulsive appearance is made even more grotesque when he engages in what seems to be a favorite activity: pulling down the corners of his mouth with his middle fingers and making fright-mask faces in the mirror.

Like other serial killers, from Jack the Ripper to Son of Sam and Zodiac, Beckert sends taunting letters to the press, promising more murders to come. Among its other groundbreaking aspects, Lang's film is the first motion picture to depict the kind of forensic police work that would become a staple of popular entertainment a half century later. We see lab technicians studying the fingerprints on Beckert's letter; a handwriting expert creating a psychological profile of the killer; a crime-scene investigator discovering a crumpled piece of paper that, when analyzed, proves to be a candy wrapper containing traces of fruit drops—the treats Beckert purchased for his little victim before leading her to her death.

Prodded by mounting public hysteria over the monster at large in the city, the police also intensify their raids on known criminal hangouts. To get the police off their backs, the denizens of the underworld organize their own manhunt. While attempting to snare another little victim, Beckert is finally identified by the blind balloon vendor, who recognizes him by the tune he is whistling. At the vendor's urging, a teenage boy follows Beckert and, to ensure that he doesn't get away, manages to chalk the letter *M* on the back of his coat. When Beckert discovers the incriminating mark and realizes that he has been identified, he hides in an office building. (The shot of a horrified Peter Lorre peering over his shoulder into a mirror and seeing the *M* on his back is one of cinema's iconic images.)

Nabbed by the gangsters who have been pursuing him and hauled before a kangaroo court in an abandoned warehouse, Lorre delivers a harrowing monologue. Comparing himself to his captors—petty thieves and gamblers who could easily give up their criminal activities if they weren't such "lazy pigs"—he shrieks: "I can't help it! I have no control over this cursed thing inside me! Who knows what it is like to be me?"

Thanks to Lorre's shattering performance—and to how his character was conceived by Lang and his cowriter, his wife, Thea von Harbou—it is possible to feel some sympathy for the tormented Beckert. The same cannot be said for the real-life serial killer on whom he was based, Peter Kürten. In the estimate of one eminent historian of world crime, Kürten was a leading contender for the title of "the worst man who ever lived."

Born in 1883, Kürten was one of thirteen children. The entire family inhabited a single-room apartment, a living arrangement that gave Kürten ample

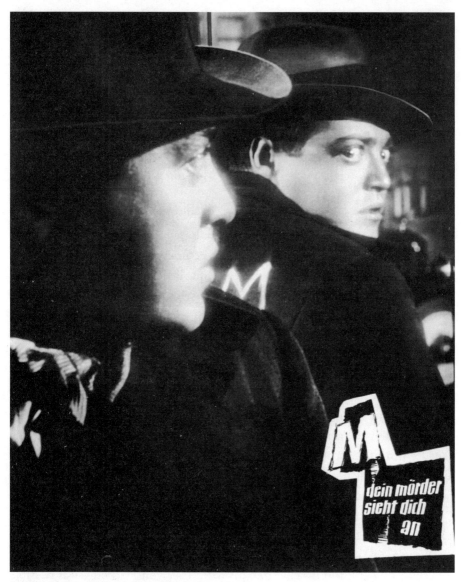

dein mörder sieht dich an

A German lobby card for *M*, 1931, shows lead Peter Lorre.

opportunity to observe his parents' sex life. Besides manhandling his children, his alcoholic father brutalized his wife during his frequent drunken rages. In 1897, when Kürten was fourteen, his father was sentenced to eighteen months at hard labor for committing incest with his eldest daughter.

In addition to the vicious beatings he habitually suffered at his father's hands—and the sexual savagery he regularly witnessed at home—the young Kürten received an education in sadism from another source. At around nine years of age, he befriended the neighborhood dogcatcher, a degenerate who taught him how to masturbate and torture dogs. By the time he reached sexual maturity in early adolescence, Kürten had developed a keen appetite for bestiality, deriving especially intense pleasure from stabbing, beheading, or slitting the throats of various creatures—pigs, sheep, goats, even barnyard fowl—while (as he put it) "forcing his member" into the animal.

Between 1899, when he was sixteen, and 1921, Kürten did seventeen stints in prison for crimes ranging from burglary and embezzlement to terrorizing women who rebuffed his advances. Released in 1921 after a seven-year term for military desertion, he met and married a former prostitute; she was three years his senior and had spent five years in jail for shooting a boyfriend who had jilted her.

Following their marriage, Kürten found work in a factory. For a while, he managed to keep his bloodlust in check. It began to reassert itself in 1925, when he and his wife moved to Düsseldorf. Taking up with various young women, he attempted, on at least four occasions, to strangle them to death during sex. All managed to break free and escape. Whatever self-restraint he had managed to achieve gave way entirely in February 1929.

Sometime between 6:00 and 7:00 p.m. on Sunday, February 10, Rose Ohliger, an eight-year-old schoolgirl who had spent the afternoon at a friend's house, set off for home. She never arrived. Workmen found her body the following morning. She had been stabbed in the temple and breast more than a dozen times, evidently with a pair of scissors. Her throat also bore signs of strangulation.

Less than a week later, on the morning of February 13, a man's corpse was found sprawled in a ditch in the same neighborhood where the earlier crime had occurred. He was quickly identified as Rudolph Scheer, a forty-five-year-old mechanic last seen alive late the previous night, when he'd left a local beerhouse drunk. The powerfully built Scheer had been stabbed twenty times in his temples and neck.

A young housewife named Frau Mantel was walking home from a county fair on the evening of Wednesday, August 21, when a well-dressed stranger

suddenly appeared at her side and asked if he might accompany her. She ignored him and kept walking. She had only gone a short distance when she was stabbed twice in the back with a dagger. Within the span of thirty minutes, two more victims, eight-year-old Anna Goldhausen and thirty-eight-year-old Gustav Kornblum, were also set upon and stabbed, the girl in the breast and Kornblum in the back.

Two nights later, two young girls, five-year-old Gertrude Hamacher and her fourteen-year-old adopted sister, Louisa Lenzen, failed to return home after visiting the county fair. It wasn't until 6:00 the next morning that their bodies were found lying face down in a bean patch only two hundred yards from their home. Autopsies revealed that both had been strangled before having their throats slit.

The same day that the two slaughtered children were found—Saturday, August 24—a twenty-six-year-old domestic servant named Gertrude Schulte was on her way to the fair when she was accosted by a nicely dressed man who politely asked if he might accompany her. After a few pleasant hours together, the two repaired to a grassy spot on the banks of the river, where they began to exchange kisses. Suddenly, he pushed her backwards and ripped off her knickers with one hand, pulled out a dagger with the other, and sliced at her throat. Her screams brought some passersby hurrying to her aid. With one final stab, her attacker leapt to his feet and ran. Though Schulte survived, she was in such dire condition that she was unable to provide any useful information to the police.

Ida Reuter, another servant girl on a Sunday outing in Düsseldorf, was not as fortunate as Schulte. Reuter also allowed herself to be picked up by a suave, well-dressed gentleman, who treated her to a beer, then took her for a stroll to a deserted spot near the Rhine. Her body, naked from the waist down and sprawled obscenely in the grass, was found early the following morning, Monday, September 30. A postmortem examination confirmed that she had been raped, most likely after death. In contrast to all the previous victims, who had been stabbed or slashed to death with scissors or a knife, Reuter had died from a series of savage blows to her head inflicted with a hammer.

Over the next few weeks, three more women were attacked in the same way: a servant girl named Elizabeth Dorrier, whose skull was crushed by a hammer-wielding rapist; a thirty-four-year-old woman, Frau Meurer, felled by two vicious hammer blows to her head, one of which laid bare her skull; and a young

prostitute named Wanders, whose assailant struck her so savagely on the skull that the hammer handle snapped.

Horrors continued to pile upon horrors. On Thursday, November 7, five-year-old Gertrude Albermann was playing by herself on the street near her home when she was approached by a friendly man who struck up a conversation. When he said that there was something he wished to show her, she readily took his hand and let him lead her away. Her body was found two days later, on the morning of Saturday, November 9. She had been sexually molested, strangled, and stabbed three dozen times.

That same day, a local newspaper received an anonymous letter, post-marked November 8—twenty-four hours before searchers found the little girl's body. The letter, containing details that could only have been known by her killer, identified the exact location of the body. It also contained a crudely drawn map marking the spot in a meadow on the outskirts of the city where, according to the writer, another body was buried. Following the map's directions, a team of investigators proceeded to the specified area and began to dig. On November 14, they uncovered the naked corpse of a woman bearing more than a dozen stab wounds in her temple and breast. She was quickly identified as Maria Hahn, a young housekeeper who had never returned from her day off several months earlier.

The revelation that the Düsseldorf butcher was now writing taunting letters to his pursuers, in apparent emulation of Jack the Ripper, aroused widespread outrage. A team of crack detectives from the central criminal investigation department at the Alexanderplatz—Berlin's Scotland Yard—was dispatched to Düsseldorf. In the end, however, the case was finally broken not by the efforts of the police but—as so often happens—by a momentary lapse of caution on the part of the killer.

On May 14, 1930, twenty-year-old Maria Büdlick, a native of Cologne, traveled by train to Düsseldorf, where she hoped to find work. At the station, she was approached by a well-dressed gentleman who addressed her politely and asked if he could be of assistance. When Maria explained her circumstances, he offered to show her the way to a respectable girl's hostel. Following a short tram ride, they began to walk along the deserted streets. As the houses thinned, it became clear to Maria that, rather than taking her into the heart of the city, her companion was leading her toward its wooded outskirts. As they approached a secluded dell,

he suddenly seized her by the throat and began to choke her. She managed to gasp that she was willing to let him have her if only he would not harm her. He agreed. Afterward, prompted by a rare merciful impulse, he decided not to kill her. Finding her way to a hostel run by nuns, Maria told the sisters of the ordeal she had just suffered. When the authorities learned of the incident, Maria was promptly visited by a pair of plainclothesmen who asked if she could identify her attacker. In short order, Kürten was under arrest.

The confession he ultimately offered confirmed the opinion of Chief Inspector Ernst Gennat, who had declared that the Düsseldorf killer made Jack the Ripper look like "a mere beginner." Speaking as matter-of-factly as though discussing his favorite flavor of ice cream, Kürten explained to his psychiatric examiners that, in perpetrating his atrocities, "the main thing for me was to see blood." The frantic struggles of five-year-old Gertrude Hamacher, in August 1929, "had an exciting effect on me," he recalled, "and the sound of blood when I cut her throat made me ejaculate." With Maria Hahn, Kürten "stabbed her throat and, lying across her . . . drank the blood that gushed out"; he admitted, "I probably drank too much because I vomited." He also sucked blood from the head wound of Rose Ohliger and "from the stab in Rudolph Scheer's neck."

His appetite for such depravity was so extreme that, as he cheerfully confessed, while strolling through a Düsseldorf park shortly before his arrest, he came upon a sleeping swan, cut off its head, and ejaculated while drinking the blood that gushed from its neck stump.

Charged with nine murders and seven attempted homicides, "the Vampire of Düsseldorf" (as he was now called) was brought to trial on April 13, 1931. The hordes of curiosity seekers who flocked to the courthouse for a glimpse of the monster were startled to see not a wild-eyed maniac or ravening ogre, but a meticulously dressed, middle-aged gentleman who looked as menacing as the proprietor of a haberdashery shop. His calm, clinically detailed recitation of his atrocities, however, left no doubt in the minds of everyone who heard it that they were in the presence of a being of unparalleled depravity. The jury took only ninety minutes to convict him on all counts. He was condemned to die by the guillotine, a prospect that filled him with pleasure. "Tell me," he excitedly asked the prison doctor as his execution approached, "after my head has been chopped off, will I still be able to hear, at least for a moment,

the sound of my own blood gushing from the stump of my neck?" He found out at daybreak, July 2, 1931.

PETER KÜRTEN AND THE INVENTION OF THE TERM *SERIAL KILLER*

For many years, credit for coining the phrase *serial killer* was given to (and claimed by) former FBI special agent Robert Ressler, one of the founding members of the bureau's elite Behavioral Science Unit. In his 1992 memoir, *Whoever Fights Monsters*, Ressler writes that, in the early 1970s, while attending a week-long conference at the British police academy, he heard a fellow participant refer to "crimes in series," meaning "a series of rapes, burglaries, arsons, or murders." Ressler was so impressed by the phrase that, after returning to Quantico, he began to use the term *serial killer* in his own lectures to describe "the killing of those who do one murder, then another and another in a fairly repetitive way."

While it's possible that Ressler thought up the term independently, its origins can be traced to much earlier sources. The authoritative *Oxford English Dictionary*, for example, cites a 1961 piece by the German film historian Siegfried Kracauer, who, discussing Peter Lorre's character in *M*, writes that "Beckert denies that he is the pursued serial murderer." Five years later, the term appears repeatedly in the book *The Meaning of Murder* by British writer John Brophy. Speaking of Jack the Ripper, for example, Brophy describes him as "still the most famous of all serial murderers."

It has recently been discovered, however, that the phrase dates back even further—to the case of Peter Kürten and the man responsible for tracking him down. Leading the investigation into the crime spree of the so-called Düsseldorf Ripper was Ernst Gennat, head of the Berlin homicide bureau and one of Europe's greatest criminologists. In characterizing the individual whom he and his men were hunting, Gennat came up with the term that others would later take credit for coining. The citizens of Düsseldorf were

not being preyed on by "a creature of sub-human brutality" or "a maniac of almost supernatural powers" (as described by the sensationalistic press) but by a specific variety of criminal sociopath—what Gennat called a *serien-mörder*, a serial killer.

MONSIEUR VERDOUX (1947)

DIRECTED AND WRITTEN BY CHARLES CHAPLIN. WITH CHARLES CHAPLIN, MARTHA RAYE, ISOBEL ELSON, MARILYN NASH, ROBERT LEWIS, MADY CORRELL, ALLISON RODDAN, MARGARET HOFFMAN, AND WILLIAM FRAWLEY.

First set down in writing by the French author Charles Perrault in his classic collection of Mother Goose tales, the story of Bluebeard concerns a sinister nobleman who slays a succession of wives and stores their corpses in a locked room of his castle. The term *bluebeard* was subsequently imported into criminology to describe the type of male serial murderer who does away with one wife after another.

One of the most notorious such killers of the twentieth century was Henri Landru, "the Bluebeard of Paris." Like his fictional counterpart, Landru sported an exceptionally creepy beard, normal in color but unusually thick, spiky, and shaped like a pointy-edged garden spade. He was also bald and whey-faced, with bristling black eyebrows and deep-set "ferret eyes" (in the phrase of one

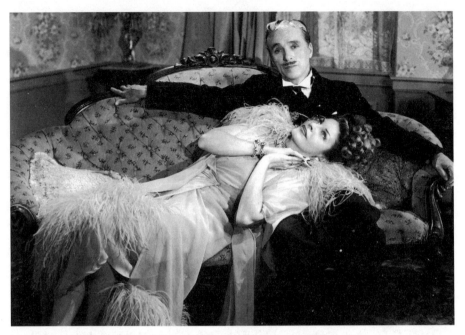

Martha Raye and Charlie Chaplin in a promotional image for *Monsieur Verdoux*, 1947.

contemporary). Despite his strikingly unattractive appearance, he was irresistible to the opposite sex—the "greatest love criminal of his age," as newspapers described him—winning the hearts of an estimated 283 women, at least ten of whom, plus one sixteen-year-old boy, would die at his hands.

Born in April 1869 to respectable, devoutly religious, hardworking parents, Landru showed no signs of his future psychopathology during childhood. Teachers at the Catholic school he attended would recall him as "one of their most brilliant students," a deeply pious young man who loved to sing in the choir and served as subdeacon at mass. Graduating at sixteen, he went to work for several architects, all of whom, as his biographer Dennis Bardens writes, "gave Landru the most excellent character and competence certificates when he left their employment."

Conscripted into the army, he quickly rose to the rank of sergeant. During this period, he seduced and impregnated a sixteen-year-old neighbor (sometimes described as his cousin), Marie Catherine-Remy, who gave birth to a daughter in June 1891. Two years later, after his discharge from the military, Landru legitimized the child, marrying Marie in October 1893.

Landru's criminal proclivities began to surface in the following years. Even while engaged in a series of reputable businesses—toy maker, bicycle manufacturer, used-furniture dealer—he compulsively committed a steady stream of frauds that earned him seven prison sentences between 1901 and 1914. With the outbreak of the Great War, he abruptly made the leap from petty con man to diabolical killer. With nearly nine million young men off to the battlefields—almost half of whom would never return—the country was full of lonely females. In these vulnerable women, desperate for male companionship, the increasingly rapacious Landru saw a flock of easy prey.

Though still a married man who lived sporadically with his family, Landru began placing a matrimonial ad in newspapers:

> Widower, with two children, aged forty-three, possessing comfortable income, affectionate, serious, and moving in good society, desires to meet widow of similar status, with a view to matrimony.

One of his first respondents was an attractive thirty-nine-year-old, Mme Jeanne Cuchet, a war widow with a sixteen-year-old son, André. Landru, who had rented a small villa in the Paris suburb of Chantilly and was using the pseudonym Raymond Diard, exerted his considerable charm upon the well-to-do woman, and she quickly succumbed to his seductive spell. He wooed her with flowers and gifts and impassioned letters. "Without you I cannot live, my own sweet one!" he wrote effusively in one of these missives. "I am longing for each hour to pass when I can again be at your side and press your soft hand to my lips. I love you, my darling—I love only you! You are all that I have in the world to live for."

In anticipation of marriage, Mme Cuchet moved into Landru's villa with her son. Before the nuptials could take place, however, her fiancé sadly informed her that he had lost half his fortune by "foolishly speculating in a cinema company" and was in no financial position to wed. To help him out of this fix, Mme Cuchet made him a generous loan from her considerable savings. In the following weeks, he managed to divest her of the rest.

Soon afterward, in January 1915, both the trusting widow and her teenage son vanished. Precisely how Landru did away with them has never been definitively established. Poison seems likely, though it is also possible, as one crime

historian speculates, that he "drugged [them] into insensibility, then suffocated or strangled them." What is known for certain is that their corpses were dismembered and incinerated in an oven constructed specifically for that purpose.

Over the next four years, employing different aliases, Landru lured a string of lovelorn women into his clutches. His MO was always the same. He would place his classified ad in the papers. When a sufficiently wealthy widow would nibble at this bait, the courtly, smooth-talking con man would sweep her off her feet and whisk her away to his villa outside Paris. Once she had signed over all her worldly possessions to him, she would never be seen or heard from again.

In addition to Mme Cuchet and her son, Landru is known to have murdered nine women, though it is possible that he killed many more. Of his ten identified female victims, all were middle-aged widows except one. Andrée Babelay was a poor nineteen-year-old servant girl whom Landru picked up at a train station and brought back to the small flat that he was renting in Paris, where she became his live-in housekeeper and lover. That this penniless young woman eventually met the same fate as his other victims reinforces the belief that, like all bluebeard killers, Landru was motivated not just by greed but by homicidal compulsion.

A chance encounter brought his murderous career to a close—and almost certainly saved the life of the woman who was with him at the time. Fernande Segret, a twenty-seven-year-old actress and singer, was soon to gain international notoriety as "Landru's last mistress." On April 11, 1919, as the couple entered a china shop on the fashionable Rue de Rivoli, he was recognized by a woman, Mlle Lacoste, whose sister, Celestine Buisson, had gone missing nineteen months earlier after announcing her engagement to Landru, who was then using the name Fremiet.

Mlle Lacoste immediately notified the police, who lost no time in tracking down Landru—now calling himself Lucien Guillet—at the apartment he was renting on the Rue de Rochechouart. On April 12, the infamous lady killer was arrested.

His trial for the murders of his eleven known victims, which commenced on November 7, 1921, was an international sensation, covered by newspapers throughout the world. Though investigators had been unable to turn up any human remains in the several villas where Landru had murdered and incinerated his victims, they found ample evidence of his nefarious enterprise, including

a trunk containing intimate correspondence with no fewer than 283 women, many of whom seem to have vanished without a trace. Throughout the three-week proceedings, Landru steadfastly protested his innocence, sparring with the prosecutor, mocking the witnesses, maintaining a breezy, impudent manner that made for colorful newspaper copy, even as it infuriated the presiding judge.

Mistakenly believing, as many people do, that the term *corpus delicti* refers to the physical body of a murder victim and that he could not possibly be convicted without such evidence, he repeatedly challenged the prosecution to "produce your corpses!" In the end, the overwhelming mass of circumstantial evidence was more than enough to convince the jury of his guilt. Condemned to the guillotine, the Bluebeard of Paris went to his death on February 22, 1922, still declaring that he was "innocent and at peace."

The idea for doing a movie about Landru originated with Orson Welles, who wanted to direct a documentary-style film about the French bluebeard with Charlie Chaplin as the star. Though Chaplin demurred, he eventually decided to make the film himself, not as the serious drama envisioned by Welles (whose contribution is acknowledged in an opening credit) but as a black comedy. While there might seem something odd, if not highly questionable, about milking serial murder for laughs, Frank Capra's smash-hit farce *Arsenic and Old Lace*, released three years before *Monsieur Verdoux*, proved that such a thing could be accomplished with great success (see p. 15).

Although Chaplin regarded it as his best movie, *Monsieur Verdoux* bombed at the box office. Its failure had partly to do with Chaplin's own clouded reputation at the time. Red-baiters had branded him a Communist sympathizer, and the American Legion called for a nationwide boycott of the film, threatening to stage protests outside any theater that showed it. It didn't help that Chaplin had recently been embroiled in a sensational paternity suit. The reviews were also largely tepid, many critics finding the movie tasteless, tendentious, and only intermittently funny. Over the years, however, its reputation has grown, and it is now widely regarded as one of Chaplin's greatest works.

Employing a device that Billy Wilder would famously use several years later in *Sunset Boulevard*, Chaplin's film begins with the protagonist's voice-over narration from beyond the grave. Over a shot of his tombstone, inscribed with the dates 1880–1937, Verdoux's departed spirit explains that, after spending thirty years as "an honest bank clerk," the Great Depression left him unemployed. At

that point, he "became occupied in liquidating members of the opposite sex"—a "strictly business enterprise to support a home and family."

When we first meet the still-living Verdoux, he is already well into his career as a bluebeard, having already dispatched a dozen victims. Residing in a "small villa somewhere in the South of France" (as a title card informs us), the elegant little man is clipping roses in his garden while, behind him, a large outdoor incinerator belches a cloud of black smoke—the cremated by-product of his current victim, Thelma Couvais.

After taking delivery of the late Mme Couvais's life savings and investing it in stock, he returns to Paris, where he is informed by his broker that he must immediately come up with an additional 50,000 francs or lose everything. Undaunted, Verdoux—now calling himself Floray—takes a train to another of his several wives, a battle-axe named Lydia (Margaret Hoffman) and, after tricking her into removing all her savings from the bank, does away with her in the night.

Following a brief visit with his legitimate, adored family—his wheelchair-bound wife, Mona (Mady Correll), and their little one, Peter (Allison Roddan)—the dapper polygamist returns to his homicidal enterprise. Under still another of his identities, a cargo-ship captain named Louis Bonheur, he arrives at the home of his wife Annabella, a braying harpy hilariously played by the popular comedienne Martha Raye. Verdoux's increasingly desperate efforts to bump off the oblivious Annabella (including one priceless scene on a rowboat that plays like a burlesque of Theodore Dreiser's *An American Tragedy*) are comic highlights of the film.

In the end, after "losing everything" (including his beloved wife and child) as a result of the stock market crash, a defeated Verdoux is recognized at a restaurant by the sister of Thelma Couvais. Arrested and tried, the world-weary bluebeard does not, like his real-life prototype, deny his guilt, though he offers some earnest, if dubious, arguments in his defense. Prior to his sentencing, he is asked if he has any statements to make on his behalf. The answer is yes, which comes as no surprise to anyone familiar with the former silent-film star's propensity for speechifying in his later sound films. He then launches into a diatribe against the modern age, which vilifies criminals like himself while lavishing immense rewards on war-mongering industrialists.

"As for being a mass killer, does not the world encourage it?" he asks. "Is it not building weapons of destruction for the sole purpose of mass killing? Has it not blown unsuspecting women and little children to pieces and done it very scientifically? As a mass killer, I am an amateur by comparison."

He offers some final thoughts on the morning of his execution, suggesting that, in essence, he was different from other businessmen only in the matter of scale: "Wars, conflict—it's all business," he says. "One murder makes a villain, millions a hero." Then, having delivered himself of this self-exonerating philosophy, he is marched off to the guillotine.

MURDER ON THE ORIENT EXPRESS (1974)

———

DIRECTED BY SIDNEY LUMET. WRITTEN BY
PAUL DEHN. WITH ALBERT FINNEY, LAUREN
BACALL, MARTIN BALSAM, INGRID BERGMAN,
JACQUELINE BISSET, JEAN-PIERRE CASSEL,
SEAN CONNERY, JOHN GIELGUD, WENDY
HILLER, ANTHONY PERKINS, VANESSA
REDGRAVE, RACHEL ROBERTS, RICHARD
WIDMARK, AND MICHAEL YORK.

MURDER ON THE ORIENT EXPRESS (2010)

DIRECTED BY PHILIP MARTIN. WRITTEN BY STEWART HARCOURT. WITH DAVID SUCHET, TOBY JONES, JESSICA CHASTAIN, BARBARA HERSHEY, HUGH BONNEVILLE, EILEEN ATKINS, SUSANNE LOTHAR, AND DAVID MORRISEY.

MURDER ON THE ORIENT EXPRESS (2017)

DIRECTED BY KENNETH BRANAGH. WRITTEN BY MICHAEL GREEN. WITH KENNETH BRANAGH, DAISY RIDLEY, JUDI DENCH, PENÉLOPE CRUZ, JOSH GAD, WILLEM DAFOE, MICHELLE PFEIFFER, AND JOHNNY DEPP.

Though it isn't regarded as the greatest of Agatha Christie's sixty-six detective novels (that honor belongs to *The Murder of Roger Ackroyd*, her 1926 mystery masterpiece with one of the genre's trickiest endings), *Murder on the Orient Express*, first published in 1934, is certainly the most frequently filmed. Fans of Dame Agatha's brand of cozy "locked room" whodunnits have three handsomely made versions to compare and contrast. Each, while closely following the original story and climaxing with its famous surprise reveal, offers its own distinct pleasures and interesting variations.

The plot is as follows: Traveling on the legendary luxury train from Istanbul to London is Hercule Poirot, the vain, fussy, world-famous Belgian detective who, thanks to the workings of his extraordinary mind (his "little gray cells," as he likes to say), never fails to unravel even the most seemingly insoluble crimes. Soon after the train's departure, Poirot is approached by a shady American character, Samuel Ratchett, who fears that his life is in danger and wishes to hire Poirot as his bodyguard. Put off by Ratchett's coarse personality, Poirot declines.

Shortly thereafter, Ratchett's premonition is fulfilled when he is murdered at night in his compartment. Examining the crime scene, Poirot discovers that Ratchett was actually a gangster named Lanfranco Cassetti, responsible for one of the most sensational crimes of the day: the kidnap-murder of three-year-old Daisy Armstrong, daughter of war hero Colonel Toby Armstrong, recipient of the Victoria Cross. As Poirot pursues his investigation, he finds that each passenger has a close connection to the Armstrong family and thus a possible motive for having wanted Ratchett dead. In the celebrated twist ending, the great detective assembles all the suspects into one car and meticulously lays out the startling solution.

The earliest—and, in the opinion of most critics, best—cinematic adaptation of the book is the 1974 version. Directed by Sidney Lumet (the acclaimed filmmaker behind such classics as *12 Angry Men, Serpico, Network*, and *Dog Day Afternoon*), this opulent production is an homage to the Hollywood extravaganzas of the 1930s. Cast as the coachload of suspects is a glittering roster of big-screen luminaries, including Sean Connery, Lauren Bacall, Richard Widmark, John Gielgud, Vanessa Redgrave, Anthony Perkins, and Ingrid Bergman (who won that year's Oscar for best supporting actress for her role as a mousy Swedish missionary). If there's one flaw in this lavish entertainment, it's the over-the-top lead performance of British actor Albert Finney. Hamming it up as the prissy

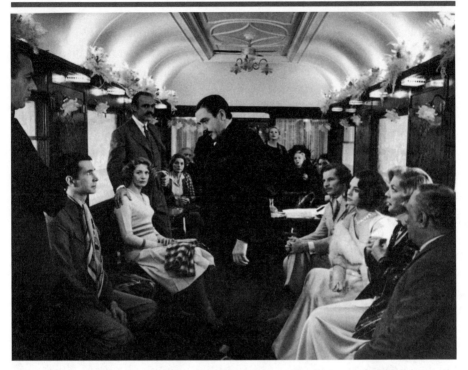

Sean Connery, Lauren Bacall, Jacqueline Bisset, Michael York, Anthony Perkins, and Albert Finney in the 1974 film adaptation of the Agatha Christie classic *Murder on the Orient Express.*

Poirot and deploying an accent of indeterminate origin, Finney—though fun to watch—seems more like Peter Sellers's Inspector Clouseau than Christie's idiosyncratic but unfailingly brilliant supersleuth.

The same criticism cannot be leveled at the 2010 made-for-TV version. Part of the acclaimed British series *Agatha Christie's Poirot*, this movie-length episode stars David Suchet, who, over the course of twenty-five years and seventy installments, brought the beloved Belgian detective to such perfectly realized life that Christie's own daughter invited him to dinner to say how much her mother would have loved his portrayal of her famous creation.

What distinguishes this version from the others is its pervasively dark tone. It opens with two disturbingly violent scenes not found in the novel. Even before the opening credits have finished rolling, a young English army lieutenant, caught in a shameful lie by Poirot, shoots himself in the head in front of the detective, and a Turkish woman, accused of adultery, is stoned to death by a mob while Poirot observes. The murder of Ratchett, never shown directly in

the book, is depicted in graphic detail in the TV film. Most striking of all is the ending. Though Poirot, as always, arrives at the famous surprising solution, he is confronted, in this controversial revision, with an agonizing moral dilemma that leaves him in searing emotional and spiritual pain—a radical departure from his typical self-satisfied attitude.

Of the three cinematic portrayals of Poirot, Kenneth Branagh takes the greatest liberties with the character in his sumptuous, star-studded 2017 adaptation. In glaring contrast to Christie's somewhat comical creation—a rotund, "funny looking" little man, standing barely five feet, four inches tall, with an egg-shaped head and a dandified, somewhat effeminate manner—Branagh, sporting a distractingly over-the-top moustache, turns him into a dashing, virile figure, who, at one point in the film, chases a suspect through the trestles of a precarious mountain bridge (action-hero behavior unimaginable by the original, sedentary Poirot, whose main form of physical exertion is brushing stray specks of dust from his impeccably neat clothing). Branagh also modifies the ending in much the same way that Suchet's version does, making Poirot deeply conflicted about his moral obligations once the mystery has been solved.

While *Murder on the Orient Express* is almost entirely pure invention, Christie's plot was partly inspired by one of the most sensational crimes of the twentieth century, a case that was fresh in the minds of the public when the novel was first published. In contrast to our own disillusioned age—when once-revered statesmen are routinely exposed as compulsive adulterers, idolized athletes as drug addicts and wife beaters, beloved performers as rapists and child molesters—the early decades of the twentieth century were a far more innocent time, when the whole country could still get swept up in unabashed hero worship. And no American inspired more frenzied adulation than Charles Lindbergh (at least until his own considerable feet of clay came to light).

The moment his single-engine monoplane, *The Spirit of St. Louis*, landed just outside Paris following his epochal transatlantic flight in May 1927, "Lucky Lindy" was transformed from a obscure airmail pilot into the world's most famous man—not merely a celebrity but a virtual demigod, so glorified by the

public that, in the words of one biographer, it was as if he "had walked on water, not flown over it." In New York City alone, four million people roared cheers as he was paraded up Broadway through a blizzard of confetti. Two hundred songs were composed in his honor. Schools, parks, and streets—even a mountain and a lunar crater—were named after him. Violating its own rule against honoring a living person, the US Postal Service issued a stamp commemorating his historic flight. He was awarded the Congressional Medal of Honor. For the next few years, the nation would remain in the grip of "Lindbergh-mania."

In the summer of 1930, seeking a measure of peace and privacy away from the overwhelming glare of such unrelenting publicity, Lindbergh—by then married to the former Anne Morrow—purchased a 390-acre tract in a remote area of New Jersey, near the town of Hopewell. Construction began at once on a rambling, two-story fieldstone house that would take more than a year to complete. In the winter and fall of 1931, before their new home was ready for permanent occupancy, Lindbergh, Anne, and their twenty-month-old son, Charles Jr., would stay in Hopewell on weekends, spending Monday through Friday at the country estate of Anne's mother in Englewood.

On the afternoon of Saturday, February 27, 1932, the Lindbergh's arrived at Hopewell for their regular weekend stay. Normally, they would have returned to Englewood late Sunday. Because the baby was suffering from a slight cold, however, they thought it best to stay put for a few more days, until he fully recovered.

He seemed much better by Tuesday evening, March 1. At 7:30 p.m., after having some Vicks VapoRub applied to his chest, he was diapered, dressed in his one-piece Dr. Denton sleeping suit, and tucked into his crib. When his nurse, Betty Gow, peeked into the room at around 7:50 p.m., little Charlie was sound asleep.

At around 9:00 p.m., following a late dinner, Lindbergh was chatting with his wife by the living room fireplace when he heard a sudden crack outside the window, like the snapping of a tree branch. His wife had heard nothing except the ordinary noises of a gusty night. They listened for a moment, then headed upstairs to their bedroom, where Lindbergh took a bath and dressed again before repairing to the downstairs library to do some reading. Anne remained upstairs, preparing for bed. By then, it was almost ten o'clock.

A few minutes later, before retiring for the night, Betty Gow decided to check on the baby one last time. To her surprise, the crib was empty. Perhaps his mother had removed him? Betty hurried to the master bedroom and asked

Anne if the baby was with her. When Anne responded with a bewildered no, Betty raced downstairs and put the same question to Lindbergh who, after hearing that his infant son was missing from his crib, leapt from his chair and ran to the nursery. He sized up the situation at once. Striding into his own bedroom, he grabbed the loaded rifle he kept in the closet, then returned to the nursery, followed by Betty and Anne. Glancing around, he spotted a small white envelope on the radiator cover beneath the windowsill. He had no doubt what the envelope contained. "Anne," he said to his stricken wife, "they have stolen our baby."

Displaying the preternatural coolness under pressure that had allowed him to achieve his world-changing feat, Lindbergh held back from touching the envelope. He called the local and state police, who were quickly on the scene. Searching the grounds, troopers found a pair of indentations in the mud beneath the nursery window, clearly made by the feet of a ladder. They found the ladder itself—a handmade wooden affair in three sections—lying about seventy-five feet away. Part of it had split, evidently when the kidnapper had climbed back down the ladder with the baby.

Inside the nursery, the envelope left by the window was dusted and opened. As Lindbergh had expected, it contained a ransom note. Handwritten in blue ink and rife with misspellings that suggested its author was German, the letter demanded $50,000 in exchange for the safe return of the baby.

Given the worshipful regard in which Lindbergh was held by his countrymen, the theft of his child seemed not only heinous but almost inconceivably wicked: "the most revolting crime of the century," as one reporter put it. President Hoover issued a statement deploring the crime, while the US Congress quickly moved to make kidnapping a federal offense punishable by death. Franklin Delano Roosevelt, then governor of New York, put his state's police resources at Lindbergh's disposal. Both William Green and Dr. James E. West—president of the American Federation of Labor and chief executive of the Boy Scouts of America, respectively—called on their entire memberships to help track down the perpetrator. Will Rogers, beloved "cowboy philosopher" and star of radio, film, and stage, conveyed the nation's outrage in his syndicated newspaper columns. From a holding cell in the Cook County jail, where he was awaiting transfer to the Atlanta penitentiary to begin an eleven-year sentence for income tax evasion, Al Capone offered a reward of $10,000 for the return of the child.

The weeks that followed were a nightmare of false leads, dashed hopes, wild rumors, and cruel hoaxes. During that time, the distraught parents received over one hundred thousand letters offering comfort, advice, and a staggering quantity of well-intentioned but thoroughly useless information. While Anne issued heartbreaking bulletins to the kidnapper, detailing the baby's dietary needs, her husband broadcast a fervent appeal over the radio, offering not only the ransom money but full immunity from prosecution in exchange for his unharmed child. In desperation, he enlisted two notorious bootleggers to serve as go-betweens with the underworld.

Among the countless individuals volunteering wholly unsolicited assistance in the case was an eccentric character named John F. Condon. A retired teacher and administrator who had worked in the New York City public school system for many years, the seventy-two-year-old Condon was variously viewed as an "altruistic and honorable educator" and a pompous self-promoter who liked nothing better than to see his name in print, no matter how obscure the publication. A relentless booster of his native borough, the Bronx, he was a frequent contributor to the neighborhood newspaper, the *Bronx Home News*, submitting a steady stream of essays, poems, and letters under assorted hokey pseudonyms like P. A. Triot, L. O. Nestar, and J. U. Stice.

On March 7, 1932, Condon took purple-inked pen in hand and wrote a characteristically overblown letter to the kidnapper, urging him "to restore the beautiful baby to its mother's arms" and offering to add $1,000 of his own savings to the $50,000 ransom. He dispatched it at once to the *Bronx Home News*, which ran an edited version on the following day. On the evening of March 9, Condon—who had been motivated more by his insatiable need for attention than by any serious hope of hearing back from the kidnapper—was stunned to receive a reply, asking if Condon would be "willing to act as go-between in Lindbergh cace." Enclosed with this letter was a second one addressed to Lindbergh. After determining that these communications were authentic, Lindbergh immediately authorized Condon to act as an intermediary. Over the following weeks, under the pseudonym Jafsie (derived from his three initials, JFC), Condon communicated with the kidnapper through coded classified newspaper ads and had a face-to-face meeting with him in a Bronx cemetery. The negotiations culminated on the evening of April 2, when Condon, following the intricate instructions provided by the kidnapper, met him in another Bronx

cemetery and handed over $50,000 in cash in exchange for a note indicating that the boy was being held on a 28-foot boat called *Nelly*, moored between Cape Cod and Martha's Vineyard. Lindbergh, piloting a Sikorsky seaplane, scoured the area, assisted by a half-dozen coast guard cutters and a navy warship. After two futile days of searching, Lindbergh was forced to acknowledge the bitter truth: "We've been double-crossed."

Just over a month later, on Wednesday, May 12, the drama of the hunt for the missing Lindbergh baby, which had kept the American public spellbound for seventy-two days, came to a devastating climax in a dreary clump of woods less than five miles away from the child's home. At around 3:15 p.m. that afternoon, two men, Orville Wilson and William Allen, were driving down a deserted stretch of road outside the village of Hopewell when they pulled to the side so that Allen could empty his bladder. Wandering about fifty feet into a thicket of maple and locust, Allen suddenly came upon the half-buried remains of what he took, at first, to be an animal. Peering closer, he saw a tiny human foot protruding from the shallow grave. The police were quickly summoned. Though the corpse was badly decomposed and partly eaten by scavengers, the golden curls atop the blackened skull, along with other signs, including its dimpled chin and still-intact clothing, left no doubt as to its identity. An autopsy revealed that the baby had died of a skull fracture. Investigators theorized that the baby's head had smashed against the stone wall of the house when the ladder broke as the kidnapper carried him down.

News of the dreadful discovery sent the country into a paroxysm of outrage and sorrow—"the greatest public display of grief since the assassination of Lincoln," in the words of one chronicler. With no suspects or leads, however, the story gradually faded from the news.

Even as the public turned its attention to other matters, investigators continued to hunt for the kidnapper. After subjecting the handmade ladder to minute scientific analysis, Arthur Koehler, the country's leading "wood technologist," managed to track the source of its side rails to a lumberyard in the Bronx. In the meantime, a fifty-seven-page pamphlet containing the serial numbers of every one of the ransom bills was distributed to thousands of banks around the country. Businesses were also urged to keep a lookout for anyone passing one of the bills, many of which had been paid in gold certificates.

On the morning of Saturday, September 15, 1934, a 1930 blue Dodge sedan pulled into the Warner-Quinlan gas station at the corner of Lexington Avenue and 127th Street in Manhattan. Its driver, a trim, fair-complexioned man who spoke with a thick German accent, asked the manager, Walter Lyle, for five gallons of gasoline. When the man handed over a ten-dollar gold certificate to pay the ninety-eight-cent tab, Lyle looked at it uncertainly. A year-and-a-half earlier, to prevent the hoarding of gold that had become epidemic during the Depression, President Roosevelt had issued an order requiring all citizens to turn in their gold coins, bullion, and certificates within a month. As a result, few gold certificates remained in circulation. Fearing that the ten-dollar note might be a counterfeit, Lyle jotted down the man's license plate number on the margin of the bill as the driver pulled away.

Within twenty-four hours, after being alerted by the bank where Lyle deposited his earnings, investigators had identified the owner of the vehicle as a German-born carpenter, Bruno Richard Hauptmann of East 222nd Street, the Bronx—an address just a few blocks away from the lumberyard that had supplied the wood for the ladder and from the cemetery where the kidnapper had met with John Condon. On the morning of September 19, Hauptmann was arrested by a team of law enforcement officers from the FBI, the New York City Police Department, and the New Jersey State Police. He was carrying a twenty-dollar gold certificate, quickly identified by its serial number as part of the ransom money. More of the money—over $12,000—was found in Hauptmann's garage. Searching his apartment, which was crammed with luxurious new furnishings, investigators also discovered a notebook containing a sketch of a three-piece ladder identical in design to the one used by the kidnapper, road maps of New Jersey, John Condon's address and phone number penciled on the inner door trim of a closet, and—most damningly—a missing portion of pine board in the flooring of the attic. Summoned by the police, wood expert Arthur Koehler easily determined that one of the side rails of the kidnap ladder was a perfect match for the missing piece. Though Hauptmann claimed he had no criminal record prior to his arrival in America as a stowaway in 1923, investigators soon learned from their German counterparts that he had served four years in prison for armed robbery. He had also committed a series of burglaries, in one of which he employed a ladder to climb into the second-story window of the town burgomaster's home.

The proceedings against Hauptmann, which began on the morning of January 2, 1935, instantly supplanted the 1924 sentencing hearing of Nathan Leopold and Richard Loeb as "the Trial of the Century" (see p. 243). Invaded by an army of newspapermen, curiosity seekers, and hucksters of various stripes, the little town of Flemington became, in the words of one historian, "nothing less than an amusement park devoted to the Hauptmann trial." Seven hundred reporters were on hand to cover what the ever-caustic H. L. Mencken described as "the greatest story since the Resurrection." On the first Sunday of the trial, an estimated sixty thousand tourists flocked to the town, and street vendors hawked little wooden models of the kidnap ladder, fake clippings of the Lindbergh baby's hair, and photos of Charles and Anne Lindbergh, complete with forged autographs. Such was the grotesquely festive atmosphere of the scene that Pulitzer Prize–winning writer Edna Ferber, there to cover the trial for the *New York Times*, proclaimed that "it made you want to resign as a member of the human race."

The trial, which lasted just over six weeks, culminated in a verdict of guilty. Particularly devastating to the defense was the testimony of Arthur Koehler, who, with the help of enlarged photographs, demonstrated beyond a reasonable doubt that the kidnap ladder had been partially constructed from a floor plank in Hauptmann's attic.

Stoutly maintaining his innocence to the end, Hauptmann was sent to the electric chair on April 3, 1936. In the ensuing decades, a steady stream of books has appeared arguing that he was framed, one conspiracy theorist going so far as to claim that Lindbergh himself accidently killed his baby, then fabricated the kidnapping to cover up the deed. Though most legal experts agree that Hauptmann's trial was unfair in many regards, the overwhelming weight of evidence against him points almost certainly to his guilt.

THE NIGHT OF THE HUNTER (1955)

DIRECTED BY CHARLES LAUGHTON. WRITTEN
BY JAMES AGEE. WITH ROBERT MITCHUM,
SHELLEY WINTERS, LILLIAN GISH, PETER
GRAVES, BILLY CHAPIN, AND JAMES GLEASON.

In the words of his earliest biographer, he was "the most fiendish human being of his day"—perpetrator of "one of the most monstrous mass murders in world history, the most horrible tragedy in American annals." And yet, this Depression-era psycho, whose crimes appalled and titillated millions of his contemporaries, is barely remembered today. He stands as a prime example of the curious workings of infamy—the mysterious forces that bestow near-mythical status on some notorious killers while consigning others to near-total oblivion.

In the bygone days before internet dating services, singles looking to meet prospective mates sometimes availed themselves of the services of matrimonial bureaus—mail-order matchmaking agencies that provided subscribers with lists of potential partners. One of these operations was the American Friendship Society of Detroit, which lured customers with classified ads in pulp

true-romance magazines: "LONELY HEARTS—Join the world's greatest social extension club, meet nice people who, like yourself, are lonely (many wealthy). One may be your ideal. We have made thousands happy. Why not you?"

Among the many desperate love seekers who replied to this come-on was a fifty-year-old, Danish-born widow named Asta Buick Eicher, resident of Oak Park, Illinois, and mother of three young children, fourteen-year-old Greta, twelve-year-old Harry, and nine-year-old Annabelle. In early 1931, Mrs. Eicher—a cultivated, artistically inclined woman who had reputedly inherited a tidy sum from her late husband, a prosperous silversmith—received a letter from a gentleman who identified himself as Cornelius O. Pierson of Clarksburg, West Virginia.

Pierson claimed that he was a successful civil engineer with a net worth of $150,000 (more than $2 million today) and "a beautiful ten-room house, completely furnished." Because his heavy business responsibilities prevented him "from making many social contacts," he had turned to the American Friendship Society to help him "make the acquaintance of the right type of woman." From Mrs. Eicher's listing, he felt she might be a suitable partner. "My wife," he wrote, "would have her own car and plenty of spending money."

Before long, the two had embarked on a long-distance, mail-order courtship. As their epistolary romance heated up, Pierson plied the full-fleshed widow with his particular brand of sweet talk. In response to a Kodak photograph she sent, he exclaimed over how "well preserved" she was and assured her that he "preferred plump women." He also let her know that he understood the deepest needs of the opposite sex. "The great trouble is that men are so ignorant that they do not know that women must be caressed," he purred.

Sometime in the spring of 1931, at Mrs. Eicher's invitation, Pierson made the first of several trips to her home in suburban Chicago. History does not record how she reacted to her first glimpse of her long-distance suitor. From his letters, she expected a tall, handsome, distinguished-looking gentleman with dark wavy hair and "clear blue eyes." What she saw was a bespectacled, beady-eyed, moon-faced fellow standing barely five feet, seven inches tall and weighing just under two hundred pounds—"squat, pig-eyed, and paunchy," as one contemporary described him. Nevertheless, she appears to have been quite taken with him, inviting him back for several more visits in the following months and proudly introducing him to her neighbors as a man of substance, with investments in

oil and gas wells, farm land, and "stocks and bonds paying from six to forty percent dividends."

Those same neighbors were the ones who notified the police when Mrs. Eicher and her children mysteriously disappeared in late June. Searching her house, detectives discovered twenty-seven letters from Cornelius Pierson. Two months passed before authorities managed to trace Mrs. Eicher's love interest to his home in Clarksburg, West Virginia. His name was not Pierson. It was Harry F. Powers. And far from being a wealthy bachelor with money from oil wells, dairy farms, and high-yield bonds, he was a married vacuum cleaner salesman whose wife, Luella, supplemented their meager income by selling sundries from a little shop adjacent to their cottage.

At first, Powers denied any knowledge of Mrs. Eicher. Confronted with the incontrovertible evidence of his more than two-dozen love notes, he admitted that they had corresponded but insisted that he knew nothing about her disappearance.

It wasn't long, however, before investigators learned that Powers and his wife owned a small plot of land, inherited from her father, in a place called Quiet Dell, a bucolic little village nestled in the hills just a few miles outside Clarksburg. Proceeding to the property, detectives discovered a tumbledown wooden bungalow that had clearly been vacant for years. Directly across the narrow dirt road, however, stood a large, shed-like structure that appeared to be a newly built garage. The door was secured with a pair of heavy padlocks that were quickly opened with a crowbar. The interior was big enough to accommodate three automobiles. But there were no cars inside—just a pile of cartons and trunks that turned out to be packed with the personal belongings of Mrs. Eicher and her three children.

One of the officers noticed a trapdoor in the concrete floor. Swinging it open, he was assaulted by a heavy stench wafting up from below. Beaming their flashlights into the darkness, several officers descended the wooden steps. As they swept their lights around, they saw at once that the cellar had been used as a prison. The space was divided into four cramped, soundproofed cells, each fitted with a heavy wooden door. Small, iron-grated apertures in the exterior walls allowed some weak rays of sunshine to penetrate the gloom. Otherwise, there was no light or ventilation. Nor were there any furnishings—just a bare, filthy mattress on the concrete floor of each cell.

Apart from a few bloodstained articles of clothing scattered about, there were no signs of the victims. The corpses weren't discovered until the following day, when officers from the sheriff's department and the state police—supplemented by a road gang from the county jail—began excavating the property. Stuffed in burlap sacks, the bodies were buried in a shallow drainage ditch that ran from the rear of the garage to a nearby creek. That same evening, the diggers came upon the remains of a fifth victim. She was quickly identified as fifty-one-year-old Dorothy Lemke of Northboro, Massachusetts, who had not been seen since the previous month when she withdrew $1,555 from her bank and went off with her mail-order fiancé, Cornelius Pierson.

Based on the autopsy results, authorities concluded that Mrs. Eicher and her children had been starved and tortured before being put to death. Evidence in the "death dungeon"—as the tabloids promptly dubbed the cellar—suggested that the mother had been hanged from a ceiling beam, perhaps in full view of her children. When the boy, Harry—who had been bound with rope and gagged with "garage waste"—had tried to struggle free to save his mother, his skull had been beaten in with a hammer. He also had been castrated. His sisters, like Dorothy Lemke, had been strangled.

Informed of these grisly finds, Powers continued to maintain his innocence, insisting that the bodies must have been buried on his property by someone else. At that point—around 8:30 p.m. on Friday, August 28—his interrogators began applying the "third degree." For the next eight hours, Powers was punched, kicked, flogged with a rubber hose, beaten with a ball-peen hammer, burned with cigarettes, and jabbed with needles. His left arm was broken, and hot boiled eggs were pressed under his armpits. Finally, at around four o'clock Saturday morning, he broke. "I did it," he sobbed. "My God, I want some rest." His face badly swollen and his flabby body a mass of bruises, burns, puncture wounds, and welts, he was taken to the infirmary, where he signed a statement confessing to the murder of Mrs. Eicher and her children "by using a hammer and strangulation."

In the meantime, news of the atrocities had spread across the region. Throughout the night, hundreds of people streamed through the Romine Funeral Home in Clarksburg for a glimpse of the five victims, who had been laid out in open coffins. The following day, Sunday, August 30, an estimated thirty thousand curiosity seekers overran the "murder farm" (as the papers immediately

dubbed the property), turning that sweltering summer Sabbath "into a morbid holiday." A dozen county policemen were dispatched to the scene to direct traffic, while a few enterprising locals attempted to erect a six-foot wooden fence around the "death den" and charge an admission fee. Outraged at having the site of the tragedy transformed into what one observer called a "mass-murder amusement park," an angry mob tore down the barricade, "and everyone was then free to visit the death spot without charge or restraint."

Over the following weeks, investigators dug deep into the background of the man now known in the tabloids as "the Bluebeard of Quiet Dell." It quickly emerged that Harry F. Powers was merely another pseudonym, one of many that the lifelong criminal had employed over the years. His real name was Herman Drenth. Born in Holland in 1892, he had immigrated to New York in 1910. Over the next dozen years, he had led a rootless life, residing for brief periods in Indiana, Ohio, Virginia, Illinois, and Pennsylvania before ending up in West Virginia in 1926. During that period, he had done two stints in jail, once in Iowa for burglary and the second in Indiana for defrauding a widow of $5,400.

In 1929, he had married the former Luella Strother of Clarksburg. A forty-one-year-old divorcée with an unfortunate marital track record, Strother had previously been wed to a local farmer named Ernest Knisely, who was arrested and tried for murder after fracturing the skull of a neighbor during a violent altercation. It was not long after she and Powers exchanged vows that he hit on his matrimonial-bureau scheme, joining several mail-order services (including one that advertised itself as "Cupid's Headquarters") and securing the names of several hundred potential victims. At the time of his arrest, five letters—sealed, stamped, and addressed to women in New York, Maryland, Detroit, and North Carolina—were found in his possession.

As the investigation dragged on, rumors began to swirl that the outraged citizens of Clarksburg planned to take matters into their own hands. The crisis came to a head on the night of Saturday, September 19—nearly a month after Powers's arrest—when a lynch mob of more than four thousand men and women surrounded the jailhouse, crying out for the monster's blood. They were met by a contingent of heavily armed lawmen—the sheriff and all his deputies, the entire city police force, and a detachment of state troopers—who warned the crowd "to stay back or they would be shot down in their tracks." Ignoring the threat, the mob surged forward. After firing a few warning shots over the crowd,

the police let loose a barrage of tear-gas bombs. In the ensuing confusion, eight of the rioters were grabbed and arrested, while the rest—"choking and crying from the fumes"—fell back and eventually dispersed. In the midst of this uproar, Powers was hustled out the rear of the building into a waiting automobile and, escorted by a pair of police cars, driven to the state penitentiary at Moundsville a hundred miles away, where he would remain locked in a solitary cell until the start of his trial.

Anticipating an insanity plea on the part of the defense, prosecutors called in a well-known forensic psychiatrist, Dr. Edwin H. Meyers, to examine Powers. After meeting with Powers for several hours in his cell, Meyers pronounced him legally sane, someone who "knows right from wrong" but who is clearly psychopathic—"possessed of an exaggerated lust to kill which dominates his entire personality." Though motivated partly by financial greed, Powers derived his deepest gratification from contemplating, planning, and then carrying out his atrocities—"tormenting, torturing, and punishing his victims before strangling or beating them to death." He was driven, in short, "by the mere love of killing."

Knowing how many spectators would flock to Powers's trial, county officials decided to conduct it in the largest venue available, the city opera house. The show opened on December 7, 1931, with the principal players—the judge and jury, the witnesses, the defendant and his lawyers, and the prosecuting attorneys—seated onstage. For the five days of its duration, it drew an SRO crowd who watched with rapt absorption. Powers, by contrast, sat through the proceedings with a look of utter indifference—"a bland gum-chewing observer of a drama that seemed to bore him," as one reporter wrote.

His expression remained impassive even when the jury returned a guilty verdict on the afternoon of December 11, after less than two hours of deliberation. Nor did he evince the slightest emotion three months later when he was led to the gallows in the Moundsville State Penitentiary. The town itself, as the local paper reported, "had taken on a holiday festive appearance in preparation for the execution of the man whose crimes startled the world. Outside the prison a crowd gathered along the curbs. Automobiles were lined up for blocks."

Nattily dressed in a black pinstripe suit, white broadcloth shirt, and gaudy blue necktie, the condemned man ascended the scaffold with absolute composure and gazed steadily at the forty-two assembled witnesses before the black hood was slipped over his head. Asked if he had any last words, he calmly replied

no. A moment later, at precisely 9:00 a.m. on Friday, March 18, 1932, the trap was sprung. Neck broken, he dangled from the end of the rope for eleven full minutes before the prison physicians declared him dead.

Though relatively few people are aware of the fact, Harry Powers inspired a bestselling book, the 1953 thriller *The Night of the Hunter* by Davis Grubb, a native of West Virginia who grew up near Powers's home in Clarksburg and who set his novel in Moundsville, where the Bluebeard of Quiet Dell was incarcerated in the state penitentiary. Set during the Great Depression, Grubb's novel centers on a psychotic ex-con named Harry Powell who passes himself off as an itinerant preacher. In his relentless hunt for $10,000 in stolen cash, he woos, weds, and murders a young mother, then pursues her orphaned children, who take flight with the money.

Two years after Grubb's novel was published to great commercial success and critical acclaim (including a National Book Award nomination), a darkly brilliant movie version hit the screens, directed by renowned British actor Charles Laughton and adapted by Pulitzer Prize–winning author James Agee. At the time of its release, the highly stylized movie—with its expressionistic, black-and-white cinematography and dreamlike texture—was a box office failure, putting a quick end to Laughton's incipient directorial career. Reviewers, too, dismissed it as "weird" and "offbeat." Over the years, however, its status has soared. Today, it is consistently ranked as one of Hollywood's greatest films.

In essence, Laughton's version of Grubb's suspense novel is a nightmarish fairy tale with a supremely evil stepparent, in this case a man in place of the traditional wicked stepmother. That villainous role is played by Robert Mitchum as the psychopathic preacher, Harry Powell. His knuckles tattooed with the words *love* and *hate*, his honeyed voice oozing menace, Mitchum turns in one of the most chilling performances ever recorded on celluloid.

We first meet this "false prophet in sheep's clothing" as he is tooling through the Depression-era south in a stolen Model T, having just dispatched his latest female victim—one of a dozen "widow[s] with a little wad of bills hid away in a sugar bowl" whom he has evidently wed, robbed, and murdered. Money, however, is not his primary motive. What truly drives him is his pathological hatred of the opposite sex: "perfuming-smellin' things, lacy things, things with curly hair," as he describes them. The homicidal rage provoked in this madman by women who arouse his lust is chillingly conveyed in the following scene: Seated

A 1932 mugshot of serial killer Harry F. Powers, a.k.a. Herman Drenth.

in a burlesque house, watching a stripper do her bump and grind, Powell—his face contorted with loathing—reaches a hand into his pocket. Suddenly, the blade of his springblade knife pops straight up through the fabric, a bit of symbolism that does not require an advanced degree in Freudian psychology to interpret.

The main plot gets going when, jailed for car theft, Powell becomes cellmates with a condemned prisoner, Ben Harper (Peter Graves, perhaps best remembered as the vaguely pedophiliac Captain Oveur in the blockbuster comedy *Airplane!*). Moments before his capture, Harper, who is sentenced to hang for killing two men during a bank robbery, had managed to make it back home and stash the stolen $10,000 in a rag doll belonging to his little daughter, Pearl. Though Harper goes to the gallows without revealing the precise whereabouts of the money, the cunningly malevolent preacher assumes that it must be hidden somewhere on his former cellmate's property.

No sooner is he paroled than Powell sets out for Harper's hometown, Cresap's Landing, and immediately insinuates himself into the life of the dead man's widow, Willa (Shelley Winters). Fully possessed of the manipulative charm typical of psychopathic personalities, Powell has no trouble impressing Willa

and her gullible neighbors with his supposed piety. In the film's most celebrated scene, he delivers a mesmerizing sermonette that powerfully captures his con-man charisma.

Noticing Willa's young son, John, staring at his tattooed knuckles, Powell proceeds to relate "the little story of Right Hand–Left Hand—the tale of good and evil." First, he extends his left hand, inscribed with the letters *H-A-T-E*. "It was with this hand," he declares, "that old brother Cain struck the blow that laid his brother low." He then holds up his right hand to display the tattooed letters *L-O-V-E*. "You see these fingers, dear hearts?" he asks. "These fingers have veins that run straight to the soul of man. The right hand, friends! The hand of love! Now watch and I'll show you the story of life." Then, intertwining his fingers, he puts on a grotesque manual wrestling match while declaiming:

> These fingers, dear hearts, is always a-warrin' and a-tuggin', one agin the other. Now, watch 'em. Ol' brother Left Hand, he's a-fightin'. And it looks like *LOVE*'s a goner. But wait a minute, wait a minute! Hot dog! *LOVE*'s a-winnin'! Yes sirree, it's *LOVE* that won, and ol' Left Hand *HATE* is down for the count!

Egged on by her busybody neighbors, who are totally taken in by the religious huckster's snake-oil spiel, Willa accepts Powell's marriage proposal, believing that providence has sent her a kind, loving mate. That illusion is dispelled on her wedding night, when, instead of physical consummation, she is treated to a fire-and-brimstone sermon on the shameful nature of her desires. Her thwarted sexuality converted into religious mania, she falls ever more deeply under Powell's malignant spell. Her son, John, however, remains deeply suspicious of the preacher, who devotes most of his energy to pressuring the boy and his little sister into revealing the hiding place of the stolen loot.

When Willa's eyes are finally opened to the truth—that Powell is after the money—he murders her and disposes of her body in the river. In the film's most haunting image, we see the dead woman underwater, seated in her submerged Model T, "her hair waving soft and lazy like meadow grass under floodwater" (as one character describes it). When Powell finally discovers where the $10,000 is concealed, the children barely escape his clutches and flee for their lives.

At this point, *The Night of the Hunter*, often categorized as a film noir, turns into sheer horror—"one of the most frightening movies ever made," in the opinion of esteemed *New Yorker* critic Pauline Kael. A terrifying embodiment of that primal childhood nightmare, the monster father, Powell relentlessly pursues his little prey through a dreamlike landscape. In the end, like many fairy tales, the film takes on an allegorical quality as John and Pearl find shelter with a saintly farm woman, Rachel Cooper (silent-film legend Lillian Gish), the human incarnation of Christian love in its perpetual struggle with cosmic evil.

THE PHENIX CITY STORY (1955)

DIRECTED BY PHIL KARLSON. WRITTEN BY
CRANE WILBUR AND DANIEL MAINWARING.
WITH RICHARD KILEY, JOHN MCINTIRE,
KATHRYN GRANT, EDWARD ANDREWS,
LENKA PETERSON, BIFF MCGUIRE,
JOHN LARCH, AND CLETE ROBERTS.

For a place now regarded as one of America's "Best Affordable Suburbs to Raise a Family" (according to *Business Week* magazine), Phenix City, the county seat of Russell County, Alabama, has a notoriously unwholesome past. It traces its origins to the pre–Civil War village of Girard, a lawless settlement on the west bank of the Chattahoochee River, so rife with vice that it was nicknamed "Sodom." Throughout the early decades of the twentieth century, before Las Vegas laid claim to the title, it gained a well-earned reputation as the nation's preeminent "Sin City." In a memorable description by its leading historian, the town was

an unending series of night clubs, honky tonks, clip joints, B-girl bars, whorehouses, and gambling casinos. Every highway leading into the city was lined with the institutions, and they were scattered throughout the residential districts. You could climb a tall tree, spit in any direction, and where the wind wafted the splutter, there you would find organized crime, corruption, sex and human depravity.

While the illicit pleasures of Phenix City were available to any sucker looking for a good time, its primary patrons were soldiers from nearby Fort Benning, Georgia. Informed of all the young infantrymen being fleeced in its infamous dives, Henry Stimson, FDR's secretary of war, proclaimed it "the wickedest city in America." And General George Patton—outraged over the number of soldiers who ended up cheated, rolled, beaten, and sometimes dumped in the river in cement shoes—threatened to send tanks across the river to raze the city.

Corruption was so deeply entrenched in the local government and police force that periodic campaigns by reformers invariably came to nothing. It wasn't until the early 1950s that the Phenix City rackets were threatened by a formidable foe.

His name was Albert Patterson. A native of Alabama whose birth year is a matter of some dispute, Patterson left his family farm as a teenager and made his way to Texas, where he worked for a time in the oil fields before enlisting in the army. Shipped overseas during the Great War, he saw combat in France and, after suffering severe wounds from German machine-gun fire, returned to the States with a permanent limp and the Croix de Guerre for bravery.

Back in Alabama, he served as a high school principal while completing his bachelor's degree. In 1926, having decided to switch careers, he entered law school, graduating the following year and opening a practice in the town of Opelika. By 1933, he and his family had settled in Phenix City. In the ensuing decade, he became increasingly active in local politics, beginning as a member of the board of education and eventually serving a term as state senator.

During the 1940s, Patterson counted some of Phenix City's most notorious mobsters among his clients. Gradually, however, he found himself unable to abide the crime syndicate's stranglehold on his community. Aligning himself with a crusading merchant named Hugh Bentley, he became a prominent figure in the Russell Betterment Association (RBA), an organization determined to purge Phenix City of corruption. Gangland efforts to intimidate the two

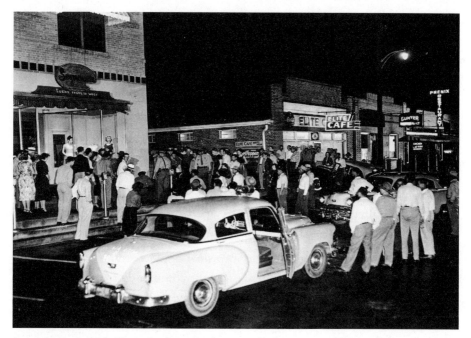

A crowd scene from *The Phenix City Story*, 1955.

reformers, which included the dynamiting of Bentley's home and the torching of Patterson's law office, only strengthened their resolve.

When the RBA proved ineffective against the powerful Phenix City machine, Patterson decided on another course of action. In the spring of 1954, he ran for state attorney general on the pledge (as one of his campaign ads put it) "to stamp out organized crime wherever it exists" and to protect Alabama's "young people" from "dope-dealing [and] sex crimes." Despite the concerted efforts of the city's mobsters to manipulate the outcome, Patterson squeaked out a win as the Democratic nominee, essentially ensuring his victory in the general election.

He would never get a chance to take office.

On the evening of Friday, June 18, 1954, just days before he was scheduled to testify before a grand jury investigating vote fraud in the election, Patterson left his law office and headed for his car, parked in an alleyway around the corner. Before he could get behind the wheel, a man described by witnesses as "wearing a light brown suit and a light hat" stepped up to him, stuck a .38-caliber pistol in his face, and—in what historian Alan Grady calls "either a conscious or unconscious symbol of silencing Patterson"—shot him directly in the mouth. A

second shot to the back passed through his left lung, then "ranged upward and to the right, severing Patterson's trachea, glottis, and epiglottis—the organs that made speech possible." A third, nonlethal shot tore through his left arm about an inch above the elbow.

As Patterson staggered out of the alley and collapsed onto the sidewalk, a teenager named Jimmy Sanders, who'd been hanging out with a buddy nearby, ran up to him and cried, "Who shot you, Mr. Patterson, who shot you?" Patterson tried to answer but the only sounds that came from his shattered mouth were ghastly liquid gurgles. He was dead before the hospital's ambulance arrived.

If the men behind Patterson's murder believed that, by eliminating him, they would end the crusade to clean up Phenix City, they had badly miscalculated. Responding to public outrage over the assassination, Governor Gordon Persons sent hundreds of national guardsmen under the command of General Walter J. Hanna (nicknamed "Crack" for his sharpshooting skills). "The show is over in Phenix City," Hanna declared. "My job here is to preserve law and order and we intend to do just that. If it means closing every honky-tonk in Phenix City, we'll do that." Hanna proved as good as his word. Martial law was imposed, and, within months, every gambling den and whorehouse had been raided and shut down, scores of arrests were made, and the political machine was dismantled. Within a year, the reformation of Phenix City would be so complete that it was honored with a coveted All-American City Award by the National Civic League.

Though reluctant to enter politics, Patterson's thirty-three-year-old son, John—a decorated ex-army major who had begun practicing law in Phenix City three years earlier—bowed to the importunities of his father's supporters and entered the race for state attorney general. He had another motivation, too: his hunger for revenge against his father's killers. "I wanted to get those people so bad," he later admitted. "That was the driver, and I never had such a human drive as that in my life . . . Vengeance is a strong thing." The public was powerfully moved by "the symbol of the son picking up the father's fallen standard" (as put by biographer Gene L. Howard) and swept him into office.

On the testimony of various eyewitnesses, three men were indicted for the murder of Albert Patterson: a corrupt deputy sheriff named Albert Fuller, who reportedly "took in as much as six thousand dollars weekly from gambling and prostitution protection," and two bitter political foes of the victim, circuit solicitor

Arch Ferrell and Silas Garrett, attorney general at the time of the assassination. In the end, only Fuller was convicted. Sentenced to life imprisonment, he was paroled after ten years. Ferrell was acquitted, while Garrett was consigned to a Texas mental hospital after suffering a nervous collapse and never brought to trial.

In 1955, as the murder trials of Fuller and Ferrell were in progress, a Hollywood crew descended on Phenix City for the on-location shoot of *The Phenix City Story*, a brutal little exploitation movie now regarded as a minor masterpiece of film noir. No less an eminence than Martin Scorsese has named it as one of his all-time favorites and a major influence on his own work.

Its director, Phil Karlson, a no-nonsense B-movie journeyman devoid of artistic pretension, had been churning out hard-hitting, poverty-row pictures since the mid-1940s. Another two decades would pass before he scored his first big commercial success, the ultraviolent 1973 action film *Walking Tall*, which so closely parallels the subject matter of *The Phenix City Story* (high-minded hero returns to his southern hometown and, finding it overrun with vice and corruption, wages a one-man war against the local crime syndicate, at great personal cost) that many consider it to be virtually a rewrite of the earlier film.

Following a nearly fifteen-minute newsreel-style prologue in which Los Angeles reporter Clete Roberts interviews actual townspeople about the events that catapulted their city into the national headlines (a somewhat plodding introduction often cut from later editions of the film), Karlson's bare-knuckled, highly fictionalized crime drama gets underway. From a voice-over narrator, we learn that Phenix City's "principal industry"—generating $100 million a year— is the peddling of vice. Quasi-documentary footage shows the town's "factory workers" toiling away at their jobs: making loaded dice, marked cards, rigged slot machines, and watered-down whiskey "made to look like the bonded stuff."

The film then cuts to the inside of the Poppy Club, a honky-tonk in the heart of the town's tenderloin district, where, to the accompaniment of a low-rent jazz band, a slinky brunette in a low-cut dress performs a suggestive number to a roomful of leering male patrons, many of them GIs from Fort Benning. When one of the card-playing customers kicks up a fuss because he realizes he's been cheated, he is promptly beaten, stomped, and dragged outside, where one of the town's on-the-take sheriffs hauls him away for disturbing the peace.

Running the joint is crime boss Rhett Tanner (a fictitious character played by the portly, avuncular-looking Edward Andrews, one of those ubiquitous

second-string actors familiar to millions by face, if not by name). When we first meet Tanner, whose genial good-old-boy manner gives no hint of his utterly ruthless nature, he is cheerfully trying to figure out a way to fix a race involving his pet turtles. Shortly afterward, he pays a visit to his old pal, attorney Albert Patterson (John McIntire, best known to boomers as the star of the hit 1960s TV western *Wagon Train*). Phenix City, we learn, is torn between two warring factions, the God-fearing citizens of the RBA and the thuggish members of Tanner's crime syndicate. Both are eager to have the highly respected Patterson on their side.

Patterson, however, wants no part of either group. Having seen all previous efforts to clean up his crime-ridden city come to nothing, he has no interest in joining the reformers. At the same time, though he has done legal work for Tanner in the past, he refuses his old friend's lucrative offer to serve as the syndicate's lawyer. Wearily accepting the status quo, he wants nothing more than to live out his professional life in a state of untroubled neutrality.

All that changes with the arrival of his crusading son, John (Richard Kiley, who achieved a late career triumph as Don Quixote in the original Broadway production of the musical *Man of La Mancha* and—fun fact!—also supplied the voice of the vehicular tour guide in the first *Jurassic Park* movie). On the very night that he and his family return from overseas—where John, an army major, has been prosecuting Nazi war criminals—he witnesses a bunch of Tanner's goons beating up members of the RBA while one of the town's corrupt lawmen stands by, doing nothing. Leaping into the fray, the two-fisted hero breaks up the fight, then pursues the assailants to Tanner's club, where he gets into a slugging match with lead henchman Clem Wilson (played by tough-guy character actor John Larch).

Inflamed with righteous fury, John immediately allies himself with the reformers. The next morning, as a little African American girl is skipping across a bridge, she is snatched by Wilson and his cronies, killed, and dumped from their speeding car onto the lawn of the Patterson family home (a scene made only marginally less shocking by the glaring substitution of a dummy for the child's supposed corpse). Attached to the body is a warning note to John: "This will happen to your kids too."

The little girl's murder is only the first in a string of savage slayings that makes *The Phenix City Story* one of the most uncompromisingly violent

movies of its era (and that undoubtedly accounts for the film's impact on the young Martin Scorsese). Two of John's allies meet brutal ends: Fred Gage (Biff McGuire), an RBA leader's adult son, is bludgeoned to death by Wilson and dumped in a ditch, and a Poppy Club employee named Ellie Rhodes (played by Kathryn Grant, the future Mrs. Bing Crosby) is murdered by Tanner when he discovers that she has been serving as a spy for the RBA. Most graphic of all is the assassination of Albert Patterson, who has gradually come around to his son's point of view and gotten himself elected state attorney general. His father's murder rouses John to new heights of impassioned eloquence as he rallies the decent townsfolk of Phenix City to his crusading cause.

The killing of the elder Patterson was filmed with great historical accuracy at the very spot where the assassination took place (and with the actor, John McIntire, wearing Albert Patterson's actual suit jacket, supplied by the latter's widow). At the same time, the film as a whole offers a wildly exaggerated portrayal of John Patterson, transforming him into the kind of archetypal figure found in countless American action movies: the heroic loner who rides into a town riddled with corruption and, with dauntless courage and at great personal sacrifice, inspires the terrorized citizenry to rise up and vanquish the bad guys who have held their community in thrall.

At the time of the film's release, the real-life John Patterson, who had stepped into his father's shoes as attorney general, was considering a run for governor. Aided in no small measure by the movie's highly glorified portrayal of him, he triumphed at the polls against his main adversary, George Wallace, in 1958. His election revealed another flagrant disparity between Karlson's romanticized movie and reality. In the film, John's enlightened attitude toward African Americans stands in stark contrast to the bad guys' virulent racism. The real John Patterson, however, campaigned for governor as a staunch opponent of desegregation and an ardent foe of the NAACP.

A PLACE IN THE SUN (1951)

DIRECTED BY GEORGE STEVENS. WRITTEN BY MICHAEL WILSON AND HARRY BROWN. WITH MONTGOMERY CLIFT, ELIZABETH TAYLOR, SHELLEY WINTERS, AND RAYMOND BURR.

At the time of its release in 1951, George Stevens's engrossing adaptation of Theodore Dreiser's 1925 literary classic *An American Tragedy* (which had been filmed once before, in 1931) earned widespread critical acclaim, including a Directors Guild of America Award, a Golden Globe for best drama, and six Oscars. Los Angeles film critic Charles Champlin called it unequivocally "the best film ever to come out of Hollywood." Though Champlin's praise seems inflated today (in early editions of the American Film Institute's list of the one hundred best Hollywood films of all time, *A Place in the Sun* ranked number ninety-two), the film still retains its power, thanks in large part to the first-rate performances of its three stars, Montgomery Clift, Elizabeth Taylor, and Shelley Winters.

The story concerns an ambitious, if socially insecure, young man named George Eastman (Montgomery Clift) who has been offered a job by a rich uncle, the owner of a booming bathing-suit company. In the very first scene, we see

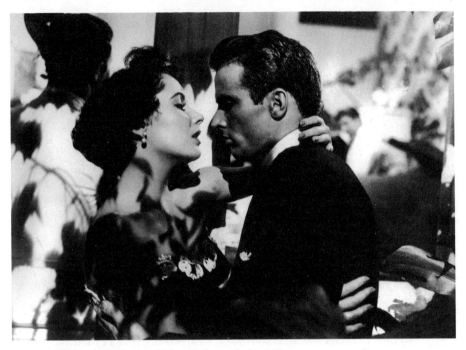

Elizabeth Taylor and Montgomery Clift in *A Place in the Sun*, 1951.

George hitchhiking along the highway on his way to a new life. Suddenly he notices a roadside advertisement for his uncle's swimwear, a billboard of a dark-haired bathing beauty, posing provocatively on the beach. The picture represents everything that George (who comes from a poor, fundamentalist background) most desperately yearns for: all the pleasure and luxury and freedom of the American dream.

He soon meets the living embodiment of that dream in the form of a wealthy young beauty named Angela Vickers (Elizabeth Taylor at her most youthfully radiant). Eventually the handsome young man and the ravishing debutante fall madly in love. Everything that George hungers for seems within his grasp: money, social position, and the love of the world's most beautiful woman.

Unfortunately, there is just one small problem. By this point, George—who has been working his way up from the assembly line—has already impregnated Alice Tripp, a factory girl with whom he got involved when he first came to work. As portrayed to perfection by Shelley Winters, "Al" is the antithesis of Angela. Though endowed with a crude sensuality, she is dumpy, whiny, and even poorer than George. Instead of a life filled with comfort, glamour, and erotic

passion, she offers a future involving a large brood of runny-nosed children, crushing poverty, and the constant complaints of a coarse, nagging wife. When she demands that he marry her, his thoughts turn to murder.

Suggesting an outing to a remote wilderness lake, he takes her for a ride in a rowboat with the intention of killing her. But at the last minute, he changes his mind and decides to do the right thing by Alice. Ironically, when she gets up to embrace him, the boat overturns and Alice, who can't swim, drowns. George makes it to shore and, in a panic, tries to flee. He is arrested and tried for murder by a fanatical prosecutor (played by Raymond Burr, who, switching legal sides, would soon gain fame as ace defense lawyer on the long-running TV drama *Perry Mason*). George is convicted and sentenced to the electric chair but not before a soul-searching scene in which he acknowledges his guilt for not having done more to save the drowning Alice.

Though the movie somewhat oversimplifies the issues in Dreiser's book (essentially reducing George's predicament to a choice between rich, gorgeous, adoring Elizabeth Taylor and penniless, dowdy, annoying Shelley Winters), it does suggest the larger social themes that interested Dreiser when he wrote *An American Tragedy*. In a 1935 magazine article, Dreiser explained that, while working as a reporter in 1892, he "began to observe a certain type of crime in the United States. It seemed to spring from the fact that almost every young person was possessed of an ingrowing ambition to be somebody financially and socially." The kind of crime he was referring to involved the "young ambitious lover of some poorer girl who in the earlier state of affairs had been attractive enough to satisfy him, both in the manner of her love and her social station. But nearly always with the passing of time and the growth of experience on the part of the youth, a more attractive girl with money or social position appeared." In order to get rid of the first girl—who refused to let him go, often because she was pregnant—the young man resorted to murder. To Dreiser, this kind of crime was a distinctly American phenomenon, symptomatic of our country's diseased obsession with "making it" at all costs.

With an eye to treating this topic in fiction, Dreiser began collecting news-paper clippings on cases involving killers motivated by sexual desire and social ambition, including those of Clarence Richeson, a Baptist minister who impreg-nated a young parishioner, then killed her in order to marry a wealthy woman, and Roland Molineux, an amateur chemist who, competing for a lover's hand,

sent a bottle of poisoned Bromo Seltzer to another of her suitors. The crime that became the basis for Dreiser's bestselling book and the subsequent movies was one of the most sensational of its day, the Chester Gillette/Grace Brown murder case of 1906.

Born in 1883, Chester Gillette was the son of a successful Spokane businessman who, following a religious conversion, renounced his worldly pursuits and, along with his wife, became a roving missionary for the Salvation Army. For several years, young Chester assisted his father and mother in their charitable work. Far from endowing him with a sense of higher vocation, however, the experience only left him with a keen distaste for the ascetic existence embraced by his parents and a corresponding belief that the purpose of life was, as he put it, to "have as good a time as you can." After an aborted stint at Oberlin College's preparatory school (financed with a loan from a wealthy relation) and a few knockabout years as a railroad brakeman in the Midwest, he moved to the upstate New York town of Cortland to work at the skirt factory of his uncle, Noah Gillette.

Among the 250 other employees at his uncle's plant was eighteen-year-old Grace Brown, a slender, attractive brunette who had grown up on a farm in the nearby village of South Otselic. Though posthumously portrayed in the sentimentalizing press as a meek and docile maiden, she was in fact a vivacious, fun-loving, and sharp-witted young woman—nicknamed "Billy" after her favorite song, the popular jazz tune "Won't You Come Home, Bill Bailey"—and so fond of dancing that she was banned from membership in the town's Baptist church.

Exactly how she first connected with her employer's handsome nephew is unclear. Legend has it that their relationship began when Grace's opal ring slipped off her finger at work and Chester, who was walking by, chivalrously stooped to retrieve it. In any event, the two quickly became romantically involved, Chester paying nightly visits to Grace at her sister's house, where she boarded and where they spent hours spooning in the parlor. By the summer of 1905, after fending off Chester's increasingly importunate advances for as long as she was able, Grace became his lover.

No sooner had they consummated their relationship than Chester, who had previously professed his undying devotion, began to turn his attentions elsewhere. His charm and polished manners—to say nothing of his status as Noah Gillette's nephew—had won him admission to a glittering circle of young people from the upper stratum of Cortland society. Chester soon began leading a double life. Though he still visited Grace regularly for sex, his leisure hours were increasingly spent with his new friends, bicycling, playing tennis, attending their dances and formal-dress parties. However satisfying this existence was for Chester, it grew intolerable for Grace, particularly when, in the spring of 1906, she discovered that she was pregnant.

In mid-June, Grace moved back to her parents' home in South Otselic, where she spent the next few weeks writing desperate letters to Chester. Terrified that her life would be ruined once her condition became obvious, she begged him to make her his lawful wife. "Oh, Chester," she pleaded, "please come and take me away. I am so frightened, dear."

Despite his declarations of love, however, Chester seemed in no rush to settle down. In Grace's absence, he had happily pursued other women, including a well-to-do beauty named Harriet Benedict, daughter of a prominent Cortland attorney. When Grace got wind of his dalliances, she threatened to expose him as a heartless seducer. If her life was ruined, she wrote, *his* would be too. Her warning seemed to work. In early July, Chester invited her to join him on an Adirondacks vacation—a trip that would culminate in their wedding. Or so Grace assumed.

On the brilliantly sunny morning of July 11, 1906, the couple arrived at the Glenmore Inn, a picturesque hotel on the shore of Big Moose Lake in Herkimer County. After checking in under an assumed name, Chester—carrying his suitcase and tennis racket—escorted Grace down to the water, where they rented a rowboat for the day.

Precisely what happened in the following hours will never be known. At various times during the afternoon, the two were spotted on the lake by other boaters. At one point, they were seen picnicking on shore. When they failed to return at sundown, Robert Morrison, who had rented out the rowboat, was not especially alarmed. Tourists often misjudged the sheer size of the lake and, finding themselves too far away to make it back before nightfall, rowed to the nearest shore to spend the night at another inn.

It was not until the following morning that Morrison, by then seriously concerned, organized a search party. Setting off in a steamer, they scoured the lake and eventually came upon the rowboat, floating upside down on the water. Peering into the depths, one of the searchers spotted a strange object caught in the weeds on the bottom. Hauled up with a long, spiked pole, the object turned out to be the corpse of Grace Brown.

At first, Morrison and the others assumed that she had died in a boating mishap along with her companion, Carl Graham, as he had called himself. A search of the lake and shoreline, however, failed to turn up the body of the young man. When the coroner discovered that Grace was pregnant—and found suspicious wounds on her face and head—he became convinced that she was the victim of foul play. By then, investigators, looking into Grace's background, had learned of her romantic relationship with her coworker, Chester Gillette.

Three days would pass before Chester—still using his alias—was arrested. At first, he insisted that Grace had, in fact, drowned accidentally when the boat overturned. Later, he changed his story, claiming that, in her despair, she had deliberately thrown herself overboard. Neither explanation, however, accounted for her ugly head wounds; according to the autopsy report, these were caused by a bludgeoning implement, very possibly a tennis racket.

Chester's three-week trial, which commenced on November 12, 1906, was a media sensation, covered by so many reporters that (as one historian notes) "a special telegraph station had to be set up in the courthouse basement to handle the thousands of words sent out each day" by the press. In his impassioned opening statement, prosecuting attorney George Ward depicted Chester as a heartless brute who, after taking the virginity of an innocent maid and getting her with child, had coldly planned and carried out her murder, so that he could be free to pursue his affairs with "girls from a better class of society."

The dramatic highpoint of the proceedings—and the moment that, more than any other, aroused a general "revulsion of feeling against the prisoner"— occurred when Ward read aloud some of the most heartrending passages from Grace's letters to Chester. "O dear, if you were only here and would kiss me and tell me not to worry any more I would not mind this," Ward read in a quavering voice, "but with no one to talk to, and ill all the time, I really believe I will be crazy. Darling, if you will only write and tell me that you will surely come Saturday and not to worry. I am crying so, I can't see the lines and will stop.

You will never know, dear, how badly I feel or how much I want you this very minute." By the time Ward finished his recitation, there was not a dry eye in the house.

Though Chester's attorney mounted a vigorous defense, arguing that Chester's actions were not those of a calculating killer but of a scared boy who had panicked when Grace accidentally tipped over the boat, the jury took only a few hours to find him guilty of murder.

Following a failed appeal, he was executed in the electric chair on the morning of March 30, 1908. According to both his mother and his spiritual advisor, the Reverend Henry MacIlravy, Chester, who had consistently protested his innocence, made statements to them just prior to his execution that convinced them of his guilt. No written confession exists, however, and the matter remains unresolved among students of the case.

AN AMERICAN TRAGEDY

Directed by Josef von Sternberg (who, the previous year, had turned Marlene Dietrich into an international superstar with his masterpiece *The Blue Angel*), this 1931 version of Theodore Dreiser's bestseller lacks the sheer Hollywood glamour of *A Place in the Sun*. But in many ways (though Dreiser himself was not a fan), it is truer to its literary source than is George Stevens's retitled 1951 remake.

Matinee idol Phillips Holmes stars as Clyde Griffiths (the original name of the character George Eastman in the later film). In place of Montgomery Clift's quivering sensitivity, Holmes projects an emotional blankness suggestive of the character's shallow, morally stunted nature. Clyde's relationship with the spoiled socialite Sondra Finchley (Frances Dee) has none of the passion that characterizes the affair between the gorgeous leads of *A Place in the Sun*. What motivates the lower-class Clyde in von Sternberg's film, as in Dreiser's novel, is not romantic love but lust for social status and all the luxuries that money can buy.

Perhaps the most striking difference between the two films, at least in terms of characterization, involves the doomed factory girl (named Alice

Tripp in Stevens's movie and Roberta Alden in von Sternberg's). As played by Shelley Winters, Alice is so insufferably blubbery and annoying that, as a viewer, you feel like strangling her yourself. By contrast, Sylvia Sidney's Roberta is utterly lovable—sweet, adoring, and radiantly pretty. In Stevens's movie, we see Alice's death only from a distance, whereas von Sternberg shows Roberta's death in unblinking close-up. In Clyde's abandonment of his drowning, pregnant girlfriend, we clearly see the character as Dreiser conceived him: an infantile, pathological product of a society obsessed with self-gratification.

PSYCHO (1960)

DIRECTED BY ALFRED HITCHCOCK. WRITTEN
BY JOSEPH STEFANO. WITH ANTHONY PERKINS,
VERA MILES, JOHN GAVIN, JANET LEIGH,
MARTIN BALSAM, JOHN MCINTIRE,
AND SIMON OAKLAND.

A beautiful blonde slides out of her bathrobe, steps into the shower, and turns on the water. She pulls the plastic curtain closed. The water gushes down. She soaps herself, smiling. Suddenly, over her shoulder, a shadow appears on the other side of the curtain. It draws nearer. The curtain rips back. The shadow, shaped like an old woman, clutches a butcher knife. The big blade slashes downward, then slashes again. And again. The screeching chords on the soundtrack match the dying shrieks of the victim as her streaming blood whirlpools into the drain.

The sequence, of course, is the famous shower scene from Alfred Hitchcock's *Psycho*, the most frightening moment from the most influential horror movie of modern times. After *Psycho*, a new kind of monster began stalking the movie screens of America—the psychotic "slasher." And showering was never the same again.

The brilliance of Hitchcock's film derives from his genius for drawing us into a world of total insanity—a nightmare realm where a bathroom becomes a chamber of horrors, a shy young man changes into a crazed transvestite, and a

Janet Leigh in the iconic shower scene from Hitchcock's *Psycho*, 1960.

sweet little old lady turns out to be a mummified corpse. By the time the film is over, the shaken audience steps away from the screen saying, "Thank God it was only a movie."

Perhaps the scariest thing about *Psycho*, then, is this:

It was based on the truth. There really was a maniac whose unspeakable deeds served as the inspiration for *Psycho*. His name wasn't Norman Bates, however. It was Ed Gein.

Edward Theodore Gein was born in La Crosse, Wisconsin, on August 27, 1906, the son of George Gein and the former Augusta Willamina Lehrke. In

1913, the family (which included Ed's older brother, Henry) moved to a small dairy farm in Juneau County, forty miles east of La Crosse. Less than one year later, they relocated again—this time permanently—to a 195-acre farm six miles west of Plainfield, a remote, tiny town in the south-central part of the state.

All available evidence indicates that Gein was subjected to a deeply pathological upbringing. His mother was a hostile, domineering, fanatically religious woman (the family was Lutheran) who railed incessantly against the sinfulness of her own sex. Keeping her two boys tightly bound to her apron strings, she imbued them with her twisted sense of universal wickedness, the whorish ways of women, and the vileness of carnal love. Her ineffectual husband alternated between periods of sullen passivity and alcoholic rage.

Gein's emotional suffering was undoubtedly exacerbated by the extreme harshness of the environment and the bitter isolation of his life. In Augusta's profoundly warped view, the God-fearing town of Plainfield was a hellhole of depravity, and she made sure that her boys, particularly Eddie, had as little as possible to do with its inhabitants. A pariah even in childhood, he was generally treated as a laughingstock during his school years (which ended with his graduation from eighth grade). He grew up in total thrall to his ferociously strong-willed mother, utterly incapable of forming normal human relationships.

When George Gein died after a lingering illness in 1940, no one—not even his family—was sorry to see him go. Left alone with their mother, the two brothers fell even more deeply under her poisonous spell. Henry, at least, seems to have had some sense of Augusta's destructive influence and tried to help his brother break away. But Eddie wouldn't listen. He worshipped Augusta and didn't take kindly to his brother's criticisms.

In 1944, Henry perished under ambiguous circumstances while fighting a marsh fire on the family property. At the time, his death was attributed to a heart attack, though in later years, many townspeople came to believe that, in addition to his other outrages, Eddie was guilty of fratricide.

Now Eddie had his mother all to himself. But not for very long. Three days before Christmas 1945, the sixty-seven-year-old Augusta suffered a minor stroke. Eddie tended to her night and day at home, praying to God to spare his mother's life. His prayers went unheeded. One week later, Augusta was stricken with another, far more devastating stroke and was rushed to Wild Rose Hospital, where she died on December 29. Overcome with grief, Eddie composed a

heartfelt poem, "In Loving Memory of My Mother, Augusta," that appeared along with her obituary in the local newspaper:

I WILL MISS HER ALWAYS,

HER LOVING SON EDWARD.

> Gone, from sorrow, grief, and anguish,
> Gone, no more with pain to languish,
> Gone, thy longing soul set free,
> But, oh, how hard to part with thee,
> My mother!

Living alone in the grim, ramshackle farmhouse, Gein began to retreat into a world of violent fantasy and bizarre ritual. Though he remained tenuously connected to the community—doing odd jobs for neighbors, plowing snow for the county, making occasional trips into town—he was in the grip of a deepening psychosis.

Two years after his mother's death, he began making nocturnal raids on local cemeteries, digging up the graves of recently deceased middle-aged or elderly women whose obituaries he had read in the newspapers. His necrophiliac activities continued for at least five years. In 1954, he murdered a middle-aged tavern keeper named Mary Hogan and brought her two-hundred-pound corpse back to his farmhouse.

During this period, rumors started circulating that Gein kept a shrunken-head collection in his bedroom—supposedly war souvenirs sent to him by a relative who had fought in the South Pacific. These stories, however, were dismissed as the colorful imaginings of the village children, who had begun to regard Gein's place as a haunted house. The truth, which would prove infinitely more appalling than the hearsay, finally came to light in the fall of 1957.

On Saturday afternoon, November 16—the first day of deer-hunting season—Frank Worden returned from a fruitless day in the woods and proceeded directly to the corner hardware store owned and managed by his mother, Bernice, a fifty-eight-year-old widow. To his surprise, his mother wasn't there. Searching the premises, Worden discovered a trail of blood leading from the storefront out

the back door. He also discovered a sales receipt for a half gallon of antifreeze made out to Mrs. Worden's last customer, Eddie Gein.

When the police arrived at Eddie's farmhouse to question him about Mrs. Worden's whereabouts, they came upon the body of the fifty-eight-year-old grandmother in the summer kitchen behind the house. Hanging by her heels from a pulley, she had been beheaded, disemboweled, and strung up and dressed like a butchered deer.

The stunned and sickened officers called for reinforcements. Before long, a dozen or more lawmen showed up at the farm and began exploring the contents of Gein's house of horrors. What they found in the course of that long, hellish night was appalling beyond belief. Soup bowls made from skulls. Chairs upholstered in human flesh. Lampshades fashioned from skin. A boxful of noses. A shade pull made from a woman's lips. A shoebox containing a collection of preserved female genitalia. A nipple belt. The faces of nine women, carefully dried, stuffed with newspaper, and mounted on a wall like hunting trophies. A skin vest, complete with breasts, flayed from the upper torso of a middle-aged woman. Later, Eddie confessed that, at night, he would lace the vest around himself and mince around the farmhouse, pretending he was his mother.

At around 4:30 a.m., after searching through the ghastly clutter of Gein's home, an investigator discovered a bloody burlap sack shoved under a fetid mattress. Inside was a freshly severed head. Two ten-penny nails, each with a loop of twine tied to the end of it, had been inserted into the ears. The head was Bernice Worden's. Eddie Gein was going to hang it on the wall as a decoration.

The discovery of these Gothic horrors in the home of a quiet, midwestern farmer during the proverbially bland Eisenhower era jolted—and transfixed—the country. In Wisconsin, Gein quickly entered regional folklore. Within weeks of his arrest, macabre jokes, called Geiners, became a statewide craze (e.g., What did Ed Gein say to the sheriff who arrested him? Have a heart!). The media descended in droves on Gein's hard-pressed hometown and turned him into an instant celebrity. During the first week of December 1957, both *Life* and *Time* magazines ran features on Gein, the former devoting nine pages to his "house of horrors." For a while, Gein's farmhouse became a popular tourist attraction, an intolerable development as far as the outraged community was concerned. On the night of March 20, 1958, a mysterious fire broke out in Gein's house. It was not extinguished until the hated place was reduced to ashes.

At first, everyone assumed that Gein had been running a murder factory. But during his confessions, he made a claim that, at first, seemed too incredible to accept. He wasn't a homicidal maniac, he insisted. True, he had killed two women—Bernice Worden and the tavern keeper, Mary Hogan, whose preserved, peeled-off face had been found among Gein's gruesome collection. But as for the rest of the body parts, Eddie revealed that he had gotten them from local cemeteries. For years following his mother's death, he had been a grave robber, turning to the dead for the companionship he could not find among the living. Eddie Gein, in short, wasn't a serial killer. In the strict definition of the term, he was a ghoul.

Diagnosed as a schizophrenic, Gein was committed to Central State Hospital for the Criminally Insane in Waupun, Wisconsin. After a pro forma trial in 1968, he was returned to the mental hospital and, despite an effort to win release in 1974, remained institutionalized for the rest of his life. A model inmate, he died of cancer at Mendota Mental Health Institute in Madison on July 26, 1984, and was buried beside his mother in Plainfield.

Residing in Wisconsin when the Gein story first broke was Robert Bloch. A longtime resident of Milwaukee, Bloch had been publishing mystery and horror fiction since adolescence, having received his earliest encouragement from the celebrated fantasist H. P. Lovecraft. After a successful career as an advertising copywriter, Bloch had decided in 1953 to devote himself to full-time freelance writing; his stories—many of them published in pulp magazines—were known for their gruesomely clever twist endings, which often made them read like extended sick jokes. Psychopathic killers featured prominently in his fiction. One of his best-known works was a tale titled "Yours Truly, Jack the Ripper."

In the fall of 1957, Bloch was living in Weyauwega, Wisconsin, his wife's hometown, 120 miles north of Milwaukee and less than 30 miles east of Plainfield. Reading the newspaper accounts of the nightmarish discoveries in the nearby town, Bloch immediately saw in the Gein case the raw materials for a first-rate tale of terror. Here was a real-life horror story far grislier than anything ever dreamed up by Lovecraft. The story featured the darkest acts of depravity,

all performed by a bland, completely harmless-looking bachelor driven to his abominations by his pathological attachment to a tyrannizing mother, who continued to dominate his existence even after her death.

The result was his novel *Psycho*. Published in the summer of 1959, the book received a positive review in the *New York Times*, which praised it as "chillingly effective." The review caught the eye of Alfred Hitchcock's production assistant, who passed the novel on to her boss. Acquiring the film rights—and the services of screenwriter Joseph Stefano—Hitchcock transformed Bloch's relatively minor pulp chiller into a cinematic masterpiece.

The difference between the two versions can be clearly seen by contrasting the movie's legendary shower sequence—a forty-five-second tour de force that required seventy-eight camera setups and consists of fifty-two cuts—with the perfunctory scene in Bloch's novel (in which the Marion Crane character is named Mary):

> Mary started to scream, and then the curtains parted further and a hand appeared holding a butcher's knife. It was the knife that, a moment later, cut off her scream.
> And her head.

Insofar as *Psycho* initiated the modern cycle of "slasher" movies, the madman who inspired it, Ed Gein, has come to be regarded as a culturally seminal figure: the prototype of every knife-, axe-, and cleaver-wielding maniac who has stalked America's movie screens for the past half century. As aficionados of horror put it, he is the "Grandfather of Gore."

ED GEIN, SUPERSTAR

Among film buffs, Ed Gein is legendary not only as the "real Norman Bates" but as the direct inspiration for several other celebrated horror films, primarily *The Texas Chain Saw Massacre* and *The Silence of the Lambs*.

Tobe Hooper, the director of *The Texas Chain Saw Massacre*, reportedly heard stories about Gein from midwestern relatives and grew up haunted

by these tales. In his splatter-movie classic, the Gein-inspired character is not a mild-mannered motel keeper with a split personality but a bestial hulk named Leatherface who sports a mask made of dried human flesh.

Thomas Harris, author of *The Silence of the Lambs*, researched the FBI's file on Gein before creating his fictional character Jame Gumb (a.k.a. "Buffalo Bill"), a transsexual wannabe who attempts to fashion a suit from the flayed torsos of his victims.

Psycho, *Chain Saw*, and *Silence of the Lambs* all take considerable liberties with the Gein story. Sticking closer to the facts is a 1974 low-budget shocker, *Deranged*, which has developed a cult following among horror buffs.

Besides these movies, there are any number of grade-Z gore films about mild-mannered hicks who turn out to be cannibalistic butchers— films with titles like *Invasion of the Blood Farmers* and *I Dismember Mama*. All spring from the real-life horrors perpetrated by America's "seminal psycho," Ed Gein.

ROPE (1948)

DIRECTED BY ALFRED HITCHCOCK.
WRITTEN BY ARTHUR LAURENTS AND HUME
CRONYN. WITH JAMES STEWART, JOHN DALL,
FARLEY GRANGER, JOAN CHANDLER, AND
CEDRIC HARDWICKE.

*R*ope was Alfred Hitchcock's first color film, as well as his first with Jimmy Stewart, who would later star in such 1950s Hitchcock classics as *The Man Who Knew Too Much*, *Rear Window*, and *Vertigo*. What really makes *Rope* distinctive, however, is the *way* it was filmed. The whole movie was shot in continuous, ten-minute takes that were then stitched together to create the illusion of unbroken camera movement.

As a filmmaking experiment, *Rope* is still intriguing to watch. (It's especially fun to see the ingenious tricks Hitchcock devised to conceal the cuts between segments.) But even Hitchcock's virtuoso technique can't resolve the basic problem with the movie—namely, its flagrant staginess. Based on a play by Patrick Hamilton, the movie—confined to a single, penthouse set and taking place in "real time"—is an undeniably clever but overly theatrical piece that, despite the fluid camera work, has the static quality of a talky Broadway parlor mystery.

Even so, the film is energized by intense, compelling performances and moments of high suspense that are pure vintage Hitchcock. The first few minutes

deliver a powerful jolt. After focusing on a New York City street during the opening credits, the camera moves in through a curtained penthouse window, where a shocking murder is reaching its climax. A young man in dinner clothes is being brutally strangled by a pair of his pals, who proceed to stash his body in an antique living room chest.

We are quickly introduced to the killers: Brandon (John Dall), a haughty, brittle psychopath who fancies himself a Nietzschean superman, and his pretty-boy companion, Phillip (Farley Granger), a quivering bundle of nerves who spends the whole movie teetering on the brink of hysteria. As the homicidal chums (and, by implication, gay lovers) discuss their crime, we learn that they have strangled the victim, their friend David Kentley, simply for the thrill of it—to prove that they are superior beings who can commit the perfect crime.

To add an extra dash of excitement to the proceedings, Brandon has invited David's parents, fiancée, and a few mutual friends for a dinner party that very night. Indeed, throughout the movie, Brandon (who is far and away the more perverse of the two thrill killers) is constantly dreaming up ways to make the experience as titillating as possible—even going so far as to serve the meal, buffet-style, atop the very chest in which David's corpse is stashed.

Tension builds as the evening proceeds. While David's family and friends grow increasingly concerned about his inexplicable absence, one of the guests, Rupert Kadell (Jimmy Stewart), Brandon and Phillip's former prep-school mentor, becomes more and more suspicious. In the end, Rupert—who has passed many late-night hours at prep school discussing Nietzschean concepts with the two younger men—realizes that, to his horror, the twisted pair has turned these philosophical musings into a justification for murder. After wrestling a revolver away from Brandon, he fires it through the apartment window. As sirens approach in the background, the three men sit down to await the arrival of the police.

The opening credits of the film are followed by the standard disclaimer: "The story, all names, characters and incidents portrayed in this production are fictitious. No identification with actual persons, living or dead, is intended or should be inferred." While it is true that the action of *Rope*—the macabre dinner party with the makeshift bier serving as a buffet table—is strictly make-believe, it is disingenuous to pretend that the main characters are equally ficti-tious. There is nothing at all coincidental about the striking similarity between

Brandon and Phillip and the real-life 1920s thrill killers, Nathan Leopold and Richard Loeb.

Their case is a perfect example of the phenomenon the French call a *folie à deux*, literally translated as "double insanity" or "insanity in pairs." Originally coined to describe a rare psychological disorder in which a closely related couple falls victim to a shared paranoid delusion, it is nowadays used to describe a pernicious bond between two people who bring out the worst in each other, egging each other on to engage in criminal acts that neither person, individually, would commit on their own. In most cases of *folie à deux*, there is one dominant personality who instigates the crime and one subordinate member who serves as an eager, even slavish, accomplice to the more sociopathic leader. Two of the most notorious mass murders at the turn of the millennium were the work of such toxic twosomes: the Columbine massacre of 1999 and the Beltway Sniper shootings of 2002.

Seven decades before these horrors, the American public was riveted by one of the most sensational instances of *folie à deux* in the nation's history. In contrast to the Columbine and Beltway murders, which claimed a combined total of twenty-three lives, the earlier case involved only a single victim. What made it so shocking was not the scope of the crime but the character of its perpetrators: a pair of pampered rich kids who, in their utter amorality, seemed to embody the darkest impulses of the Jazz Age generation, the so-called flaming youth of the 1920s who (in the view of their outraged elders) cared for nothing but the quest for cheap thrills.

On the afternoon of Wednesday, May 21, 1924, fourteen-year-old Bobby Franks left the Harvard School for Boys in the Kenwood neighborhood on Chicago's South Side and headed for home a few blocks away. He never made it. That evening, his frantic parents, Jacob and Flora, received a phone call that confirmed their worst fears. The caller, identifying himself as "Mr. Johnson," informed them that their son had been kidnapped. Further instruction would follow.

At 8:00 a.m. the next morning, a special delivery letter arrived at the Franks' home, demanding $10,000. "Mr. Johnson" assured Bobby's parents that their

son would be returned unharmed once the ransom was paid. Jacob—a one-time pawnbroker who had parlayed investments into a multimillion-dollar fortune— immediately set out for his bank to withdraw the cash: $8,000 in well-worn fifty-dollar bills and the balance in twenties, as specified in the letter.

At roughly the same time that morning, a Polish factory worker named Tony Manke (née Mankowski), just off from his night shift, was walking near Wolf Lake, a remote marshy area twenty miles south of Chicago. As he approached a railroad track that ran through the wetlands, he glanced down at a ditch and was brought up short by a startling sight, a pair of bare feet sticking out of a drainage pipe.

At that moment, he spotted an approaching handcar with four men on board. Flagging it down, he cried out in broken English while gesturing wildly toward the pipe. The four signalmen jumped from their car and hurried down the embankment. Inside the pipe was a child's naked body, lying belly down in a foot of muddy water. At first, they thought he had drowned. When they pulled him out and turned him over, however, they found several ugly wounds on his forehead, along with copper-brown discolorations around his mouth, chin, and exposed genitals.

Wrapping the body in a tarp, they carried it to the handcar. As they did, one of the men noticed a pair of horn-rimmed eyeglasses lying in the grass nearby. He stooped and slipped them into his pocket. Within the hour, the body had been turned over to the on-duty sergeant at the nearest police station, who assumed the glasses belonged to the boy and placed them on his badly cut forehead.

When news of Manke's grim discovery reached the Franks household, Jacob felt certain that the child found in the drainpipe could not possibly be his son. After all, the kidnapper had assured him that Bobby was safe. Besides, Bobby didn't wear glasses. Other family members weren't so sure. One of them, Bobby's uncle, Edwin Gresham, drove to the morgue, where the child's corpse had been taken. At his first glimpse of the body, he let out a groan. Despite the damage to the boy's face, Gresham had no trouble recognizing his nephew. When the telephone rang at the Franks' home a few minutes later, it was Gresham with the shattering news.

With the press trumpeting the crime as "the strangest and most baffling homicide in Chicago's history," the police launched a massive investigation. Everyone—from Bobby Franks's English teacher, "an effeminate man, suspected of being a homosexual," to dozens of known sex offenders and drug addicts—was hauled in for questioning. Typewriter experts analyzed the ransom note and determined that it been written on a portable Underwood. Eyewitnesses to the snatching, including a schoolmate of Bobby's who had seen him climb into the kidnapper's car, were able to identify the make of the automobile. Thousands of tips poured in from people hoping to collect the $5,000 reward offered by a grieving Jacob Franks.

Despite their efforts, the police made little progress for a week. Then came the lead that broke the case open. Since the start of the investigation, detectives had been trying to trace the eyeglasses found at the crime scene. It didn't

Nathan F. Leopold Jr. and Richard Loeb are seated on either side of their defense attorney, Clarence Darrow, in 1924.

take them long to discover that they had been sold by a Chicago firm called Almer Coe. There was nothing special about the lenses: the prescription was so common that several were filled every week. The frames, however, were unusual. Composed of a material called zylonite and featuring distinctive rivet hinges, they were made by a company in Brooklyn and distributed exclusively in Chicago by Almer Coe. After checking its voluminous records, the company discovered that it had sold only three pairs of the zylonite frames: one to a well-known attorney, one to a woman, and one to a young man named Nathan F. Leopold Jr.

The youngest of four sons of one of Chicago's wealthiest businessmen, Nathan Leopold was a quintessential example of what adolescents of a later age would deride as a nerd. A sickly child who developed into an undersized teenager with odd bulging eyes and an asymmetrical face, he was a classic social misfit, "one of those unfortunate children who attract the relentless, unforgiving attention of schoolboy bullies," as one chronicler describes. Shy, awkward, and physically uncoordinated, he abjured sports in favor of bird watching, eventually amassing a collection of more than two thousand stuffed specimens. With his off-the-charts IQ—estimated at higher than 200—he was an intellectual prodigy who entered the University of Chicago at the age of fifteen, spoke five languages fluently, contributed articles to prestigious ornithology journals, and embraced the philosophy of Friedrich Nietzsche, who argued that, for a certain type of superior individual—the *Übermensch*, or superman—the rules of conventional morality did not apply. He was also in love with Richard Loeb.

If Leopold was an almost stereotypical nerd, Loeb was a textbook psychopath. Another child of wealth—his father was vice president of Sears, Roebuck—"Dickie," like Nathan, possessed an extraordinary intelligence, becoming, at the age of fourteen, the youngest student ever to matriculate into the University of Chicago. In other ways, however, he was the polar opposite of the socially inept Leopold. Handsome, charming, and popular, he possessed, as one acquaintance put it, "an inborn knack of making friends." The charismatic surface, however, concealed a frighteningly pathological personality. An inveterate risk taker with a long history of increasingly serious crimes that ranged from shoplifting to arson, he was—like others of his breed—an effortless liar, utterly devoid of conscience and addicted to dangerous, antisocial thrills.

His relationship with Leopold, which began when the two met in college in 1920, quickly developed into a sociopathic symbiosis, in which Loeb masterminded criminal capers that Leopold eagerly threw himself into, partly in exchange for the sexual favors that Loeb agreed to dole out to him. Among their escapades was a break-in at a fraternity house, where they made off with the portable typewriter later used to write the ransom note to Jacob Franks. Loeb conceived of the plot to kidnap and murder an innocent victim. Pulling off such a supposedly "perfect crime" would not only provide them with the ultimate thrill but also confirm their status as Nietzschean supermen.

After several months of planning, they put their scheme into action on May 21. Cruising the neighborhood in a rented car, they spotted a likely victim—Bobby Franks, a distant cousin of Loeb's who had occasionally played tennis at the Loebs' private court. Easily lured into the car, the unsuspecting boy, who was chosen purely at random, was savagely bludgeoned with a chisel, then suffocated to death with a gag shoved down his throat. The murderers headed out of the city to kill time until nightfall, when they could safely dispose of the body. After refreshing themselves with hot dogs and root beer, they proceeded to Wolf Lake, where they stripped the corpse naked and doused the face with hydrochloric acid to prevent identification, splashing some on the genitals for good measure.

Stripping off his jacket and tossing it onto the ground, Leopold then helped Loeb carry the body down to the culvert, where they shoved it into the drainpipe. Before hurrying from the crime scene, they gathered up Bobby's discarded clothing, along with Leopold's jacket. Neither noticed the eyeglasses slip from the breast pocket of the jacket and fall to the grass. Leopold would later claim that Loeb had picked up the jacket and handed it to him upside down. Their "perfect crime" had been thwarted by sheer accident. Others would believe that accident had nothing to do with it: God's hand had plucked the glasses from the pocket and left the telltale clue behind.

Brought in for questioning and asked about the eyeglasses, Leopold had a ready explanation: he had been bird watching near Wolf Lake several days before the murder and must have lost the glasses then. As for his whereabouts at the time of the kidnapping, he and his pal Dickie Loeb had been cruising in Loeb's car all afternoon and into the evening. They had picked up a couple of girls and, after doing some drinking, made unsuccessful sexual passes at them

before heading home. Loeb, likewise taken into custody, confirmed the story. After hours of relentless interrogation, however, their alibis began to unravel. In the early morning hours of May 31, ten days after the murder of Bobby Franks, the two would-be supermen broke down and confessed.

The sheer senselessness of the murder, the random choice of the victim, the youth and social prominence of the perpetrators, as well as rumors of their "perverted" sexual relationship—all these factors combined to make the Leopold and Loeb case a tabloid sensation. When legendary attorney Clarence Darrow agreed to take on the defense, the public got ready to enjoy what was immediately advertised as "the Trial of the Century."

As a piece of courtroom drama, the proceedings lived up to the billing, though in one sense the label was a misnomer. Knowing that any jury would surely convict the young thrill killers and sentence them to hang, Darrow surprised everyone involved by having them enter a plea of guilty. As a result, "the Trial of the Century," which kept the nation transfixed for an entire month, was not, technically speaking, a trial at all but a sentencing hearing, in which Darrow sought to convince the judge that, owing to mitigating psychological factors, his clients should be spared the death penalty. A parade of defense experts testified to the psychopathology of the two teenagers. (Sigmund Freud himself was promised a small fortune to come to Chicago and psychoanalyze the pair but declined the offer.) Darrow's closing plea, which lasted twelve hours, reduced even hardened reporters to tears and is still regarded as one of the greatest pieces of oratory in American legal history. In the end, the judge could not bring himself to condemn two minors to death. Each was sentenced to life, plus ninety-nine years.

In 1936, Richard Loeb was slashed to death in a shower by a former cellmate. After more than thirty years in prison, Nathan Leopold was paroled in 1958. Hounded by the press, he moved to Puerto Rico, where he married, worked as an X-ray technician, taught mathematics, and wrote a book on ornithology before dying of a heart condition in 1971 at age sixty-six. He donated his body to the University of Puerto Rico for research. His eyes were removed and the corneas given for transplant.

COMPULSION

Besides *Rope*, another standout movie based on the Leopold and Loeb case is *Compulsion*. Based on a bestselling novel by Meyer Levin (a classmate of the killers at the University of Chicago, who covered the case for the student newspaper), this 1959 film was directed by Richard Fleischer, a prolific, perennially underrated craftsman of unpretentious entertainments in virtually every Hollywood genre, from B-movie thrillers (*The Narrow Margin*) to musical extravaganzas (*Dr. Doolittle*), science fiction adventures (*Fantastic Voyage*) to sword-and-sorcery fantasies (*Conan the Destroyer*), costumed epics (*The Vikings*) to war dramas (*Tora! Tora! Tora!*), and dozens more. Like his other true-crime movies, *Compulsion* is a tense, efficiently executed, black-and-white thriller that studiously avoids sensationalism. The ghastly murder at its core is never shown. Bradford Dillman and Dean Stockwell star as Artie Straus and Judd Steiner, such barely disguised versions of their real-life counterparts that both Levin and producer Richard D. Zanuck were sued by Nathan Leopold for violation of privacy when the movie was released. A product of its repressive age, the film doesn't explore its protagonists' homosexual bond. Even so, it manages to convey the erotic hold that the swaggering sociopath Artie exerts over his slavish confederate. As the rumpled Clarence Darrow surrogate, Jonathan Wilk, Orson Welles delivers a moving rendition of the epic closing speech that saved the young defendants' lives, while E. G. Marshall is suitably sharkish as the state's attorney out for their blood.

SCREAM (1996)

—

DIRECTED BY WES CRAVEN. WRITTEN BY KEVIN WILLIAMSON. WITH NEVE CAMPBELL, DAVID ARQUETTE, COURTENEY COX, JAMIE KENNEDY, MATTHEW LILLARD, SKEET ULRICH, ROSE MCGOWAN, DREW BARRYMORE, AND HENRY WINKLER.

Scream is widely credited with revitalizing a genre that, by 1996, had descended into tired clichés. Often described as a postmodern horror movie, it pulls off the ingenious stunt of admitting it is a work of artifice—a Hollywood slasher film that operates by certain formulas—while delivering genuine shocks, in effect terrifying viewers who have just been told exactly how the filmmakers plan to scare them.

The movie begins with a prologue that epitomizes its winking, self-referential approach. Alone at night in her isolated suburban home, a high school girl named Casey (Drew Barrymore) is heating up some Jiffy Pop in preparation for watching a teen horror movie on video, when she receives a series of telephone calls from a raspy-voiced stranger whose flirtatious banter turns increasingly menacing. After ascertaining that her favorite scary movie is *Halloween*, the anonymous caller, who has waylaid her boyfriend and bound him to a poolside deck chair, challenges her to a game of horror movie trivia.

Drew Barrymore in *Scream*, 1996.

When she incorrectly identifies the killer in the original *Friday the 13th* as Jason (it was actually his mother, Mrs. Voorhees), the caller—a costumed psycho killer, dubbed "Ghostface," with a creepy white mask inspired by Edvard Munch's famous painting *The Scream*—murders the boyfriend and comes after her. Thanks to the virtuosic direction of horror maestro Wes Craven, the ensuing chase sequence, which climaxes with Casey's gruesome murder, works as both a wild parody of teen slasher movies and a completely blood-chilling example of the genre.

That same improbable combination holds true for the rest of the film, in which Ghostface stalks and dispatches a string of Casey's classmates (along with their principal, played by the former Fonz, Henry Winkler). At one point, a horror geek named Randy (Jamie Kennedy) goes so far as to deliver an extended lecture to his buddies on the immutable laws governing slasher movies. If you're going to survive, he tells them, you can never have sex, do drugs, or drink alcohol, or, under any circumstances, say "I'll be right back." True to the rules the movie both honors and pokes fun at, Randy is one of the few survivors ("I never thought I'd be so happy to be a virgin," he says). When the film's female hero, Sidney (Neve Campbell), shoots the now-unmasked psycho at the movie's end,

Randy, with his encyclopedic knowledge of such matters, warns: "Careful, this is the moment when the supposedly dead killer comes back to life for one last scare." Sure enough, the killer suddenly springs up, only to receive a coup de grâce between the eyes from Sidney, who declares, "Not in my movie."

Though *Scream* provokes chuckles along with chills, its true-life inspiration was no laughing matter. The idea for the movie came to its screenwriter, Kevin Williamson—then an aspiring filmmaker taking classes at UCLA—while watching a TV show about a serial murderer terrorizing the college town of Gainesville, Florida. Williamson, who was housesitting at the time, "was being scared out of my mind" by the program, as he later told an interviewer. "During the commercial break, I heard a noise. And I had to go search the house. I went into the living room and a window was open. I'd been in the house for two days. I'd never noticed the window open. I got really scared. So I went to the kitchen, got a butcher knife, and got the mobile."

Seeking to calm his nerves, Williamson called a friend, who only made matters worse by reminding him of particularly scary scenes from *Halloween*. "One thing led to another," Williamson recalled. "I went to bed that night so spooked I was having nightmares, so I woke up at like three or four in the morning and I started writing the opening scene to *Scream*."

The program that freaked Williamson out so badly was an episode of *Turning Point*, an hour-long "news magazine" show that aired on ABC. Its subject was the notorious psycho killer Danny Harold Rolling, whose crimes, committed over a single weekend of terror in the summer of 1990, seemed like the stuff of a low-budget slasher movie: five college students were savagely murdered in their sleep by an unknown madman. Virtually overnight, the idyllic town of Gainesville, which had just been ranked by a national magazine as the "thirteenth best place to live in the United States," became infamous as one of the country's scariest communities—"Grisly Gainesville," as the media dubbed it.

The first victims died on August 24. Christina Powell and Sonja Larson, seventeen-year-old roommates at the University of Florida, were found butchered in their student apartment. The killer had broken in while they slept, bound and gagged them with duct tape, then raped and savaged them with a foot-long military KA-BAR knife. Afterward, he mutilated the corpses and arranged them in obscene poses as a final insult to the victims and an affront to the people who would discover them.

The next night, he struck again. This time, the victim was eighteen-year-old Christa Hoyt, a sophomore at Santa Fe Community College. The killer broke into her home, then waited for her to return. When she did, he duct taped her mouth and raped her. In a frenzy of violence reminiscent of the atrocities of Jack the Ripper, he stabbed her to death, sliced off her nipples, cut her open from breastbone to groin, and decapitated the corpse, placing the head on a shelf before fleeing the scene. The savagery of the crime would earn him the tabloid nickname "the Gainesville Ripper."

Hysteria gripped the community. Hundreds of students fled the state. Many who remained traveled in groups and avoided being alone.

Though twenty-three-year-old Tracey Paules shared in the general unease, she was not overly concerned. Her roommate, also twenty-three, was an old high school pal, Manuel Taboada, a strapping six-foot, three-inch senior who weighed over two hundred pounds. With Manny around, no harm would befall her, she believed. She was wrong.

In the early morning hours of August 27, the Gainesville Ripper broke into their apartment while they slept. Manny awoke to find himself under attack by the knife-wielding maniac. Though the young man put up a ferocious struggle, he was no match for the Ripper's blade. The medical examiner would testify that the young man suffered thirty-one wounds, including "a slash of the chin, a stab wound of the neck, a grouping of eleven stabs and cuts in the upper chest, a large stab wound in the upper abdomen, a slash on the right thigh, two cuts on the lower right leg, and cuts and stabs on the left wrist and hand and right hand."

As court documents later recorded, Tracy was awakened by the commotion:

> [She] opened her door to investigate. Seeing [the blood-drenched assailant], she ran back into her bedroom, locking the door. Danny kicked it in and was on her. He taped her hands behind her back and taped her mouth. He removed her T-shirt and raped her, turned her over on her stomach, and stabbed her once in the back through the heart. She died quickly. Eight to ten seconds, and it was over. He removed the tape and dragged her into the hallway, went into the bathroom, wet a washcloth, wiped the blood from her face, and raped her again. He douched her out with a kitchen cleanser and left.

With the city in a panic, police intensified their search for the sex killer. Suspicion fell heavily on a local man named Edward Humphrey, a chronic troublemaker with a history of violently erratic behavior. But as the authorities focused their attentions on Humphrey, the real killer, Danny Rolling, was miles away.

Born in Shreveport, Louisiana, in 1954, Rolling seems never to have had a chance at a normal life. His policeman father was a brutal martinet who terrorized the family, subjecting his children—especially young Danny—to unrelenting physical and verbal abuse. By his early adolescence, the boy was heavily into alcohol and drugs and had made several failed suicide attempts. He had also become a Peeping Tom, a compulsion that would later evolve into housebreaking, rape, and ultimately sex-murder.

At seventeen, he joined the air force but was discharged two years later after being caught with marijuana. By 1979, he had turned to armed robbery, an offense that earned him several stints in the penitentiary. Paroled in 1988, Rolling returned to Shreveport and tried living with his parents. This ill-advised move culminated in an explosion of gun violence between father and son. After putting two bullets into the old man, Rolling fled to Kansas City, then made his way down to Florida. August 1990 found him in Gainesville, camping in the woods not far from the homes of the women who would become his first victims.

After the slaughter in Gainesville, Rolling headed for Ocala, where, on September 8, he was captured after robbing a supermarket at gunpoint. At first, the police didn't realize that they had bagged the Gainesville Ripper. Rolling seemed like nothing more than a petty thief, short on talent and luck. Further investigation into his background, however, uncovered some disturbing facts. Officials learned that Rolling was wanted in Shreveport for the attempted murder of his father. Moreover, there had been a horrific triple homicide in Shreveport during the time that Rolling resided there with his parents: the brutal stabbing of twenty-four-year-old Julie Grissom, a student at Louisiana State University; her fifty-five-year-old father, William; and his eight-year-old grandson, Sean—a crime that bore marked similarities to the Gainesville horrors.

An examination of evidence gathered from the campsite where Rolling had stayed after arriving in Gainesville produced overwhelming physical evidence linking him to the murders of the five college students, including a pubic hair that, thanks to DNA analysis, was matched to one of the victims. Before long,

Rolling had confessed to the crimes, though he tried to pin the blame on an evil alter ego named Gemini—a ploy that fell apart when investigators discovered that he had gotten the idea from watching the movie *Exorcist III.*

At his 1994 trial, his lawyer tried to persuade the jury that Rolling deserved sympathy because of his brutal upbringing. Whatever sympathy they might have felt for the mistreatment he had suffered as a child, however, failed to mitigate their outrage at the atrocities he had committed as an adult. On April 23, 1994, he was sentenced to death for five counts of murder.

A dozen years would pass before that sentence was carried out. The week before his execution, he passed a note to his spiritual advisor, admitting to the Grissom murders: "I, and I alone, am guilty," it read. "It was my hand that took those precious lights out of this ole dark world."

At around 5:00 p.m. on Wednesday, October 25, 2006, after polishing off a whopping last meal—lobster tail with drawn butter, butterfly shrimp with cocktail sauce, baked potato with sour cream, and strawberry cheesecake, washed down with sweet tea—he was wheeled into the death chamber. Forty-seven witnesses, including more than a dozen family members of his eight victims, were there to witness his execution. Asked if he had any last statement, the condemned man broke into song, an original hymn that he apparently had composed for the occasion: "He who flung the stars into heavens above, created the oceans, mountains, eagles, and doves," he warbled, "none greater than thee, oh Lord, none greater than thee!" He was still mouthing the lyrics as the fluids were pumped into his arm. Thirteen minutes later, he was pronounced dead. Outside the prison walls, a crowd of celebrants—many wearing the University of Florida's blue and orange colors and holding signs that read "Kill the Killer!"— sent up a cheer.

SHADOW OF A DOUBT (1943)

DIRECTED BY ALFRED HITCHCOCK. WRITTEN BY
ALMA REVILLE, SALLY BENSON, AND THORNTON
WILDER. WITH JOSEPH COTTEN, TERESA
WRIGHT, HENRY TRAVERS, PATRICIA COLLINGE,
HUME CRONYN, AND MACDONALD CAREY.

Alfred Hitchcock made so many brilliant films that it's hard to name his greatest. For some it's *North by Northwest*, for others it's *Rear Window*, or *Strangers on a Train*, or *Psycho* (see p. 235), or *Notorious*. In 2012, *Sight & Sound* magazine, the venerable monthly publication of the British Film Institute, made international headlines when, for the first time in fifty years, it ranked *Vertigo* above *Citizen Kane* as the greatest motion picture ever made. Hitchcock's own avowed favorite, however, was none of the aforementioned films but his 1943 psychological thriller, *Shadow of a Doubt*.

As the opening credits roll, we watch a ballroom full of formally dressed couples dancing to Franz Lehár's "Merry Widow Waltz," an image that will recur throughout the film. The story proper begins in a run-down neighborhood of Philadelphia. A sign affixed to a seedy apartment building advertises "Rooms to Let." Inside one of the rooms, the movie's villain, Charles Oakley (Joseph

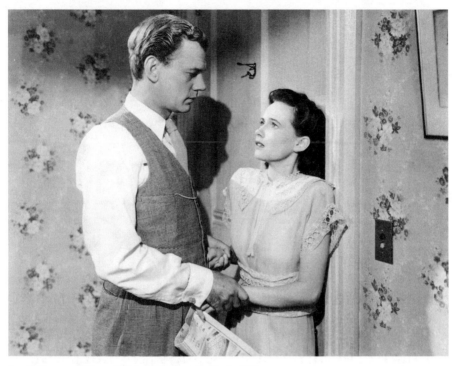

Joseph Cotten and Teresa Wright in *Shadow of a Doubt*, 1943.

Cotten), reclines on the bed, puffing a cigar. When his landlady informs him that two men have been asking for him, he hurriedly departs and makes his way through the vacant streets, the two strangers in pursuit. Eluding them, he puts in a call to Western Union and dictates a telegram to be sent to his sister, Mrs. Joseph Newton of Santa Rosa, California, informing her that he is coming for an extended stay.

The film then cuts to Santa Rosa (where it was shot on location), an idyllic all-American town straight out of a Norman Rockwell painting. Inside the tidy clapboard home of the Newton family, we meet the movie's heroine, Oakley's pretty young niece Charlotte (Teresa Wright), known to everyone as "Charlie." Stretched out on her bed in the same pose as her uncle in the opening scene, Charlie is in a funk, as she reveals to her doting, bank-teller papa, Joseph (Henry Travers). Her life, she complains, is crushingly ordinary, utterly devoid of excitement or drama. The family is "in a terrible rut," she exclaims. "We just sort of go along and nothing happens. We eat and sleep and that's about all."

Suddenly, she has an idea. She will send a telegram to "a wonderful person who'll come and stir us all up, just the one to save us": her glamorous, widely traveled namesake, Uncle Charlie. When she hurries to the telegraph office and discovers the message announcing his imminent arrival, the coincidence confirms what she has always believed: there is a deep psychic bond between her and her idolized uncle—that, as she later tells him, they are "sort of like twins."

Shortly thereafter, the charming, handsome, utterly sociopathic Uncle Charlie arrives by train. Dense black smoke spewing from the engine pollutes the cloudless sky—a visual metaphor for the evil he is introducing into the Newtons' innocent, sunlit world. Mrs. Newton (Patricia Collinge) sheds tears of joy at the sight of her brother, whom she hasn't seen in years. His presence unleashes a flood of memories. At one point, she reminisces about a terrible childhood accident he suffered when he took his new bicycle out for a spin on "an icy road and skidded into a streetcar. We thought he was going to die . . . He fractured his skull. And he was laid up so long." When he finally recovered, he was never the same. "It was just as if the rest he had was too much for him, and he had to get into mischief to blow off steam."

Uncle Charlie has come bearing gifts for all the members of his family: a fur stole for his sister, a wristwatch for Mr. Newton, a stuffed elephant and toy cowboy pistol for the two younger children, Ann and Roger. When alone with Charlie in the kitchen, he presents her with an expensive emerald ring engraved with an enigmatic inscription ("TS from BM"), which she is reluctant to accept. Their relationship is so close that she requires no gift: having him there is all that she wants. "We're not just an uncle and a niece. I know you," she insists. "I have a feeling that inside you somewhere there's something nobody knows about. Something secret and wonderful—and I'll find out."

"It's not good to find out too much, Charlie," he responds.

Charlie learns the wisdom of that advice when a pair of detectives—the two men we glimpsed in the opening scene—show up. From the handsomer of the two, Jack Graham (Macdonald Carey), she learns that her uncle is suspected of being the notorious "Merry Widow Murderer," a serial strangler who preys on wealthy widows. Though she initially refuses to believe Graham, she can't ignore the mounting evidence against her uncle: his efforts to destroy any newspaper article about the crimes; her discovery that the two sets of initials engraved on the ring he gave to her are those of the strangler's

most recent victim and her late husband; and a profoundly disturbing speech that Uncle Charlie delivers over the dinner table about "useless" middle-aged widows—"horrible, faded, fat, greedy women" who do nothing but fritter away all the money their hardworking husbands left them. "Are they human," he asks, "or are they fat, wheezing animals?"

Eventually, an anguished Charlie reveals to her uncle that she knows who he really is. However, for the sake of her mother, who would be devastated to know the truth about her adored brother, she agrees to remain silent for a few days and give him a chance to escape. Not long afterward, a second suspect is killed while fleeing the police. Persuaded that he was the Merry Widow Murderer, authorities declare the case closed. With detectives no longer after Uncle Charlie, young Charlie now stands as the only threat to his security. Following several failed attempts to eliminate her by means of staged accidents, the monstrous Uncle Charlie manages to get his niece onto a fast-moving train, leading to a classically nail-biting, Hitchcockian climax.

Three writers are credited with the screenplay for *Shadow of a Doubt*: Alma Reville, Sally Benson, and Thornton Wilder (best known for his Pulitzer Prize–winning play, *Our Town*). The idea for the movie, however, originated with another author, Gordon McDonell, who was inspired by newspaper accounts of a notorious 1920s serial strangler, Earle Leonard Nelson; though a far more brutish character than the urbane Uncle Charlie, he shared Uncle Charlie's homicidal hatred of women.

Born in San Francisco in May 1897, Nelson was only nine months old when his young mother, Frances, died of syphilis. His father, James, followed her to the grave seven months later, a victim of the same disease. The tiny orphan was taken into the home of his maternal grandmother, Mrs. Jennie Nelson, a Bible-thumping widow who instilled in him a lifelong fascination with scripture.

Even as a baby, Earle had a deeply unsettling effect on people. According to one crime historian, the earliest surviving photograph of little Earle, taken shortly after his parents' death, showed "a loose-mouthed degenerate infant with a vacant expression." To be sure, that description owed a great deal to hindsight. At the time it was written, Nelson had already grown up to be a monster—a killer so terrifying that, to his Jazz Age contemporaries, he seemed like a figure out of a horror movie. Still, there is no doubt that he displayed extremely disconcerting behavior from a very early age.

At the dinner table, he seemed barely socialized, devouring his food with the ferocity of a caged beast. He routinely managed to lose his clothing whenever he left the house. When he was sunk into profound, self-pitying depressions, he was gripped by uncontrollable rages. By the age of seven, he had already been expelled from grade school and earned a neighborhood reputation as a petty thief and shoplifter—the sort of youngster that parents warn their own children to stay away from.

In 1907, shortly after his tenth birthday, Earle suffered a serious head injury when he bicycled in front of an oncoming trolley car and was sent flying onto the cobblestones (an episode used in *Shadow of a Doubt* to explain the cause of Uncle Charlie's psychopathology). He was in a coma for nearly a week. When he finally regained consciousness, the family doctor assured Earle's distraught grandmother that the boy would be "just fine"—a prognosis that would prove to be one of the least prescient in medical history.

By the age of fourteen, Earle had dropped out of school and launched into a succession of menial jobs, supplementing his meager earnings (most of which he spent in the brothels of the Barbary Coast) with burglary. By then he was residing with his aunt Lillian, his grandmother having died a few years earlier. As she would be throughout his life, Lillian was staunchly supportive of young Earle, despite his increasingly erratic behavior: his Tourette's-like tendency to spew obscenities at the dinner table; his freakish habit of walking around on his hands whenever a guest dropped by for coffee; his brooding obsession with the book of Revelation (particularly the passage about the Whore of Babylon, "the Mother of Harlots and Abominations of the Earth"). When he was arrested for housebreaking in 1915, she made a tearful appeal on his behalf at his trial. Her plea was ignored, however, and Earle was sentenced to two years in San Quentin.

Released from prison during the height of the Great War, Earle enlisted in the military but spent a good part of his stint in a naval mental hospital, where he was diagnosed as a constitutional psychopath. Discharged in 1919, the twenty-two-year-old Nelson took a job as a hospital janitor and soon fell in love with a grizzled fifty-eight-year-old spinster named Mary Martin. Before long, this very odd couple had married.

The new Mrs. Nelson found herself living with a madman who continually accused her of infidelity, when he wasn't ranting about the Great Beast of the book of Revelation and proclaiming that he was Jesus Christ. Not long after

Earle raped her in a hospital bed while she was recuperating from a serious ill-ness, Mary decided to leave him. A year later, he attacked a twelve-year-old girl in the basement of an apartment building and landed back in a mental hospital.

He was discharged in June 1925. Less than one year later, he embarked on the rampage that would make him the most feared and prolific serial killer of his era. On February 20, 1926, he showed up at the doorstep of Mrs. Clara Newman, a sixty-year-old spinster who ran a boardinghouse in San Francisco. There was a vacancy sign in her front window (as shown in the opening sequence of *Shadow of a Doubt*, Uncle Charlie, like Earle, is drawn to nondescript lodgings advertising "Rooms to Let"). Explaining that he was looking for a place to stay, Nelson asked to see the available room. Once he had the landlady alone, he strangled her with his bare hands, then raped her corpse.

During the next few months, Nelson ranged along the West Coast—from San Francisco to Seattle and back—on a monstrous spree of murder and sexual mayhem. Ten more women died at his hands between February and November 1926. All his victims were landladies. All were strangled, then raped after death. A number of the corpses were left stuffed in small spaces—inside a trunk, behind the basement furnace. By now, the press had dubbed the unknown maniac "the Dark Strangler." A massive manhunt was launched all along the West Coast.

Nelson moved inland. On December 2, he murdered Mrs. John Brerard, forty-nine, of Council Bluffs, Iowa. On December 27, he strangled twenty-three-year-old Bonnie Pace of Kansas City, Missouri. The following day, he killed another Kansas City woman, twenty-eight-year-old Germania Harpin. He also choked Mrs. Harpin's eight-month-old son to death by stuffing a rag down the infant's throat.

A nationwide alert was now on for the monster. Witnesses had provided the police with a description of the suspect: dark hair, stocky build, sloping forehead, protruding lips, and grotesquely oversized hands. There was something apelike about his appearance. The press hung a new tag on the phantom killer: "the Gorilla Murderer."

Nelson headed eastward. Between April and June 1927, he murdered four more women in Philadelphia, Buffalo, Detroit, and Chicago. Then he turned north into Canada, where he was finally captured after murdering two final victims in Winnipeg: a sixteen-year-old flower girl named Lola Cowan and a housewife named Emily Patterson, whose violated corpse he stuffed under a bed.

Her body was discovered by her frantic husband as he knelt by the bedside to ask the Lord for help in finding his missing wife.

Tried and convicted in November 1927, Nelson was hanged the following January in Winnipeg. "Tomorrow morning, I expect to be in Heaven," he told a reporter on the night before his execution. "There are no police or detectives up there—only the good. Maybe I'll finally find the peace and happiness that have been denied me here on earth." He went to the gallows clutching his Bible and still proclaiming his innocence. His blood rampage had lasted for slightly more than a year, from February 1926 until June 1927. During that brief span of time, twenty-two victims met their deaths at the beastlike hands of the Gorilla Murderer.

THE STRANGERS
(2008)

DIRECTED AND WRITTEN BY BRYAN BERTINO. WITH LIV TYLER, SCOTT SPEEDMAN, GEMMA WARD, KIP WEEKS, AND LAURA MARGOLIS.

A fave among fans of home-invasion horror films (of which Michael Haneke's *Funny Games* is, hands down, the most deeply disturbing example), this 2008 shocker begins with a device taken straight from the playbook of *The Texas Chain Saw Massacre*: an ominous voice-over meant to create the impression that the crime about to be portrayed is completely factual. "On the night of February 11, 2005," the speaker somberly intones, "Kristen McKay and James Hoyt left a friend's wedding reception and returned to the Hoyt family's summer home. The brutal events that took place there are still not entirely known."

We first meet the unfortunate pair (played by Liv Tyler and Scott Speedman) as they are driving back from the party. James, behind the wheel, looks exceedingly grim, while Kristen sits silently beside him, her face streaked with tears. A flashback reveals the source of their unhappiness: James has used the romantic occasion to pop the question to his longtime girlfriend who, much to his dismay, turns him down ("I'm just not ready yet" is all the explanation she gives). Back at the Hoyt family's isolated vacation home in some unspecified, densely forested

locale, the two spend the first twenty or so minutes of the movie in a state of mutual depression. Their happy evening has turned out to be a total bust. They have no idea just how much worse it's about to become.

Things begin to take a sinister turn when their reconciliatory lovemaking is interrupted by a strange young blonde (Gemma Ward) pounding on the front door. A short time later, after James drives off on an errand and leaves Kristen alone, the blonde woman returns. Only this time, she is wearing a supremely spooky doll mask (hence her character's name, as given in the credits, is Dollface). Freaked out, Kristen tries calling James on her cell phone, but in standard horror-film fashion, the battery promptly dies.

Hearing more unnerving noises in the backyard, she pulls back a curtain and—in one of the movie's several cheap but highly effective jump scares—is confronted by another creepy figure, the rather unoriginally named Man in Mask (Kip Weeks), a man with a burlap scarecrow sack covering his head. A third nasty character soon shows up, Pin-Up Girl (Laura Margolis), a sexy brunette in a Betty Boop–like mask. By then, James has returned; though not given to the screaming hysterics of Kristen, he doesn't prove any better in fending off the bad guys (as demonstrated, for example, when he inadvertently blows the head off his best friend, Mike, a potential rescuer who has driven over to the house).

For no reason other than sheer sadistic joy, the diabolical trio proceeds to terrorize the hapless couple. In keeping with slasher-movie conventions, the protagonists behave in reliably illogical ways, ensuring that they will end up in the clutches of the sicko intruders, who bind the couple to chairs and take turns slowly sinking a butcher knife into their bodies.

In the end, the great virtue of *The Strangers* is that it never pretends to be anything other than a well-crafted exercise in audience manipulation that delivers exactly the experiences customers pay good money to enjoy: grinding tension, periodic jolts, and the kind of torture-porn violence demanded by today's hard-core horror buffs.

Though writer-director Bryan Bertino is on record as saying that he had the Manson murders in mind when he conceived the film, critics have identified another potential source, one that bears an even closer resemblance to the events of *The Strangers* than does the 1969 massacre of Sharon Tate and her friends.

US poster art for *The Strangers*, 2008.

Keddie, a tiny railroad town established in 1910 and situated in the heavily timbered foothills of northern California's Sierra Nevada Mountains, became a popular resort for city dwellers looking to enjoy the pleasures of its spectacular hiking trails, trout-packed fishing streams, and breathtaking scenery. A rustic two-story lodge, originally built to accommodate travelers, was renovated into a hotel-restaurant, where vacationers could spend their nights in well-appointed rooms and dine on such local delicacies as barbequed bear ribs and sherry-basted raccoon steaks. Those who preferred more-private quarters could stay in one of thirty-three sturdy log cabins.

By 1981, however, the once-thriving resort had fallen onto such hard times that the cabins, now badly run down, were turned into housing for low-income residents. Among these were thirty-six-year-old divorcée Glenna Sharp and her five children, three sons and two daughters ranging in age from five to fifteen.

Little is known about Glenna Sharp. Fleeing a troubled marriage from a reportedly abusive husband—a career navy man stationed in Groton, Connecticut—she took her kids to Quincy, California, in late 1979, moving into a trailer recently vacated by her brother. A few months later, in November 1980, they relocated to Keddie, renting a shabby but relatively spacious four-room cabin—number 28—for $175 a month.

In the eighteen months that she lived in the run-down resort, she made virtually no close friends. In the redundant words of the local newspaper, "she was a private person who kept to herself." She had several casual boyfriends during that time but no serious relationships. To support herself and her brood, she enrolled in a federal education program, receiving a small stipend that supplemented her welfare payments and a monthly $250 allotment check from the navy.

Though described in the papers as a caring mother—one who "saw to it that her children had warm clothes for the winter even if it meant that she had to sacrifice her own comfort"—Glenna clearly had trouble keeping her kids in line, particularly the two adolescents. Her oldest, fifteen-year-old Johnny, had already been in trouble with the law for breaking into a house and stealing some marijuana; his fourteen-year-old sister, Sheila, had been impregnated at thirteen and, immediately upon the birth of her baby, had given it up for adoption.

On Saturday night, April 11, 1981, Glenna turned down an invitation to a double date with a neighboring couple, Marty and Marilyn Smartt, and their house guest, Bo Boubede. She chose instead to stay home with her two younger

sons, Greg and Ricky, five and ten, respectively, who had invited their pal, Justin Eason, for a sleepover. The boys were eating popcorn and watching *The Love Boat* when, at around 9:30 p.m., Glenna's twelve-year-old daughter, Tina, returned from a friend's house and joined her brothers and Justin in front of the TV.

Tina's big sister, Sheila, was spending the night at the home of her best friend, Paula Seabolt, who lived in the cabin next door. Johnny Sharp also was away, having hitchhiked to Quincy with his buddy, seventeen-year-old Dana Wingate. Like Johnny, Dana had already run afoul of the law and was on probation for going on a tire-slashing spree at a local used-car dealership a year earlier. Exactly how the two teenagers spent that Saturday evening is unclear, though they were seen outside a motel in Quincy at around 10:00 p.m., thumbing a ride back to Keddie.

At about 7:45 a.m. the next morning, Sheila, who had decided to accompany the Seabolts to church, went to her cabin to get her Sunday clothes. The sight that greeted her when she opened the front door sent her screaming back to the Seabolts.

In the blood-drenched wreckage of the living room, three savaged corpses lay sprawled on the floor. Glenna, bound, gagged, and naked from the waist down, had been stabbed repeatedly in the chest with a steak knife and bludgeoned so viciously with a claw hammer that her skull was pulverized. Sheila's brother, Johnny, lay beside Glenna, his wrists and ankles also tightly wrapped with tape and electrical cord, his throat slit, his mutilated torso bearing the same marks of frenzied overkill. Dana Wingate had been bound, beaten, and manually strangled.

The law officers who quickly arrived at the scene soon made another alarming discovery: Tina was missing, apparently abducted by the intruders. Remarkably, given the degree of mayhem wrought by the killers, the two younger Sharp boys and their overnight guest appeared to have slept through the slaughter.

In the immediate aftermath of the atrocity, investigators put forth several theories. One was that the people who had picked up Johnny and Dana in Quincy were the killers. After driving the boys back to Keddie, they had entered the cabin, by either force or invitation, and—perhaps in a drug-fueled frenzy—committed the massacre. An alternative theory held that the people who gave the boys a lift had nothing to do with the crime. In this scenario, Glenna was

the primary target of the killers, and her murder was already in progress when the two boys walked in on the terrible scene.

For a while, Marty Smartt and his visitor, Bo Boubede—who had bonded with Smartt when the two met at a veteran's hospital where Smartt was being treated for PTSD—were regarded as persons of interest, though both were soon dismissed as suspects. Over the next three years, according to crime historian Michael Newton, "local police spent some 4,000 man-hours investigating the murders" but to no avail. A final shock was still to come. In June 1984, three years after Tina Sharp's abduction, her skull (subsequently identified through dental records) was discovered by a bottle collector scavenging for empties almost sixty miles south of Keddie. Pathologists later determined that she was killed sometime after November 1, 1981—"meaning," as one journalist grimly noted, "that she was held captive for at least six months before her death."

In the ensuing years, cabin 28 gained a reputation as a haunted house, featuring the standard supernatural phenomena: levitating furniture, spooky apparitions, ghostly graffiti appearing spontaneously on the walls. It was finally demolished in 2004. The case remains unsolved. In its appalling details—a sadistic multiple murder perpetrated for unknown reasons by nameless intruders in an isolated rustic setting—it parallels to a striking degree the imaginary horrors conjured in *The Strangers*.

TARGETS (1968)

DIRECTED AND WRITTEN BY PETER BOGDANOVICH. WITH BORIS KARLOFF, TIM O'KELLY, NANCY HSUEH, SANDY BARON, AND PETER BOGDANOVICH.

While mass murder is by no means a uniquely modern—or American—phenomenon, it remains depressingly true that the decade between 2007 and 2017 witnessed the five worst mass shootings in US history, including the 2012 Sandy Hook rampage that claimed the lives of twenty schoolchildren and six adult staff members; the 2016 Orlando nightclub massacre that left forty-nine LGBT people dead; and—the current holder of this grim record—the 2017 Las Vegas shooting that killed fifty-eight concertgoers. Indeed, of the dozen deadliest such crimes, only one occurred before the late 1980s. In a turbulent decade of political assassinations, urban riots, and rising inner-city crime, the so-called Texas Tower shooting of 1966 dealt another serious blow to the nation's already shaky sense of security.

Its perpetrator was twenty-five-year-old Charles Whitman Jr. The oldest of three sons born to an upwardly mobile, middle-class couple in Lake Worth, Florida, young Charlie was, to all outward appearances, an almost stereotypical embodiment of the ideal, clean-cut, all-American boy of the 1950s. Blond, blue-eyed, and handsome, he was an athletic, high-achieving student and devoted

altar boy who earned money delivering newspapers and became one of the youngest Boy Scouts ever to attain the rank of Eagle. He was also, as events would prove, a seething cauldron of suppressed homicidal rage, whose fury was directed at his martinet father.

A hard-driving, self-made success with a booming plumbing business, the elder Whitman was a strict disciplinarian who demanded that his sons address him as "sir"; in keeping with his philosophy of "spare the rod, spoil the child," he administered regular "spankings" with wooden paddle and belt. He was also a physically abusive husband; as he admitted, he beat his wife "on many occasions. My wife was awful stubborn, and . . . because of my temper, I knocked her around," he explained.

Like many American boys, Charlie Jr. was taught to shoot at an early age by his dad, a self-confessed "fanatic about guns." A snapshot of Charlie that would later run in the twelve-page *Life* magazine cover story on his crime shows him as a two-year-old on a Florida beach, gazing fondly at the family dog while holding a high-powered rifle in each hand. "I raised my boys to know how to handle guns," his father would proudly proclaim. "Charlie could plug a squirrel in the eye by the time he was sixteen."

To his high school classmates, Charlie—as one of them testified—seemed "completely normal. Just one of the guys." He pitched for the baseball team, dated girls, and did well enough in his classes to graduate seventh in a class of seventy-two. Though he seemed college bound, a violent confrontation with his father altered the course of his life.

Shortly before his eighteenth birthday, Charlie returned from a party drunk. Enraged, his father went at him with his fists, then shoved him into the swimming pool, where the intoxicated, fully clothed teen nearly drowned. It was the final humiliation for Charlie. A few days later, both to spite his father and to get as far away from him as possible, he enlisted in the marines.

Following his basic training, he was posted to the Guantanamo Bay Naval Station in Cuba, where, among his other distinctions, he excelled as a marksman, earning especially high ratings in the categories of "rapid fire from long ranges" and "accuracy against moving targets." Ambitious for advancement, he applied for and won a USMC scholarship to the University of Texas at Austin, where—if he had maintained the requisite standards—he would have earned a

degree in mechanical engineering, then spent ten months at Officer Candidate School before becoming a commissioned officer.

A few months after he entered the university, twenty-two-year-old Charlie met and began dating a pretty education major, Kathleen Leissner, two years his junior. After a six-month courtship, they were married in August 1962. By then, the first cracks in Charlie's golden-boy façade had begun to show. He was arrested for poaching a deer (which he then dragged back to his dormitory and butchered in the communal shower), ran up serious poker debts with unsavory characters, and barely managed to eke out passing grades in his courses. On one occasion, he disconcerted a friend with an offhand remark that proved chillingly prophetic. Gazing at the university's landmark Tower, Charlie mused: "A person could stand off an army atop of it before they got him."

In February 1963, Charlie's scholarship was revoked, and he returned to active duty at Camp Le Jeune, North Carolina. Before the year was out, he was court-martialed for gambling, possession of an unauthorized firearm, and usury (the result of threatening to "kick the teeth out" of another marine who refused to pay 50-percent interest on a thirty-dollar loan). Found guilty, he was sentenced to a month in the brig and demoted from lance corporal to private. Despite this ignominious record, he received an honorable discharge when he left the service in December 1964.

Returning to Austin, Charlie reenrolled at the university, majoring first in mechanical engineering before switching to architectural engineering, a course of study that, as he told his faculty advisor, allowed him to "express his artistic talents better." Largely supported by Kathy, who had found a job as a high school science teacher, he supplemented their income with part-time work as a bank teller, bill collector, and clothing store salesman, while carrying an exceptionally heavy course load and serving as a scoutmaster for a local troop. The combined pressures of work and study began to show on him. He suffered from debilitating headaches, gained so much weight that his scouts called him Porky, gnawed his fingernails to the quick, and sweated profusely, even on cold December days. Adding to the strain was the breakup of his parents' marriage. After enduring years of abuse, his mother left her husband in March 1966 and moved to Austin, where Charlie—assuming yet another burden—dutifully "took care of her and tried to see that she wasn't overworked."

Sliding into depression, Charlie briefly dropped out of school, talked openly of killing his father, and announced that he was leaving Kathy. She finally persuaded him to see a psychiatrist at the university health center, Dr. Maurice Dean Heatley, who concluded that the young man was "oozing with hostility." Though Charlie confessed that he was "thinking about going up on the tower and . . . shooting people," Heatley—who had often heard such "sweeping statements of general hostility" from patients—was not overly alarmed. He gave Charlie a prescription for the tranquilizer Librium and made an appointment to see him again in a week. But Charlie never returned.

At 6:45 p.m. on Sunday, July 31, 1966—while his wife was at her part-time job as a telephone information operator—Charlie, in anticipation of the enormities he was about to commit, sat down at his portable typewriter and started to peck away at the keyboard. "I don't quite understand what it is that compels me to type this letter," he began:

> Perhaps it is to leave some vague reason for the actions I have recently performed. I don't really understand myself these days. I am supposed to be an average reasonable intelligent young man. However, lately (I can't recall when it started) I have been a victim of many unusual and irrational thoughts. These thoughts constantly recur, and it requires a tremendous mental effort to concentrate on useful and progressive tasks . . . I talked with a Doctor once for about two hours and tried to convey to him my fears that I felt come overwhelming violent impulses. After one session I never saw the Doctor again, and since then I have been fighting my mental turmoil alone, and seemingly to no avail.

Then, in a declaration made all the more appalling by its calm, considered tone, he wrote:

> It was after much thought that I decided to kill my wife, Kathy, tonight after I pick her up from work at the telephone company. I love her dearly, and she has been as fine a wife to me as any man could ever hope to have. I cannot rationally pinpoint any specific reason for doing this. I don't know whether it is selfishness, or if I

don't want her to have to face the embarrassment my actions would surely cause her. At this time, though, the prominent reason in my mind is that I truly do not consider this world worth living in, and am prepared to die, and I do not want to leave her to suffer alone in it. I intend to kill her as painlessly as possible.

"Similar reasons provoked me to take my mother's life also," he added, as though that outrage was a fait accompli. "I don't think the poor woman has ever enjoyed life as she is entitled to."

Three hours later, Charlie picked up his wife at the Southwestern Bell Telephone Company building and dropped her off at home before proceeding to his mother's apartment. Exactly how he killed his mother is unknown, though, from the forensic evidence, it appears that he strangled her into unconsciousness with a five-foot rubber hose, stabbed her in the chest with a hunting knife, then either shot her in the back of the head or crushed her skull with a heavy object. After washing the blood from his hands, he sat down with a legal pad and ballpoint pen and wrote:

> To Whom It May Concern:
> I have just taken my mother's life. I am very upset over having done it. However, I feel that if there is a heaven she is definitely there now. And if there is no life after, I have relieved her of her suffering here on Earth. The intense hatred I feel for my father is beyond description. My mother gave that man the 25 best years of her life and because she finally took enough of his beatings, humiliation, degradation, and tribulations [she chose] to leave him . . . I am truly sorry that this is the only way I could see to relieve her suffering but I think it was best. Let there be no doubt in your mind that I loved the woman with all my heart. If there exists a God, let him understand my actions and judge me accordingly.

It was shortly after 2:00 a.m. when Charlie returned to his apartment. Kathy was fast asleep, naked beneath the bedclothes. Uncovering her body, he stabbed

her five times in the chest with his hunting knife. He then added a handwritten addendum to the note he had typed earlier in the evening:

> I imagine it appears that I brutally kill[ed] both of my loved ones. I was only trying to do a quick thorough job. If my life insurance policy is valid please . . . pay off all my debts . . . Donate the rest anonymously to a mental health foundation. Maybe research can prevent further tragedies of this type. Charles J. Whitman.

Charlie spent the next seven hours making meticulous preparations for what he clearly intended to be an extended assault. After packing his military footlocker with an assortment of weapons and enough provisions to last several days—everything from water and canned food to deodorant and toilet paper—he made several trips, first to rent a dolly and then to purchase additional high-powered firearms and hundreds of rounds of ammunition. When a gun store clerk asked what he needed all the ammo for, Charlie replied, "To shoot some pigs."

With his arsenal and footlocker stowed in his car, Charlie drove to the campus, arriving around 11:30 a.m. He took an elevator to the Tower's twenty-seventh floor, then hauled his gear up a few steps to the observation deck. When the receptionist, forty-seven-year-old Edna Townsley, approached him, he delivered a mortal blow to the back of her skull with a rifle butt, then hid her body behind a couch. Minutes later, a family of sightseers appeared at the top of the stairs. Charlie blasted them with his sawed-off shotgun, killing two and permanently disabling two others.

Barricading the door leading to the observation deck, Charlie then settled down to his main business. From his vantage point atop the 280-foot Tower was an unobstructed view of the campus—an ideal hunter's platform for a psychopathic sniper; he began firing down at random targets with his scoped high-powered rifle. A bicycling newsboy was the first down. He was followed by a pair of strolling freshmen, one of them an eight-months-pregnant newlywed; a thirty-three-year-old visiting mathematics professor on his way to lunch with a friend; a policeman running toward the Tower; an electrical service repairman on his way back to his truck from a call; and many more. By the time the massacre ended more than ninety minutes later, twelve people would be killed and another thirty-one wounded.

Shielded by the stone parapet surrounding the observation deck, Charlie was invulnerable to the barrage of gunfire from the more than one hundred lawmen who rushed to the scene. When a police sharpshooter in a light plane tried to pick him off from above, Charlie chased the aircraft off with a few well-aimed shots to its fuselage.

It wasn't until off-duty patrolman Ramiro Martinez, along with two other officers and a courageous university employee, managed to reach the Tower that the horror came to an end. Making his way to the observation deck, Martinez was able to sneak up on Whitman and empty his revolver into him, while another officer, Houston McCoy, delivered the coup de grâce with a shotgun. "The most savage one-man rampage in the history of American crime"—as *Life* magazine called it—was over. But, as events would tragically prove, the modern age of the mass shooter had just begun.

Two nonfiction films have been made about the University of Texas massacre: *The Deadly Tower*, a 1975 made-for-TV movie starring Kurt Russell as Whitman, and *Tower*, a gripping 2016 documentary that combines archival footage and rotoscope animation to tell the story entirely from the point of view of those who lived through the horror—witnesses, survivors, and unsung heroes of the shooting. The Texas sniper case also served as the inspiration for a fascinating B movie that launched the career of one of the major young directors of the 1970s, Peter Bogdanovich.

A lifelong movie nerd who, beginning at age twelve, kept file cards on every one of the 5,316 films he eventually watched, Bogdanovich turned his cinematic obsession into a paying job in his early twenties when he began writing profiles of his favorite Hollywood directors for *Esquire* magazine. Eager to become a filmmaker himself, he and his wife moved to Los Angeles where, in 1965, he was introduced to Roger Corman, the legendary king of exploitation movies, who was responsible for such drive-in gems as *The Brain Eaters*, *Teenage Caveman*, and *Attack of the Giant Leeches*, as well as an acclaimed series of Edgar Allan Poe adaptations starring Vincent Price.

An admirer of Bogdanovich's *Esquire* articles, Corman—famous for having jump-started the careers of such directors as Francis Ford Coppola, Martin Scorsese, Ron Howard, and James Cameron—hired him as a production assistant on his latest project, a low-budget biker film, *The Wild Angels*. Bogdanovich ended up rewriting the script, scouting locations, serving as second unit director, and getting beaten up by a bunch of Hell's Angels who had been hired as extras.

When the film became an unexpected box office smash, earning nearly twenty times its $350,000 production cost, Corman offered Bogdanovich the chance to direct. There was just one stipulation. A few years earlier, Corman had cobbled together a visually striking, but not particularly coherent, horror film, *The Terror*, starring a young Jack Nicholson as a cavalry officer in Napoleon's army and, as the ghost-haunted proprietor of a spooky Gothic castle, seventy-eight-year-old Boris Karloff, whose scenes were shot in three days.

According to the terms of their contract, Karloff still owed Corman two days' work. Always looking for ways to make movies on the cheap, Corman proposed that Bogdanovich "shoot twenty minutes of Karloff in two days," then stitch the new scenes together with twenty minutes of footage taken from *The*

Director Peter Bogdanovich and Boris Karloff on the set of *Targets*, 1968.

Terror. "That's forty minutes of Karloff," he explained. "Now I want you to go shoot with some other actors for ten or twelve days and shoot forty minutes with them, and I've got a new eighty-minute Karloff picture!"

Though he leapt at the chance to direct, Bogdanovich was initially at a loss as to how to proceed. Then, as he later told an interviewer,

> we remembered that while we'd been in New York the last time, *Esquire* editor Harold Hayes had said, 'Why don't you make a film about that guy in Texas who shot all those people in 1966?' . . . So we thought, *What if Karloff played an actor who's retiring because his kind of horror isn't horrible anymore?* What's really horrible is this guy in Texas. So, what if we tell a story crosscut between these two stories?

The result was Bogdanovich's 1968 thriller *Targets*, the debut feature of a director who would achieve enormous (if fleeting) success with the trifecta of *The Last Picture Show* (1971), *What's Up, Doc?* (1972), and *Paper Moon* (1973). Both an elegy for the Gothic horror movies of the past, with their atmospheric European settings, and a chillingly prescient depiction of a new breed of monster—the bland, all-American, psycho killer—the movie casts Karloff as a barely disguised version of himself, an aging fright-film icon named Byron Orlok (whose name, besides sounding like his own, is a tribute to the terrifying vampire in F. W. Murnau's silent classic, *Nosferatu*).

After viewing a screening of his latest movie, *The Terror*, Orlok announces his intention to retire. He is, he proclaims, "an antique," "a dinosaur." Once, he was "Mr. Bogeyman, the King of Blood." As an old publicity slogan put it, "Marx Brothers make you laugh, Garbo makes you weep, Orlok makes you scream." Now the movies that made him famous are viewed as laughable anachronisms—"high camp."

His decision is a particular blow to a young screenwriter, Sammy. Affectingly played by Bogdanovich himself, Sammy has written a script that sounds much like *Targets* in which Orlok would play himself, not "some phony Victorian heavy." Showing up drunk at Orlok's hotel room, Sammy tries to persuade him to change his mind. Orlok, however, is adamant. Searching through a stack of newspapers on his coffee table, he finds the one he's looking for and tosses it onto Sammy's lap. YOUTH KILLS SIX IN SUPERMARKET reads the headline. "Look

at that," says Orlok. "My kind of horror isn't horror anymore. No one's afraid of a painted monster."

Intercut with Orlok's story is the plotline involving the movie's real monster, a clean-cut young insurance agent, Bobby Thompson (Tim O'Kelly), closely modeled on Charles Whitman. We first meet him in a gun shop, where he is purchasing a scoped high-power rifle, along with ammunition and extra clips (*Targets* is also a sobering commentary on the easy availability of deadly fire-arms in our country). He then drives to the featureless ranch house he and his wife share with his parents in the San Fernando Valley. Even while leading the stereotypically mundane life of a middle-class suburbanite—watching TV with his family on the living room couch, saying grace at the dinner table, going to the gun range with dad—Bobby begins stockpiling an arsenal.

Like Whitman, who recognized that he was increasingly subject to "irra-tional thoughts," Bobby, as he tells his wife, is starting to have "funny ideas." The next morning, after typing a letter announcing his intention to kill his wife and mother, he shoots both women, along with a hapless delivery boy, then heads out with his arsenal to continue his rampage. In a movie packed with allusions to Bogdanovich's favorite films, Bobby first positions himself atop an oil refinery tank (an apparent homage to the climax of the James Cagney classic *White Heat*), where he begins firing at vehicles on the nearby highway. Through Bobby's scope, we see passengers slumping in their seats as they are struck in the head by his bullets—images that seem deliberately modeled on the famous Zapruder home movie of the Kennedy assassination, which, at the time of *Targets'* release, was only a few years in the past.

He then heads for the drive-in theater where Karloff's character has agreed to make a personal appearance for the premiere of *The Terror*. In the climactic sequence, Bobby hides in the scaffolding behind the screen and picks off mov-iegoers with his sniper rifle until he is stopped by the fearless Byron Orlok. If viewers in 1968 were meant to associate the movie's violence with the Kennedy assassination and the Texas Tower massacre, no one watching it today can fail to be reminded of the 2012 slaughter in an Aurora, Colorado, movie theater, where a crazed shooter killed a dozen people and wounded almost sixty more during a midnight showing of *The Dark Knight Rises*—proof of the grim, continuing relevance of this seriously unsettling cult film.

10 TO MIDNIGHT (1983)

DIRECTED BY J. LEE THOMPSON. WRITTEN BY WILLIAM ROBERTS. WITH CHARLES BRONSON, LISA EILBACHER, ANDREW STEVENS, GENE DAVIS, GEOFFREY LEWIS, AND WILFORD BRIMLEY.

In the era of Hollywood hunks like Brad Pitt and Mark Wahlberg, it may seem strange that there was a time when the world's most popular movie star was an actor affectionately known to his Italian fans as Il Brutto—the Ugly One. Such was the case when the reigning box office champ in the 1970s was the granite-faced action icon Charles Bronson. After many years as a roughhewn character actor in films like *The Magnificent Seven* and *The Great Escape*, Bronson hit the big time with the 1974 vigilante fantasy *Death Wish*. With his new status as a leading man, Bronson's salary skyrocketed, even as the quality of his films underwent a corresponding decline. To more than one critic, they pretty much bottomed out in 1983 with *10 to Midnight*, somewhat harshly, if not inaccurately, described by reviewer Robert Ebert as "a scummy little sewer of a movie." For all its cinematic failings, however, the film holds a special fascination for fans of true crime.

Bronson plays LAPD cop Leo Kessler, whose credo (like that of his cine-matic forebear, Clint Eastwood's Dirty Harry) is "Forget what's legal—do what's right." The villain of the movie is a handsome but intensely creepy individual named Warren Stacy (Gene Davis), who likes to get naked and butcher the vari-ous nubile young women who have rejected his advances. It doesn't take long for Kessler to identify Stacy as the primary suspect in these serial murders. With no hard evidence to nail Stacy, Kessler doesn't let legal niceties stand in his way and plants incriminating evidence that leads to the psycho's arrest and trial for murder. Unfortunately, Stacy's shyster lawyer (the ever-sleazy Geoffrey Lewis) discovers the ruse and gets his client's case dismissed.

Hell-bent on revenge, Stacy sets his sociopathic sights on Kessler's adult daughter, Laurie (Lisa Eilbacher), a hospital nurse who lives with several of her coworkers. In the climactic sequence, Stacy breaks into their apartment and slaughters Laurie's roommates, then goes after her. At the last moment, she is saved from the same grisly fate by the timely arrival of her dad, who puts a well-deserved bullet between the eyes of the raging psycho.

What makes this low-rent cop/slasher/soft-core-porn movie worth seeing for true-crime fans is its connection to one of the most sensational murder cases of the twentieth century. Though the character of Warren Stacy has the clean-cut good looks of Ted Bundy, his climactic rampage is actually modeled on the infamous 1968 slaughter of eight student nurses in Chicago by Richard Speck.

A hulking, slow-witted sociopath whose long, horsey face was cratered with pockmarks, Speck was schooled in cruelty from an early age at the hands of his stepfather, a violently abusive drunk who made no secret of his contempt for the boy. By the time Speck dropped out of ninth grade at the age of sixteen, he was a hard-drinking, drug-taking, woman-hating misfit whose soft-spoken demeanor masked a frightening potential for violence.

Three years after quitting school, he married a fifteen-year-old girl and, soon afterward, became the father of a daughter, born while Speck—a habitual crimi-nal from his early teens—was doing a stint behind bars for disturbing the peace. During those rare intervals when he was out of jail and at home, his young wife

was reportedly subjected to savage abuse. Tired of being raped at knifepoint by her husband, she soon filed for divorce.

By his midtwenties, Speck had racked up more than forty arrests on charges ranging from forgery to aggravated assault. He was on the run from the law for burglarizing a Dallas grocery store when he made his way to Chicago in the spring of 1966. After a brief visit to his sister and her family, he traveled to his boyhood hometown of Monmouth, Illinois, where, in short order, he raped a sixty-five-year-old woman during a house break-in and became a suspect in the murder of a thirty-two-year-old barmaid. Hightailing it out of town before the police closed in, he returned to Chicago and moved in with his sister, brother-in-law, and their two teenage daughters.

After overstaying his welcome in their cramped apartment, he attempted to find work as a merchant seaman. While waiting to be shipped out, he lived a skid row existence, drinking all day in seedy taverns and crashing in flophouses or, when his money ran out, on park benches. At one point, he brought a fifty-three-year-old barfly back to his fleabag hotel room, raped her, and stole the .22-caliber handgun she carried for protection.

Close by the Maritime Union hiring hall where Speck had applied for work stood several two-story town houses that were used by a community hospital as a dorm for its nurses in training. One of the town houses served as the living quarters for nine student nurses, six Americans—Gloria Davy, Suzanne Farris, Nina Schmale, Patricia Matusek, Mary Ann Jordan, and Pamela Wilkening—and three Filipino exchange students—Merlita Gargullo, Valentina Pasion, and Corazon Amurao. "In their leisure hours, some of the nurses would sunbathe in the area directly behind the town houses," wrote Dennis L. Breo and William J. Martin, chroniclers of the case. "Some would stroll . . . past the union hall to the corner Tastee-Freeze. Most wore shorts or light summer dresses." Sometime during his shiftless weeks in the neighborhood, the pretty young nurses caught Richard Speck's malevolent eye.

At around 11:00 p.m. on July 13, 1966, twenty-three-year-old Corazon Amurao was awakened by a knock on her bedroom door. She opened it and found

Murderer Richard Speck, circa 1966.

herself face-to-face with a menacing stranger who was brandishing a .22-caliber pistol and a switchblade knife. Assuring the frightened young woman that he was "not going to hurt" her, the intruder—a drunken and doped-up Richard Speck—quickly rounded up the other five student nurses who were home at the time, herded them into a bedroom, and ordered them to lie on the floor. Using his knife to slice a bedsheet into strips, he proceeded to truss his terrified victims. Over the next hour, three more young women arrived at the town house. They, too, ended up bound and helpless on the bedroom floor, bringing the total number to nine.

The true horror commenced around midnight, when Speck untied Pamela Wilkening, led her into an adjoining bedroom, stabbed her in the breast, and

strangled her. Mary Ann Jordan and Suzanne Farris were next. Speck shoved them into another bedroom and savaged them with his knife.

Pausing to wash the blood from his hands, Speck returned to his ghastly work. One by one the young women were led into different bedrooms and brutally killed. The last to die was twenty-two-year-old Gloria Davy. Speck took his time with her—almost an hour—raping her twice before sodomizing her with a foreign object and strangling her to death.

It was half-past three in the morning when Speck, his bloodlust spent, slipped out of the town house. In his frenzy, however, he had lost count of his victims. One of them, Corazon Amurao, had managed to roll under a bunk bed and remain concealed throughout Speck's rampage, stifling the whimpers of horror that rose in her throat as she listened to the slaughter taking place just beyond her hiding place. Paralyzed with terror, she stayed there until daybreak, when she wriggled out from under the bed, climbed onto a window ledge, and began shrieking, "They're all dead! My friends are all dead! Oh, God, I'm the only one alive!"

As headlines across the country trumpeted news of the massacre—"the crime of the century," according to Chicago officials—its perpetrator returned to his low-life routine of boozing and whoring. In the meantime, Corazon Amurao, though heavily sedated in the wake of her trauma, managed to provide detectives with a detailed description of the attacker. It wasn't long before investigators knew the name of the man they were hunting.

Learning that he had left a survivor and that the police were close on his trail, Speck decamped for an even seedier part of town. Holed up in a dive where fetid, five-by-eight cubicles could be rented for ninety cents a night, he ended up slashing his wrists with the shards of a smashed wine bottle. He was taken to Cook County Hospital, where a young physician, Dr. Leroy Smith, who had been following the case in the papers, recognized the distinctive tattoo on his arm: Born to Raise Hell. When Speck begged for some water, Smith grabbed the back of his neck, squeezed the pressure point as hard as he could, and demanded, "Did you give water to those nurses?" Then he called the police.

Speck's trial, which took place in Peoria after the defense requested a change of venue, opened on April 3, 1967. Its dramatic highpoint occurred when Corazon Amurao was asked if she could identify the killer: she stepped from the witness box, walked directly up to Speck, leveled her finger at his face and said, "This is the man!" On April 15, after forty-nine minutes of deliberation, the jury brought in a guilty verdict, and he was sentenced to death.

When the death penalty was declared unconstitutional in 1972, Speck was resentenced to eight consecutive terms of 50–150 years. He suffered a fatal heart attack in the Stateville penitentiary on December 5, 1991, just shy of his fiftieth birthday. Four years later, an unspeakably obscene videotape came to light, showing Speck—who had somehow managed to acquire female hormones while behind bars and now sported a floppy set of breasts, along with women's panties and a blond bobbed hairdo—joking about his murders, snorting cocaine, and performing fellatio on his African American lover. Asked by the off-screen cameraman why he had murdered the eight young women, the monstrously repulsive Speck replies with a shrug, "It just wasn't their night."

TO DIE FOR (1995)

DIRECTED BY GUS VAN SANT. WRITTEN BY BUCK HENRY. WITH NICOLE KIDMAN, JOAQUIN PHOENIX, MATT DILLON, CASEY AFFLECK, ILEANA DOUGLAS, DAN HEDAYA, WAYNE KNIGHT, KURTWOOD SMITH, HOLLAND TAYLOR, AND DAVID CRONENBERG.

Though it's classified as a comedy, Gus Van Sant's *To Die For* isn't exactly full of yuks. A scathing satire on America's obsession with celebrity (no matter how sleazily achieved), it's a seriously unsettling film, ultimately more chilling than funny. It's no surprise that its director went on to film the deeply disturbing school-shooter drama *Elephant* (see p. 99), as well as a controversial remake of *Psycho*.

Indeed, Suzanne Stone—the lethally ditzy main character, played to perfection by Nicole Kidman—is every bit as sociopathic as Norman Bates. Beneath her cheerleader exterior, she is a frighteningly ruthless femme fatale whose single-minded ambition is to make it big in the media. The credo she lives by is repeated throughout the film: "You aren't really anybody in America if you're not on TV. Because what's the point of doing anything worthwhile if nobody's watching?"

Inconveniently, she happens to be wed to Larry Maretto, an easygoing lug (engagingly played by Matt Dillon) whose old-fashioned family values are in conflict with Suzanne's hard-driving, completely egotistical dreams. When Larry puts his foot down and refuses to move to Los Angeles, his wife has no other choice than to arrange for his cold-blooded murder. Employing her considerable sexual charms, she seduces a lovestruck, high school loser named Jimmy Emmett (a creepily effective Joaquin Phoenix in his first major role) and enlists him and a pal to do the job. The crime rockets Suzanne onto the front page of every tabloid in the country, providing her (however briefly) with the kind of media celebrity that she's always coveted.

The story ends on a deeply gratifying note as Suzanne gets her just deserts at the hands of a "Hollywood producer" (played by horror director David Cronenberg) who is really a Mafia hit man hired by the late Larry's vengeance-seeking father (Dan Hedaya).

The film (with a wickedly clever script by Buck Henry, who puts in an appearance as a sour-tempered high school teacher) was based on a novel by Joyce Maynard (also seen in a cameo as Suzanne's lawyer). Its ultimate source, however, was the true-life case of twenty-two-year-old Pamela Smart (née Wojas). Smart wasn't an insanely ambitious cable-TV weather girl, like her fictional counterpart. Nor was she whacked by a suave mafioso. But in most other respects, *To Die For* sticks close to the facts of her sensational story.

Born in Miami, Pam moved to New Hampshire at an early age, when her parents decided that the crime-ridden city was no place to raise their little girl. Full of warm memories of her native state, she returned to Florida for college. While visiting her parents in New Hampshire for spring break, she met and fell in love with a handsome young insurance salesman named Greg Smart. Two years later, they were married.

Pam went to work at a local high school as the director of the media center. To all outward appearances, she and Greg seemed like perfectly contented newlyweds. In reality, their marriage was troubled from the start. Just seven months after they tied the knot, Greg confessed that he'd already had a fling with another woman.

At the time, Pam was running the high school's drug and alcohol awareness program. One of her student counselors was a shy, slender fifteen-year-old named Billy Flynn. Before long, Billy found himself the object of

Nicole Kidman in a promotional photo for *To Die For*, 1995.

Pam's increasingly overheated attentions. She began sending him cheesecake snapshots of herself in skimpy bikinis. One weekend in February, while her husband was away on a trip, she invited Billy to stay overnight in her condominium. They drank liquor while watching the cheesy S&M movie *9½ Weeks*. Later that night, they became lovers.

The fifteen-year-old boy—who had never had sex before—must have felt as if he'd died and gone to X-rated heaven. He quickly found himself in thrall to the older, far more experienced woman. Just like the character in the movie, Pam began telling her teen lover that her husband was a violently abusive beast. She couldn't divorce him, however, without losing everything—her furniture, the condo, even her beloved little dog. The only possible solution was disposing of Greg.

At first, Billy shrugged off the suggestion. Pam, however, became increasingly insistent and threatening. In effect, she began sexually blackmailing the boy. If he wanted to keep their relationship going, he would have to kill Greg. Otherwise, she would find someone else—someone more worthy of her favors—to do the job.

With the inducement of $500 apiece (to be procured from Greg's life insurance policy), Billy enlisted the help of two high school pals, Patrick "Pete" Randall

and Vance "J. R." Lattime. On the night of May 1, 1990, while Pam was busily (and conveniently) engaged elsewhere, Billy and Pete entered the Smarts' condo through the back door, which had been left unlocked by prearrangement. After ransacking the place to make it look as if it had been burglarized, they waited for Greg to get home. As soon as he stepped through the door, the two boys grabbed him, forced him to his knees, and held a butcher knife to his throat. While the twenty-four-year-old man pleaded for his life, Billy pulled out a .38-caliber revolver and shot him once through the head. The two teen assassins then fled the condo and escaped in a getaway car driven by J. R. Lattime.

In the days following the murder, rumors abounded. Greg, some people said, had been bumped off because of gambling debts he'd run up in Atlantic City. Others claimed that the Hell's Angels were involved. In the meantime, Pam seemed suspiciously lighthearted for a young, devoted widow whose spouse had just been savagely murdered in the front hallway of their home. She seemed to revel in all the media attention being lavished on her and couldn't wait to clear the condo of her dead husband's possessions.

Greg's devastated parents (particularly his father, with whom Greg had been especially close) became increasingly suspicious of Pam. So did investigators. Within a very short time, those suspicions were confirmed by an anonymous phone call to the local police, tipping them off to Pam's involvement with Billy Flynn. On June 12, 1990, the three boys were arrested and, soon afterward, certified to stand trial as adults. Faced with the prospect of life imprisonment, Billy broke down and confessed.

At first, Pam professed absolute shock and disbelief at Billy's confession. Indeed, she claimed they'd never been lovers. Under pressure from police, however, another high schooler—a girl named Cecelia Pierce, who had been Pam's student aide and confidante—verified Billy's account, insisting that she'd once walked in on the mismatched lovebirds while they were having sex. Allowing herself to be wired, Cecelia recorded a highly incriminating conversation with Pam in which the pretty, perky, oh-so-innocent young woman spewed an ugly, profanity-ridden diatribe that amounted to a full confession.

Brought to trial in 1991, Pam continued to claim that, while she might have made an error in allowing her feelings for Billy to get out of hand, she had nothing to do with the murder. The romantically obsessed Billy, she insisted, had committed the murder entirely of his own accord, driven by sexual jealousy. In

the end, however, the jury found Billy's tearful, lurid tale of sexual manipulation at the hands of the scheming, older woman far more convincing. On March 22, 1991, Pam Smart was found guilty of being an accomplice to first-degree murder, conspiracy to commit murder, and witness tampering. She was sentenced to life imprisonment without the possibility of parole.

Billy Flynn and his two accomplices received sentences for second-degree murder. All three have since been paroled. Pam Smart, who has earned two master's degrees while in prison and still stoutly maintains her innocence, remains behind bars.

WHILE THE CITY SLEEPS (1956)

DIRECTED BY FRITZ LANG. WRITTEN BY CASEY ROBINSON. WITH DANA ANDREWS, RHONDA FLEMING, VINCENT PRICE, IDA LUPINO, GEORGE SANDERS, THOMAS MITCHELL, JOHN BARRYMORE JR., AND JAMES CRAIG.

The penultimate American film by the great émigré director Fritz Lang, *While the City Sleeps* (based on the 1953 novel *The Bloody Spur* by Charles Einstein), features Vincent Price as Walter Kyne, a low-budget Citizen Kane who, after inheriting a major metropolitan newspaper at the death of his father, creates a cutthroat competition among three of his top employees. A serial sex killer is stalking the city. The slimy Kyne decrees that whichever of the trio cracks the case will be rewarded with the plum post of executive director.

Though advertised as an edge-of-the-seat thriller ("Suspense as startling as a strangled scream!" ran the tagline), *While the City Sleeps* devotes much of its screen time to the machinations of the three rivals for the big corporate prize: wire-service honcho Mark Loving (played by the ever-oily George Sanders), crusty newspaper editor John Day Griffith (Thomas Mitchell, best known to moviegoers as Scarlett O'Hara's father in *Gone with the Wind* and Jimmy

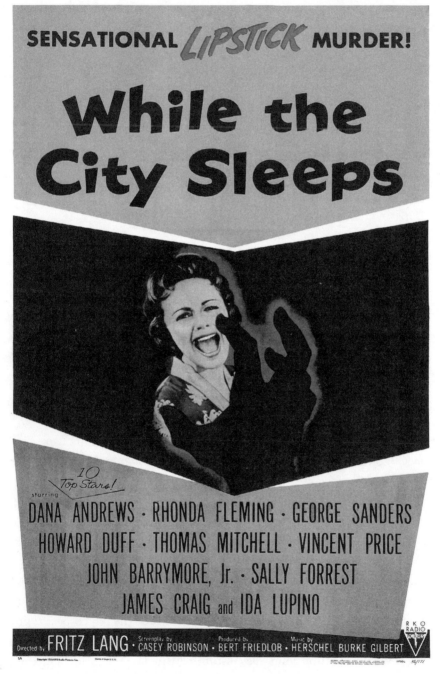

While the City Sleeps US poster art from 1956.

Stewart's hapless Uncle Billy in *It's a Wonderful Life*), and photo editor Harry Kritzer (James Craig), who, in his spare time, is cuckolding Kyne with the latter's bombshell wife, Dorothy (Rhonda Fleming). The movie's protagonist, Edward Mobley (film noir stalwart Dana Andrews), is a hard-drinking, skirt-chasing, Pulitzer Prize–winning journalist who finally forces the killer into the open by the highly dubious means of using his own fiancée as bait.

For fans of true crime, the real attraction of the movie is, of course, the villain, a psycho killer named Robert Manners, played to maniacal perfection by John Barrymore Jr., scion of the legendary acting family. In the precredit sequence, he invades the apartment of a twenty-three-year-old librarian who is about to step into the bathtub. What happens next is left to the viewer's imagination. We are subsequently informed that, before fleeing the crime scene, the killer used his victim's lipstick to scrawl "Ask Mother" on the bedroom wall—a taunting clue that earns him the tabloid nickname "the Lipstick Killer." In the film's climactic scene, he is nabbed by cops after an exciting chase scene through a subway tunnel with Mobley in pursuit.

In bringing the monstrous Manners to the screen, Lang and his writer, Casey Robinson, clearly drew on every criminal boogeyman that haunted Eisenhower-era America. The killer's fashion sense is straight out of the teenage-rebel handbook: black leather jacket, motorcycle cap, ducktail hairdo Brylcreemed to a high polish. In an age obsessed with Freudian psychopathology, he is depicted as in the grip of a lethal Oedipal complex, driven to sadistic murder by his repressed hatred of his mommy. He is also a compulsive reader of crime comic books, the leading cause of juvenile delinquency, according to child-rearing experts of the time.

The most direct influence on the creation of this nightmarish creep, however, was an actual serial murderer who terrorized Chicago in 1946 and was dubbed, like his fictional counterpart, "the Lipstick Killer."

At around 1:00 p.m. on June 5, 1945, the nude body of a forty-three-year-old Chicago woman, Mrs. Josephine Alice Ross—"an attractive twice-divorced widow" (as newspapers described her)—was discovered by her teenage daughter, Jacqueline, a clerk in a neighborhood grocery store, who had come back to the

family apartment for lunch. Sprawled on a tumbled bed, Mrs. Ross had been stabbed repeatedly in the face and neck, and her jugular vein had been severed. A red evening gown, secured with a nylon stocking, was wrapped around her head, as though to conceal the dreadful injuries. Though the bedsheets were drenched in blood, there was none on her body. Bloody water in the half-filled bathtub indicated that her killer had washed the corpse clean. He had also closed the gaping wound in her throat with a piece of adhesive tape, though not—as the medical examiner determined—before she had bled to death. Crime-lab technicians made a painstaking search of the apartment, but the killer had scrubbed the place clean of fingerprints.

The local press gave prominent coverage to the Ross slaying and the fruitless police search for her killer, but it wasn't until his next murder that the case exploded into the national headlines and earned him the sinister nickname by which he would forever be known. On December 10, Mrs. Martha Engles, a maid at a residential hotel on Chicago's north side, came to clean the apartment of Frances Brown, a thirty-year-old stenographer, recently discharged from the WAVES after her honorable wartime service. The maid found Brown's half-naked corpse draped head down over the bathtub, her pajama top wrapped around her neck. When police removed it, they discovered a ten-inch bread knife shoved through her throat. She also had been shot twice, in the head and right arm. As in the Ross murder, the killer had carefully washed the body, as indicated by a heap of bloody towels on the bathroom floor.

It was clear to the authorities that the Brown and Ross murders were the gruesome handiwork of the same perpetrator. What made the latest crime so sensational, however, wasn't the proof of a homicidal maniac on the loose in Chicago. It was the bizarre message left at the crime scene. Inscribed in red lipstick on the living room wall were the words:

FOR HEAVENS

SAKE CATCH ME

BEFORE I KILL MORE

I CANNOT CONTROL MYSELF

"The Mad Lipstick Killer," as one newspaper called him, committed his third, last, and most horrific crime less than one month later. Just after midnight on January 7, 1946, six-year-old Suzanne Degnan, daughter of a Chicago city executive, was abducted from her first-floor apartment bedroom. A ransom note demanding $20,000 in exchange for the child's safe return was left at the crime scene. As events quickly proved, however, it was a hollow offer. Late that same afternoon, police found Suzanne's severed head in a sewer not far from the Degnans' home. Other body parts—left leg, severed at the hip; right leg and buttocks; lower torso with a portion of thigh attached—were recovered from various sewers in the following hours. Six weeks would pass before two Con Edison workers found the little girl's arms.

Panic seized the city. At the order of the mayor, Edward J. Kelly, one thousand temporary police officers were added to the force, assisting in the biggest manhunt in the city's history. Though the killer had spattered his ransom note with oil to obscure any fingerprints, the FBI experts managed to retrieve the clear print of a left pinkie finger. "This is one crime that is going to be solved," declared State's Attorney William Tuohy.

Six months later, on the evening of Wednesday, June 26, 1946, several tenants of an apartment house in north Chicago notified the janitor, Francis Hanley, that there was a prowler in the building: a dark-haired young man had entered an unlocked third-floor apartment, then rushed down the stairs when confronted by an alert neighbor. Hurrying to the lobby, Hanley came face-to-face with the youth, who pulled a pistol and threatened to let the janitor "have it in the guts" if he didn't get out of the way. Stepping aside, Hanley let the stranger go, then telephoned the police.

Quickly arriving at the scene, Detective Tiffin P. Constant cornered the suspect, who was crouched on the rear stairway of a nearby building. The young man aimed his gun at Constant and began working the trigger, but his weapon was jammed. He hurled it at Constant's head, then flung himself down onto the detective. As the two men grappled ferociously, an off-duty officer, Abner T. Cunningham, who had just returned from the beach and was still in his swimming trunks, ran up, grabbed three flowerpots sitting on a porch rail, and battered the assailant into unconsciousness.

Taken to Bridewell Hospital, the young man—"a husky six-footer," as the papers described him, with "powerful shoulders [and a] massive hairy

chest"—was quickly identified as William Heirens, a seventeen-year-old University of Chicago student who had already accumulated a lengthy criminal record. A compulsive housebreaker, he had been convicted of nearly two dozen burglaries before the age of fourteen and had spent time in several homes for wayward boys. Searching his dorm room, police found two suitcases crammed with stolen goods: jewelry, watches, war bonds, and more, along with several handguns. What at first appeared to be a relatively minor burglary case—the earliest article on Heirens's arrest was buried on page thirteen of the *Chicago Daily Tribune*—became a front-page, nationwide sensation when police matched the fingerprint of Heirens's left pinkie finger to the print recovered from the Degnan ransom note.

Strapped to his hospital bed, Heirens was subjected to a three-day interrogation that, at least according to certain accounts, included genital torture, vicious pummeling by police, and the usual relentless grilling under a blazing spotlight. On the fourth day, he was injected with sodium pentothal. Under the effects of this "truth serum," he claimed that the crimes had been committed by an evil alter ego, George Murman, whose last name, as the papers were quick to declare, was evidently a contraction of *murder man*. Though psychiatrists dismissed the claim as a ploy to establish his insanity, their examination of Heirens revealed a pathological personality in thrall to a powerful sexual fetish.

It first manifested at the age of nine, when he began stealing women's panties, "at first from clothes lines, then from basements, and later from strange houses, the doors of which he found open or ajar." At home, he would put the panties on and "experience sexual completion." By the age of thirteen, he was a compulsive housebreaker. Though his primary object remained women's underwear, he had decided that it was "sort of foolish to break in and not take anything" else. The mere act of sneaking through a window induced such excitement in him that he would occasionally have multiple orgasms. "Often," as his examiners noted in their report, "when sexual completion occurred in the entered room, it was preceded by defecation or urination or both. He would leave the consequences in the room." As for "normal sexual stimulation and experience," they were "unpleasant, indeed repulsive to him." When he kissed a girl, he said, "he would burst into tears and vomit."

To avoid the electric chair, Heirens confessed to all three slayings. Soon after being sentenced to three consecutive life terms, he recanted his confession

and maintained his innocence. Many supporters agreed that he was railroaded, pointing to another suspect—a drifter named Richard Russell Thomas with a long record of brutal crimes—as the likelier culprit. A model prisoner, Heirens became the first convict in Illinois to earn a degree from a four-year college. He achieved another distinction, too. When he died in March 2012 at the age of eighty-three years—more than sixty-five of them spent behind bars—he was the fourth-longest-serving prisoner in US history.

THE SNIPER

Another movie influenced by the William Heirens case is the gripping 1952 thriller *The Sniper*. In the years immediately following the end of World War II, America was gripped by a so-called sex-crime panic. Thanks to the sensationalistic reporting of the popular press and the fear-mongering proclamations of FBI director J. Edgar Hoover, the public became convinced that, as Hoover declared, a virtual army of "degenerate sex offenders" was on the loose in the country, "posing a sinister threat to American childhood and womanhood." A product of this media-fueled mass hysteria (which did not begin to subside until the mid-1950s), *The Sniper* begins with a title card announcing that, during the "last year alone," no fewer than "31,175 women" had fallen victim to sex criminals. The film about to be presented was the story of one such frightening case: "a man whose enemy was womankind."

That female-hating psycho is a lonely, seemingly mild-mannered bachelor, Eddie Miller (Arthur Franz), a World War II veteran now working as a deliveryman for a dry-cleaning company in San Francisco. We learn that Eddie has a history of assaulting women and has recently been released from prison, where he received psychiatric treatment. (This being the Freud-besotted 1950s, we are given to believe that his detestation of the opposite sex derives from his unresolved mother complex.) Tormented by his urges to kill women, he attempts to get himself incarcerated in a mental hospital by scorching his hand on a red-hot stove top but is turned away by overworked physicians. When one of his sexy female customers invites him into her apartment, offers him a beer, changes out of her dress and into a bathrobe,

and then kicks him out when her boyfriend shows up, his barely suppressed misogynistic rage boils over; he embarks on his murder spree, picking off attractive brunettes with his M1 rifle from rooftops around the city.

To the local tabloids, the serial shooter is a monster—"the Rifle Fiend," as he is labeled. The movie, however, offers a different perspective. Produced by the politically progressive filmmaker Stanley Kramer (responsible for such high-minded fare as *The Defiant Ones* and *Guess Who's Coming to Dinner?*), it portrays Eddie as a sick man, struggling against homicidal impulses that he is powerless to control. In a scene clearly inspired by the Heirens case, he inscribes a message on a scrap of cardboard from one of his ammunition boxes: "TO THE POLICE—<u>STOP</u> <u>ME</u>—FIND ME AND STOP ME—I'M GOING TO DO IT <u>AGAIN</u>." When the cops finally do track him down, they find him seated on his bed, clutching his rifle like a teddy bear, his eyes welling with tears of both sorrow and relief.

A WOMAN'S VENGEANCE (1948)

DIRECTED BY ZOLTAN KORDA. WRITTEN BY ALDOUS HUXLEY. WITH CHARLES BOYER, JESSICA TANDY, ANN BLYTH, CEDRIC HARDWICKE, MILDRED NATWICK, AND RACHEL KEMPSON.

I t's a safe bet that, apart from serious students of classic cinema, few people below retirement age would recognize the name Charles Boyer (pronounced Boy-YAY). During Hollywood's golden age, however, he was a major star. In the course of his career, he appeared in more than eighty films, epitomizing the debonair Frenchman no woman could resist. He was so closely associated in the popular mind with that romantic role that, when the makers of Looney Tunes created Pepé Le Pew, the amorous skunk with the Gallic accent, they based the character on Boyer.

One of the most intriguing movies in Boyer's filmography is 1948's *A Woman's Vengeance*. Part murder mystery, part courtroom drama, part psychological study of a mind torn between hatred and guilt, it is the kind of sophisticated,

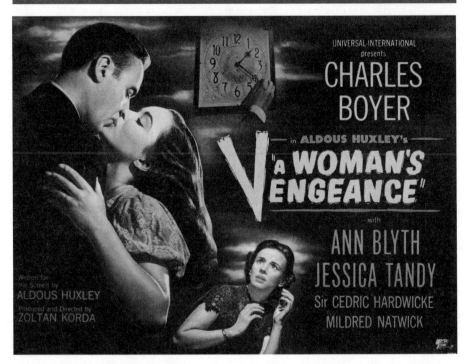

Poster art for *A Woman's Vengeance*, 1948.

thought-provoking movie that Hollywood studios used to turn out by the hundreds before the era of blockbuster comic-book franchises.

Though Boyer's ultimate plight in the film elicits a certain degree of sympathy, he is far from a heroic—or even a very likable—character. He plays Henry Maurier, a dashing, middle-aged philanderer, who lives off the money of his wealthy wife, Emily (Rachel Kempson), a whiny, self-pitying invalid who does nothing but lie around on her settee feeling sorry for herself. At the climax of one of their frequent arguments, she cries out, "You can't deny it, you do wish I were dead!" The exasperated Henry replies, "I certainly shall if you go on much longer like this!" Unfortunately, the remark will come back to haunt him, thanks to Emily's busybody nurse, Caroline Braddock (renowned character actress Mildred Natwick), who bears no great love for Henry.

After storming out of the house, Henry seeks out close family friend Janet Spence (Jessica Tandy, the legendary stage actress who originated the role of Blanche DuBois in *A Streetcar Named Desire* and costarred in several dozen movies, including Alfred Hitchcock's *The Birds*). An attractive thirty-something woman on the verge of spinsterhood, Janet makes no secret of her adoration of

Henry, who is oblivious of the effect that his suave, continental manners have on her. Watching them together, the viewer, like Janet, might believe that her erotic attraction to him is reciprocated. Unlike Janet, we quickly learn otherwise when Henry bids her goodbye and proceeds directly to his chauffeur-driven limousine, where his gorgeous eighteen-year-old mistress, Doris (the ravishing Ann Blyth), is waiting in the back seat.

The next day, Janet visits the Mauriers and, while Henry goes off to fetch his wife's medication, slips a lethal dose of arsenic into Emily's coffee. Given her precarious health, Emily's death is attributed to natural causes. With Emily out of the way, Janet assumes that she will become the new Mrs. Maurier. Hardly has the murdered woman been consigned to the grave than Janet declares her love for Henry—only to be informed that he has already married his teenage lover.

In the meantime, Nurse Braddock, who recalls Emily's accusation that her husband wished her dead, suspects that her mistress was murdered. When Emily's body is exhumed and the poison discovered, Henry is charged with homicide. Janet, who has become consumed with hatred for Henry and a burning desire to see him suffer (hence the movie's rather heavy-handed title), gloats when he is tried, convicted, and sentenced to death. At the same time, she is gripped with Lady Macbeth–like guilt over her crime. Unable to sleep and haunted by visions of Emily's agonizing death, she comes under the treatment of kindly, all-seeing Dr. Libbard (Cedric Hardwicke, the celebrated British actor whose many films include Hitchcock's *Suspicion* and Cecil B. DeMille's *The Ten Commandments*). The movie becomes a race-against-the-clock thriller as Libbard, who has come to perceive the dark secret behind Janet's tortured mental state, tries to extract a confession from her before Henry's time runs out.

The psychological complexity of the characters in *A Woman's Vengeance* is no surprise, given the credentials of its screenwriter, Aldous Huxley, the English novelist and philosopher, whose famous books include *Brave New World* and *The Doors of Perception* and who based his script on his short story "The Gioconda Smile." That story, in turn, was inspired by a sensational real-life case, the Greenwood Poison Mystery. In contrast to the fictional Henry Maurier—a Frenchman with no gainful employment who lives off his wife's money—Huxley's real-life prototype, Harold Greenwood, was a Yorkshire lawyer (specifically, what the British call a solicitor, a legal professional who writes contracts, draws up wills, and handles other paperwork but doesn't argue cases

in court). In 1898, at the age of twenty-three, he and his wife, Mabel—two years his senior and the sister of a former mayor of London—moved to Wales, where they purchased a large home in the town of Kidwelly and eventually raised four children.

By 1919, the forty-six-year-old Mrs. Greenwood had aged into a gray-haired, prematurely wizened semi-invalid. In addition to frequent fainting spells, she had begun to suffer from bouts of abdominal pain and severe diarrhea, ailments that the family physician, Dr. T. R. Griffiths, attributed to menopause ("change of life," in the euphemism of the day) and treated with various nostrums.

Immediately before lunch on Sunday, June 15, 1919, Greenwood, who had been working in his flower garden, went into the little pantry beside the dining room, where—somewhat to the surprise of the parlormaid, Hannah Williams—he spent a full twenty minutes before joining his family at the table. The meal consisted of cold lamb, vegetables, and gooseberry tart. Mrs. Greenwood washed down her food with a glass of burgundy from a decanter that was kept in the pantry.

Not long after the meal ended, Mrs. Greenwood was stricken with intense stomach cramps. "It must have been the gooseberry tart," Mrs. Greenwood groaned. "It always disagrees with me."

When his wife's distress became even more acute—"a suffocating pain like a red-hot skewer over [my] heart," as she described it—Greenwood went to summon Dr. Griffiths. Though the physician lived just across the road, a half hour passed before Greenwood returned with him.

Griffiths gave the ailing woman some bismuth powder and a few sips of brandy for her nausea. Then, at Greenwood's invitation, he went outside into the garden, where the two men played several rounds of the lawn game known as clock golf.

The doctor returned to his own house around dusk after giving the patient two pills—morphia, he said, to help her sleep. Within an hour or so, however, the poor woman became so violently ill that, once again, her husband went for the doctor. This time, he stayed away for nearly an hour, chatting with the doctor's sister, Miss May Griffiths, whose friendship with Greenwood was a source of bitter jealousy to his wife. When he finally returned, he was alone. The doctor was asleep and couldn't be roused, he explained to the night nurse keeping watch over his wife.

When Mrs. Greenwood's condition deteriorated even further, the nurse herself ran across the road, awoke the doctor's household, and brought him back with her. By then, however, Mrs. Greenwood had fallen into a coma and was unresponsive to the doctor's ministrations. She died in the early morning hours of Monday, June 16. Dr. Griffiths listed the cause of death as "valvular disease of the heart."

The story might have ended there had it not been for Greenwood's highly indiscreet behavior in the wake of his wife's sudden death. Within weeks of her burial, he was actively wooing two women: May Griffiths, to whom he penned a letter proclaiming her to be "the one I love most in this world," and a woman named Gladys Jones, daughter of the local newspaper publisher, who was soon sporting a diamond engagement ring. Just four months after the death of Harold Greenwood's first wife, Gladys Jones became his second.

Unlike Charles Boyer's Henry Maurier, who marries a woman of barely legal age, Greenwood was no cradle robber. At thirty years old, the former Miss Jones was an age-appropriate mate for the forty-five-year-old solicitor. Still, she was considerably younger than the recently deceased Mabel. That fact, plus the unseemly speed with which Greenwood had remarried, scandalized his close-knit community.

Rumors that the solicitor had hastened his wife to her grave began to spread. By the spring, they had reached the ears of authorities, who undertook a quiet investigation into the case. When they discovered that, just prior to Mabel Greenwood's last meal, her husband had purchased two packages of a weed killer in which the main ingredient was arsenic, her corpse was exhumed, examined, and found to contain traces of the poison. On June 17, 1920, a year after his wife's death, Harold Greenwood was charged with her murder.

The trial began on November 2, 1920. Partly because it was a rare case in which a member of the legal profession was accused of murder and partly because of the ostensibly prurient motive for the crime—a still-virile middle-aged man eager to dispose of his invalid wife so that he could take a younger woman into his bed—the proceedings became an international sensation, keeping newspaper readers on both sides of the Atlantic transfixed for the week of its duration. Greenwood was represented by Britain's famed barrister Sir Edward Marshall Hall, whose brilliant oratory and dramatic courtroom triumphs had earned him the honorific "the Great Defender."

The testimony of medical experts and lay witnesses was rife with contradictions. On the prosecution's side, Dr. William Wilcox declared positively that Mabel Greenwood's death was "due to heart failure consistent with prolonged vomiting and diarrhea, due to arsenical poisoning." Defense expert Colonel Toogood, on the other hand, asserted that she "died from morphia poisoning, following acute gastroenteritis set up by eating gooseberry skins."

Dr. Griffiths created a stir when he claimed that he had been mistaken about the sleeping pills he had given Mrs. Greenwood. They were not morphia—which, he conceded, might have accidently killed his patient—but the less potent opium. His apparent confusion about the drugs he dispensed made it possible for Hall to suggest that the physician himself had inadvertently administered arsenic in the form of a then-popular tonic known as Fowler's solution, which included potassium arsenite.

When the parlormaid, Hannah Williams, testified that Greenwood had spent a suspiciously long time alone in the pantry just before the fateful lunch—during which, she suggested, he could have easily tampered with the burgundy favored by his wife—Irene Greenwood, the defendant's eldest daughter, countered that her father had been outside washing his car during that period. Rebutting the maid's assertion that Mabel had been the only person to drink the ostensibly poisoned wine, Irene also insisted that she had taken a glass of it at lunch and suffered "no ill effects."

In his fiery summation, prosecutor Sir Edward Marlay Samson denounced the defendant as a "conscienceless ingrate" who cared for nothing but the pursuit of his own pleasure—"a rural Don Juan who made love to every woman who crossed his path." Hall countered with an uncharacteristically short address lasting less than thirty minutes, in which he argued that his client was nothing more than "the victim of gossip."

The prosecution's contention that Greenwood had slipped arsenic into his wife's burgundy, Hall declared, was completely undercut by Irene Greenwood's testimony that she had drunk the supposedly poisoned wine at lunch and felt perfectly fine afterward. Reminding the jurors that "only a 127th part of a grain of arsenic was found in the whole of Mrs. Greenwood's viscera," he cited Alfred Swaine Taylor's standard work, *Principles and Practices of Medical Jurisprudence*, which stated that "unless a grain, or practically a grain [of arsenic], was found in a person's viscera, it was not safe to say a person died of arsenical poisoning."

Given the fragile state of Mabel Greenwood's health, it was entirely possible, even likely, that Dr. Griffith's admitted "blunder" in dispensing his medicines "had hastened her demise." Greenwood's hasty remarriage was not a sign of his supposed promiscuity but of the opposite—proof of his deeply monogamous nature, of the "desolation which had come to him with [his wife's] passing" and his "consuming desire for congenial companionship."

The outcome of the Greenwood trial differed dramatically from that of the wrongly accused Henry Maurier. After six hours of deliberation, the jury voted for acquittal, explaining in a note attached to the written verdict that, while they were "satisfied on the evidence of the case that a dangerous dose of arsenic was administered to Mabel Greenwood," they were "not satisfied that this was the immediate cause of death. The evidence before us is insufficient and does not conclusively satisfy us as to how and by whom the arsenic was administered. We therefore return a verdict of not guilty."

A celebratory Harold Greenwood returned to Kidwelly and, after selling an exclusive interview to a newspaper syndicate for £3,600, settled back into his domestic life, this time with his new wife. The following year, he was awarded an additional £150 after suing the proprietors of a Cardiff wax museum, who had included his effigy, alongside those of various notorious murderers, in their Chamber of Horrors.

YOU ONLY LIVE ONCE (1937)

DIRECTED BY FRITZ LANG. WRITTEN BY C. GRAHAM BAKER AND GENE TOWNE. WITH SYLVIA SIDNEY, HENRY FONDA, BARTON MACLANE, JEAN DIXON, WILLIAM GARGAN, JEROME COWAN, AND MARGARET HAMILTON.

The son of a failed tenant farmer turned junk man, Clyde Barrow was raised in such hardscrabble circumstances that, when the Great Depression hit in 1929, his family—already eking out a bare-bones existence in a West Dallas campground—hardly noticed. By then, the twenty-year-old Clyde—a preening sociopath with a taste for fancy clothes and "high livin'" far beyond his impoverished means—had already embarked on a career of petty criminality. Under the influence of his ne'er-do-well older brother, Buck, he quickly progressed from hijacking a truckload of turkeys to housebreaking and car theft.

The pair's first serious run-in with the law occurred in November 1929 when, heading home in a stolen Ford after a disappointing night of burglary, they broke into a small-town garage and absconded with a locked safe. Chased down by police, Buck was shot in the legs, captured, and ultimately sentenced to four years in prison, while Clyde, after hiding all night underneath a house, managed

to escape. Two months later, he met the woman with whom his name would forever be linked.

A slight, sharp-featured, amoral nineteen-year-old with delusions of grandeur, Bonnie Parker believed that she was destined for greatness as a Broadway actress, movie star, or renowned poet, despite all evidence to the contrary. After an abortive marriage at sixteen—commemorated with a double-heart tattoo on the inside of her upper right thigh—she found herself stuck in a soul-crushing life as a waitress and part-time prostitute. Desperate for excitement—"bored crapless," as she put it—she was dazzled by the sharp-dressing, fast-living Clyde, whose daring criminal escapades offered a way out of her dead-end existence. They immediately became a couple.

No sooner had they embarked on their affair than Clyde was arrested for seven counts of burglary and sentenced to two years behind bars. He immediately enlisted his new girlfriend in a breakout scheme. Smuggling a gun into jail during one of her visits, the drama-hungry Bonnie finally found herself in the thrilling role of gangster's moll. Clyde pulled off his escape but was swiftly captured. This time, he was sent to Eastham prison farm, a notorious hellhole, where he was assigned to backbreaking field work and regularly raped by a sadistic overseer. After sixteen months of unendurable labor, he resorted to a desperate measure, chopping off two of his toes with an axe. In a bitter irony, just six days after this self-mutilation, he was granted a parole. He emerged from prison with a limp, a bitter hatred of the law, and a vow to his long-suffering mother (who had lobbied tirelessly for his early release) that he meant to go straight.

His resolve lasted roughly one month. Rounding up a bunch of like-minded confederates, he began pulling a string of small stickups to finance his big, ultimately abandoned scheme: a raid on the Eastham prison farm to free its inmates. Bonnie herself got a taste of life behind bars when their getaway car got stuck in the mud following the botched burglary of a hardware store and she was captured while attempting to flee on a mule. Persuading the authorities that she had been kidnapped by Clyde, she was released after three months.

Reunited, the pair embarked on the spree that would eventually earn the histrionic Bonnie the limelight she had always craved. Composed of a shifting cast of reprobates, including big brother Buck and his wife, Blanche, the Barrow Gang roamed from state to state—Missouri, Colorado, Oklahoma, Texas, Arkansas, New Mexico—hitting filling stations, luncheonettes, jewelry

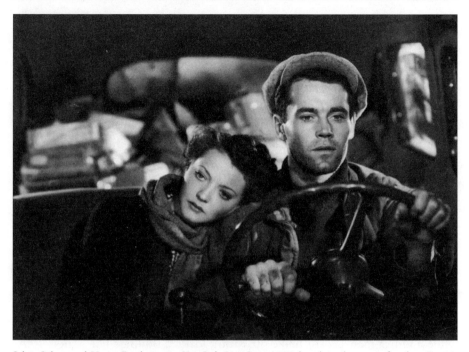

Sylvia Sidney and Henry Fonda star in *You Only Live Once*, 1937, based on the story of outlaws Bonnie Parker and Clyde Barrow.

shops, drug stores, groceries, and other small businesses, along with the occasional town bank. For the most part, they camped in the open or slept in their car. Though Clyde was capable of taking a police officer hostage, riding him around all night, then handing him bus fare and releasing him unharmed, he was also a cold-blooded killer, ultimately responsible for the murder of nine lawmen and three civilians. The gang suffered casualties of its own, most dramatically in July 1933, when—while holed up in some tourist cabins outside Platte City, Missouri—Buck suffered fatal wounds during a blazing gun battle with police.

By then, the increasingly brazen and violent activities of the Barrow Gang had made them front-page news throughout the Southwest. Their notoriety also owed much to the publicity-hungry Bonnie, who eagerly supplied newspapers with her doggerel poetry (most famously, "End of the Line," a.k.a. "The Story of Bonnie and Clyde"), along with photographs of the outlaw couple posing with guns and cigars. Though big-time gangsters like John Dillinger derided

them as penny-ante crooks—a view shared by J. Edgar Hoover—the reckless, shoot-'em-up exploits of the rampaging couple captured the public imagination.

The Barrow Gang might have been regarded as criminal small fry by the FBI, but after Clyde staged a daring raid on a prison to free a trusted confederate, Texas authorities became hell-bent on wiping them out. To that end, they hired Frank Hamer, a forty-nine-year-old former Texas Ranger and implacable man hunter. After three-and-a-half months on their trail, Hamer got word, via a double-crossing pal of Clyde's named Henry Methvin, that his quarry was hiding out in Bienville Parish, Louisiana. With the collusion of Methvin's father, Ivy, a trap was set for the fugitive couple. On May 23, 1934, Hamer and a posse of six other lawmen set up an ambush along a rural road regularly traveled by the pair. Ivy Methvin was planted along the side of the road, his truck jacked up as though he were fixing a flat. When Clyde slowed down to see what the trouble was, the posse opened fired, massacring the outlaws with a barrage of more than 150 shots. Scavengers were on the scene within minutes, jostling for morbid souvenirs. One man had to be restrained from scissoring off one of Clyde's ears, while another managed to make off with a lock of Bonnie's hair. Though the two had been local outlaw legends in life—their notoriety largely restricted to the Southwest—their death brought them the nationwide publicity that Bonnie had always craved. BARROW AND WOMAN ARE SLAIN BY POLICE IN LOUISIANA TRAP read the page-one headline of the next day's *New York Times*. The subhead continued, AMBUSCADE ON HIGHWAY ENDS LONG CRIMINAL CAREER OF THE PAIR.

To contemporary movie lovers, the definitive version of the Barrow Gang saga is Arthur Penn's 1967 *Bonnie and Clyde*, universally credited with kick-starting the golden age of 1970s American cinema. Three decades before that watershed movie, however, Fritz Lang's *You Only Live Once* brought the story of the notorious outlaw couple, in heavily fictionalized form, to the big screen.

The idea for the film originated with the great American novelist Theodore Dreiser (who knew something about turning true crime into powerful fiction, as demonstrated by his 1925 masterpiece, *An American Tragedy*; see p. 233). As Lang biographer Patrick McGilligan recounts, actress Sylvia Sidney (star of Lang's first American film, *Fury*) was dining out one night with producer Walter Wanger when Dreiser "stopped by their table. Dreiser mentioned that he had been researching the mid-1934 Southwest robbery spree of Bonnie and Clyde for a magazine piece he intended to write and commented that if anyone ever made a film about the

two bank robbers, Sidney would be perfect for the role of Bonnie Parker." Wanger promptly hired a pair of screenwriters famed for working at breakneck speed, who quickly churned out a script based on the fugitive lovers.

At the start of the film, we are introduced to Sidney in the role of Joan Graham, the pretty, perky secretary for public defender Stephen Whitney (Barton MacLane). Much to the dismay of everyone who knows her, Jo (as everyone calls her) has fallen hard for a small-time crook, Eddie Taylor, and plans to marry him as soon as he's paroled.

Played by Henry Fonda in the prime of his matinee-idol beauty, Eddie is an acknowledged "three-time loser" who is determined to go straight. Society, however, won't let him. Reflecting the temper of the time in which it was made—the Great Depression, when millions of ordinary citizens felt hopelessly victimized by the powers that be—Eddie's bosses consistently find excuses to fire him, despite his desperate pleas. Even the owners of the honeymoon resort where he and Jo plan to spend their wedding night won't let him forget his low-life status. "Ex-convicts and their wives aren't welcome in this hotel," declares the owner's wife (Margaret Hamilton, soon to be immortalized as the Wicked Witch of the West in *The Wizard of Oz*).

Framed for a terrible crime he had nothing to do with—an armored-car holdup that leaves six officers dead—Eddie plans to flee but is persuaded to turn himself in by Jo, who is sure that, being innocent, he will be exonerated. Her faith in the fairness of the justice system proves to be tragically naive when Eddie is tried, convicted, and sentenced to death. Stripped of his last vestiges of hope, Eddie turns bitterly against the entire world, Jo included. With the help of fellow inmates, he engineers an escape on the eve of his execution, shooting and killing a sympathetic priest, Father Dolan, just as word arrives that the true perpetrators of the lethal robbery have been identified and Eddie has been granted a last-minute pardon.

Reunited and reconciled with Jo, Eddie and his now-pregnant wife go on the lam. At this point, the film comes closest to recreating the Bonnie and Clyde saga. Living out of their car, knocking off the occasional gas station for fuel or food, they are portrayed in the press as murderous desperados, "blamed for every crime in the country." Even as the public pictures them enjoying the high life on the fortune they have reportedly robbed, the fugitives are holed up in a tumbledown hobo shack, where Jo gives birth. Intending to flee the country,

they decide to consign the baby to the care of Jo's sister (named, in an apparent nod to the film's inspiration, Bonnie). The handover takes place at an isolated motel—or "auto court," in the lingo of the time—whose proprietor recognizes Jo from a wanted poster and alerts the police.

Consistent with Lang's view of the implacable workings of fate, the movie climaxes with the preordained death of the doomed outlaw couple. The cruelly victimized Eddie, however, is granted a final absolution. As he dies with his slain lover in his arms, he hears the gentle voice of the all-forgiving Father Dolan issue from the great beyond: "You're free, Eddie! The gates are open!"

GUN CRAZY

Another pre–*Bonnie and Clyde* movie inspired by the exploits of the legendary pair is the 1950 cult film *Gun Crazy*. Directed by Joseph H. Lewis and cowritten, under the pen name Millard Kaufman, by the great blacklisted screenwriter Dalton Trumbo, this low-budget thriller begins by introducing us to thirteen-year-old Bart Tare (played by Russ Tamblyn, future leader of the Jets in *West Side Story*). Having clearly watched one too many cowboy movies, young Bart has become obsessed with firearms. Spotting a handsome six-shooter displayed in his local hardware store, he smashes the window with a rock, snatches the gun, and is promptly arrested and taken to court, where he is sentenced to spend the remainder of his adolescence in reform school.

After serving his time and doing a stint in the army, the grown-up Bart returns home, his gun mania as powerful as ever. Now played by John Dall (who would costar in another classic based on a true crime, Alfred Hitchcock's *Rope*; see p. 243), Bart reunites with his childhood buddies, newspaperman Dave and town sheriff Clyde (another minor character, like sister Bonnie in *You Only Live Once*, who is named in apparent tribute to the film's real-life inspiration). Attending a carnival with his pals, Bart is instantly smitten by the "famous, dangerous" markswoman, Annie Laurie Starr (Peggy Cummins), a sharpshooting beauty attired in sexy cowgirl regalia. In short order, Bart has joined her act, performing trick shots while decked out like a B-western gunslinger.

Though warned by his roommate, Bluey-Bluey the Clown, that Annie "ain't the type that makes a happy home," the infatuated Bart falls ever more deeply under the spell of the gun-loving seductress. After being canned by the jealous carny boss, the two promptly get married and, at Annie's instigation, embark on a daring robbery spree, beginning with liquor stores, groceries, and gas stations and working their way up to small-town banks. (Ingeniously shot in extended single takes from the back seat of the getaway car, the bank sequences are celebrated as early examples of seat-of-the-pants "guerilla" filmmaking.) Blaring headlines trumpet stories about the latest crimes of the notorious "Holdup Pair."

Their biggest and final job is the stickup of the payroll office of the Armour Meat Company, where Annie once worked. As we learn from a flash-back, Bart has a revulsion against violence, dating back to a childhood trauma when he killed a baby chick with his BB gun. In true film noir fashion, however, Annie turns out to be a quite literal femme fatale; she already has one murder to her credit and, much to Bart's dismay, doesn't hesitate to shoot her female supervisor and a security guard during the getaway.

Intending to hightail it to Mexico and live off the loot from their heist, they drive to Los Angeles and spend a romantic night at an amusement park, only to find that the FBI has tracked them down by means of the serial numbers on the stolen currency. The fugitives take desperate flight by taxi, freight car, and ultimately by foot, ending up in a fog-shrouded swamp, where Bart's old friends, Dave and Clyde, try to persuade them to surrender. When the homicidal Annie leaps to her feet and threatens to kill them, Bart shoots her and is swiftly cut down by a barrage of police gunfire, bringing to a satisfyingly melodramatic end what many cineastes regard as the greatest of all Hollywood B movies.

THE YOUNG SAVAGES (1961)

DIRECTED BY JOHN FRANKENHEIMER. WRITTEN BY EDWARD ANHALT AND J. P. MILLER. WITH BURT LANCASTER, DINA MERRILL, EDWARD ANDREWS, SHELLEY WINTERS, TELLY SAVALAS, AND JOHN DAVIS CHANDLER.

In an age when the weapon of choice for any self-respecting inner-city gang member is a 9 mm semiautomatic Glock, the switchblade-wielding juvenile delinquents of yesteryear seem almost quaint in their relative harmlessness. In their own time, however—that is, the 1950s—they were viewed as the nation's greatest public menace: a vast horde of greasy-haired teen barbarians who sneered at all social norms and posed a mortal threat to the safety and security of decent citizens. So extreme was the panic over this presumed epidemic of adolescent lawlessness that, according to one national poll, juvenile delinquency ranked higher on the list of public concerns than open-air atom bomb testing. This widespread hysteria was fueled not only by the relentless media coverage given to every crime involving teenage miscreants but by social problem movies like *The Blackboard Jungle*, *Rebel Without a Cause*, and *The Young Savages*.

Directed by John Frankenheimer (who, just a year later, would give the world one of the greatest thrillers ever to come out of Hollywood, *The Manchurian Candidate*), this taut black-and-white film, shot on location, begins like a nonmusical *West Side Story*. In a Manhattan slum neighborhood, a trio of punks, members of an all-white gang called the Thunderbirds, stride in unison along the crowded sidewalks. Shoving children aside, kicking over a little girl's doll carriage, paying no attention to oncoming vehicular traffic or the teeming tenement life around them, they march forward as if they own the streets. All three are attired in accordance with the juvenile delinquent dress code: black leather jacket, blue jeans with high-rolled cuffs, engineer boots. One of them—whose nickname, we later learn, is "Batman"—also sports a black cape. When they reach their destination—a stoop in Spanish Harlem, where a blind Puerto Rican teen is playing a harmonica—the three Thunderbirds whip out their switchblades, set upon the boy, and stab him to death.

Since the slaying takes place in broad daylight on a street swarming with witnesses, it isn't long before the perpetrators are under arrest. Whipped into a bloodlust by the tabloids, the public clamors for their execution. Knowing that sending the boys to the chair will win him votes, the politically ambitious district attorney, who has his eyes on the governorship, is determined to have them convicted of premeditated murder. To that end, he assigns his best man to prosecute the case, Assistant District Attorney Hank Bell, played with understated intensity by Burt Lancaster.

We come to learn that Hank grew up on the same mean streets as the killers. His family name, before his father Americanized it, was Bellini. He has escaped his lower-class origins partly through his own energy and talents and partly through his marriage to an elegant WASP socialite, Karin, played by the elegant WASP socialite Dina Merrill (daughter of the breakfast-cereal heiress Marjorie Merriweather Post and Wall Street broker E. F. Hutton, founder of the eponymous firm). A liberal of the sort that the Archie Bunkers of the world deride as "bleeding hearts," Karin is horrified by her husband's efforts to secure the death penalty for the young defendants. Though her idealistic sentiments are severely put to the test when she is terrorized in an elevator by a couple of hoods, she persists in seeing the teen killers as products of their disadvantaged background, not as the animals portrayed in the press.

Hank finds himself torn not only between the opposing wishes of his boss and his wife but also between those of two anguished parents: the grief-stricken mother of the victim, who demands eye-for-an-eye justice for her murdered son, and Mary diPace (Shelley Winters), the mother of one of the accused, who is convinced that her boy could never have committed such a deed. Complicating matters is the fact that Mary and Hank had once been lovers and nearly gotten married.

As Hank investigates the crime (assisted by a police detective named Gunderson, played by the future Kojak, Telly Savalas), he discovers that the case is not as straightforward as it seemed. The victim, it turns out, was not a helpless, handicapped innocent but a crucial member of the Horsemen, the Thunderbirds' Puerto Rican adversaries. Evidence emerges that Mary's son, Bobby, had once intervened to save the life of a young Puerto Rican boy who was in danger of being drowned by the Thunderbirds' psychopathic leader, Arthur Reardon (played by the ever-repulsive character actor John Davis Chandler).

In its final act, the movie becomes a courtroom drama, complete with the kind of climactic, Hollywood twist that not only upends the expected outcome but also leads Hank, at the risk of his career, to defy his boss and do the right thing, in keeping with the film's progressive attitudes.

Though *The Young Savages* reverses the races—in actuality, the perpetrators were Puerto Rican and the victims were white—the black cape worn by the character called Batman clearly points to the film's real-life inspiration: the sensational crime known as the Cape Man murders that sent shock waves through New York City two years before the movie's release.

"Cape Man" was the sinister nickname bestowed by the tabloids on the leading figure in the tragedy, a severely disturbed sixteen-year-old, Salvador Agron. Born in the small Puerto Rican town of Mayaguez in 1943, Sal endured a nightmarish childhood after his mother, who had married at thirteen, fled her much older husband, charging him "with beating her with a machete, neglecting her for other women, and drunkenness." Along with her two children—eighteen-month-old Sal and his older sister, Aurea, both of whom were suffering from malnutrition—she found shelter in a Roman Catholic asylum for the poor, a Dickensian place that Sal would always remember as "a house of madness."

Separated from his mother, who was given work in the ward for the aged and allowed to see her children only on Sundays, Sal "never adjusted to life in

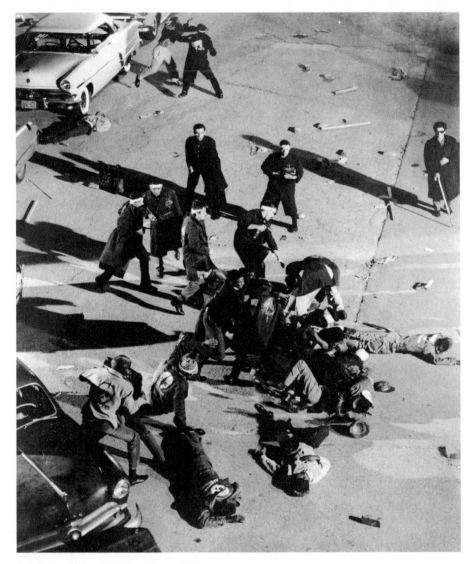

A chaotic scene from *The Young Savages*, 1961.

the poorhouse," as reported by Ira Henry Freeman in a *New York Times Magazine* article, "The Making of a Boy Killer":

> He developed a habit of tumbling out of bed and sleeping on the floor. He could never sit still, pay attention, or take orders. When spanked, he threw temper tantrums, and ran away from the asylum several times. Unable to play with other children peaceably in the playground, he attacked them with stones.

A chronic bed wetter whose enuresis persisted until he was fourteen, Sal—as he later wrote in an informal memoir—underwent various tortures at the hands of the nuns (or, as he referred to them, "those Bitches from Hell"). He was forced to stand in the yard in front of the other children with the urine-soaked mattress on his head, spanked "unmercifully," made to "piss on hot bricks," and, on one occasion, thrown onto an anthill: "When I opened my eyes, all I could see were ants, thousands of ants, all over my body, biting and crawling . . . I had been thrown into hell by six Sisters of Charity as a way of curing me from pissing in my bed . . . when I tried to get up, one of the nuns pushed me down again."

Following what he called the "incident with the ants," Sal, then five-and-a-half years old, was sent to live with his father. "Young as he was," writes Freeman, "Sal ran the streets day and night, rarely returning home to eat and sometimes not to sleep. He was often found sleeping on the sidewalk or in alleys." As Sal later revealed, it was during this period that, while wandering under a bridge, he was sexually molested by a stranger. He also began to manifest a "strange compulsion to collect razor blades" and to cut himself on the arms and chest.

Just a few months later, he was returned to "the castle of the living dead" (his other name for the almshouse), because his "father and his woman were having fights and he was about to leave her for another woman." Except for his aborted stay with his father, Sal spent eight years in that grim institution. When he emerged at age ten, he had gotten "the equivalent of only one year's schooling" and was unable to read or write. His teachers reported that "his speech remained 'babyish,' that he spent his time making 'weird' drawings, that he could not pay attention in class, that he fidgeted constantly, caused disturbances, and kept wandering out. Once, he fled to the garden and buried himself."

In 1952, Sal came to New York City where his mother, now remarried to a Pentecostal minister named Carlos Gonzales, had moved a year earlier. Badly abused by his stepfather—who administered regular beatings with a strap to "drive out his demons"—Sal took to skipping school and hanging out on street corners. After breaking into a neighbor's apartment and stealing a few cigars, some cash, and a flashlight, he was sent to a youth house for nine months. Not long after his release, Reverend Gonzales, unable to deal with his unmanageable stepson, entered a delinquent child's complaint in Children's Court, and Sal was consigned to the Wiltwyck School, a "residential treatment center" for "deprived and disturbed boys."

Though officially committed to a program of "moral and spiritual enlightenment, character development, correction of behavior problems, education and training for good citizenship," Wiltwyck, like many reform schools, often proved to be a breeding ground for criminality. Such was the case for Sal, who, as he wrote, "wound up more of a juvenile delinquent than when I went in . . . I learned about crimes and gangs . . . I picked up many bad habits, such as the knowledge of pot and smoking."

Like many of the inmates—as well as their adult counselors—he also indulged in "rampant homosexuality." Typical of his experience was the "day when this other kid and I took an innocent boy to the forest and attacked him. We sexually assaulted this poor kid as he cried for help. I smacked him across the mouth and made him submit to our attack." Later, seized by remorse, Sal sought out the boy and apologized to him, only to be "shocked to hear from his very mouth that he enjoyed the rape and was looking forward to us doing the same thing to him again."

"I met lots of boys like this at the Wiltwyck School for Boys," recalled Sal.

Back home in Brooklyn after his release in 1956, thirteen-year-old Sal became a junior member of a gang, the Chaplains, whose primary activities were hanging out on street corners and engaging in knife-, chain-, and zipgun-wielding rumbles with rivals from neighboring turfs. Desperate to get him away from his hoodlum friends, his mother sent him back to Puerto Rico to live with his father, now disabled by a stroke and married to a much younger woman who hanged herself shortly after Sal's arrival (altogether, as Freeman notes, the elder Agron would have ten wives, legal and common law, before his death at age fifty-five). After a brief stint at a Mayaguez reformatory, where he was sent for assaulting

another boy with a broken bottle, Sal was returned to New York City. By then, he was showing signs of incipient psychosis, seeing "demons" and hearing voices "telling him to do bad things."

Back in Brooklyn, Sal became an initiated member of an even more fearsome street gang, the Mau Maus. He took to wielding a bayonet during gang rumbles. "I mostly used to stab people on their shoulders or their thighs," Sal later wrote, "not really wanting to kill someone, but I always wanted to hurt them—hurt them real bad. I had anger and hate in my eyes."

Fearing for his life when a rival gang, the Sand Street Angels, sought revenge on the Mau Maus for shooting one of their members in a penny arcade, Sal took refuge in the home of his sister, Aurea, now married and living in Harlem. When Aurea and her husband split up soon afterward, Sal found himself living "like an alley cat, sleeping in abandoned buildings scrounging food where he could, doing odd jobs for storekeepers, occasionally getting a handout from Aurea or his mother." He finally found a home when he joined a Puerto Rican gang, the Vampires, and moved into a seven-dollar-a-week apartment with another member, Tony Hernandez, who reportedly "earned his money as a prostitute."

In keeping with the gang's name, Hernandez occasionally sported a black nurse's cloak lined with red satin—a close approximation of the cape worn by Bela Lugosi's Count Dracula, one of the classic movie monsters then appearing regularly on "creature feature" programs on TV. Around midnight on Sunday, August 30, 1959, after getting word that one of their gang members had been beaten up by a white gang called the Nordics, Sal borrowed the cape, armed himself with a Mexican dagger with a seven-inch blade, and headed into the night with Hernandez, who was carrying an umbrella with a sharpened point. After rendezvousing with several other Vampires, along with allies from two "brother gangs," the Young Lords and the Heart Kings, they proceeded to the Nordics' usual hangout, an unlit concrete playground in the West Side tenement neighborhood known as Hell's Kitchen.

A group of neighborhood teens were sitting on the benches, shooting the breeze, when Sal and his cohorts showed up. Among them were Anthony Krzesinski and Robert Young, both sixteen, and their eighteen-year-old friend Ewald Reimer, none of whom belonged to the Nordics or any other gang. Sensing trouble, Krzesinski and his pals headed for the exit but were blocked by

one of the Vampires, who declared: "No gringos leave the park." All at once, a melee broke out. As sociologist Eric C. Schneider describes:

> fists were flying, broom handles, garrison belts and bottles were swinging, a sharpened umbrella was jabbed into a boy's stomach, and the boy with the cape flashed a sliver-handled knife that he plunged into Robert Young's back. Two boys grabbed Anthony Krzesinski and held him down while [Agron] stabbed him in the chest, piercing his heart and lung. While Young and Krzesinski managed to run out of the park despite their wounds, [Reimer] was cornered by four boys, who punched him until Agron stepped in and stabbed him in the stomach. Reimer broke free but was tripped and stomped until someone said, "He's had enough."

Young managed to drag himself up a flight of stairs to a friend's apartment, where he collapsed facedown on the living room floor and died. Krzesinski ran into a nearby building and died in the hallway. Rushed to St. Clare's Hospital, the critically wounded Reimer survived.

Two nights later, Agron and Hernandez—soon to be known in the tabloids as "the Cape Man" and "the Umbrella Man"—were spotted by patrolmen in the East Bronx and promptly arrested. Hauled before the press, Agron alternately smirked, snarled, and swaggered. "I don't care if I burn," he boasted to reporters. "My mother could watch me."

When a newsman stuck a microphone in his face and asked how he felt, Agron shrugged: "Like I always feel."

"Do you feel like a big man?"

"I feel like killing *you*," Agron sneered. "That's how I feel."

Inflamed by the tabloids—which ran page-one photos of the grinning Agron below headlines reading KILLED BECAUSE "I FELT LIKE IT" SAYS CAPE MAN—the public howled for his blood. They got what they demanded when, following a thirteen-week trial in the summer of 1960, Agron was found guilty of first-degree murder and sentenced to the electric chair in Sing Sing—the youngest person in New York State's history to receive the death penalty. One week before his scheduled execution in May 1962, New York's governor, Nelson Rockefeller—heeding

a campaign for clemency supported by, among others, former first lady Eleanor Roosevelt—commuted the sentence to life in prison.

Over the next twenty years, Sal—an illiterate, dangerously unstable adolescent when he entered the prison system—underwent a dramatic transformation, becoming a born-again Christian, reading deeply in philosophy, religion, and radical politics, and earning an associate's degree from a community college. Declared "the most rehabilitated man I've ever met" by famed attorney William M. Kunstler, he was paroled in November 1979 and went to live with his mother in the Bronx, where—as the *New York Times* noted—"he tried to find peace . . . reading, writing poetry, enjoying his sister's children and grandchildren, and working as a youth counselor for a community center in Manhattan." He died of natural causes on April 22, 1986, just a few days shy of his forty-third birthday.

CAPEMAN: THE MUSICAL

As with countless other kids growing up in New York City in the 1950s, the Cape Man murders made a powerful impression on the young Paul Simon. Still haunted by the case more than three decades later, Simon, having become one of the most celebrated singer-songwriters of his generation, hit on the idea of turning Salvador Agron's story into a Broadway musical; in the words of *New York Times* reporter Stephen J. Dubner, the project would allow him to pay homage to the "doo-wop, rock 'n' roll and Puerto Rican music that filled the city's streets when both he and Agron were teenagers."

With the guidance of a pal named Carlos Ortiz, Simon immersed himself in Spanish-language newspaper accounts of the case, steeped himself in Latin music, and traveled to Puerto Rico to interview Agron's mother, Esmeralda. He then spent five years and $1 million of his own money composing and recording the songs for the show: "an operatic memory play," as Dubner describes it, that "begins with Agron's release from prison, then flashes back to his childhood in Puerto Rico, his teenage years in New York, his prison term, a surreal visit to the Arizona desert and back home to Esmerelda."

Despite a complete lack of experience in mounting a Broadway production, the notoriously "perfectionist" Simon insisted on exerting total control over the project, assembling a seeming dream team of talent, including Nobel Prize–winning poet Derek Walcott, famed choreographer Mark Morris, and—in the roles of the teenage and grown-up Agron—salsa heartthrob Marc Anthony and renowned singer-songwriter-actor (and one-time candidate for Panamanian president) Rubén Blades. As the show neared its opening date, four-time Tony Award–winning director Jerry Zaks was also brought on board.

Partly owing to Simon's perceived arrogance in scorning all Broadway tradition, theatrical insiders predicted—with unconcealed *schadenfreude*— that the show would be a disaster. In the end, the bad buzz was largely confirmed. Though reviewers praised Simon's songs as one of the finest scores ever composed for the stage, the show itself was unanimously deemed a dud, with a confused story, one-dimensional characters, and inert staging. Panned by influential *New York Times* drama critic Ben Brantley as a "benumbed spectacle . . . one solemn, helplessly confused drone," *The Capeman* closed after only sixty-eight performances. It took Paul Simon another ten or so years to admit the obvious: "It's not that easy to write for the theater for the first time," he told an interviewer. "You really need a guide. For people coming out of popular music, writing songs that further the plot is different from writing whatever is on your mind. It's a different discipline."

BOOKS CONSULTED

Adams, Charles F. *Murder by the Bay: Historic Homicide in and about the City of San Francisco*. Sanger, CA: Word Dancer, 2005.

Anderson, Mary Ann. *The Making of* The Hitch-Hiker *Illustrated*. Albany, GA: BearManor Media, 2013.

Baatz, Simon. *For the Thrill of It: Leopold, Loeb, and the Murder That Shocked Jazz Age Chicago*. New York: Harper, 2008.

Bailey, Brian. *Burke and Hare: The Year of the Ghouls*. Edinburgh: Mainstream, 2002.

Bailey, F. Lee. *When the Husband Is the Suspect*. New York: Tom Doherty, 2008.

Bailey, Frankie Y., and Steven M. Chermak, eds. *Famous American Crimes and Trials*. Vol. 3, *1913–1959*. Westport, CT: Praeger, 2004.

Bardens, Dennis. *The Ladykiller: The Life of Landru, the French Bluebeard*. London: Peter Davies, 1972.

Bartlett, Evan Allen. *Love Murders of Harry Powers: Beware Such Bluebeards*. New York: Sheftel, 1931.

Berg, A. Scott. *Lindbergh*. New York: Putnam, 1998.

Bergman, Paul, and Michael Asimov. *Reel Justice: The Courtroom Goes to the Movies*. Kansas City, MO: Andrews McMeel, 2006.

Biskind, Peter. *Easy Riders, Raging Bulls: How the Sex-Drugs-and-Rock-'n'-Roll Generation Saved Hollywood*. New York: Simon & Schuster, 1998.

Bouzereau, Laurent. *Ultraviolent Movies: From Sam Peckinpah to Quentin Tarantino*. New York: Kensington/Citadel, 2000.

Breo, Dennis L., and William J. Martin. *The Crime of the Century: Richard Speck and the Murders That Shocked a Nation*. New York: Skyhorse, 2016.

Bruccoli, Matthew J. *The O'Hara Concern: A Biography of John O'Hara*. New York: Random House, 1975.

Burrough, Bryan. *Public Enemies: America's Greatest Crime Wave and the Birth of the FBI, 1933–34*. New York: Penguin, 2005.

Cahill, Richard T., Jr. *Hauptmann's Ladder: A Step-by-Step Analysis of the Lindbergh Kidnapping*. Kent, OH: Kent State University Press, 2014.

Carnes, Mark C., ed. *Past Imperfect: History According to the Movies*. New York: Henry Holt, 1996.

Chester, Graham. *Berserk! Terrifying True Stories of Notorious Mass Murders and the Deranged Killers Who Committed Them*. New York: St. Martin's, 1993.

Cook, Fred J. *The Girl on the Lonely Beach*. New York: Fawcett/Gold Medal, 1954.

Couchman, Jeffrey. The Night of the Hunter: *A Biography of a Film*. Evanston, IL: Northwestern University Press, 2009.

Cude, Elton R. *The Wild and Free Dukedom of Bexar*. San Antonio, TX: Munguia Printers, 1978.

Cullen, Dave. *Columbine*. New York: Hachette, 2009.

Cullen, Robert. *The Killer Department: Detective Viktor Burakov's Eight-Year Hunt for the Most Savage Serial Killer in Russian History*. New York: Pantheon, 1993.

Derry, Charles. *Dark Dreams 2.0: A Psychological History of the Horror Film from the 1950s to the 21st Century*. Jefferson, NC: McFarland, 2009.

Dickos, Andrew. *Street with No Name: A History of the Classic American Film Noir*. Lexington: University Press of Kentucky, 2002.

Einstein, Charles. *The Bloody Spur*. New York: Dell, 1956.

Eisner, Lotte H. *Fritz Lang*. New York: Oxford University Press, 1977.

Englade, Ken. *Deadly Lessons*. New York: Diversion Books, 1991.

Everitt, David. *Human Monsters: An Illustrated Encyclopedia of the World's Most Vicious Murderers*. Chicago: Contemporary Books, 1993.

Farrell, Harry. *Swift Justice: Murder and Vengeance in a California Town*. New York: St. Martin's, 1992.

Flom, Eric L. *Chaplin in the Sound Era: An Analysis of the Seven Talkies*. Jefferson, NC: McFarland, 1997.

Foery, Raymond. *Alfred Hitchcock's Frenzy: The Last Masterpiece*. Lanham, MD: Scarecrow, 2012.

Fosburgh, Lacey. *Closing Time: The True Story of the "Goodbar" Murder*. New York: Delacorte, 1977.

Freeman, Lucy. "*Before I Kill More . . .*" New York: Crown, 1955.

Gilmore, John. *L.A. Despair: A Landscape of Crimes & Bad Times*. Los Angeles: Amok Books, 2005.

Goodman, Jonathan. *The Passing of Starr Faithfull*. Kent, OH: Kent State University Press, 1996.

Grady, Alan. *When Good Men Do Nothing: The Assassination of Albert Patterson*. Tuscaloosa: University of Alabama Press, 2003.

Graysmith, Robert. *Zodiac Unmasked: The Identity of America's Most Elusive Serial Killer Revealed*. New York: Berkley Books, 2002.

Guinn, Jeff. *Go Down Together: The True, Untold Story of Bonnie and Clyde*. New York: Simon & Schuster, 2009.

Hilburn, Robert. *Paul Simon: The Life*. New York: Simon & Schuster, 2018.

Hogan, David J. *Film Noir FAQ: All That's Left to Know About Hollywood's Golden Age of Dames, Detectives, and Danger*. Milwaukee: Applause Theatre & Cinema Books, 2013.

Howard, Gene L. *Patterson for Alabama: The Life and Career of John Patterson*. Tuscaloosa: University of Alabama Press, 2008.

Jacoby, Richard. *Conversations with the Capeman: The Untold Story of Salvador Agron*. Madison: University of Wisconsin Press, 2004.

Jarossi, Robin. *The Hunt for the 60s' Ripper*. London: Mirror Books, 2017.

Jenkins, Stephens, ed. *Fritz Lang: The Image and the Look*. London: British Film Institute, 1981.

Kaes, Anton. *M*. London: British Film Institute, 2000.

Kelley, Kitty. *Elizabeth Taylor: The Last Star*. New York: Simon & Schuster, 1981.

Kelly, Gabrielle, and Cheryl Robson. *Celluloid Ceiling: Women Film Directors Break Through*. Twickenham, UK: Supernova Books, 2014.

Kirby, Dick. *Laid Bare: The Nude Murders and the Hunt for "Jack the Stripper."* Gloucestershire, UK: History Press, 2016.

Kitses, Jim. *Gun Crazy*. London: British Film Institute, 1996.

Knight, James R. *Bonnie and Clyde: A Twenty-First-Century Update*. Fort Worth, TX: Eakin, 2003.

Lavergne, Gary M. *A Sniper in the Tower: The Charles Whitman Murders*. Denton: University of North Texas Press, 1997.

Lourie, Richard. *Hunting the Devil: The Search for the Russian Ripper*. London: Grafton, 1993.

MacKellar, Landis. *The "Double Indemnity" Murder: Ruth Snyder, Judd Gray, and New York's Crime of the Century*. Syracuse, NY: Syracuse University Press, 2006.

Markowitz, Susan (with Jenna Glatzer). *My Stolen Son: The Nick Markowitz Story*. New York: Berkley Books, 2010.

Mayo, Mike. *American Murder: Criminals, Crime, and the Media*. Canton, MI: Visible Ink, 2008.

McCarty, John. *Bullets over Broadway: The American Gangster Picture from the Silents to The Sopranos*. New York: Da Capo, 2004.

McConnell, Brian. *Found Naked and Dead: The Facts Behind the Thames-side Murders*. London: New English Library, 1974.

McGilligan, Patrick. *Fritz Lang: The Nature of the Beast.* New York: St. Martin's, 1997.

Mordden, Ethan. *All That Jazz: The Life and Times of the Musical* Chicago. New York: Oxford University Press, 2018.

Nash, Jay Robert. *The Great Pictorial History of World Crime.* Lanham, MD: Scarecrow, 2004.

Nashawaty, Chris. *Crab Monsters, Teenage Cavemen, and Candy Stripe Nurses: Roger Corman: King of the B Movie.* New York: Abrams, 2013.

Neff, James. *The Wrong Man: The Final Verdict on the Dr. Sam Sheppard Murder Case.* New York: Random House, 2001.

Newton, Michael. *The Encyclopedia of Unsolved Crimes.* 2nd ed. New York: Facts on File, 2009.

Niemi, Robert. *Inspired by True Events: An Illustrated Guide to More than 500 History-Based Films.* 2nd ed. Santa Barbara, CA: ABC-CLIO, 2013.

Ott, Frederick W. *The Films of Fritz Lang.* Secaucus, NJ: Citadel, 1979.

Pardoe, Blaine L. *Sawney Bean: Dissecting the Legend of the Scottish Cannibal.* Stroud, UK: Fonthill Media, 2015.

Peary, Danny. *Cult Crime Movies.* New York: Workman, 2014.

Perry, Douglas. *The Girls of Murder City: Fame, Lust, and the Beautiful Killers Who Inspired* Chicago. New York: Viking, 2010.

Phelps, M. William. *The Devil's Rooming House: The True Story of America's Deadliest Female Serial Killer.* Guilford, CT: Lyons, 2010.

Phillips, Gene D. *Out of the Shadows: Expanding the Canon of Classic Film Noir.* Lanham, MD: Scarecrow, 2012.

Pratley, Gerald. *The Cinema of Otto Preminger.* London: A. Zwemmer, 1971.

Ramsland, Katherine. *Inside the Minds of Mass Murderers: Why They Kill.* Westport, CT: Praeger, 2005.

Rebello, Stephen. *Alfred Hitchcock and the Making of* Psycho. New York: Soft Skull, 2013.

Reiter, Gershon. *The Shadow Self in Film: Projecting the Unconscious Other.* Jefferson, NC: McFarland, 2014.

Rolling, Danny, and Sondra London. *The Making of a Serial Killer: The Real Story of the Gainesville Murders in the Killer's Own Words.* Portland, OR: Feral House, 1996.

Rosa, John P. *Local Story: The Massie-Kahahawai Case and the Culture of History.* Honolulu: University of Hawaii Press, 2014.

Rosner, Lisa. *The Anatomy Murders: Being the True and Spectacular History of Edinburgh's Notorious Burke and Hare, and of the Man of Science Who Abetted Them in the Commission of Their Most Heinous Crimes.* Philadelphia: University of Pennsylvania Press, 2010.

Rossner, Judith. *Looking for Mr. Goodbar.* New York: Simon & Schuster, 1975.

Roughead, William. *Burke and Hare.* Edinburgh: William Hodge, 1921.

Ryzuk, Mary S. *The Gainesville Ripper: A Summer's Madness, Five Young Victims— the Investigation, the Arrest and the Trial.* New York: St. Martin's, 1994.

Schechter, Harold. *Bestial: The Savage Trail of a True American Monster.* New York: Pocket Books, 1998.

———. *Psycho USA: Famous American Killers You Never Heard Of.* New York: Ballantine Books, 2012.

———. *The Serial Killer Files: The Who, What, Where, How, and Why of the World's Most Terrifying Murderers.* New York: Ballantine Books, 2003.

Scherle, Victor, and William Turner Levy, eds. *The Films of Frank Capra.* Secaucus, NJ: Citadel, 1977.

Schneider, Eric C. *Vampires, Dragons, and Egyptian Kings: Youth Gangs in Postwar New York.* Princeton, NJ: Princeton University Press, 1999.

Schutze, Jim. *Bully: A True Story of High School Revenge.* New York: Avon Books, 1997.

Scott, Robert. *Most Wanted Killer.* New York: Pinnacle Books, 2010.

Seabrook, David. *Jack of Jumps.* London: Granta Books, 2006.

Serafin, Faith. *Wicked Phenix City.* Charleston, SC: History Press, 2014.

Shirley, Glenn. *Born to Kill: He Blazed a Trail of Death and Terror Across Fourteen States.* Derby, CT: Monarch Books, 1963.

Sifakis, Carl. *The Encyclopedia of American Crime.* New York: Facts on File, 1982.

Smith, Joseph W. *The Psycho File: A Comprehensive Guide to Hitchcock's Classic Shocker.* Jefferson, NC: McFarland, 2009.

Spoto, Donald. *The Art of Alfred Hitchcock: Fifty Years of His Motion Pictures.* 2nd ed. New York: Anchor Books, 1992.

Stannard, David E. *Honor Killing: Race, Rape, and Clarence Darrow's Spectacular Last Case*. New York: Penguin, 2006.

Sterritt, David. *The Films of Alfred Hitchcock*. Cambridge: Cambridge University Press, 1993.

Strickland, Edwin, and Gene Wortsman. *Phenix City: The Wickedest City in America*. Birmingham, AL: Vulcan, 1955.

Sykes, Brad. *Terror in the Desert: Dark Cinema of the American Southwest*. Jefferson, NC: McFarland, 2018.

Toland, John. *The Dillinger Days*. New York: Random House, 1963.

Trest, Warren. *Nobody but the People: The Life and Times of Alabama's Youngest Governor*. Montgomery, AL: NewSouth Books, 2008.

Van Slingerland, Peter. *Something Terrible Has Happened*. New York: Harper & Row, 1966.

Vermilye, Jerry. *The Films of Charles Bronson*. Secaucus, NJ: Citadel, 1980.

Watkins, Maurine. Chicago: *With the* Chicago Tribune *Articles That Inspired It*. Edited by Thomas H. Pauly. Carbondale: Southern Illinois University Press, 1997.

Wolff, Geoffrey. *The Art of Burning Bridges: A Life of John O'Hara*. New York: Alfred A. Knopf, 2003.

Yule, Andrew. *Picture Shows: The Life and Films of Peter Bogdanovich*. New York: Limelight Editions, 1992.

INDEX

PHOTO CREDITS

Foreword, *The Wrong Man* (1956): © Warner Bros./Courtesy Everett Collection.

Alpha Dog (2007): © New Line/Courtesy Everett Collection.

Anatomy of a Murder (1959): © Carlyle Productions/Mary Evans/Ronald Grant/ Courtesy Everett Collection.

Arsenic and Old Lace (1944): © Warner Bros./Courtesy Everett Collection.

Badlands (1973): © Warner Bros/Kobal/Shutterstock.

Blood & Orchids (1986): Bettmann/Getty Images.

The Body Snatcher (1945): © RKO Radio Pictures/Courtesy Everett Collection.

BUtterfield 8 (1960): © Metro-Goldwyn-Mayer Studios Inc./Courtesy Everett Collection.

Chicago (1927): Courtesy Everett Collection.

Roxie Hart (1942): © 20th Century-Fox Film Corp. All Rights Reserved./ Courtesy Everett Collection.

Child 44 (2015): © Summit Entertainment/Courtesy Everett Collection.

Dirty Harry (1971): © The Malpaso Company/Courtesy Everett Collection.

Double Indemnity (1944): Courtesy the *Leader-Telegram*. Eau Claire, Wisconsin. 1928. Digitally sourced from Newspapers.com.

Eaten Alive! (1976): Bettmann/Getty Images.

Elephant (2003): © Meno Film Company/United Archives GmbH/Alamy Stock Photo.

Five Star Final (1931): © Warner Bros./Courtesy Everett Collection.

Frenzy (1972): © Universal Pictures/Courtesy Everett Collection.

The Fugitive (1993): © Warner Brothers/Courtesy Everett Collection.

Fury (1936): © Metro-Goldwyn-Mayer Studios Inc./Underwood Archives/ Shutterstock.

High Sierra (1941): © Warner Bros./Lordprice Collection/Alamy Stock Photo.

The Hills Have Eyes (1977): © Blood Relations Company/Courtesy Everett Collection.

The Hitch-Hiker (1953): © RKO Radio Pictures/Mary Evans/Ronald Grant/ Everett Collection.

The Honeymoon Killers (1970): © Roxanne/Courtesy Everett Collection.

Looking for Mr. Goodbar (1977): © Paramount/Courtesy Everett Collection.

M (1931): © Nero-Film A.G./Courtesy Everett Collection.

Monsieur Verdoux (1947): Courtesy Everett Collection.

Murder on the Orient Express (1974): © G.W. Films Limited/Album/Alamy Stock Photo.

The Night of the Hunter (1955): © United Artists/GL Archive/Alamy Stock Photo.

The Phenix City Story (1955): © *Allied Artists Pictures*/Courtesy Everett Collection.

A Place in the Sun (1951): © Paramount Pictures/Courtesy Everett Collection.

Psycho (1960): © Universal Pictures/Courtesy Everett Collection.

Rope (1948): © Warner Bros./Everett Collection Historical/Alamy Stock Photo.

Scream (1996): © Dimension Films/Courtesy Everett Collection.

Shadow of a Doubt (1943): © Skirball Productions/Courtesy Everett Collection.

The Strangers (2008): © Rogue Pictures/Mary Evans/Ronald Grant/Everett Collection

Targets (1968): © Paramount Pictures/Courtesy Everett Collection.

10 to Midnight (1983): © Cannon Group and City Films/Everett Collection/Shutterstock.

To Die For (1995): © Columbia Pictures/Courtesy Everett Collection.

While the City Sleeps (1956): © RKO Radio Pictures/Courtesy Everett Collection.

A Woman's Vengeance (1948): © Universal Pictures/TCD/Prod.DB/Alamy Stock Photo.

You Only Live Once (1937): © Walter Wanger Productions, Inc./Pictorial Press Ltd./Alamy Stock Photo.

The Young Savages (1961): © United Artists/Courtesy Everett Collection.

ABOUT THE AUTHOR

Photo © 2019 Kimiko Hahn

Harold Schechter is an American true-crime writer who specializes in serial killers. Twice nominated for the Edgar Award, he is the author of the nonfiction books *Fatal, Fiend, Bestial, Deviant, Deranged, Depraved, The Serial Killer Files, The Mad Sculptor, Man-Eater*, the Amazon Charts and *Washington Post* bestseller *Hell's Princess: The Mystery of Belle Gunness, Butcher of Men*, and the Amazon Original Stories collection *Bloodlands*. Schechter attended the State University of New York in Buffalo. A professor emeritus at Queens College, Schechter is married to the poet Kimiko Hahn. For more information, visit www.haroldschechter.com.